D1097794

missing link

THE IMAGE OF MAN IN CONTEMPORARY PHOTOGRAPHY

TRACEY MOFFATT · MARIKO MORI · YASUMASA MORIMURA · BRUCE NAUM

GINA PANE · PIERRE ET GILLES · JACK PIERSON · MAGNUS VON PLESSEN · LI

MAY POST · RICHARD PRINCE · UGO RONDINONE · THOMAS RUFF · SAM SAMO

JAN SAUDEK · RUDOLF SCHWARZKOGLER · ANDRES SERRANO · CINDY SHERM

YINKA SHONIBARE · ANATOLIJ SHURAVLEV · ERIK STEINBRECHER · ANNELI

STRBA · BEAT STREULI · MARION STRUNK · THOMAS STRUTH · WOLFGA

TILLMANS · HANNAH VILLIGER · JEFF WALL · ANDY WARHOL · WILLI

WEGMAN · CECILE WICK · JOEL-PETER WITKIN · ERWIN WURM · FAIS

ABDU'ALLAH · MARINA ABRAMOVIC · NOBUYOSHI ARAKI · STEFAN BANZ · TI

BARA · GILLES BARBIER · MATTHEW BARNEY · VANESSA BEECROFT · RICHA

BILLINGHAM · OLAF BREUNING · GÜNTER BRUS · DANIELE BUET

BALTHASAR BURKHARD · JAMES LEE BYARS · LARRY CLARK · JOHN COPLA

ERIK DETTWILER · PHILIP-LORCA DICORCIA · RINEKE DIJKSTRA · SIN

DILLENKOFER · JIRI GEORG DOKOUPIL · VALIE EXPORT · SYLVIE FLEU

KATRIN FREISAGER · JEAN LE GAC · GENERAL IDEA · GILBERT & GEORGE · N

GOLDIN · ANTON HENNING · NORITOSHI HIRAKAWA · HUBBARD AND BIRCHL

ZHUANG HUI · SARAH JONES · JÜRGEN KLAUKE · STEFFEN KOOHN · INEZ

LAMSWEERDE · SAVERIO LUCARIELLO · URS LÜTHI · MANON · ROBE

MAPPLETHORPE · CHRISTIAN MARCLAY · REMY MARKOWITSCH · BOR

MICHAILOV · TRACEY MOFFATT · MARIKO MORI · YASUMASA MORIMURA · BRU

NAUMAN · GINA PANE · PIERRE ET GILLES · JACK PIERSON · MAGNUS V

PLESSEN · LIZA MAY POST · RICHARD PRINCE · UGO RONDINONE · THOM

RUFF · SAM SAMORE · JAN SAUDEK · RUDOLF SCHWARZKOGLER · ANDR

SERRANO · CINDY SHERMAN · YINKA SHONIBARE · ANATOLIJ SHURAVL

ERIK STEINBRECHER · ANNELIES STRBA · BEAT STREULI · MARION STRU

missing link

THE IMAGE OF MAN IN CONTEMPORARY PHOTOGRAPHY

Edited by CHRISTOPH DOSWALD

with essays by CARL AIGNER, STEFAN BANZ, CHRISTOPH DOSWALD, THOMAS KOERFER, MAX KOZLOFF, KATHRIN PETERS, THOMAS PFISTER and THOMAS WULFFEN

and contributions by HOLGER EMIL BANGE, RALF BARTHOLOMAUS, DANIEL BAUMANN, KATHRIN BECKER, SILKE BENDER, PAOLO BIANCHI, MANUEL BONIK, REINHARD BRAUN, ELISABETH BRONFEN, MAIA DAMIANOVIC, CHRISTOPH DOSWALD, BEATE ENGEL, OKWUI ENWEZOR, GERRIT GOHLKE, ANNA HELWING, JENNIFER HIGGIE, GIANNI JETZER, JEAN-YVES JOUANNAIS, TOMAS KADLCIK, KLAUS KLEINSCHMIDT, JUTTA KOETHER, ANDREAS KRASE, HOLGER KUBE VENTURA, GERHARD JOHANN LISCHKA, MICHELLE NICOL, ALI ONUR, KATHRIN PETERS, URSULA PRINZ, HANS RUDOLF REUST, BEATRIX RUF, JÖRN SCHAFAFF, KARIN SCHICK, ANDREAS SCHMID, AXEL SCHMIDT, CLAIRE SCHNYDER LÜDI, ULRICH SCHÖTKER, HOLLY SOLOMON, URS STAHEL, JURI STEINER, WOLF-GÜNTER THIEL, CHRISTINA TSCHECH, BRIGITTE ULMER, LUDMILA VACHTOVA, VIOLA VAHRSON, TOBIAS VOGT, KLARA WALLNER, PETER WEIERMAIR and ANNELISE ZWEZ

EDITION STEMMLE

ZURICH NEW YORK

LENDERS

We wish to thank the many private lenders, participating galleries and representatives of foundations and corporate collections for making these often fragile photographic works available for the exhibition *Missing Link*.

The Agency, London
Collection Jean Albou, Paris
Galerie Analix Forever, Geneva
Galerie Ars Futura, Zurich
Galerie Art-Magazin, Zurich
Galerie Art & Public, Geneva
Thomas Braulke, Göttingen
Ruth Eigenmann, Herrliberg
Fotomuseum Winterthur
Galerie Erika and Otto Friedrich, Bern
Andreas Fuhrimann, Zurich
Galerie Hauser & Wirth & Presenhuber, Zurich
Alexander Jolles, Zurich
Ilya and Emilia Kabakov, Long Island, New York
Jasmin Kienast, Zurich
Galerie Peter Kilchmann, Zurich
Sammlung Thomas Koerfer, Zurich
Kunstmuseum Bern
Kunstmuseum Bern (Collection of Toni Gerber)
Kunstmuseum Bern (Swiss Confederacy)
Galerie Mai 36, Zurich
Galerie Urs Meile, Lucerne
Collection MJS, Paris
Galerie Bob van Orsouw, Zurich
Maureen Paley Interim Art, London
Ringier Collection, Zurich
Collection of Christoph Schifferli, Zurich
Christoph Schweinfurth, Zurich
Nicola von Senger, Zurich
Yinka Shonibare / Stephen Friedman Gallery, London
Holly Solomon Gallery, New York
Galerie Stampa, Basle
Foundation Kunst Heute, Bern
Galerie Daniel Varenne, Geneva
Galerie Wohnmaschine, Berlin
Collection of Zellweger-Luwa AG, Uster

Thanks are due as well to those lenders who have expressed the wish to remain anonymous.

ACKNOWLEDGMENTS

The editor and the Kunstmuseum Bern wishes to express heartfelt thank to all those who contributed in so many ways to the realization of the exhibition and this publication.

Bernhard Abegglen, Contexta, Bern
Carl Aigner, Kunsthalle Krems
Ruedi Bechtler, Küsnacht
Monika Betschart, Möbel-Transport AG, Zurich
Paolo Bianchi, Baden
Rolf Bismarck, Berlin
Waling Boers, BüroFriedrich, Berlin
Stefano Brem, Zurich
Elisabeth Bronfen, Zurich
Monica de Cardenas, Galeria Monica de Cardenas, Milan
Claudia Cargnel, Galerie Analix Forever, Geneva
Aurélia Chabrillat, Galerie Georges Philippe and Nathalie Vallois, Paris
Gerti Fitzek, Berlin
Matthias Flügge, Berlin
Michael Freitag, Berlin
Erika and Otto Friedrich, Galerie Friedrich, Bern
Johannes Gachnang, Bern
Marianne Gerny, Foundation Kunst Heute, Bern
Viktor Gisler, Galerie Mai 36, Zurich
Barbara Gladstone, Barbara Gladstone Gallery, New York
Roberto Gomez Godoy, Galerie Art & Public, Geneva
Simone Haelg, Zurich
Adriaan van der Have, Torch Gallery, Amsterdam
Christoph Heinrich, Kunsthalle Hamburg
Leslie Heitzman, Stephen Friedman Gallery, London
Matthias Herrmann, Secession, Vienna
Pierre Huber, Galerie Art & Public, Geneva
Olga Hungar, Berlin
Jean-Noël Jetzer, migros museum für gegenwartskunst, Zurich
Emilia Kabakov, Long Island, New York
Ursula Käser Aebi, USM Möbelsysteme, Münsingen
Walter Keller, Scalo Verlag, Zurich / Berlin / New York
Peter Kilchmann, Galerie Peter Kilchmann, Zurich
Udo Kittelmann, Kunstverein Cologne
Elke Knöss / Wolfgang Grillitsch, Berlin
Thomas Koerfer, Zurich
Felicitas Köchli, Pro Litteris, Zurich
Lars Bang Larsen, Copenhagen
Gudrun Lebede, Galerie Volker Diehl, Berlin
Andrew Leslie, Matthew Marks Gallery, New York
Samuel Leuenberger, Stephen Friedman Gallery, London
Friedrich Loock, Galerie Wohnmaschine, Berlin
Markus Lüttgen, Galerie Johnen and Schöttle, Cologne
Melchior Lussi, Galerie Bruno Bischofberger, Zurich
Carmela Luvino, Galleria Lucio Amelio, Naples
Harm Lux, Zurich
Judy Lybke, Galerie Eigen+Art, Berlin
Gerald Matt, Kunsthalle Vienna
Urs Meile, Galerie Urs Meile, Lucerne
Barbara Mosca, The British Council, Bern
Birgit Müller, Jablonka Galerie, Cologne
Rolf Müller, Galerie Art Magazin, Zurich
Tobias Natter, Österreichische Galerie, Schloss Belvedere, Vienna
Inken Nowak, Neuer Berliner Kunstverein, Berlin
Bob van Orsouw, Galerie Bob van Orsouw, Zurich
Nicolas Pages, New York
Maureen Paley, Maureen Paley Interim Art, London

Marc Payot, Galerie Bob van Orsouw, Zurich
Eva Presenhuber, Galerie Hauser & Wirth & Presenhuber, Zurich
Sara Jo Romero, Holly Solomon Gallery, New York
Beatrix Ruf, Ringier Collection, Zurich
Steffen Sauerteig, eBoy, Berlin
U. Schärer Söhne AG, Münsingen
Christoph Schifferli, Zurich
Rüdiger Schöttle, Galerie Johnen & Schöttle, Cologne
Nicola von Senger, Galerie Ars Futura, Zurich
Stephen Slocante, London
Holly Solomon, Holly Solomon Gallery, New York
Bea de Souza, The Agency, London
Claudia Spinelli, Galerie Walcheturm, Zurich
Urs Stahel, Fotomuseum Winterthur
Gilli and Diego Stampa, Galerie Stampa, Zurich
Thomas N. Stemmle, Edition Stemmle, Thalwil
Dorothea Strauss, Kunsthalle St. Gall
Jacqueline Uhlmann, Galerie Hauser & Wirth & Presenhuber, Zurich
Nathalie and George-Philippe Vallois, Galerie Vallois, Paris
Kerstin Wahala, Galerie Eigen+Art, Berlin
Barbara Weiss, Galerie Barbara Weiss, Berlin
Miriam Wiesel, Berlin
Iwan Wirth, Galerie Hauser & Wirth, Zurich
Robert Züblin, Edition Stemmle, Thalwil

Special thanks are due to the artists for their generous support. Worthy of particular mention are:

Stefan Banz, Lucerne
Tina Bara, Berlin
Vanessa Beecroft, New York
Olaf Breuning, Zurich
Daniele Buetti, Zurich
Balthasar Burkhard, Bern
Erik Dettwiler, Bern
Sinje Dillenkofer, Stuttgart
Katrin Freisager, New York
Anton Henning, Manker
Noritoshi Hirakawa, New York
Teresa Hubbard and Alexander Birchler, Berlin
Sarah Jones, London
Jürgen Klauke, Cologne
Inez van Lamsweerde, New York
Rémy Markowitsch, Berlin
Ugo Rondinone, Zurich / New York
Erik Steinbrecher, Berlin
Annelies Štrba, Richterswil
Marion Strunk, Zurich
Thomas Struth, Düsseldorf
Wolfgang Tillmans, London
Erwin Wurm, Vienna

We wish to thank USM Modular Furniture of Münsingen for the generous support provided for both the exhibition and the accompanying publication. We are also grateful to the British Council, Bern.

CONTENTS

ESSAYS

Christoph Doswald · Missing Link—Close the Gap! **11**
Thomas Pfister · Between Exoticism and Banality—
The Documentary Photograph as Art **21**
Stefan Banz · The Photograph as Misunderstanding **29**
Kathrin Peters · On Being One's Own Encounter Group **33**
Thomas Koerfer · Various Encounters **41**
Max Kozloff · The Self-Portrait—The Conflict between
Self-Representation and Self-Exposure **49**
Thomas Wulffen · The Fragment as Medium **57**
Carl Aigner · In the Eye of the Apparatus—On the Constitution
of the Subject in the Face of Photography **65**

PLATE SECTION

ON THE FRINGES OF DOCUMENTARY
Faisal Abdu'Allah · Paolo Bianchi **72**
Thomas Struth · Hans Rudolf Reust **74**
Annelies Štrba · Ralf Bartholomäus **76**
Boris Michailov · Andreas Krase **78**
Zhuang Hui · Andreas Schmid **80**
Nan Goldin · Anna Helwing **84**
Larry Clark · Jutta Koether **88**
Richard Billingham · Anna Helwing **92**
Stefan Banz · Gianni Jetzer **96**
Nobuyoshi Araki · Manuel Bonik **100**
Jack Pierson · Reinhard Braun **104**
Beat Streuli · Anna Helwing **106**
Rineke Dijkstra · Gianni Jetzer **108**
Andy Warhol · Holly Solomon **112**

SELF-ANALYSIS
Andy Warhol · Karin Schick **116**
Yasumasa Morimura · Ursula Prinz **118**
Jürgen Klauke · Gerhard Johann Lischka **122**
Rudolf Schwarzkogler · Christina Tschech **126**
Günter Brus · Christina Tschech **128**
Bruce Nauman · Beatrix Ruf **130**
Gina Pane · Kathrin Peters **134**
Valie Export · Christina Tschech **138**
Marina Abramović · Christina Tschech **142**
Manon · Ursula Prinz **146**
Cécile Wick · Beate Engel **150**
Tina Bara · Holger Emil Bange **152**
Katrin Freisager · Annelise Zwez **156**
Liza May Post · Gianni Jetzer **160**

SELF-PRESENTATION
Urs Lüthi · Ursula Prinz **164**
GENERAL IDEA · Holger Kube Ventura **168**
Erwin Wurm · Maia Damianovic **172**
Gilles Barbier · Christoph Doswald **174**
Anton Henning · Viola Vahrson **176**
Jean Le Gac · Brigitte Ulmer **178**

James Lee Byars **182**
Saverio Lucariello · Jean-Yves Jouannais **184**
Cindy Sherman · Anna Helwing **186**

STAGED PHOTOGRAPHY
Cindy Sherman · Beatrix Ruf **192**
Jeff Wall · Anna Helwing **196**
Yinka Shonibare · Okwui Enwezor **198**
Sarah Jones · Jennifer Higgie **202**
Philip-Lorca diCorcia · Gianni Jetzer **206**
Gilbert & George · Klara Wallner **210**
Hubbard and Birchler · Gerrit Gohlke **212**
Pierre et Gilles · Silke Bender **216**
Jan Saudek · Klaus Kleinschmidt **218**
Joël-Peter Witkin · Axel Schmidt **220**

FRAGMENTATION
John Coplans · Anna Helwing **224**
Hannah Villiger · Ludmila Vachtova **226**
Balthasar Burkhard · Brigitte Ulmer **228**
Sinje Dillenkofer · Ali Onur **230**
Magnus von Plessen · Wolf-Günter Thiel **232**
Robert Mapplethorpe · Brigitte Ulmer **236**
Andy Warhol · Karin Schick **240**
Noritoshi Hirakawa · Peter Weiermair **244**
Anatolij Shuravlev · Kathrin Becker **246**

MEDIATIZATION
Marion Strunk · Elisabeth Bronfen **252**
Daniele Buetti · Gianni Jetzer **256**
Sam Samore · Michelle Nicol **260**
Andres Serrano · Reinhard Braun **264**
Richard Prince · Daniel Baumann **266**
Tracey Moffatt · Gianni Jetzer **270**
Sylvie Fleury · Michelle Nicol **274**
Erik Steinbrecher · Tomas Kadlcik **278**
Wolfgang Tillmans · Jörn Schafaff **280**
Olaf Breuning · Anna Helwing **284**
Steffen Koohn · Juri Steiner **288**
Jiri Georg Dokoupil · Ulrich Schötker **290**
Christian Marclay · Gianni Jetzer **292**
Rémy Markowitsch · Urs Stahel **294**

RECONSTRUCTION
William Wegman · Tobias Vogt **300**
Thomas Ruff · Reinhard Braun **304**
Ugo Rondinone · Anna Helwing **306**
Vanessa Beecroft · Michelle Nicol **310**
Erik Dettwiler · Claire Schnyder Lüdi **312**
Matthew Barney · Klara Wallner **314**
Inez van Lamsweerde · Michelle Nicol **318**
Mariko Mori · Gianni Jetzer **322**

THE AUTHORS **325**

The camera is a "vital means of communication and expression. The growth of its contribution to the visual arts is the subject of this book." These words written by Beaumont Newhall in 1949 in the preface to his book for the Museum of Modern Art in New York have lost none of their currency—indeed, they now strike us as quite prophetic. While Newhall's exhibition *The History of Photography* gave the medium its museum "seal of approval," the European art world hesitated for decades before embracing the "new" technology. Only recently has the old continent joined the New World in bestowing on photography the recognition it deserves. European reticence notwithstanding, the medium has celebrated an extraordinary march of triumph through the great exhibition halls of Europe over the past few years.

The Kunstmuseum Bern may well point with some pride to its vanguard role in this context. Since the 1960s, when the medium was still held in widespread disregard, photography has been the focus of systematic collection at the museum. Having called attention to the growing significance of photography in art in a 1988 exhibition, we now wish to step back and take stock, as it were. Using the current situation in photography as his point of departure, guest curator Christoph Doswald has viewed the museum collections, to which substantial additions have been made during the past three years, and conceived an exhibition devoted to the image of man in contemporary photography: *Missing Link*.

No other medium, according to his thesis, has altered the human self-image and transformed art's perception of itself as lastingly and profoundly as photography. Widely disseminated and intensified through the mass media, photographic images of man exert a continuous formative influence upon the way we see our world and ourselves. At the same time, the medium has also undermined the sacred, centuries-old tradition that attributes an aura of uniqueness to the work of art, while engendering new ways of viewing the production of art as well. Photography functions as a *missing link* between mankind and art. Much like a two-sided mirror, it reflects the progress of art and the world at the same time—thus responding to the modernist appeal for the unification of art and life.

We recognize the magnitude of photography's impact in the tremendous rise in production and the rapid growth of collection activity throughout the world. Featuring nearly ninety exemplary positions, *Missing Link* presents only a fraction of the whole. Centered around the photographic collections of the Kunstmuseum Bern and the various foundations situated in Bern, the exhibition is further enriched by major works on loan from private collectors and galleries, some of which have never been shown in public before. Organized into thematic chapters, *Missing Link* offers insights into artists' attempts to come to terms with the human body since the late 1960s—with their own bodies and with those of their models or of randomly photographed persons. In addition to presenting new acquisitions, the exhibition also focuses on future prospects, on desirable additions and extensions in a form of *salon idéal* of the human image. This rigorous contextualization of the collections of "art with photography" already existing in Bern enables us to regard *Missing Link* as a sketch for a presentation of the medium in a future museum of contemporary art.

TONI STOOSS

MISSING LINK—CLOSE THE GAP! Christoph Doswald

Photography has always been looked upon with suspicion. At first, people feared that it would replace painting as the representational medium of choice, and thousands of mid-19th-century portrait painters had themselves trained in photography. Then, when photography turned its back on art and threw itself into the arms of the mass media, many suspected it of surreptitiously pervading our visual subconscious. Photography lost its documentary credibility during the 1980s—the consequence of doubts sown by deconstructivists and media theorists as to the truth content of the machine-made images produced during the decade. Finally, the emergence of digital manipulation techniques called the last remaining link between the depicted subject and the visual image into question. Today we know that the depicted subject need no longer have been present in the process. "If 19th-century discourse about the photographic image generally centers around its role as a copy of reality, then it is safe [...] to say that the 20th century tends to emphasize the idea of a transformation of reality through the photograph."[1] It is no wonder, then, that some authors writing in this context never tire of proclaiming the death of photography.[2]

Fictionalization vs. Documentation

Viewed in this way, it is clear that photography has undergone a continuously accelerating process of fictionalization—from the analog document to the digital simulacrum. Parallel to this trend we also observe a progressive tendency towards a rapprochement between art and photography. Ironically, recent recognition of the abstract, artificial content of photography emerges only as a product of the questioning, indeed the dissolution of the medium itself. Ultimately, the formula "the more artificial, the more artistic" has opened the doors of museums and exhibition halls to the suspect medium, although this development came to Europe only after considerable delay. Artists began using the medium as early as the mid-1960s; galleries and institutional exhibitors of arts did not welcome it until only some ten years ago. In contrast, photography has been firmly established in the museum and gallery landscape in the New World since the 1940s. The New York Museum of Modern Art devoted an exhibition to it in 1937—*Photography 1839-1937*, a

1 Philippe Dubois, *Der fotografische Akt: Versuch über ein theoretisches Dispositiv* (Amsterdam and Dresden: Verlag der Kunst, 1998), p. 41.
2 Cf. Geoffrey Batchen, "Phantasm, Digital Imaging and the Death of Photography," in: *Metamorphoses, Photography in the Electronic Age* (New York, 1994); German version entitled "Post-Fotografie. Digitale Bildherstellung und der Tod der Fotografie," *Be Magazin*, no. 1 (Berlin, 1994), pp. 10 ff.

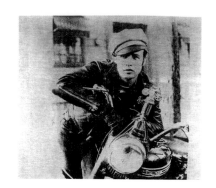

birthday celebration for the "modern" medium. "For more than a century," wrote exhibition curator Beaumont Newhall in his preface to the catalogue, the camera has been a vital means of communication and expression. The growth of this contribution to the visual arts is the subject of this book."[3]

3 Beaumont Newhall, *The History of Photography—from 1839 to the Present Day* (New York: Museum of Modern Art, Simon and Schuster, 1949), p. 5.

From the European point of view, much the same could be said today with respect to the institutional relevance of photography. Yet this present exhibition and book deal not only with a quantitative paradigmatic shift but with a thematic one as well. Photography, and especially photographs of people—human images, that is—have become a preeminent component of art and life. They shape our daily environment through advertising and periodicals; they fill galleries and museums. And in this dual role—as mass-media models and works of art still associated with a particular aura—they are reflections of human existence. We see ourselves in this photographic mirror, whereas the role of art and its own self-perception is seriously questioned by photography. In this sense, photography functions as a *missing link* between mankind and art. Like a two-sided mirror, it reflects the progress of both art and the world.

From Self-Experience to Self-Reflection

The relationship between photography and the prevailing trend toward individualization in western society remains to be clarified. There can be no doubt, however, that photographic self-presentation began to play a much more significant role in art during the period following the student movement of 1968. On the other hand, it is also true that shifting societal paradigms questioned established ideas about gender roles and cultural relationships to an unprecedented extent and, as we now recognize in retrospect, placed them on an entirely new foundation. A look at the art of this era, particularly that of the Vienna Actionists and performance artists, reveals remarkable correlations between the societal and the photographic emancipation of the human image. While advertising took advantage of the emerging pop-culture lifestyle in the field of mass media, and Andy Warhol boldly went about realizing his vision of the media character of art at the Factory in New York, newly established journals and fan magazines in Europe sparked discussion about the coming of a new political and cultural era that promised freedom and self-determination. Both here and there, photography played a leading role in the communication of these new ideas. While the Polaroid-obsessed Warhol incessantly hopped from party to party, transforming the products of his restless wanderings into mass-produced silk-screen prints, Europeans held to a more dogmatic line. Although the

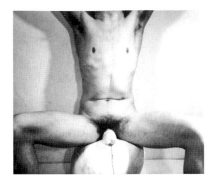

medium remained subject to deliberate creative will, it was initially enlisted into the service of ideas as a means of propaganda, and this was true in art as well: "In 1968, Brus announced an action entitled 'The Citizen Günter Brus Observes His Body' on a poster. At this point, if not earlier, art becomes a concrete political gesture, the heart of which is found in the ritual of self-observation and is mirrored analytically by means of photographic reproduction. Such an act is a confirmation of photography's role as a medium of liberation—a possibility of which the Vienna Actionists most certainly took advantage."[4]

The Actionist Brus's use of photography for the purposes of self-examination is entirely in keeping with the growing tendency toward self-reflection. Where do I come from? Where do I want to go? These are the fundamental questions every autonomous subject was compelled to ask during those years. The Actionists' practice of questioning the integrity of their own bodies by subjecting them to sometimes very painful self-mutilation is surely the most radical form of this self-discovery trip to appear in art, although it was by no means an isolated case. At about the same time, the hippie community was experimenting with consciousness-expanding drugs, gliding on an LSD high over the peaks and valleys of the individual ego. The discussion regarding the equality of women pursued by feminists appears much less militant in comparison.

All of these forms of self-experience, which were ultimately devoted to the objectives of self-determination and emancipation of the self from normative constraints,[5] were processes, transient activities. It may come as no surprise that photography, and later video—both "unmediated" and above all "democratic" media—were in tune with these aims. Simple and easy to use, inexpensive and quick, they were ideal tools for those in search of "self-discovery" as a means of "becoming a new person." It is interesting to note in this context that Rudolf Schwarzkogler, for example, generally excluded the public from his performances, making the camera lens the only witness to his staged actions. Although the Actionists originally focused on topics of relevance to art in their performances, their use of photography is highly suggestive of the *Zeitgeist* of the late 1960s. "The act of painting itself," Schwarzkogler wrote, "can be liberated from the compulsion to produce relics, by placing it in front of the reproducing apparatus that takes in the information."[6] The job of recording image data is delegated to the machine, which liberates the process of depiction from all gesture. It is the actor in front of the camera, the human being, who becomes the focal point of the image, who wants to be "in the picture." The boundary line between the pure photographic document of an art action and the deliberately created art product is in flux. Yet we note during the late 1960s, in particular, the emergence of a "nonchalant"[7] attitude toward this medium. Snapshot photography became quite popular

4 Kristine Stiles, "Unverfälschte Freude: Internationale Kunstaktionen," in: *Art of Actions: Aktionismus, Body Art & Performance, 1949–1979* (Vienna: MAK, 1990), p. 188.

5 This kind of self-emancipation was probably practiced in its most radical form in Otto Mühl's action-analysis commune.

6 Rudolf Schwarzkogler, "Panorama I / Malerei in Bewegung," in: *Le Marais*, special issue on Günter Brus (Vienna, 1965), issued in conjunction with the Brus exhibition at the Galerie Junge Generation in Vienna.

7 With respect to the concept of nonchalance and its significance to contemporary art see Christoph Doswald (ed.), *NONCHALANCE* (Biel and Berlin: Centre PasquArt / Akademie der Künste, 1997/98).

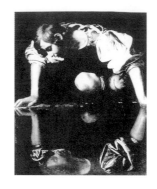

even in the general public. The personal memento photograph (and more recently the video tape) replaced verbal techniques of memory preservation and self-affirmation. Nevertheless, the relationship between the image-generating apparatus and the human image object remain fraught with tension. "Posing in front of the lens (I mean: knowing I am posing, even fleetingly), I do not risk so much as that (at least, not for the moment). [...] though this dependence is an imaginary one (and from the purest image-repertoire), I experience it with the anguish of an uncertain filiation: an image—my image—will be generated."[8] Knowledge of the effects the picture will have plays an important yet paradoxical role in this process of self-presentation, of posing. Thanks to the mass dissemination of human images in the media, our minds are filled with countless subject images, all of which have model character. Thus our behavior in front of the camera always involves recourse and reference to previously existing images. The images are inside us, and we are in the images.

Narcissism: Self-Presentation and the Affirmation of Being

It is only a small step from self-experience to self-reflection and then to self-presentation. The process involved is not one of linear development but of oscillating interaction. As viewers of images of human beings, we not only learn something about the subjects but ultimately gain insights into ourselves at the same time. The photograph also functions as a mirror in the Lacanian sense—even when it is not we ourselves who are represented, we cannot help but measure ourselves against the images we encounter, placing ourselves automatically in the scene and the picture. This somewhat Narcissistic mechanism set in motion by our knowledge of the genesis of the photographic image is symptomatic of today's society, in which perception is so intently fixed upon the visual. The dissolution of the once one-dimensional relationship between the visual image (as evidence of the world) and the world itself, is evident in such phenomena as the cult of fitness or the popularity of plastic surgery—real, physical consequences of ideals communicated through photography. The image becomes reality, and reality becomes an image. And this would not have been possible without photography, supported by broad dissemination through the mass media. Viewed from the standpoint of art history, this amounts to the fulfillment of an early 20th-century utopian vision: the ultimate merger of art and life. One hundred and sixty years after its invention, photography appears as the *missing link*, the integrative connecting link between the artificial and supposedly immediate reality. "The source paints Narkissos, the painting paints the source and the whole fate of Narkissos,"[9] wrote the Greek poet Philostratos, describing the confusing interplay of

8 Roland Barthes, *Camera Lucida. Reflections on Photography* (New York: Hill and Wang, 1981), p. 11.

9 Philostratos, *Die Bilder*, edited and translated by Otto Schönberger, Book I, Chapter 23 (Munich: Heimeran, 1968), p. 145.

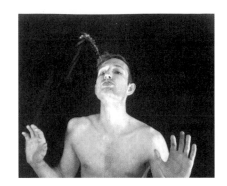

identities involving the viewer, the likeness and the self-image that is taken for granted in our daily lives today. "Narcissus stands gazing at the source; the viewer stands gazing at the painting; and the same relationship emerges in both cases."[10]

10 Philippe Dubois, op. cit., p. 142.

This constellation applies to both the viewer and the artist. In incarnating himself in a "Self-Portrait as a Fountain" (1966-67), Bruce Nauman creates an image of himself as a young man with a naked torso, an undeniable affirmation of his presence in the continuum of space and time. Yet this staged self-portrait also refers to a state of existential searching for identity. In alluding to the fountains of Greek temples, it pays tribute to the ancient forefathers who were regarded as the patrons of the divine.[11] It also honors Marcel Duchamp, the grand master of modern art, and his legendary "Fontaine." In short, Nauman gathered together in his self-portrait—a work that shows him at the beginning of his career as an artist—references of such superior art-historical potency that we may interpret the painting either as an ironic projection of delusions of grandeur or as the reflections of a doubting mind. Ultimately, it asks: Who am I? What is left for me as an artist to say, when so much has already been said?

11 This insight was provided by Tobias Vogt.

Posed in exemplary fashion in this work, the question of the justification of existence (as an artist) and thus of the affirmation of identity is a motif we find expressed with increasing vehemence in recent art. When Manon, for instance, sets herself in scene as a wandering Op-Art object, flirtatiously alluding to the staged performances of the Dadaists, or when Jean Le Gac invents a complete artist's biography, it is clear that such staged photographic presentations are always concerned with the question of existence as they place the artist-subject in the context of the here and now of art history. Articulated in this way, the paradox of the presence of the past and the pastness of the present is the exclusive domain of photography. No other medium is capable of bridging this gap. Thus Barthes's "punctum" appears in yet another variation in photographic self-presentation.[12]

12 Cf. Roland Barthes, op. cit., p. 96.

Mediatization: The human being as object. Art as a ping-pong game (transfers allowed)

The American photographer Robert Mapplethorpe built a remarkable career. With a combination of pack-shot photography and classical pictorial arrangements, he succeeded in achieving a pioneering crossover between a "commercial" and an "artistic" approach. Despite the incessant warnings of art purists against the intermingling of the two disciplines, Mapplethorpe developed a pictorial language in which no distinction is made between the depiction of an orchid and that of a human being. "My approach in

photographing a flower," he explained, "is no different from the one I use when photo-
graphing a cock. It is essentially the same thing. What is important is the use of light and
the composition."[13] Photographed with absolute technical perfection in the studio, his
people pictures are characterized by a detached, thoroughly objectifying sense of distance.
Mapplethorpe often focused his gaze on bodies, ignoring the heads of his models.
Exposed to his camera lens, the subject became an anonymous, perfectly styled, muscular,
aesthetic object—a human relic. His photographic interpretations of the human being,
often precariously balanced on the border between art and pornography, bear unfor-
giving witness to the objectification of sexuality and the body during the 1980s. We
recognized in 1989 the extent to which the *missing link* between photography and life had
taken concrete shape when Mapplethorpe's photographs were censored because of their
explicit presentation of sado-masochistic motifs.[14]

Photos meant to serve a specific commercial purpose are models. They lure us with ideals,
shock us with violations of taboos. They compete for our attention, and their job is to
help sell a product and thus to market themselves as well. Truth, as is clear to us all, is
of secondary importance at best. But such photographs allow us to dream; they evoke
feelings and stimulate our desire to imitate them. In this way they have attracted a huge
audience, but they have also entered forbidden territory in the process: They are poachers
in the realm of art. Photographs generate *en masse* precisely the kind of visual ideals whose
creation was once the exclusive domain of art. And as if that alone were not enough, the
mass media routinely plunder the last remaining products of traditional art as well—like
shoppers in a supermarket. Andy Warhol was the first artist to wage systematic war on
these violations of existing boundaries. He "closed the gap,"[15] as the popular battle cry of
the times demanded. And he did so without using the weapons of confrontation and
opposition, opting instead for infiltration, simulation and appropriation. In a sense, he
paid back television and advertising, in whose services he had worked as a commercial
artist, in kind. "His proposals were meant to reform technology in the spirit of art. It was
Pop Art that made the first real break with the ethos of an art that 'worked' and 'created'
with gifted hands in order to set itself apart from the base apparatus of modernism."[16]
Since that time, we have witnessed the endless oscillating process of recycling back and
forth between high and low culture. The cadence of this ping-pong game played with
a great deal of wit and irony is becoming steadily faster. It is subject to the cultural-
economic paradigm of the new, as Boris Groys so aptly puts it.[17] The use of instruments
of provocation and shock in this battle for the viewers' favor strikes us as virtually inevi-
table. Art, like the media, confronts us with an image of the human being with all of its
pathological aspects, its neurotic quirks, its suppressed desires and secret obsessions—not

13 Robert Mapplethorpe, quoted by Arthur
C. Danto, in: Mark Holborn and Dimitri Levals
(eds.), *Mapplethorpe* (Munich: Schirmer / Mosel,
1992), p. 340.

14 See the article on Robert Mapplethorpe
by Brigitte Ulmer in this book, p. 236.

15 "Close the Gap" is the title of the
programmatical essay published by Leslie
Fiedler in *Playboy* in 1964.

16 Beat Wyss, *Die Welt als T-Shirt. Zur
Ästhetik und Geschichte der Medien*
(Cologne: Dumont, 1997), p. 54.

17 Boris Groys, *Über das Neue. Versuch einer
Kulturökonomie* (Munich and Vienna: Hanser,
1992).

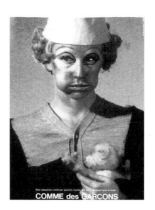

always a pleasing, much less an aesthetic view, but a part of ourselves nonetheless.

With the exception of a very few tempo-retarding intermezzos—the revival of figurative painting in the 1980s comes to mind by way of example—the match between art and the mass media has been played for quite some time on the field of technical image production. Victory, as the rules prescribe, goes to the player who attracts the most attention. Transfers are allowed. Cindy Sherman, for example, who has focused—in staged photographs since the 1970s—on the theme of the normative construction of the image of woman in the media, was engaged briefly by the Japanese *haute couture* producer Comme des Garçons for a trial training stint. In typical Sherman style, she designed a series of postcards announcing the arrival of the firm's 1993/94 fall and winter collection in fashion boutiques. The English fashion designer Vivienne Westwood, already represented with her *Pirate* collection at the Victoria and Albert Museum, made use of art on exhibit at the Louvre in 1998—Géricault's "Raft of Medusa," recreated in exact detail in the photo studio, provided the eccentric English fashion designer with a picturesque setting for an ad motif. And the Italian photographer Oliviero Toscani, a graduate of the Zurich School of Design, managed with his Benetton campaign, in which he applied the artist's stylistic tool of the taboo violation with great success to the marketing of sweaters and tee-shirts, to gain entrance to the hallowed exhibition halls of the Venice Biennale.

When the noise and clamor are at their loudest, a soft tone breaks the pattern and stands out in sharp contrast. Richard Prince focuses on the phenomena of excessive exposure in the media environment. He rephotographs subjects we no longer notice simply because of their permanent presence. The Marlboro Man, the youthful Brooke Shields, who became a fifteen-minute sex star as a flat-chested Lolita even before reaching sexual maturity, tough guys on powerful bikes—all human images that have evolved into stereotypes. Mediated and mediatized on an immense scale, they seem to dissolve into hollow, standardized symbols that attract new attention and achieve new effects only in the context of a museum presentation. Paradoxically, the museum viewer, thanks to the aura created by the context of the presentation, can now see the once mass-mediatized human image—himself, in other words—in an entirely new way.

Reconstruction: Onwards to the document or back to art?

When media models lose their appeal through uniformity and obtrusive presence, we also lose interest in joining them in brotherhood. Commerce in human images is precarious

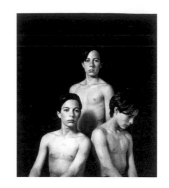

and always subject to the prevailing spirit of the time. Who would wish to be reincarnated as J. R. Ewing in our day, for example? Who is still attracted to Claudia Schiffer, now that Gwyneth Paltrow is in vogue? And when competition with the role models of the glamorous entertainment industry wanes, Mr. and Mrs. Everyman, the somewhat eccentric neighbors across the way, suddenly get their chance, and previously ignored subcultures begin to pique our curiosity. Nameless heroes of a "docu-soap," adolescent drug-addicts from Tulsa, Lower East Side Bohemians, middle-class people in Lucerne, the faceless workers of a Chinese combine, homeless people in the streets of Kiev, youthful swimmers at the beach—the panopticum of "genuine documentary" human images that promises true authenticity as a kind of counterweight to the mass-media model-producing machinery also deludes. Examined closely, the supposed return turns out to be anything but the affirmation of truth as defined by Barthes. Instead, it synthesizes, particularly in the positions of the 1990s, "real" and "mediatized" human images, producing in a sense a fictionalized form of representation. "These pictures from my real life," says the New York artist Jack Pierson with respect to the paradox of photography, "are supposed to make me believe that my real life is somehow something more, lighter, that it has more beautiful moments than it actually does. I have to convince myself of that."[18]

When new media emerge, they tend to trigger a Pavlovian defense reflex in those loyal to the old. Thus the skeptical attitude once reserved to photography is now directed toward digital imaging machines. "The presumption that aesthetic experience is deformed or perhaps even destroyed by new technologies is a constant in the history of the imagination and of image systems."[19] It is with skepticism and surprise that we observe the new image of man which these autopoietic technologies have been generating for years. On the one hand, we find the perfect surface, the faultless beauty we encounter in the photographs of Inez van Lamsweerde unsettling. Can we ever achieve such a state? On the other hand, we realize all of a sudden that the creative, the divine impulse has returned to art through the back door of technology. That old, familiar techniques of portraiture are beginning to appear once again is a sign of antagonism. The American artist Keith Cottingham actually "paints" with his digital brush—on the basis of analog, hand-drawn sketches and sculptural models that are digitized and then given their finish with tools provided by the image-processing program *Photoshop*. "The imaginary expresses itself, the electronics interpret the gesture and the mechanics reproduce it."[20] With *Photoshop*, at the very latest, the artistic strategies and theoretical arguments of the 1980s acquire their technical evidence. Now, the unarmed eye has no chance whatsoever of verifying the authenticity of a photograph. The photo has lost its "eye-witness character" (not only in a legal sense), and the redefinition of the self takes place in virtual computer worlds.

18 Jack Pierson quoted by Susanne Boecker and Rolf Dank, "Für mich ist alles Dekoration— aber Dekoration des Lebens im Gegensatz zum Bemalen einer Leinwand," in: *Kunstforum*, no. 133, pp. 270-277.

19 Hans Ulrich Reck, "Oberfläche, Augenblick, Datenfluss," in: *Der zweite Blick—Manipulation und mediale Wirklichkeit in der Fotokunst* (Munich: Haus der Kunst, 1995), p. 64.

20 Jacques Clayssen, "Digital (R-)Evolution," in: Hubertus von Amelunxen, Stefan Iglhaut and Florian Rötzer (eds.), *Fotografie nach der Fotografie* (Dresden and Basle: Verlag der Kunst, 1995), p. 80.

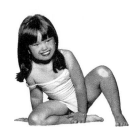

Practically parallel to the development of genetic engineering, which is expected to make the unlimited manipulation of genetic information possible, we are confronted with a human image that is capable of satisfying virtually every form of narcissistic urge. Thus the demand articulated by the Italian poet and socialite Dino Segre, alias Pitigrilli, in 1922 appears to have been fulfilled: "We have had enough of the true, the human, the probable," he wrote, concluding, "Only in falsity is beauty to be found."[21]

21 Pitigrilli (Dino Segre), *Kokain* (Hamburg: Rowohlt, 1988), p. 64. The original Italian edition was published in 1922 under the title *Cocaina: romanza*.

BETWEEN EXOTICISM AND BANALITY Thomas Pfister

The Documentary Photograph as Art

In the early years of the history of photography, photographs were occasionally referred to as "spontaneous portraits of living nature." At long last, mankind found itself in possession of a technical means of duplicating and perpetuating nature. The "photographer" became the new creator of the world, of a second world that far surpassed even the most perfect drawing in terms of precision and richness of detail. This second world enjoys certain advantages nature cannot offer. It is much easier to explore, preserve and make widely accessible. The progressive industrialization of the first world and resulting improvements in the economic situation of the middle class and the working population were accompanied by the emergence of an immense longing for "real" images from all over the world. The photo magazines which began their rise to tremendous popularity during the 1920s often printed several images connecting together, and thus the genre of the photo documentary was born.

"Humankind lingers unregenerately in Plato's cave, still reveling, its age-old habit, in mere images of the truth."[1]

1 Susan Sontag, *On Photography*, (New York: Farrar, Straus and Giroux, 1978).

With the advent of television as a mass medium—in the US during the 1950s and 1960s and somewhat later in Europe—the documentary photo feature lost much of its appeal. The moving image, now accompanied by synchronized sound, seemed much more authentic, much more real. Compared to the hypnotic effect of television, the documentary photograph looked "old." Although documentary films in the form of weekly newsreels shown ahead of feature films in movie theaters had been around since the 1920s, their reach had never encompassed the broad public in their comfortable living rooms at home. It was the television set, soon affordable for many families, that paved the way for the mass distribution of documentary films.

Committed or "concerned photography," which looks back upon a history of significant influence—one need only call to mind the documentary photo features on wars, famines and revolutions produced by the Magnum photographers—had reached the end of its "golden age" by the mid-1970s. Even in the early 1960s, such photographers as Robert Frank and William Klein broke the mold of the classical documentary photograph and

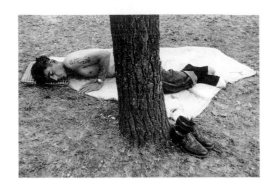

began using formal graphic elements as stylistic resources in their documentary photos. With their unique working approach, referred to as "straight photography," they were the first to focus on the medium itself and its technical aspects. Both Frank and Klein also made use of film wherever they found the limits imposed by the static photo overly confining. At the time, no one (and least of all the photographers themselves) had any inkling whatsoever that their photos would one day be looked upon as art—a notorious field of tension between "applied" and "higher" art that had been the focus of discussion ever since the invention of photography and which provided new fuel for debate in the 1970s thanks to the growing interest in photography exhibited by art museums. To add a new chapter to this chain of controversies here and now, in the age of disintegrating categories and aesthetic imperatives, would be a waste of time.

Some twenty years ago the situation was still clearer. People used to distinguish between "art photography" (done by photographers) and "art with photography" (done by artists). Many things have changed since then. The boundaries have become blurred or, in many cases, have disappeared entirely. Where a discerning view was once called for, a wave of spontaneous, often uncritical enthusiasm now made everything possible. Suddenly, everyday photographs stepped into the limelight simply because a subject, a fringe group or some exotic phenomenon happened to be "in" at a given moment. Many of these positions disappeared again just as quickly as they came, and only very few have succeeded in exploiting their fleeting fame as "overnight superstars" to establish themselves for longer periods of time in the international art scene or on the market for photographic art.

Admittedly, the question has arisen more than once as to why these everyday pictures, often out of focus and over- or underexposed, sometimes personal, narcissistic, voyeuristic and exhibitionistic (to the point of embarrassment), suddenly attracted so much attention in the art world. One might have preferred to ban many of them from the context of art altogether and to relegate them to such pigeon holes as "ethnography" and "anthropology" or "personal photos and snapshots." Suspicion grew that trendy art theorists, those eclectics who had been everywhere and seen everything, had suddenly discovered the exotic side of everyday life in their surroundings, in the housing areas covered with concrete, in the nether realms of the poor. It was noted with alarm that unbearable mediocrity had suddenly become a highly popular object of interest not only for sociologists and ethnologists but for art dealers, museum experts and art journalists as well. A sense of discomfort in the face of the sudden interest of these art people, who had only shortly before prophesied a rosy future to the very opposite, engendered skepticism

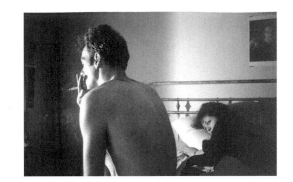

among observers of the scene. Malicious minds voiced the suspicion that the art dealers once again had their manipulative, speculative hands on the wheel and were contributing to the mystification of a new name, a new genre of art.

As so often happens, temporal distance helped clarify the view. When one is too close, one no longer sees the whole, the structure. Too far away, one loses context, immediacy and direct contact. Reflective alternation between proximity and distance, the dialectical approach to perception, objectifies the gaze. Where documentary photos come from different countries and continents, from different social classes or scenes, fascinating and often irritating interactions and insights suddenly emerge. And the presence of irritation often leads to the re-examination, perhaps even the rejection, of prejudice.

Noteworthy representatives of the new genre in question include the American photographer Nan Goldin, with her New York milieu studies, Nobuyoshi Araki of Japan, with his everyday images juxtaposed with erotic (male) fantasies, Tracey Moffatt of Australia, with her "documentary photo stories," the Swiss photographer Annelies Štrba, with her mysterious "family photos," Richard Billingham of Great Britain and Boris Michailov of the Ukraine. The list of genre representatives could go on practically indefinitely, simply because the boundary between the personal memento photo and the published image exposed to public view is in flux. Fine distinctions, categories and exclusions are not helpful here either, although the urge to make them is entirely understandable. Affinities to the now discredited "anything goes" approach are obvious, yet to accept them too readily would be to run the risk of neglecting a wonderful field of art without the thorough examination it deserves.

Nan Goldin and her "Family of Friends"

Nan Goldin's photo series evoke the effect of explicit diaries left open by the artist for others to read. Nan Goldin (* 1953) presents photos of her male and female friends, of her "family" from New York's East Village and the Lower East Side, where she once lived. Her pictures can be read like a chronicle of a romantic "lost generation." They form a structure in which the interplay of characters and themes generates a complex, almost cinematic form. Encounters between men and women and their provocatively staged sexuality, their attempts to escape the banal everyday world with the help of drugs and the resulting addiction, the advent of AIDS and confrontation with sickness and death, the dissolution of communities with shared lives and destinies, her own survival and flight to Europe and

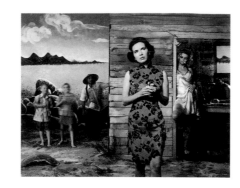

Asia are the major themes of her work. Nan Goldin photographs from the standpoint of a participant, and that is what makes her work so intimate, so immediate and moving.

"I see taking pictures," she says, "as a way of touching someone—a form of tenderness. I look with a warm eye, not a cold one. I do not analyze what goes on—I simply feel inspired by the beauty and the vulnerability of my friends."

Nobuyoshi Araki and his "Story of Tokyo" ("Tokyo monogatari")

For many years, Nobuyoshi Araki (* 1940) was associated more closely with the pornography scene in Japan than with the art world. It was not until his photos were exhibited in a context along with the work of other "straight photographers" such as Robert Frank, William Klein and Nan Goldin in the US and Europe some ten years ago that his rapid rise to fame began. Araki took up photography as a professional and personal vocation in 1963. In the early years, he presented his photographs anywhere and everywhere: in noodle shops and laundries, in food automats and restaurants. He put together actual exhibitions consisting of collections of photocopies and sent them to his friends. He then conceived books of photographs featuring his original photos and had them printed in small editions. Most of these were devoted primarily to his own life and his erotic obsessions. Araki has since published more than one hundred photo books, and the number continues to grow steadily. In this way, Araki makes the private sphere public, documenting everyday life and acting as a witness of his time and an interpreter of the world. Until her death in 1990, his wife Yoko was the central motif in his photographic work. Their honeymoon in 1971 became a kind of sentimental journey that continued through the ensuing years. His report on the suffering and death of his wife took him farther and farther away from fiction (Araki has also produced films and videos), and the photo books created since that time have progressively assumed the form of diaries kept with an almost manic obsessiveness and bearing testimony to the everyday events of his surroundings. Araki is a picture-crazy, obsessive chronicler of Japanese society in the waning 20th century. We devour his photos with astonished eyes even today.

Tracey Moffatt and her "Invented Documentary Photographs"

The Australian Tracey Moffatt (* 1960) is an artist, a photographer and a film-maker in one. She refers to herself as an "image maker," a creator of pictures who approaches her

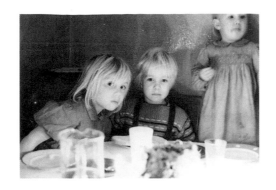

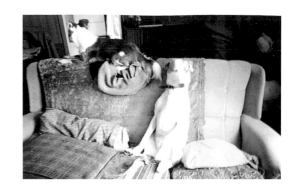

ANNELIES ŠTRBA
IN DER KÜCHE, 1976
(IN THE KITCHEN)

RICHARD BILLINGHAM
UNTITLED, RAY'S A LAUGH #23 1994

photographs as a painter does his canvas. Her own cultural background—Moffatt is an Aborigine who was adopted as a young girl by a white family—has prompted her to focus on such themes as cultural, racial and gender conflicts. Her photo series have film-like quality and are produced with meticulously staged sets, actors, props and sophisticated lighting. Although her photos are artificial and thus cannot be regarded as "documents" in the classical sense, they have a strong documentary effect nonetheless. The boundary lines between reality and the surreal are blurred, and one has the impression that, by staging reality, the artist comes closer to the truth she seeks.

Annelies Štrba and her "Magic Family Stories"

Annelies Štrba (* 1947) of Switzerland needs neither actors nor studios for her photographs. Even her photographic technique is minimal. She finds most of her pictures within the circle of her own family. Although she has photographed her three children again and again over a period of twenty years, the results are not classical family photos. Her images do not fit the mold of private documentary. Štrba, who waited many years before presenting her pictures to the public, has developed a kind of intuitive photographic technique not characterized by perfect craftsmanship (which does not interest her) yet evoking a mysterious aura which the photos transport but do not divulge. Her works are devoted to an exploration of inner relationships. Highly poetic, these photos exhibit timeless lightness and depth at once. They express both closeness and distance, although it is impossible to explain exactly why they do so.

Richard Billingham: "The Family as a Story"

Richard Billingham (* 1970) comes closest to classical, "involved" documentary photography with the pictures of his family. Yet these photographs of a hopelessly impoverished lower-class family, of an alcoholic father, a drug-using, usually unemployed brother and an obese, tattooed mother, who endlessly assembles the pieces of huge jigsaw puzzles, radiate an almost surreal hyperreality in the merciless light of the camera flash, thus creating distance. One shudders at the sight of this miserable everyday lower-class existence and at the same time feels like a voyeur caught in the act. One simply does not stare at others in their misery. The idea of some well-dressed collector purchasing these photos and hanging them in his living room or office as examples of exotic photo art makes the whole thing seem even more absurd and cynical. Distracted by reflexive negative

THE PHOTOGRAPH AS MISUNDERSTANDING Stefan Banz

"… Did you see the body? Did you visit the scene of the crime?"

"No."

"No? You're investigating a case and haven't seen the body? And you didn't even go to the crime scene to secure evidence?"

"No."

"Why not?"

"When the body was discovered last Thursday, it wasn't my case. It was Henk Steiner's case. … The body is at the morgue. I saw no reason to go there myself until the autopsy report is ready. But I've got the photos of the body at the crime scene."

"That's a touchy situation, if you ask me." Jan raised his eyebrows in disbelief. "Photography is often a source of major misunderstandings …"

"What misunderstandings? I don't know what you mean." He chewed his fingernails, although there hadn't really been anything left to chew for some time. "What a subject!," Jan thought to himself and asked, "Can I photograph your fingers?"

"Can you do what?" Wein was hardly prepared for such a question.

"I'd like to photograph your fingers," said Jan.

"Does that have some special significance?" Wein was vain and anxious as well. He didn't want to find himself compromised.

"No, it doesn't have any special significance. I photograph everything that strikes me as interesting."

"And you find my fingers interesting?"

"Oh, yes. Very!"

"Why?"

"Because your nails are bitten practically to the bone."

"Oh, well. … Yes. But my face musn't be in the picture."

"There you have it, Mr. Wein. You think photography can reproduce reality. That it could reveal something about you, something you believe yourself to be but apparently don't wish to disclose. Isn't that a misunderstanding? I don't believe in that kind of truth in photography. I believe that photography inspires the imagination and awakens things in us that have nothing to do with reality."

"What do you mean by that? You surprise me."

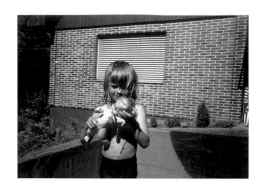 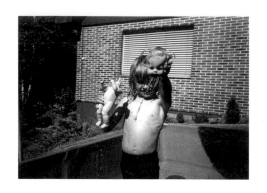

"Look," Jan continued in a soft voice, "I'll give you a simple example: A little girl is playing with her favorite doll. Suddenly the doll falls into a pool of water and fills completely with water. It begins to sink. The little girl quickly grabs the doll and pulls off its head, letting the water run out. Then she puts the head and body back together again. Now, at the very moment the girl is pulling the doll's head off, you take a snapshot. In fact, you take three photos. The pictures show the girl beheading the doll, then pouring the water out of the head and finally pouring the water out of the body. To a stranger, these photos tell a completely different story. It looks as if the child had a marked inclination toward sadism and was abusing its doll. The water suddenly becomes a metaphor for blood, and the harmless episode appears as a 'merciless' and 'bloody' deed in the photos."

"What are you trying to say?," asked Wein warily.

"A photograph is always an extraction, of $1/125^{th}$ of a second, for instance, from life. It is a Now, and there is no Before or After. Thus, strictly speaking, photography has nothing to do with life. Life, reality, takes place in time and space. But a photograph is neither time nor space. It is simply this Now or this Then and therefore tells us nothing about life as it really unfolds. If you wrote a text, for example, and I plucked a single word from it and declared that the word expresses the whole content of the text, you would protest that the word says nothing about the content of the text, that it merely refers to itself, to its own meaning. If I selected an IS, a THAT or a WHERE, then I would be choosing words which can be linked in an infinite number of ways and can thus generate an infinite number of meanings. If I chose a word like PRISON or MURDER or WEIN, I would be limiting myself somewhat but would still be dealing with a multiplicity of possible meanings. Since I know you as a police detective, the word WEIN stands not only for all the kinds of wine I know but also for police detective Wein, who embodies certain specific qualities. If I didn't know you, then the level of meaning represented by Wein = police detective would not exist for me. In this sense, photography is the most abstract medium there is, since it has essentially nothing to do with the facts of life. This is not to say that it really has nothing at all to do with life but simply that it is not life itself and cannot represent it. Its meaning depends solely upon us as recipients. We determine the kind of life we breathe into the photograph—in contrast to painting, sculpture or video art, for example, in which the author always injects or implies this Before or After through composition, design, invention or estrangement. Of course this doesn't mean that an artist could not deliberately imply or express this specific photographic quality in a work of painting, sculpture or video art. But that would be a different story."

Wein was overcome with enthusiasm. "How can I make use of that in my work?"

"You could start with the crime-scene photos, taking an inventory of what's visible and then imbuing them with a life of their own. If you succeed in reconstructing the real

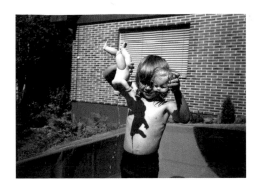

events of the crime through interpretation, then you'll know what took place and you'll find your murderer. If you don't—if your imagination is too abstract, too radical—then the photos won't help you solve the case. In fact, they will lead you astray, and the murderer will have the last laugh. Thus the question is: What do these photos reveal to you? It might also be useful in this regard to familiarize yourself first with some of the different possibilities offered by photography, such as the peculiarities of the works of Andres Serrano, Cindy Sherman and Larry Clark."

"Who are Andres Serrano and Larry Clark?"

"Andres Serrano is a New York photographer known primarily for his unusual close-ups of murder, suicide and accident victims. He photographed people who died of gunshot wounds and beatings, poisonings, burns and stabbings, people who lost their lives in unusual ways and whose corpses are often horrible to look at. Larry Clark photographed the youth drug scene during the late sixties and early seventies, taking photos of himself and his friends in Tulsa and later of the prostitution scene on 42nd Street in New York. They are snapshots of unpretentious yet uncompromising directness, unretouched, decadent and brutal. Cindy Sherman's photographs, on the other hand, are staged. They deal with the themes of glamour, sexual perversion and extreme horrific visions. They constantly focus attention on the viewer and the question of his relationship to authenticity, manipulation, artificiality, fantasy, delusion and imagination. ... In general we can say that the photo itself does not tell us what is genuine, what is posed, what is staged or what is voyeuristic or different from what really is or was. It is always left to us viewers to believe or to distrust the implied commentary and to read photographs in such a way that they communicate something to us—an insight, a feeling, an emotional surge, an ah-ha experience, etc. We must be capable of interpreting photographs in terms of their factual content, in terms of what we actually see and what we are looking for. These interpretations must bring across a certain self-evident quality; otherwise, we learn nothing and get nowhere with them. In that case, the photographs lead us both emotionally and factually astray. They remain a misunderstanding."

This text is an excerpt from the as yet unpublished novel *Mord. Die gesammelten Werke von Jan Eide* by Stefan Banz.

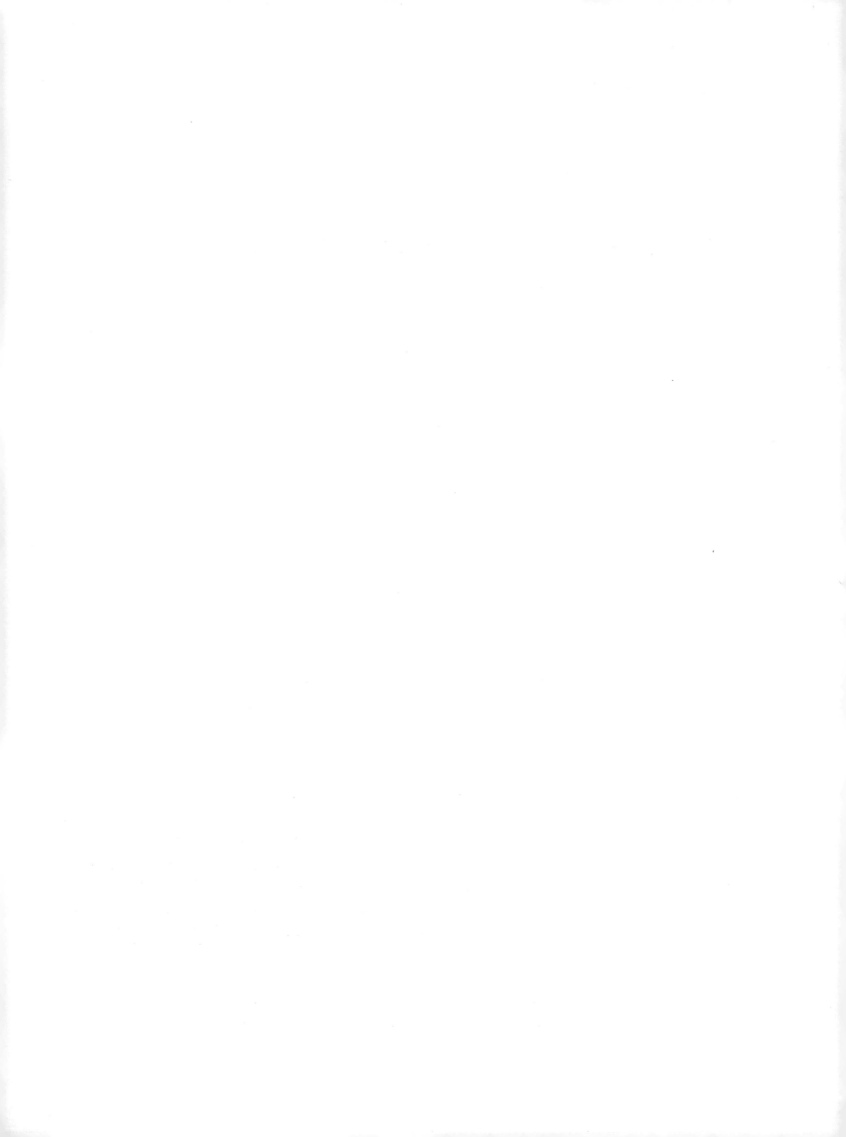

ON BEING ONE'S OWN ENCOUNTER GROUP Kathrin Peters

The self-discovery boom is over. It grew forth from the basic premise that the self lies buried under social constraints, cultural norms and external influences. The idea was to uncover the true, hidden self under the guidance of a facilitator or group leader or in the context of encounter with others. But what kind of self could this be which expresses itself as real, true and authentic without reference to any culture or social construct whatsoever? And what is one to do with this self and its almost archaic, perhaps pre-social energy?

Body and Event in Actionism

In response to an invitation from the Austrian Socialist Student Union, members of the "institut für direkte kunst wien" (Vienna Institute of Direct Art) took part in the exhibition entitled "Kunst und Revolution" (Art and Revolution) in June 1968. On this occasion, Günter Brus cut his chest with razor blades, excreted feces in the auditorium at the Vienna University and began masturbating while Otto Mühl performed the Austrian national anthem. Members of the audience left the room, and sanctions were imposed by the authorities.

That same year, and also in Vienna, Valie Export presented what she referred to as the "first genuine women's film."[1] In her action, she appeared with a wooden box affixed around her torso, its front side open so that passers-by, both male and female, could touch her breasts. The "Tapp und Tastkino" (Walk-by and Touch Theater) replaced pure voyeurism with a tactile experience and, as Export commented, led to "the direct emancipation of sexuality. It is woman's first step from object to subject. [...] When a woman's breasts are no longer a man's property, when, instead, a woman has complete control over them, state-regulated morality (with respect to state, family, property) is nullified."[2]

During the 1960s and 1970s, actions and performances were staged in opposition to an art business that presented paintings as masterpieces in museum halls. Their aim was to negate the object character of the work of art through events which could not be shown in museums. These events took place outside the institutions of art. They were transient,

1 Valie Export with reference to her action entitled "Tapp und Tastkino. Expanded Movie," 1968, printed in: Hedwig Saxenhuber and Astrid Wege (eds.), *Oh boy, it's a girl! Feminismen in der Kunst* (Munich: Kunstverein, 1994), p. 35. See also: Roswitha Mueller, *Valie Export. The Fragments of the Imagination* (Indiana: University Press, 1994).
2 ibid.

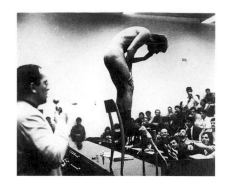

irreproducible and thus impossible to represent. The dominant political gesture of Performance and Actionism was that of anti-representation.

How, then, are the conditions and expressions of female or male authorship inscribed in forms of art that articulate the critique of representation as social criticism? And in what way does the art of the event or the event as art, within the context of a critique of representation, turn its attention to the visual image—namely to photography and other media-based techniques?

With their radical critique of authority, the Vienna Actionists of the period 1965 to 1970 were intent upon breaking away from repression and taboos through the public presentation of perversion ("Perversion exposes society's defects."—Otto Mühl[3]). Renouncing traditional techniques and media of art, they used the body as a material in exhibiting processes of transformation and destruction before the eyes of their audiences. "Direct Art" signifies a dual form of directness: the authenticity of the exposed body and the presence of the audience, which is not permitted to view the work of art from a comfortable distance but is literally hounded by the performance. Art is not conceived as a means of imagining, depicting or representing life; instead, life must be present in art.

There is a certain ambivalence in the message communicated with respect to the artist-subject by displays of bodily excretions (feces, urine, blood, sperm) and operations carried out at the limits of physical integrity. On the one hand, the subject is exposed as vulnerable, disabled and undeniably "feminine;" on the other, the suggested castrations and self-inflicted injuries (themes addressed by Günter Brus, Rudolf Schwarzkogler and the American artist Vito Acconci) are demonstrations of virility, for—especially—when blood flows, the artist's body is seen in its most vital, "authentic" form. In a masochistic position, the victim is presented as a heroic body which cannot be defeated by self-inflicted violence.[4] And is it possible to see the heroic body as anything but masculine?

The art scholar Sigrid Schade quite aptly refers to this demonstration of mastery over life and death through which the position of male authorship is sustained as "self-creation."[5] It comes as no surprise that the institutions at which the attack was directed—art and art history—have adapted to these changed circumstances, as the figure of the eccentric artist and avant-gardist[6] is a fundamental tenet of modern art. Recognizing this trend, Otto Mühl abandoned the art business in 1970 in order to dedicate himself to the practical unification of art and life in the action-analysis commune he had founded.

3 Otto Mühl, cited and translated from "Herbert Stumpfl zu den Ereignissen an der Wiener Universität im Juni 1968," reproduction of a typescript printed in: Johannes Lothar Schröder, *Identität, Überschreitung, Verwandlung: Happenings, Aktionen und Performances von bildenden Künstlern* (Münster, 1990), p. 235.

4 Cf. Amelia Jones, *Body Art. Performing the Subject* (Minneapolis: University of Minnesota Press, 1998), particularly the chapter entitled "Masochism: Threatening or Reinforcing the Male Body?".

5 Sigrid Schade, "Andere Körper, Kunst, Politik und Repräsentation in den 80er und 90er Jahren," in: Sigrid Schade (ed.), *Andere Körper* (Linz: Offenes Kulturhaus, 1994), p. 16.

6 Herbert Stumpfl, himself associated with Actionist circles, referred to the Actionists' approach as "an outpost of critical consciousness [devoted to] breaking through the veiled taboos of society," and thus provided a useful description of avant-garde art; printed in: Schröder, 1990.

VALIE EXPORT
TAPP UND TASTKINO,
EXPANDED MOVIE 1968
(WALK-BY AND TOUCH THEATER)

In her action, Valie Export raises the issue of power as a function of gender. In doing so, she does not expose her body for the purpose of demonstrating its naturalness and vitality; instead, she works with and on the culturally determined attributes of the female body. Because there are no true, adequate images of women, the "first true women's film" dispenses with images entirely. Export can break through the stereotyped representations of femininity in art and the mass media only by redefining the whole apparatus of representation itself.

The Women's Movement of the 1970s engendered two basic approaches—to put it in somewhat simple terms—to an aesthetic response to patriarchal society. The first was the attempt to articulate a "feminine aesthetic"[7] which juxtaposes supposedly essential femininity with male universality, to enhance appreciation for such uniquely "feminine" experiences as motherhood, for example, yet does no more than reflect the status quo. The second was a tendency evident in works of art by women—of which Export's work presented here is an example—to undertake a critical review of images of femininity, focusing not upon the "naturalness" of the body but upon its symbolic character. In this context, female artists were compelled to deal with a historical cultural tradition in which women go largely unnoticed as producers in the history of visual art yet constitute a significant part of that history by virtue of their presence as pictorial objects.

In order to accomplish the transfer from object to subject, many woman artists made use of technical media such as photography, film and video, as these technologies were for the most part still untainted, from the viewpoint of art history, in the 1960s and 1970s and thus enabled female artists to avoid male-contorted artistic techniques employed in production of high art, such as painting and print-making. Known as the "Media Documenta," *Documenta 6* (1977) featured a significant number of female artists.[8] Moreover, the presence of technical media images at this *Documenta* also related to the perceived need for representation of process-based art.

High-Art, Low-Tech: Photography and Performance

To a significant degree, Performance and Actionism are dependent upon technical media. The documentary recording of an event has always involved a shift—because the images thus produced cannot be the equivalent of the event and because the mere presence of a photographer or cameraman necessarily influences the action. Yet if they are to be communicable at all beyond the confines of the one-time event, they must be documented.[9]

7 See in this regard Silvia Bovenschen, "Is There a 'Feminist Aesthetic?,'" in: New German Critique, no. 10, Milwaukee, Winter 1977.

8 Exhibiting artists included, among others, Marina Abramović, Valie Export, Ulrike Rosenbach, Joan Jonas, Friederike Pezold and Gina Pane as well as Jürgen Klauke, Vito Acconci and Bruce Nauman.

9 In addition to the use of photography and video for documentary purposes, there have also been closed-circuit installations in which the video camera is incorporated into the performance and thus provides for real-time control of the image of the body. See, for example, the work of Friederike Pezold, Ulrike Rosenbach and others.

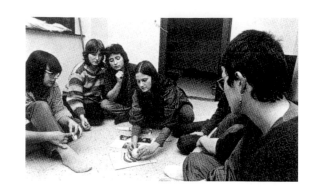

The critique of visual imagery implied in Performance and Actionism thus inevitably culminates in a different image—inevitably, because the attack on the art business is pursued from the position of the artist and thus remains dependent upon the artist's need for something that can be exhibited and reproduced. Thus both Performance and Body Art are to be understood as inquiries into the nature of the pictorial within the context of visual imagery. As such, they replace the work of art with technical images which, by virtue of their origins in popular media and utilitarian art, always have a certain non-artistic quality about them. It is all the more surprising, then, that the amateurish photographic images produced in the spirit of demystification of the work of art now seem so much like relics and take on the special character of an original. One reason for this tendency toward remystification may be found in the temporal distance from which we view these photographs today. Yet it is also the product of a structural affinity between Performance or Actionism and photography. As an evidence-preserving medium, the photographic image underscores the unrepeatable presence of the event, showing, as Roland Barthes expressed it: "That-has-been."[10] The cuts made in their own skin by Rudolf Schwarzkogler, Günter Brus and Vito Acconci and by the female artists Gina Pane and Marina Abramović can be interpreted as traces of an event left on the body by an event, as references to a presence that will always belong to the past.

In retrospect it becomes clear that changes in the relative values attached to image-producing techniques, specifically the acceptance of the utilitarian medium of photography in art, were not set in motion by art photography—which has maintained its claim to artistic value since the turn of the century—but by Actionism and Performance Art. Technical images and media-based art forms have since become new master disciplines. For some years now, they have been associated with a significant degree of craftsmanship and precision of the kind evident in large-format photographs bearing a certain resemblance to paintings.[11]

The Self as the Other (Gender)

The 1960s and 1970s have been the focus of increasing attention in the recent historical discourse on art—in the totality, that is, of exhibition practice, catalogues, reviews, interviews and scholarly art theory. One of the guiding motifs in this line of inquiry has been the quest for the origins of self-presentation in art. It is indeed true that perceptions of the body as well as sexual identities have been explored in a variety of ways in art since the 1970s. Male artists have exhibited themselves in front of the camera as transsexuals

10 As early as in 1977, the art historian Rosalind Krauss called attention to the indexical character of the art of the 1970s. The relationship between Performance Art, Land Art, Body Art, etc. and photography is not restricted to the documentary function. These forms of art are events and traces in themselves. See Rosalind Krauss, "Notes on the Index (1977)," in: Rosalind Krauss, *The Originality of the Avant-Garde and Other Modernist Myths* (Cambridge, Mass., and London: MIT Press, 9th edition, 1994).

11 In works by students of the photographers Bernd and Hilla Becher, for example, including Thomas Ruff, Andreas Gursky and others, or by Jeff Wall.

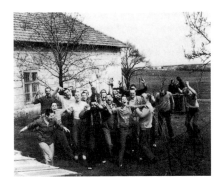

(Morimura), prostitutes (Jürgen Klauke), drag queens (Andy Warhol) and as entirely conventional women (William Wegman). Female artists have disguised themselves as movie stars (Cindy Sherman), had their faces surgically altered (Orlan), stuck on false mustaches and masturbated unabashedly in front of an (art-viewing) audience (Elke Krystufek).

The emergence of artists' interest in the image of the body and self-presentation in art can also be related to other changes that took place outside the pale of the art world. The development of digital spaces, for example, fueled discussion about the dissolution of gender identities in the Internet.[12] Research and new possibilities discovered in medicine and the biological sciences have shaken the foundations of the widely applauded concept of the natural body. Not only has pop music, in the music video, appropriated elements of experimental film and video, the figure of the star has clearly begun to compete with that of the artist with regard to the violation of taboos. These societal developments confirm a discovery made by post-structuralist and post-psychoanalytical theorists some time ago—namely, that it is impossible to locate either a hermetic center of power or a true self.

Against the background of these developments, proclamations of the dissolution of gender difference have been heard frequently. Sexual identity, so the argument goes, is up for grabs and a matter of free choice. One need only select the right clothing, and one can be a woman one day, a man the next, etc.[13] With its theory of the constructed nature of gender difference, the contemporary gender debate is responsible for the contention that everyone—man or woman—has the capacity to construct himself/herself. Clearly, such a claim has never been made within the context of gender studies.

The category of "gender" does not seek to reaffirm the difference between the two genders again and again but to analyze the process of differentiation itself. Thus "gender studies" can be seen as a reaction to the crisis in the Women's Movement during the 1980s. At that time it became evident that, in its fixation on the opposition between men and women, the community which proudly referred to itself as "we women" created exclusions of its own (of women of different ethnic origins, for example, of socially underprivileged women, of lesbians). The term "gender studies" represents a scholarly discipline that reflects upon values and relationships of power which—in culturally and historically different ways—are related to social, gender-related and ethnic differences. The model of heterosexuality upon which the relationship between the genders is based is subjected to scrutiny as a historical and scientific construct.[14] Accordingly, the concepts "male" and

12 On this topic in general see Marie-Luise Angerer, *Body Options* (Vienna: Turia & Kant, 1999) and (by the same author) "Space Does Matter on Cyber and other Bodies," in: *European Journal of Cultural Studies*, vol. 2, London, New Dehli, 1999.

13 This line of argumentation was pursued at the exhibition entitled "*Post Human*," for example. Jeffrey Deitch, *Post Human* (Hamburg: Deichtorhallen, 1992).

14 See the study of the development of the two-gender model from the standpoint of the history of science by Thomas Laqueur, *Making Sex. Body and Gender from the Greeks to Freud* (Cambridge: Harvard University Press, 1990, 1992).

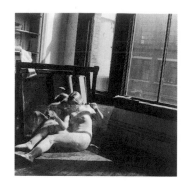

"female" are to be understood as figures that emerge not from biological substrates but from cultural interpretations. They are figures which—and this is the (controversial) political potential inherent in the concept of "gender"—are open to refiguration. The empirical subject, i.e. every individual man and woman, is a bound up in socio-cultural attributions, and only this subject is capable of rendering the continuously unfolding process of affirmation and stabilization of gender identity visible and diverting it into areas of ambiguity.[15]

"A Woman is a Mirror for a Man"[16]

Accordingly, the position of the female artist differs from that of the male artist at the end of the 20th century, and this remains true even though female artists can easily appear in the disguise of the other. For the crucial issue is not what is said, but who is speaking and from what position the speaker speaks. While cross-dressing by men remains recognizable as a transgression of the boundaries of their "true" gender, women costumed as men either simply pass as men or appear even more erotic with their female bodies draped in men's clothes (these patterns of perception are evident in the many different qualities attributed to lesbians). One explanation for this lies in a cultural definition of femininity that has always identified it as illusory and superficial, a masquerade purporting to conceal something that is not there.[17] Moreover, the male artist has considerably more freedom than his female counterpart (and the non-artist) to occupy queer positions that deviate from the heterosexual norm, as such violations of taboo "are (still) the domain of male subjects, who receive society's approval for them within the context of the cult of genius."[18]

The political relevance of art remains an open question. Can the subversive power of cross-dressing, transvestism or feminism as practices of art extend to fields outside the world of art as well?

Forms of feminism that have emerged since the advent of the Feminist movement continue to question the status of "woman as image."[19] Female artists have taken a deconstructive approach to the available abundance of images from art and mass culture, much in the way as Cindy Sherman has always done on her way to becoming, one must almost say, a heroin of (feminist) art studies. Others have worked with strategies of over-affirmation—Inez van Lamsweerde, who erotically distorts photographs of young girls' bodies through digital processing, for example, or Orlan, who had her face surgically altered to match

15 See also Judith Butler, an often-cited author who has provided a particularly penetrating analysis of the deficiency of the sex-gender system (biological sex vs. socio-culturally determinded sex) system and explored the possibilities for counteracting the naturalization of gender differences. Judith Butler, *Bodies that Matter* (New York: Routledge, 1993) and Barbara Vinken, "Der Stoff, aus dem die Körper sind," in: *Neue Rundschau*, no. 4, 1993, p. 21.

16 Title (excerpt) of a photo series (1975–78) by Francesca Woodman.

17 See Liliane Weissberg (ed.), *Weiblichkeit als Maskerade* (Frankfurt on the Main: Fischer, 1994). The work cited contains essays by Joan Rivière, Laura Mulvey, Mary-Ann Doane, Abigail Solomon-Godeau, Emily Apter and others.

18 Sigrid Schade, Silke Wenk, "Inszenierung des Sehens: Kunst, Geschichte und Geschlechterdifferenz," in: H. Bußmann, Renate Hof (eds.), *Genus. Zur Geschlechterdifferenz in den Kulturwissenschaften* (Stuttgart: Kröner, 1994), p. 361.

19 Silvia Eiblmayr, *Die Frau als Bild. Der weibliche Körper in der Kunst des 20. Jahrhunderts* (Berlin: Reimer, 1993).

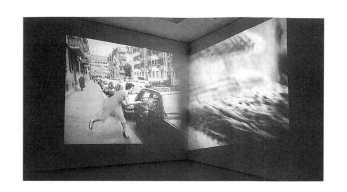

ideal proportions generated by a computer and recorded the surgical procedures on video tape. In the work of these female artists, cited here as examples, representations of women are not criticized as adequate or discriminating in comparison to empirical women; instead, they serve as projection screens and mirrors of a desirous gaze which they seek to subvert. The question of the original source of the (false) copy is no longer posed; the point is the theme of "femininity" and "representation" as simulacra, as copies for which there are no originals.

Recently, one particular approach has caused considerable uproar: an attitude that proclaims "pleasure in womanhood." Its most prominent advocate is the Swiss artist Pipilotti Rist.[20] In her video installation entitled "Ever is Over All" (1997), a young woman in a blue dress and red high-heeled shoes smashes the windshields of parked cars with a huge steel flower. It is difficult to make out whether the installation represents an attack on middle-class fetishes of affluence or a flirtation with a girlish "Pippi-Langstrumpf" image. The latter would hardly be very subversive, since the idea that girls are pretty, sexy and sometimes a bit fresh has always been regarded as an acceptable image of femininity.

20 See her solo exhibition "*Remake of the Weekend*" at the Hambuger Bahnhof in Berlin, 1998, and Sabeth Buchmann, "Produktionssysteme. Zu den Arbeiten von Pipilotti Rist," in: *Texte zur Kunst*, no. 32, December 1998.

VARIOUS ENCOUNTERS Thomas Koerfer

At the kinky, late-night parties at the Factory, he roved around with his Polaroid camera. Involved only visually in the lustful activities—"sex is so abstract" was his laconic response— he used the notebook camera, a device which, interestingly enough, produced only one-of-a-kind images, to take razor-sharp, meticulously composed shots of torsi, genitals and other body parts, most of them male, as if the female body was of little interest to him or interesting only in smooth, girlish form. He then used these Polaroids, which could not be directly reproduced, as sources for finely stylized drawings, some of which were done in ball-point pen. Other Polaroids served as "models" for large-scale silk-screen prints, which he overpainted extensively in graphic style. Thus with his Polaroids he set in motion an expanding tide of images involving other techniques—he who had dispensed once and for all with the classical concept of the unique work of art, or at least redefined it, he who made copies, scrigraphs and serial photographs in photo-booths, using them as sources for paintings, he who made movies from which he extracted film stills to be blown up in silk-screen prints, he, Andy Warhol, converted both his found images and those of his own creation over and over again into new "aggregate states" and, through all of his creative activities, became the shining light for devotees of modern photography. He made large-scale pictures from the smallest sources, created icons of his time from mundane, everyday sources and developed murals from news photos of catastrophes. Everything with which photography concerns itself today, had already been done by him. He put everything in touch—fashion with classic art and kitsch, the small with the large, moving and still images, the *memento mori* with the *memento vivendi* and vice versa.

Back then, things had not yet begun to flow, to intermingle and to cross boundary lines. He was the lone border-crosser. Today, nearly everybody is one. Wilson takes from film and passes what he finds on to Wagner in opera. He taps the resources of the horror movie to bring elements from it back to the theater stage in *Death, Disaster and Detroit*. Cindy Sherman creates "Film Stills" in which the fictional focus, the plot, is not identified yet can be guessed. She stages herself in the roles of countless heroines in frozen film scenes and dissects both the cinema dream and the American Dream at the same time. Clever Matthew Barney leaves no marketable medium untouched. He makes films for presentation in movie theaters or for distribution in mini-editions on video discs. He creates photos

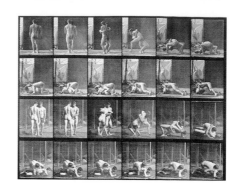

from film images, as autonomous series. Or he markets film props as sculptural works of art. Richard Prince has lost all belief in the utility of his own image creations. He is content with found image material—from the Marlboro Man to fashion images to motorcycle girls—which he shapes into new "originals" using different detail views, new contexts and altered coloration. He rephotographed "Spiritual America," an image of an adolescent Brooke Shields photographed by a fashion photographer, and exhibited it as sole work of art at a New York gallery, holding up to America the mirror of its own state of mind.

Fifty years before Warhol there was another who did all kinds of things with photography, things from which contemporary photography continues to draw nourishment and profit. What techniques he developed, this sorcerer of optics and the darkroom, what world of images he created! He staged scenes, rayographed, solarized, ironized, created countless icons in details from his own negatives, brought African masks to life and froze women's faces to ice—in black-and-white, in *noire et blanche*—and he celebrated images of women: Kiki de Montparnasse, Lee Miller, Meret Oppenheim—made goddesses of women through photography. The fact that Warhol collected these portraits bears witness to his admiration for them. It is only a small step from a Man Ray portrait of Lee Miller to Warhol's "Jackie Series"—Jackie, Jackie and more Jackie, overpainted with red or blue, separated and rearranged in rows of multiple images to become a picture series with one and the same picture.

At the close of the 19th century, photography was still motionless and static. Long exposure times compelled subjects to assume thoughtful, almost statuesque attitudes reminiscent of poses typical of early portrait painting. Such photographs were one-of-a-kind images and, from the very moment they were made, memories of the persons portrayed. A strange aura of death emanated from them.

One photographer refused to accept this absence of motion. Stubborn, relentless yet deeply inspired, he sought to document human and animal movement through photography. He became a motion fetishist, this Eadweard Muybridge, a chronophotographer, a student of human and animal locomotion. He had animals, undressed ladies and gentlemen pass in front of a row of cameras, the shutters of which were released on contact with attached threads, he had them marching, running, climbing ladders and leaping over obstacles. His yearning to document movement would make him one of the forefathers of the motion picture. Warhol admired his photo series, and Muybridge's photo sequences were even found among the stacks of pictures in the chaotic studio of Francis Bacon,

another fetishist of arrested motion. Muybridge's series of men wrestling immediately call to mind the twisting, grappling male bodies pressed close together in Bacon's diptychs and triptychs. And Muybridge's photo sequences have something else in common with Bacon: the scene-oriented view with a frontal perspective. In Muybridge's photos the human figures passed in front of the camera as if walking across a stage. Without exception, Bacon's paintings focused exclusively on the presentation of people on a stage, in set scene or perhaps in spaces resembling arenas.

This scene-oriented perspective is represented in contemporary photography as well. The scenic or theatrical aspect is a significant determinant of image staging and visual expression. In terms of the compositional stringency of pictorial structure, Robert Mapplethorpe also belongs to this tradition. Photographing primarily in the studio in order to achieve total control of light and pictorial detail, he developed the scene-oriented perspective of balanced frontality. In his series entitled "The Z-Portfolio," he celebrated the black male body in theatrical poses. The close-up shots of loins, buttocks and penises are consistently characterized by carefully composed staging and the absolute symmetry of pictorial structure held in perfect balance. Mapplethorpe approached the staging of floral still lifes just as he did that of human bodies or body parts. His "Cala Lilies" are as radiant as if illuminated by stage lights. With respect to the formal tasks of composition and illumination, he made no distinction between an erect penis and a lily. It is interesting to note his use of this classical approach even in his early Polaroids. In the black-and-white self-portraits, a series of nudes, he presented himself in a "scenic" manner, although with poetic effects that are no longer evident in his late work. Whereas Mapplethorpe's scene-based perspective keeps the viewer of his photographs at a distance—much like Edward Weston in his tightly composed female nudes and form studies—we find in contemporary photography the theatrical devices of seduction in the work of such photographers as Jan Saudek or Joël-Peter Witkin. Just as the silent film and the later full-length feature movie trace their origins to the context of the carnival side show, Saudek and Witkin take inspiration from the pleasureful representation of the abnormal as exhibited at carnivals and fairs around the turn of the century. The photograph as the image of an absurd theater of the world, rearranged in Witkin's case on a series of new and increasingly larger stages, while Saudek goes underground, retreating into the studio in the basement of his home. Despite its imaginative quality, this photography is oddly retrospective.

Revolutionary, ruthless and constantly rushing forward on the tide of his own images is Araki, whose photography presents the living spaces and inner sanctums of Japan as a

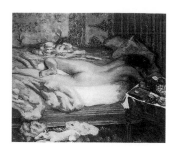

constantly changing series of stages. His female nudes in bondage are deliberately exaggerated scenes which, despite their highly artificial quality, reflect the image of women in his country. Nor is he content with merely staging scenes, with making photos. He intervenes with his ink brush in his photographs, underscoring the voyeurism of the photographer and viewer by overpainting eyes, mouths, breasts and female genitals. Most radical of all is his approach to the reproducibility of the photographic image. He imposes no limits on the number of prints made from individual images. Everything is available, everything can be ordered—in small or large formats, as paper prints or laser printouts. Araki has taken Warhol's rejection of the concept of singularity to its farthest extreme.

Where, then, has contemporary photography acquired this sense of an unbearable lightness or heaviness of being? Its treasure trove of visual expression comprises film and early photography as well as imagery from painting, drawing and graphic art. The convenience of the photographic technique engenders an electrifying immediacy. Images captured with a 35-mm camera without artificial light can be preserved precisely and can easily be transferred to prints of every conceivable size. Suddenly, the photographic note can assume the dimensions of a mural. What once could be achieved in painting only with the "light media" of the watercolor and the drawing—the rendering of a specific intimate moment within a very short period of time—is now possible with a small camera anytime and anywhere, be it an embrace, a view from a window, an act of sexual intimacy, a walk along a street at night, the brilliant radiance of a body in a bath. Celebrating the female body in pastels and watercolors in a series of countless images, Bonnard painted his wife in her bath, performing her morning ablutions or lying on her bed, immersed in bright southern light. Nan Goldin captured the bodies of her male and female friends with similar sensuality, although her subjects found themselves in completely different— namely desperate or depressing—life circumstances. In her case, the camera has become a life companion, and it is sometimes hard to determine whether photography exerts a formative influence upon life—were the tears prolonged for the photograph?—or whether life points photography in a new direction. A new kind of give and take emerges in the relationship between photography and life.

The speed at which images appear, beamed around the world on the Internet, the alacrity with which suitable images are appropriated from art by fashion photography, from where they are catapulted into video clips, and these wild plundering campaigns between art and junk have produced a situation in which the functions of recording and rendering visible are assigned to art photography. No other contemporary artistic medium possesses the immediacy and the capacity to concentrate a present sense of life the way photography

does. Everything appears to be in the process of intermingling, and without great dramatic ado, photography simply captures and records the essential images.

Proceeding from the assumption that it is no longer possible to sustain an intact, holistic view of the body, photography performs the task of recording the dismembering operations. What was first heralded in the paintings of Francis Bacon is pursued further in the wax sculptures of Robert Gober. Boys' or men's legs protrude from walls; a man's leg emerges from between a pair of woman's thighs pressed into the corner of a room in the sculpture "Man Coming out of Woman." Gober's bodies bear a certain resemblance to shadowy, nocturnal figures from horror movies. Yet they do not merely appear waxen, they are real, almost gently inviting the viewer's touch. Cindy Sherman appropriated these mutilations of the body for the photos of her "Sex Series," although her love dolls are not assembled from wax parts. Everything is made of plastic or latex, from gynecological, medical and pornographic dolls, and then bathed in a light reminiscent of Caravaggio. In some cases, the large color photos show only isolated body parts. Sometimes the gaze becomes voyeuristically involved in the events, as if the camera itself were participating in the distortions of the dancing dolls. In other photos, Sherman looks on calmly as the wild scenes unfold. And, in an almost mysterious way, she succeeds in awakening life in these dolls, turning them into figures that have been given the breath of life in the manner of silent Expressionist films of the 1930s.

The influence of film on modern photography is impossible to overlook. Yet it appears to be the early movie worlds that are taken up as pictorial material and human images in modern photography. Photography is categorically and pleasingly silent. The conversations people have engaged in before or during shootings, the sounds that accompanied the photographed scenes—all of that has been cut out. Thus photography has a much closer affinity to the silent film than to the psychologically probing feature film with its dialogues and orchestral background music, in which the visual image is subordinate to the progress of the plot. Picasso pronounced the death of film following the advent of the sound track, arguing that film had thus lost its capacity to form chains of freely associated images. Unconsciously, much of modern photography seems to have embraced this attitude in its orientation toward early film images.

In the 1950s and 1960s, the New American Cinema was alone in liberating itself from the confining corset of dedication to a self-contained plot line. This cinematic school dealt quite freely with sequences of images and cuts, with the rendering of moods and changes of light. The worlds of imagery created by Markopoulos in the early 1950s, as in the movie

Psyche, with its links to the silent movie and Greek tragedy, have had a direct influence upon the imagery of modern photography. The dark blue and dark red of his interiors, with the longing white of the bodies moving toward or away from one another, have become an essential element of color expression and formal language in modern photography. Direct light, bleaching sunlight, the passage of brilliant light rays through corridors, windows or other openings into interiors, glaring backlight in scenes set in nature—these qualities of light appear once again in the work of Nan Goldin and Cindy Sherman. And this practice of recording gestures, shoulder movements, twitching lips or two bodies leaning against one another was commonly used in the Free Cinema movement long before the birth of modern photography.

It is entirely possible that contemporary photography will in turn influence and shape contemporary film or, to be more precise, that it is already doing so. The feature film of the 1990s has already been robbed of much of its spontaneity by its own gigantic technological production machinery. Forgotten is the *Nouvelle Vague*, forgotten the life-affirming hand-held camera in *A bout de souffle*, forgotten the exchange of glances between Jean-Paul Belmondo and Jean Seberg in front of a bathroom mirror—images of the kind now found in contemporary photography. What modern photography discovered with regard to immediacy and richness of pictorial expression through the use of the 35-mm camera, this lightness of recording and narrative, the feature film now seeks to regain with the aid of the digital video camera. No longer are hours of filming required; instead, two or three compact recording units leap into the fray to capture the action—thus, at any rate, is the intent of the *Dogma* movement and its united advocates. It is acceptable once again in movies to bleach out human figures or rooms with light, to underilluminate interiors, to cloak an actor in virtual darkness, so long as the intensity of action or mood is right. Modern photography has given back to film what it once borrowed from it.

Modern art photography today, like the focus of various different currents in art, is closely connected with the transient sense of life at the end of the 20th century. For a brief moment, movement and encounter are frozen, captured in one or several sequences of images and made visible. Time is brought to a standstill for fractions of a second in order to render its further progress palpable in the motionless interim. All of the bodies depicted in earlier or contemporary photographs have grown older in the meantime. The people have moved closer to death.

Yet photography is not free artistic expression alone. It is also an incorruptible witness to reality. Patient or impatient analysts of reality have become rarer in contemporary

photography. Today's photography has created a space for itself in which worlds of images can emerge without reference to a social context. The incisively precise yet emphatically poetic eye of a Robert Frank reminds us of something very close to early classical photography, but he, and with him Diane Arbus, have paved the way for an appreciation of modern photography. Observing and analyzing, recording the sometimes gruesome gifts of real life as black-and-white icons, they have explored the world of America and made it visible, immersing scenes and people in baths of delicate day or night light. In their own, much less gentle ways, Boris Michailov and Gilles Perres pursue this process of observation, which presents the human being in the context of its society.

THE SELF-PORTRAIT Max Kozloff

The Conflict between Self-Representation and Self-Exposure

Whatever it had been before, the public regard for privacy at this moment is on the wane. In the past, one averted one's personal affairs and feelings from strangers, maybe because of reserve, or through modesty, or out of a justified sense that they were no one's business. Each person was, socially, at least, understood to be an integrated being, more or less presentable but with unknown depths. That concealed depth still occasionally emerges when supposedly normal individuals go on a killer rampage. It turned out that they were possessed by murderous rage, hardly if at all suspected. With a real frenzy, the media plunge into their "psyche," apparently taken aback by anyone who could have given so little past clue of his inner consciousness. For confessions have such a publicity value that even wrong-doers are expected to be seduced by it. An undisclosed self seems to be just one more of those social phenomena that are going out of fashion.

It's remarkable, however, that just at the moment we see a rise of unsolicited memoirs in print or E-Mail, an intellectual vogue (deconstruction) still insists that personality is only an exterior arrangement. Post-modernist theory has been heavily involved in questions of personal inauthenticity, the artifice of bad faith, and the substitution of performance for an increasingly questionable spontaneity. Individualism—so goes the argument—is merely an outdated liberal cliché, with no relevance to current behavior. No one of us chooses, so much as he or she is programmed, to play a social role. For all practical purposes, we are defined by the set of impersonal protocols through which we interact. In contrast to the widespread influence of this academic doctrine, the media certainly assume that a person has a genuine, interior self, all the more enthusiastically excavated when it may appear to be soiled. But at the same time, the media act as if an itinerary of flaws was the same as a revelation of character, and as if they themselves weren't part of our programming.

At the root of this matter are the current (at least in the U.S.), broad definitions of fame, which are satisfied when even a momentary spotlight falls on an individual. We're long accustomed to revel in the private life of our public celebrities. They hanker after and yet at the same time are offended by the media gaze, when it inevitably becomes prurient.

Nevertheless, the people who crave some kind of renown or notoriety have increased in number. It appears to comfort them with the thought that they are just like the famous, that fame—contrary to its hierarchical structure—is a democratic condition in which everyone has a right to share.

In the brochure for their exhibition "Fame After Photography" (Museum of Modern Art, New York, July 8 through October 5, 1999), Marvin Heiferman and Carole Kismaric write of Tinseltown, a theme restaurant in Anaheim, California, where "a make-believe version of fame comes to any dinner guest who'll pay forty dollars to be treated like a movie star, surrounded by actors impersonating excited fans, fawning reporters, and pushy paparazzi." This sounds like a gala event where pseudo-exhibitionists are served by crypto-voyeurs […] in what is presumably imagined to be a fun time.

Behind these extravagant charades, however, exist more diffuse opportunities for an individual to compel or solicit public attention. Two of them that come to mind are the cellular phone and the glamor industry. The first transgresses into and changes the etiquette of civic space; the second confuses the distinction between natural and artificial bodies.

Where they were once confined to home or office, intimate conversations with distant speakers are now increasingly carried on in crowded restaurants, trains, and along streets. Phone cell action in such locales not only opens itself to everyone within earshot, it includes them as an unwilling audience. Some Italian phone cell talkers are even equipped with attachments which free their hands to gesticulate expressively. The cell phone allows for the conduct of private business, but that conduct, when displayed before an undetermined number of spectators, is additionally, a narcissistic act.

Narcissism, and its cousin, vanity, also energize the markets for glamor goods and cosmetic surgery, whose purpose is the defeat of age. Untold women—and now, men—are beguiled by products that offer to remove spider veins, services that lift faces, and chemistry that enhances lips (for up to 12 hours between uses). And this is not to speak of "Brain Gums" that are supposed to increase cognitive function. As a columnist (Maureen Dowd) wrote recently in *The New York Times*, "We are a generation of Dr. Frankensteins and our monster is us. We don't mind perishing by the image as long as we get to live by the image." Now, an image may be good for assuming an attractive identity, yet the resort to such an image is also imbued with pathos, since the desired identity is known to be impermanent, and is suspected of being false.

Artists, of course, are expert students of this dilemma. It's not just that their success depends on inventing values and meanings; they deal in images as a form of self-expression. One artist certainly brings both these goals to quite an extreme. A French-woman, Orlan, has her face photographed while under plastic surgery. We are not spared closeups of the clamps, the retractors, the cut of the knife, opened or re-sectioned flesh, the swelling and stitches. By her emphasis on the reality of this painful and eerie spectacle, Orlan deflects our interest away from the "improved," yet counterfeit outcome. One might think of Orlan as a kind of perverse deconstructionist, willing to undergo mutilation in order to prove a point about sacrifices to the culture of beauty. Equally, one could imagine her to be more a compelled and obsessional personality than a didactic artist. Could she even be a victim of Münchhausen's syndrome, a sickness which affects disorders so as to draw solicitude and care to the sufferer? But the evidence of the pictures, alone, is inconclusive. All we see is a person in the process of acquiring skin that will become a mask.

In a critical way, masks underline the difference between the artistic portrayal of the self, and the self that is portrayed. The gallery of self-representations in recent photography and art is marked by a high incidence of masks, distorting mirrors, impostures, allegorical staging, disinformation, clowning and melodrama. Many of these performances exert a disfiguring pressure upon self-portraiture, the genre to which they nominally belong. For what we intuit in artistic self-portraits are fantasies constructed for the sake of the image rather more than they are in accord with the ego.

With their affectless, buttoned-up corporate style, Gilbert and George present themselves to us as suits, merely. Such contrivance may be interpreted as a satire on the repressions of the British class structure. Or their automaton-like behavior might be a comment on contemporary alienation. Yet the effect of opacity achieved by these "living sculptures" is so pronounced that it would be ludicrous to think we could ever know such unreachable men. Oddly enough, the same goes for Lucas Samaras grimaces and capers with such furor, and on occasion seems to fuse monstrously with his room, as to leave us with only a deliberately calculated persona, not a person.

A persona is a representative of the author, the one who controls the appearance, even if, in self-portraiture, they have to be the same creature. The two basic schemes for depicting that creature are the iconic—as in Gilbert and George—and the narrative, as with Orlan. Either way, the intent is to advertise the distinction between the character on view and the purposes active behind the scene. That character is supposed to demonstrate certain

THE FRAGMENT AS MEDIUM Thomas Wulffen

With every turn of reflection, the darkness created by knowledge increases by one order.
MICHEL SERRES

Success is a coincidence, an exception. Error is inherent in the system. We do not realize this because we assume precisely the opposite. Philosophy has taught us to distinguish between the body and the mind. Science constructs order where chaos prevails. Politics suggests goal-oriented action where "trial and error" is the rule. History appears to tell us that progress is unstoppable.[1] Yet a look back at the history of our century as it comes to a close clearly indicates that things are not as simple as we would like them to be. What we find are ruins, fragments full of faults themselves, rejected goods. What remains is the memory of fragments completed in the mode of abstraction.

Every photographic image is a work of memory in a dual sense: as a personal experience and as a technical process. In this context, the term "technical process" is understood to comprise not only production of the photographic image but its history and distribution as well. Acceleration of images, their distribution and acceleration within the image have little effect upon this work of memory. The phrase "acceleration of images" denotes the process by which the image is reproduced with increasing speed. Acceleration of images is to be distinguished from acceleration within the image. In the latter process, the image takes precedence over the subject; the image itself upstages the subject and claims complete autonomy. The world is experienced in images.

This experience is mediated, and this would appear to suggest that there is such a thing as direct perceptual experience of the world. Yet memory is involved in every perception. Without this memory we would have no orientation, since every act of perception would have to be decoded anew. What actually occurs is a process of comparison with previous experiences stored within us. This experience is also stored in the form of images, and these images have been preserved as likenesses of images since mankind created images— from the early cave drawings up to classical painting and even today's electronic media. Thus human concern with images and visual abstraction precedes all conceptual abstraction. As the latter strikes us as the most recent accomplishment, we have displaced the abstract in visual imagery. One reason for this may be that conceptual abstraction is more aptly discussed in concepts, while a different level of representation is used in discourse on the visual image. As such discussion will always be in some ways deficient, we find

1 Johann Nestroy's epigraph to Wittgenstein's *Philosophical Investigations* (Oxford: Basil Blackwell, 1859; p. viii) appears to have been overlooked or read and forgotten: "Moreover, progress is characterized by the fact that it looks much bigger than it really is."

IN THE EYE OF THE APPARATUS Carl Aigner

On the Constitution of the Subject in the Face of Photography

For Genoveva

> *The Photograph then becomes a bizarre medium, a new form of hallucination: false on the level of perception,*
> *true on the level of time.*[1]
> ROLAND BARTHES

> *... every photograph, no matter who takes it, no matter whom it represents, is an absolute affront to human dignity,*
> *a monstrous falsification of nature, a base inhumanity.*[2]
> THOMAS BERNHARD

1 Roland Barthes, *Camera Lucida. Reflections on Photography* (New York: Hill and Wang, 1981), p. 115.

2 Translated from: Thomas Bernhard, *Auslöschung* (Frankfurt on the Main: Surkamp, 1986), p. 26/27.

Photography has expanded the joy of making pictures into a desire to experience the world *as* image. Nothing, so it seemed for a very long time, was better suited to transforming the world into pictures than the photographic apparatus. It constructed and documented the world as an endless chain of images which succeeded in suggesting a transparency of visibility that finally secularized the divine gaze. For photography not only demolished the traditional concepts of the pictorial image and art in the 19th century, it also eliminated the dividing line between the real world and the visual image once and for all.

The human being as a creature of images is the credo of the 19th century, when pictures ceased to serve as symbolic representations and ordering structures of the world and became real, substantive objects of reference. The photographic image no longer required interpretation but demanded only a *showing as a witness-creator* of the world. Thus the "Age of the World Image" (Martin Heidegger) was rung in for good, an era in which it (the world) existed only to the extent that it entered the enchanted realm of photographic analogy. But what brought about this "pictorial turn," this joy in making pictures?

It was the "dromologization" (Paul Virilio) of European culture in the wake of industrialization and urbanization in the 19th century (and vice versa). The accelerated pace of society required new (visual) possibilities for (self-)assurance and the placement of society and the individual on a firm footing in the world (the image as information could and must no longer differ from the world as information). Photography offered the logical and most efficient set of pictorial instruments with which to respond to these new social demands—not only because it made it possible on the basis of its photochemical foundation to *picture* the world in a new, infographic way, but above all because it also realized its new pictorial order in the context of time. But what does this actually mean?

Faisal Abdu'Allah

Nobuyoshi Araki

Stefan Banz

Richard Billingham

Larry Clark

Rineke Dijkstra

Nan Goldin

ON THE FRINGES OF DOCUMENTARY

Zhuang Hui

Boris Michailov

Jack Pierson

Beat Streuli

Annelies Štrba

Thomas Struth

Andy Warhol

Faisal Abdu'Allah

*1969, lives and works in London

Post-colonialism implies a critical reorientation involving the exploration of such issues as hybridism, syncretism and the impossibility of distinguishing among cultures. If in post-colonial cultural criticism, as defined in encyclopedias, "in a subversive rejection of imperialist discourse and the appropriation of indigenous discourse emerges a dialectically dynamic hybridism that releases creative energies in the continuing confrontation with the 'imposed' culture, whereby the methods of reinterpretive rereading assume an important function,"[1] then such practice is applicable to the work of a new generation of artists such as Mary Evans, Yinka Shonibare, Virginia Nimarkoh and Faisal Abdu'Allah. Faisal Abdu'Allah's photographic œuvre takes a close look at such post-colonial concepts as orientalism, alteration, mimicry or center and periphery.

Born as Paul Duffus, the son of Jamaican immigrants and members of the Pentecostal community in London, Abdu'Allah converted to Islam at the age of twenty, after reading the books of Malcolm X and becoming acquainted with the Nation of Islam during a study tour in the US. One theme is a constant in his photography: The meanings shared by the members of a group (and which distinguish them from those of any other group), give them a sense of identity. For Faisal Abdu'Allah, Islam is a concept of life.

The three-part work entitled "Statesman Nos. I, II, III. Silent Witnesses" (1997), represents a rereading of Islam, particularly of the concept of the *Shahadah* as an Islamic profession of faith, from the perspective of "Black Experience." Two of the black men in the portraits (all of which showing a view of the back of the subject's head) are converted Moslems. The figure in the third portrait is a man whose attitude toward Islam is ambivalent and who remains stubbornly undecided. The portraits on glass prisms describe three different yet interwoven spiritual experiences, the joys and suffering of a "return" to Islam and the growth of faith, ideas and practice in a religious life.

The unconventional dogma of a portraiture of black men as Nubians (rather than "niggers") is a constant presence as a symbolic form of self-determination in the work of Faisal Abdu'Allah. The objective is an intellectual struggle for control of the contents of a "Black Life," and especially of the emancipation of the souls of black people. The artist poses such questions as "Which religion serves our interests?" and "What lies have been spread on our religious heritage?"[2] In large-format works like "The Last Supper I & II" (1995), the artist continues to pursue his analysis of the role of religious ideologies in the emancipation of black people. "The Last Supper," part of the fundamental mythology of Western culture, is transformed into a community of Moslems and then into a hip-hop community, an image that is less suggestive of a "battle of cultures" than of a "circuit of cultures."

PAOLO BIANCHI

1 Translated from Ansgar Nünning (ed.), *Metzler Lexikon der Literatur- und Kulturtheorie* (Stuttgart / Weinheim: J. B. Metzler, 1998), p. 435.

2 Translated and quoted from Robert Beckford, in *Faisal Abdu'Allah. Out of the Blue* (Glasgow: Glasgow Museum, 1997), p. 3.

FAISAL ABDU'ALLAH
STATESMAN NO 1 (SILENT WITNESSES) 1997
Silkscreen print on glass prism, 29.5 x 29.5 x 29.5 cm
Courtesy The Agency, London

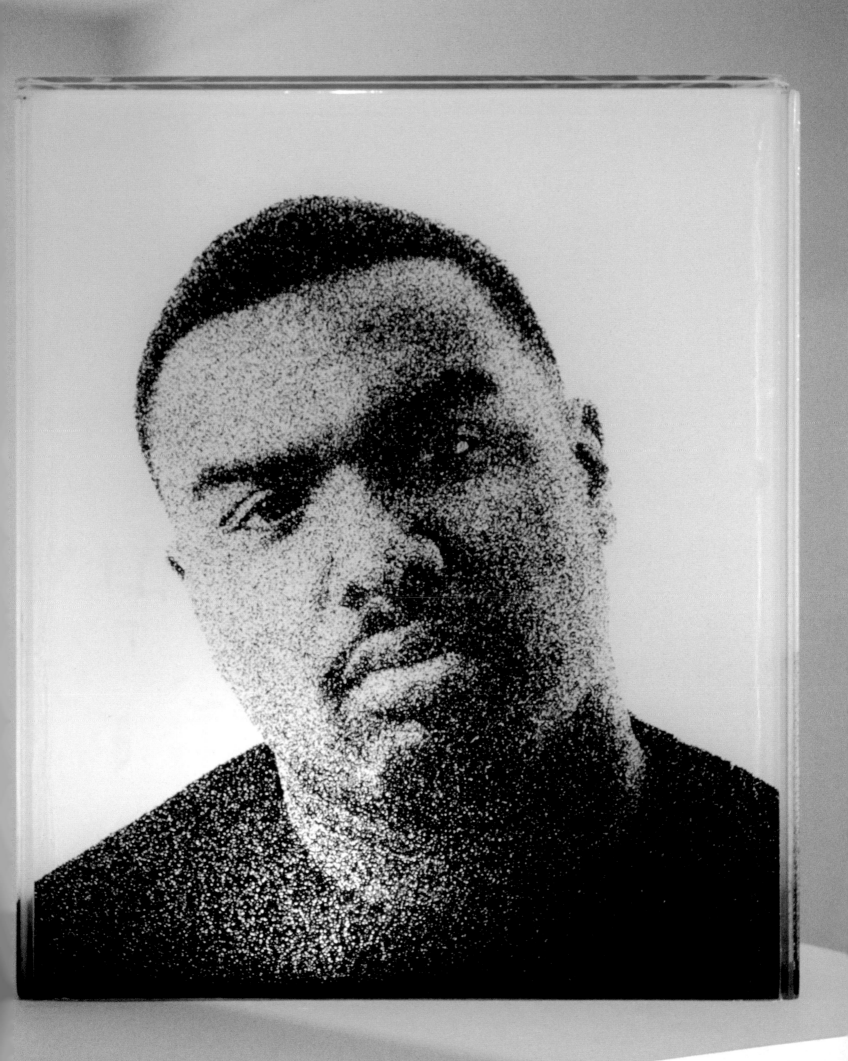

Thomas Struth

*1954, lives and works in Düsseldorf

A young woman wearing a summery, yellow tank-top sits facing the camera. She is symmetrically framed by a blurred background that does not mystify but is readily recognizable as an apartment interior. The background presents an interplay of light and dark, a nuanced mood of light that incorporates the human figure without distracting from it. In this session, Thomas Struth apparently waited for the moment in which his subject, attentive and relaxed at the same time, anticipated the release of the shutter. "The shooting situation is never neutral. For the person being photographed there is always a period of waiting until the photographer releases the shutter. If it takes five seconds, the subject wonders during those five seconds: Am I still focused on myself or am I already flying onto the negative? Am I trying to 'see' myself photographed in my thoughts? How people feel in this moment of encounter is very important. Is the person taking my picture my friend, or do I feel uncomfortable, like some kind of an outcast? [...] As a photographer, I try to get a feel for these psychic oscillations, this back-and-forth, in the few seconds before releasing the shutter."[1]

A video portrait of Anna Grefe was done the same year. For a full hour she gazes at us in a large-scale projection. The back-and-forth between the camera and the model, the simple acts of breathing and watching, are stretched in time to the extent that the viewer senses a closely related intensity of perception. It is as if the roles could be exchanged, and the portrait were looking out. The mediating effect of the recording camera unexpectedly gives way to the immediacy of the gaze directed back toward the viewer.

Thomas Struth's portraits avoid precise sociological codes.[2] And this is a psychological portrait only in a limited sense. At first glance, Anna Grefe's smile may call to mind the most famous of all women's portraits. It reveals little about the person but so much more about the artist's way of dealing with the world. The aspect of ambivalence between distance and closeness becomes a model for an attitude that does not subject people to a formative gaze but permits them to remain themselves in their perception.

HANS RUDOLF REUST

1 Translated from "Thomas Struth im Gespräch mit Hans Rudolf Reust," in: *Kunstforum*, no. 144, March / April 1999, p. 247.

2 See Benjamin H. D. Buchloh, "Portraits / Genre: Thomas Struth," in: *Thomas Struth / Portraits* (Munich, 1997), pp. 158ff.

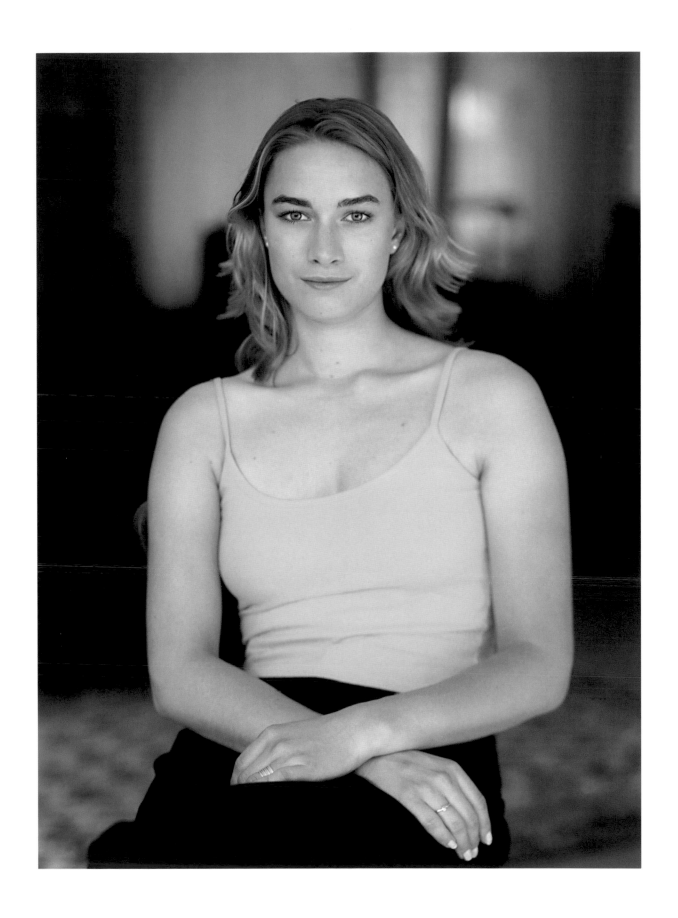

THOMAS STRUTH
ANNA GREFE, SITZEND, DÜSSELDORF 1997
(ANNA GREFE, SEATED, DÜSSELDORF)
Color photograph, 9/10, 114 x 91 cm (with frame)
Private collection Alexander Jolles (Courtesy of Galleria Monica de Cardenas, Milan)

Annelies Štrba

*1947, lives and works in Richterswil und Melide

The intriguing title of this photo is based, as one quickly realizes, on the words printed on the subject's clothing. She is the photographer's daughter, barely sixteen years old at the time the picture was taken. Thus she belongs to a generation that at this very moment is beginning to express itself in a way that could be called new—namely in total difference, even with respect to the rebellions of past decades. Given sufficient distance to the Bronx, Hip-Hop socialization requires no confrontation in order to be cool, since one sees oneself as fundamentally different anyway—not exalted, just special. Barricades are not stormed but used instead to set oneself apart. Yet the message is not "up with rave, down with rebellion" but a much more skeptical and hopeful "entertain, educate, stimulate!"

That is basically the background of the photo, in a brief sketch. The portrait says little, but what it does say is essential. Only a few unspectacular items of clothing might be regarded as "typical": the wool cap, of course, the white stripes on the sport jacket and naturally the waist bag with the visionary imprint. The non-standard aspects are more revealing. A few details appear to have been sufficient to express the sense of belonging, for what matters is how something is worn, namely authentically. The girl's posture is straight. There is no pose. Her gaze appears somewhat aloof, aristocratic. She knows at this particular moment where she belongs, and so she feels no need to emphasize it. In 1990, the Hip-Hop crowd could still regard itself with certainty as exclusive. And Linda embodies that feeling with no hint of agitation.

The mode of representation is equally important, however. Annelies Štrba describes a situation without expressing judgment. She simply lets the image speak for itself: Linda. Vision. 1990. In this simple clarity it becomes a monument of its own presence. And as devoid of vision as it may appear at first, its deeper portent is indisputable. Perhaps we simply expect the wrong things of a vision, only to realize later that it has been revealed to us without our noticing it. Any attempt to link it with a specific meaning would reduce it to something that leaves us unsatisfied—visions are boundless [...] like the attitude of the photographer, who does not interpret but instead informs, without ideological overtones. In the case of Wolfgang Tillmans, the absence of judgment is a given. He himself is a representative of the scene he observes. Yet even Annelies Štrba is more than a chronicler. At the crucial moment she is actually part of a youth movement herself, exhibiting absolute confidence in the capacity of the motif to speak for itself. And in this sense she is as non-dogmatic as the newly awakening generation. This photograph is thus valid both as a work of art and a document, for it is fully appropriate to its subject. Vision does indeed exist.

RALF BARTHOLOMÄUS

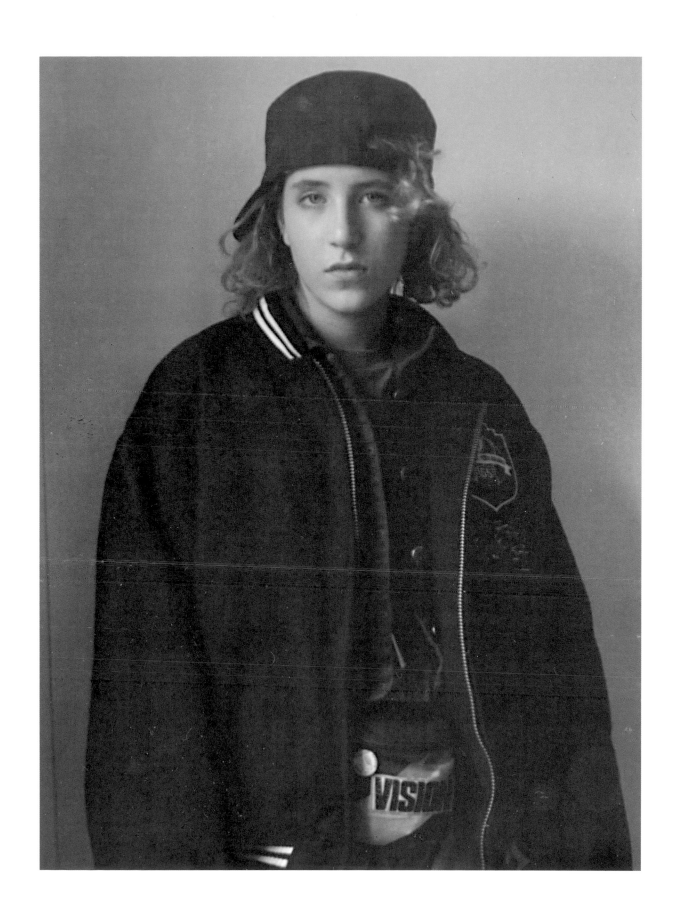

ANNELIES ŠTRBA

LINDA VISION 1990

Black-and-white photograph on photo canvas, 150 x 100 cm

Courtesy of Galerie Eigen+Art, Berlin / Galerie Urs Meile, Lucerne

Boris Michailov

*1938, lives and works in Charkov (Ukraine)

Michailov's photographic work, which began in the sixties, bears the imprint of his efforts to come to grips with the social and political circumstances in the Soviet Union and its successor states. Stylistically speaking, his highly diverse works range between staged photography and documentary. Their unique aesthetic qualities are grounded in a very complex context involving the iconic system and the Soviet Communist interpretation of history, in its art censorship and in phenomena deriving in part from Russian art, which Michailov questioned in an ironic, sarcastic approach. Characteristic of his art is a combination of photographic notes and handwritten commentaries which do not construct stories but instead expose the manipulative operation of language on an eidetic sense of meaning that is posited as speculative.

The series entitled "U Zemli" (Down and Out) marks the artist's focus on the expressive tools of "straight" street photography. It was done in 1991 in Charkov and in the Ukrainian capital of Kiev within a span of just a few weeks. Prompted by his perception of the inevitable decline of post-Soviet society and the impending collapse of the foundations of civilized existence, Michailov turned his attention in this series to "cruel reality."[1] Typical settings include streets, derelict urban fringe areas and industrial wastelands. Only rarely are interior spaces exposed to view. Michailov presents absurd-looking aspects of everyday life, pointing out signs of ethical and moral decline in a population threatened by poverty and the loss of orientation. Disturbing spatial relationships emerge in photos taken with a wide-angle panoramic camera, with which Michailov constantly photographed from a concealed, hip-level position. In its published form, the work comprises well over a hundred photographs, all given a brownish tint after enlargement and gathered together in a kind of photo volume. Michailov describes the intended associative reference of the tint to decay, filth, dust and above all to the appearance of historical photographs as "parallel historical association."[2] The series entitled "Sumerkj" (Twilight), 1993 was conceived as a sequel to "U Zemli" with a heightening of effect. It was realized with the same means as its predecessor. The noxiously shimmering, variously spotted, iridescent blue of the photos is used deliberately by the artist in an allusion to childhood memories as the color of war, hunger and cold. The color overflows the contours, making certain aspects of content virtually unidentifiable. "Sumerkj" intensifies the sense of a rapid decline of a society, of its terminal phase, an impression that is underscored by collapsing pictorial spaces and the inclusion of blurred contours. Viewed against the background of the artist's development to date, his monumental "Case History" appears a logical culmination. In his traumatic scenes from the everyday lives of homeless people in Charkov, now photographed for the first time in color, Michailov, a herald of the apocalypse, confronts the viewer with his own "cruel, merciless empathy and destructive, consuming pity."[3]

ANDREAS KRASE

1 Lech Lechowicz in: *Boris Michailov* (Lodz: Galeria FF, 1997), n.p.

2 Translated from Boris Michailov, as quoted in Brigitte Kölle (ed.), *Boris Michailov / Boris Mikhailov* (Stuttgart: Oktagon, 1995), p. 16.

3 Translated from Victor Tupitsyn, *Boris Michailov, Case History*, (Zurich / Berlin / New York: Scalo, 1999), p. 484.

BORIS MICHAILOV
U ZEMLI 1991–1992 (DOWN AND OUT)
Black-and-white photograph, tinted brown, 11.5 x 27.5 cm
Ilya and Emilia Kabakov, New York (Courtesy of Scalo, Zurich)

BORIS MICHAILOV
SUMERKJ 1993 (TWILIGHT)
Black-and-white photograph, tinted blue, 11.5 x 27.5 cm
Ilya and Emilia Kabakov, New York (Courtesy of Scalo, Zurich)

Zhuang Hui

*1963, lives and works in Beijing

Staging, self-presentation and the staged presentation of others comprise one of the most import themes in contemporary Chinese art of the nineties. Since 1995, artists have turned their attention to developments affecting people in Chinese society during an era marked by profound and rapid change. Zhuang Hui's photographs place him in the forefront of recent contemporary art, as they expose these economic, social and political upheavals through deliberate and systematic staging.

Using a panoramic camera with a rotating lens capable of covering a sweep of 180 degrees, Zhuang Hui captures images of selected social groups in black-and-white the inhabitants of a village, school classes, police at a training academy or hospital medical staff. The products are elongated, horizontal photographic "rolling images." In terms of style, Zhuang Hui uses the technique of the set group portrait commonly used by Chinese photographers during the twenties, an approach that is mirrored in the calligraphic captions describing the subjects. He also makes use of the strict frontal presentation typical of photos from the Mao era.

The groups portrayed are ordinarily entire units ("danwei")—the higher organizational entity encompassing all classes of participating members in China. Thus a university, for instance, is a labor unit composed of all participants, including instructors and students. The administration of the "unit" provides work and living space as well as preventive medical care. It manages vocational and personnel affairs, grants approval for marriages, divorces and childbirth. In short, it exerts a major influence on the lives of its members.

With the growing orientation toward a capitalist-style market economy it is now becoming apparent that these "units" are cumbersome and increasingly less capable of keeping pace with contemporary developments. They have become relics of an obsolete ideology which, under Mao, molded and merged society and the individual together. The group photographs have become empty shells. Reality today is to be seen in the very different faces of the individuals photographed, who appear quite distinctive. At the same time, each individual is compelled to depend upon himself to a much greater extent than before, and many people are baffled and helpless in the face of the overheated pace of change.

Appearing as a standing figure at one edge of his photographs, the artist incorporates himself as a participant and organizer. He places himself and his role as an artist in a social context. He demonstrates the distance that separates his work from his models from the Mao era and those of the twenties, casting light at the same time on the current condition of Chinese society. The viewer is confronted with a wide range of levels of reflection, which give these works a position of significance within the sphere of recent Chinese photography and the international art world.

ANDREAS SCHMID

ZHUANG HUI

DOCTORS AND NURSES

OF THE PEOPLE'S HOSPITAL IN ANYANG, HENAN, JULY 2, 1997

Black-and-white photograph, 3/20, 19.5 x 143 cm

Courtesy of Galerie Urs Meile, Lucerne

ZHUANG HUI

**TRAINERS AND TRAINEES AT THE POLICE ACADEMY IN LUOYANG,
HENAN, MAY 30, 1997**

Black-and-white photograph, 3/20, 19.5 x 143 cm

Courtesy of Galerie Urs Meile, Lucerne

ZHUANG HUI

**ENTIRE FACULTY AND STUDENT BODY
OF THE WU LONG GOU ELEMENTARY SCHOOL, MARCH 19, 1997**

Black-and-white photograph, 2/6, 19.5 x 77 cm

Courtesy of Galerie Urs Meile, Lucerne

公元一九九七年五月十三日河南

公元一九九六年十月二十日河南省新安

公元一九九七年八月十三日河北省

ZHUANG HUI

**ALL INHABITANS OF THE VILLAGE OF GAOZHUANG, JIUZHI,
DAMING, HEBEI, OCTOBER 30, 1997**

Black-and-white photograph, 3/20, 18.5 x 101 cm

Courtesy of Galerie Urs Meile, Lucerne

Nan Goldin

*1953, lives and works in New York

The photo series entitled *The Ballad of Sexual Dependency*[1] is Nan Goldin's very personal visual diary, which she permits others to read. It contains photographs of friends and members of her family, people who live in New York, Boston, Berlin or London. In an accompanying text she writes: "This is the history of a re-created family, without the traditional roles." […] "The diary is my form of control over my life."[2] Goldin wants to show the pubic what her world looks like, without attempting to beautify or glorify it, while processing her experiences and preserving her memories at the same time. Thus she is first and foremost a participant, a witness to a moment, but she is also a voyeur who probes the intimate spheres of others with her camera.

The series begins with a photograph taken at the Coney Island Wax Museum of the Duke and Duchess of Windsor, whom many regard as the perfect married couple, and ends with a picture of two skeletons locked in an embrace. In between are photos of Nan Goldin and friends, shown in single or group portraits but always in private settings. As the artist states, she wants to find out "what makes coupling so difficult."[3] Her interest is focused on an exploration of gender-specific roles that significantly influence the essence of relationships in the struggle between autonomy and dependence. On the one hand, Nan Goldin's photographs document prevailing behavioral norms; on the other, she chips away at accepted role assignments. By portraying women as couples, she underscores their Amazon-like strength, whereas her portraits of men on their own emphasize their vulnerability. Goldin ignores social conventions in the process, showing no concern for taboos or concepts of unbecoming behavior. Instead, she is intent upon tracing the endless, complicated quest for love and warmth in an honest and authentic manner. Thus we hear in her pictures (in both the snapshot-style and the artistic photographs), the voices of both pain and pleasure, despair and joy, tenderness and violence. Ultimately, however, it is Nan Goldin's own involvement that makes these photographs so convincing and so moving.

ANNA HELWING

1 Nan Goldin, *The Ballad of Sexual Dependency* (New York: Aperture, 1986).

2 op. cit., p. 6.

3 op. cit., p. 7.

NAN GOLDIN
SELF-PORTRAIT IN BLUE BATHROOM, LONDON 1980
Color photograph, 51 x 61 cm
Collection of Christoph Schifferli, Zurich (Courtesy of Scalo, Zurich)

NAN GOLDIN
VIVIENNE IN THE GREEN DRESS, NEW YORK CITY 1980
Color photograph, 61 x 51 cm
Collection of Christoph Schifferli, Zurich (Courtesy of Scalo, Zurich)

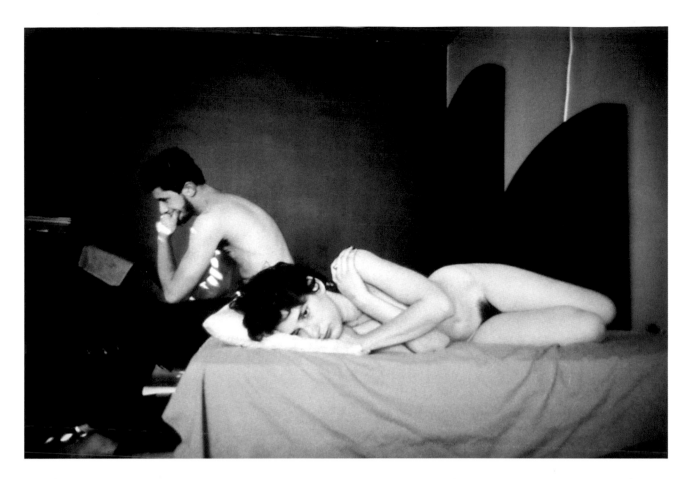

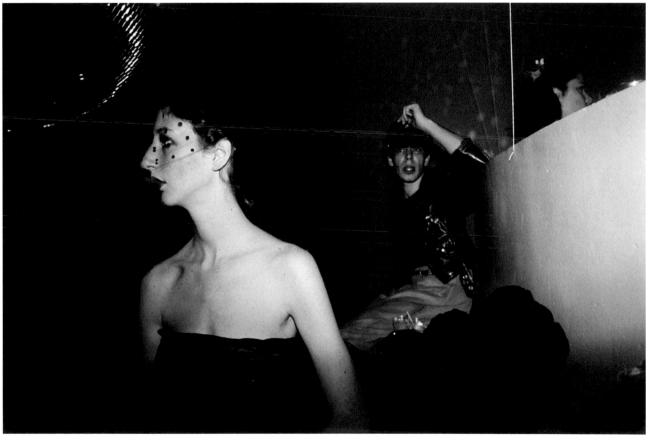

NAN GOLDIN

COUPLE IN BED, CHICAGO 1977

Color photograph, 51 x 61 cm

Collection of Christoph Schifferli, Zurich (Courtesy of Scalo, Zurich)

NAN GOLDIN

ROBIN AND KENNY AT BOSTON / BOSTON, BOSTON 1978

Color photograph, 50.5 x 72 cm

Collection of Christoph Schifferli, Zurich (Courtesy of Scalo, Zurich)

Larry Clark

*1943, lives and works in New York

Larry Clark is the most radical social realist among contemporary photographers. His photographs deal with the excesses and obsession of his own life, his scene, his social surroundings—not as industrial rock-authenticity but as a photographic logic applied to life. Shots with cameras and shots with guns.

Larry Clark first rose to stardom in the early seventies. As the roughest and most realistic representative of a new style of documentary photography that refused to elevate itself above what it photographed, he was an important figure in a new movement. Yet because he was always directly involved in what went on in front of his camera lens—drugs, sex, crime and hippie idylls—the career he might have had was not open to him.

Clark was born in Tulsa, Oklahoma, in 1943. As a teenager he took portraits of families and especially of babies at his parents' photo shop. After finishing college he studied commercial photography at Layton Art School. After completing his studies there (1961–1963), he began photographing the local scene in Tulsa: bums, junkies, rockers. Eventually, he decided to publish these photos from his own life.

In 1971 this documentary of the sixties, much of which has the look of a manual of style for the eighties, appears in his first book, *Tulsa*.[1] Larry Clark became an underground cult figure, but no one seemed to care. With *Tulsa*, the image of Larry Clark, "tough-guy photographer," was born. He later worked with male prostitutes on 42nd Street in New York. During these years he lectured occasionally but more or less disappeared from view until 1984, when his *Teenage Lust* appeared (a work he was forced to publish himself, as other publishers had rejected it as too "explicit"). The book documents his early years in Tulsa and his 42nd -Street studies, but it also portrays his life as a provincial hippie on the way to an outlaw existence, always at the point at which incredible fun suddenly turns into some (life-) threatening disaster. In the last section of the book, Clark tells his life story, dictated into a tape recorder and typed. To accomplish this, he had to go "clean." He tells of putting himself through withdrawal so that he could write a long text—a worthwhile ordeal, for Larry Clark's own self-assessment surpasses every other commentary ever written about himself and his photographs.

The terms Larry Clark uses most often are "feeling" and "reality." That is indicative not only of his classical view of photography but, more importantly, of the fact that he has never been a voyeur. He is often featured in his own photos and, in fact, usually involved in the action. His great trauma and the point at which his work in art began was the moment when his father said to him: "You look like shit," after which he never spoke to him again.

JUTTA KOETHER
(excerpt from "Larry Clark, Terminal Teenager," in: *Spex*, 6/1991)

1 Larry Clark, *Tulsa* (New York: Lustrum, 1971).

LARRY CLARK
TULSA 1968–71
Gelatin-silver print, 43/50, portfolio, 10 parts,
each 28 x 36 cm (with passe-partout)
Courtesy of Galerie Art & Public, Geneva

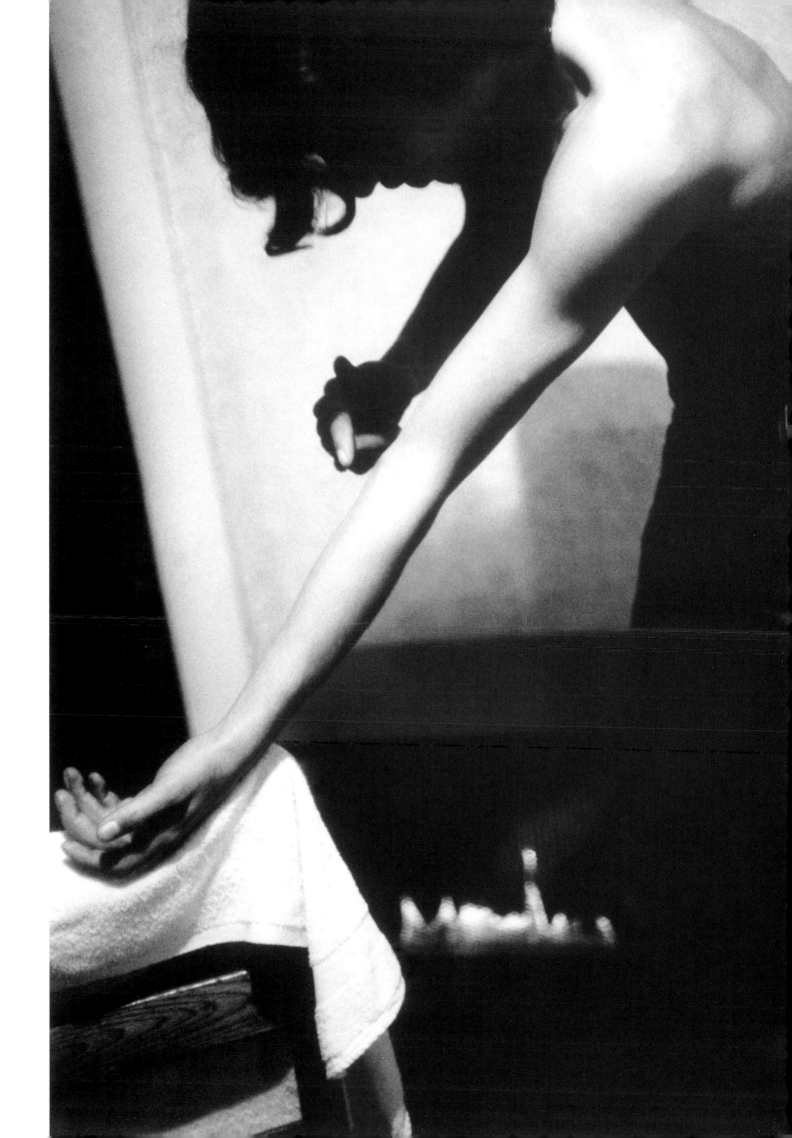

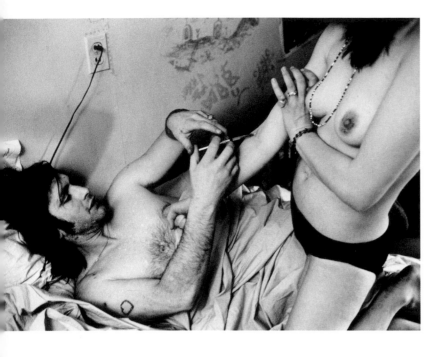

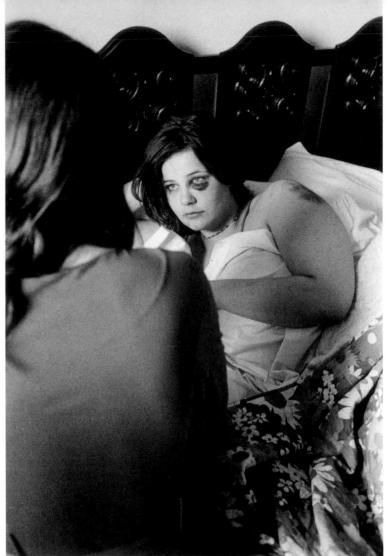

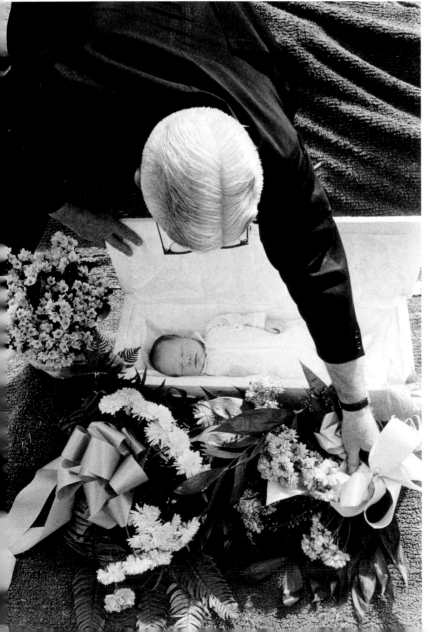

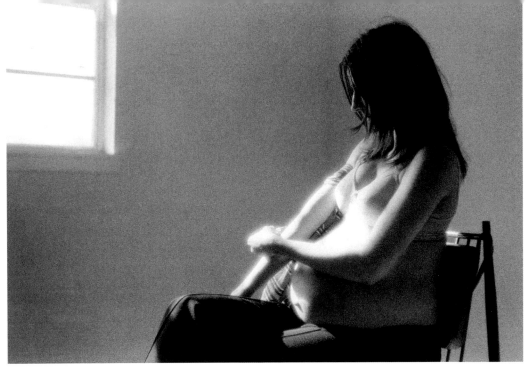
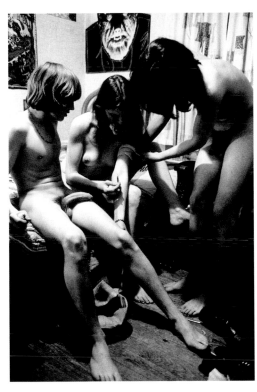
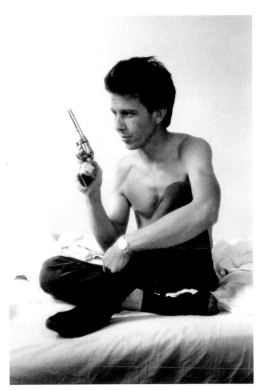
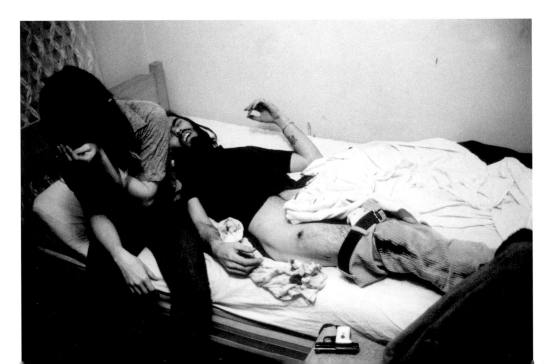

Richard Billingham

*1970, lives and works in Stourbridge

"My father, Raymond, is a chronic alcoholic. He doesn't like going out and usually drinks home-brewed beer. My mother Elizabeth doesn't drink much at all, but she smokes a lot. She loves pets and decorative knickknacks. The two of them got married in 1970, and I was born shortly afterward. My younger brother Jason was sent to foster parents at the age of eleven, but he's now living with Ray and Liz again. He became a father just a little while ago. Ray says Jason is rebellious. Jason says 'Ray's a laugh,' but doesn't want to be like him." These are the words with which Richard Billingham describes his relatives in the accompanying text for his photo series "Ray's a Laugh," which offers a direct view of his home life without a trace of false modesty. With merciless precision, Billingham captures with his camera the most significant features of the everyday life of his family: poverty, alcoholism, apathy and social neglect. His snapshot-style photos are strikingly authentic documents of the hopeless world in which the young British artist—like many others—has lived since his birth. The product is an intimate photo album devoted less to memories of times past than to the artist's own attempt to come to grips with fateful family constellations.

Billingham took his first photos in 1990 without ever having attended a photography class. At the time, he needed them only as models for his drawings, the primary focus of his work in art at the time. The possibility of using photography as a means of studying family circumstances did not occur to him until later. Billingham still regards himself as a painter and draftsman, as an artist for whom photography is a tool that allows him to approach the reality around him as objectively as possible as he learns to understand it. Given their snapshot quality, the photographs assert no claim to perfection, nor are they based upon principles of staging. They lose some of their neutrality only by virtue of the selection process Billingham later employs. Although guided by substantive and painterly criteria, his selection nonetheless provides insight into the artist's very personal way of dealing with his own experience.

ANNA HELWING

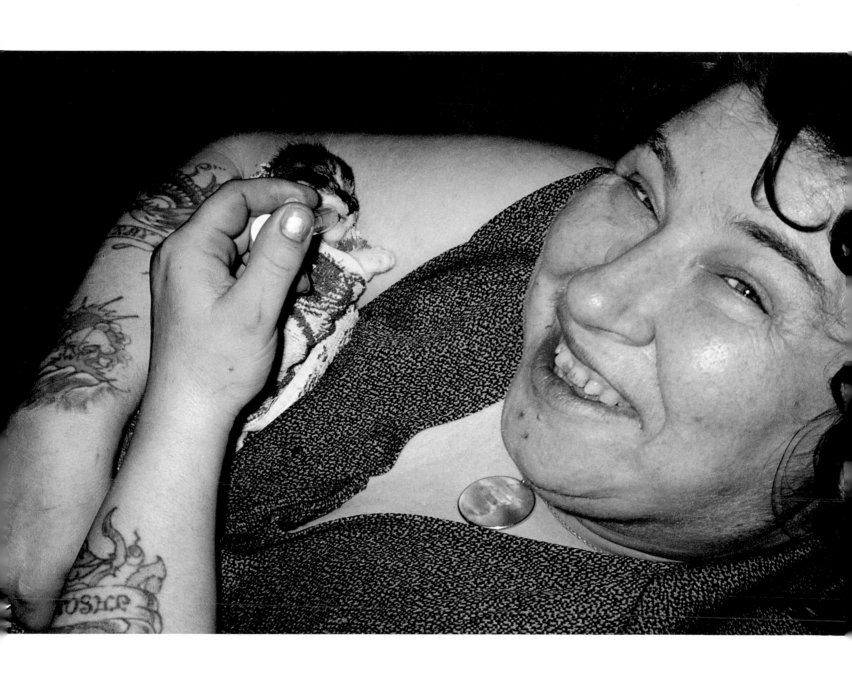

RICHARD BILLINGHAM
UNTITLED (RAY'S A LAUGH #4) 1992
Color photograph, 80 x 120 cm
Ringier Collection, Zurich

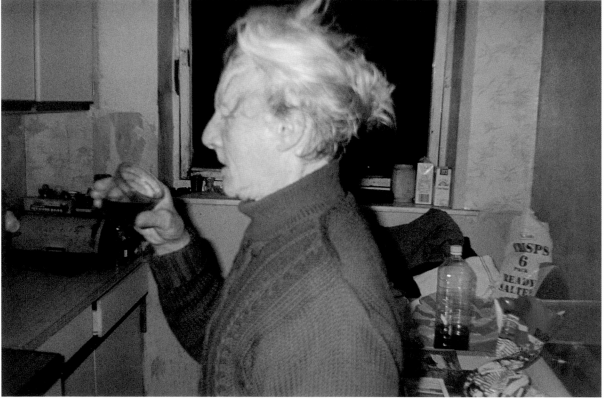

RICHARD BILLINGHAM
UNTITLED (RAY'S A LAUGH #37) 1994
Color photograph, 50 x 75 cm
Ringier Collection, Zurich

RICHARD BILLINGHAM
UNTITLED (RAY'S A LAUGH #3) 1995
Color photograph, 105 x 158 cm
Ringier Collection, Zurich

RICHARD BILLINGHAM
UNTITLED (RAY'S A LAUGH #24) 1995
Color photograph, 105 x 158 cm
Ringier Collection, Zurich

Stefan Banz

*1961, lives and works in Lucerne

The Swiss artist Stefan Banz works from within his own immediate surroundings. Since 1987, his own family has been the focus of his artistic interest, a circumstance based in part on economic considerations: Banz sees himself in the dual role of a dedicated father and an artist.

He has systematically documented his life with daughter Lena, son Jonathan and wife Sabine Mey in countless photographs. At first glance, these look much like ordinary family photos. Yet a closer look reveals something "irritating" about the Banz "family album."[1] It is not the idylls of family life that are memorialized here. In a kind of spatial and temporal in-between space, Banz freezes fragments with an ambivalent potential, deliberately exploiting that ambivalence as a stylistic resource. "Photography," Banz says, "is the most abstract pictorial medium there is, because it has nothing to do with life and because it does not move in time. Because it selects only a second from life, and there is no before and no after. That is why you find such abstract solutions."[2]

Always based upon a conceptual foundation, Stefan Banz's work includes photography, video art, installations and texts. He is interested primarily in the mechanisms involved in the reception of things and the ways in which misunderstandings arise. "The misunderstanding is a kind of overriding theme for me," he explains. Other important contents include childlike imagination, archetypal scenes of the kind one finds in fairy tales, darkness and fears. His role as a father is a great help to him. "Banz takes his own small world as a point of departure for the articulation of questions about the authenticity and validity of perception. Where does reality begin—both that of the image and that of the viewer? Where does the world end and the imagination begin?"[3]

A visually generated ambiguity evokes a sense of uncertainty even in the portrait of his daughter with vampire's teeth. Although we never doubt for a second that what we see in the picture is really and truly a child at play with a pair of false fangs between its baby teeth, the photographic image teeters at the verge of enigma and multiple meaning. A child's game? Lolita and/or Dracula? A vanitas image? The Adam's family. The Young Girl and Death? Uncertain and at a loss for an explanation, we choose to see what seems most obvious: the artist's daughter engaged in harmless play.

GIANNI JETZER

1 A selection of these photos was recently published in book form: Christoph Doswald (ed.), stefan banz, *i built this garden for us* (Zurich: Edition Patrick Frey, 1999).

2 Stefan Banz in an interview with Thomas Wulffen, *Kunstforum*, vol. 145, 1998, p. 275. See also the essay of Banz in this book, pp. 29-31.

3 Christoph Doswald, "The Origin of the World," op. cit., p. 150.

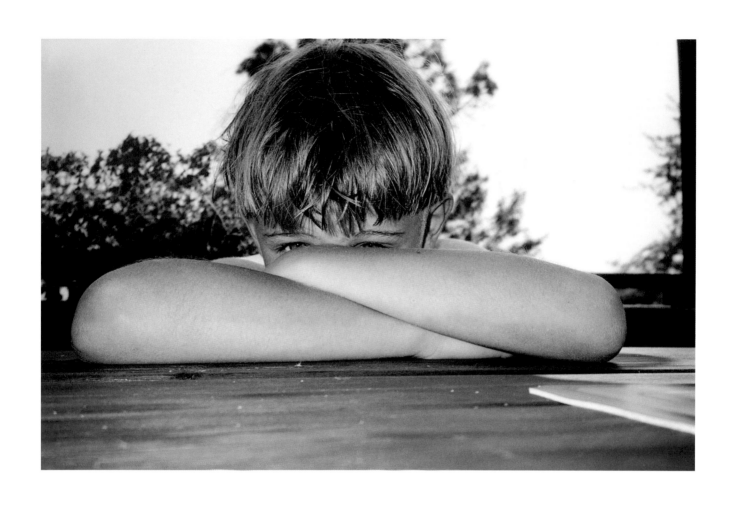

STEFAN BANZ
I BUILT THIS GARDEN FOR US (FINE) 1997
Color photograph, 1/3, 150 x 225 cm
Courtesy of Galerie Ars Futura, Zurich

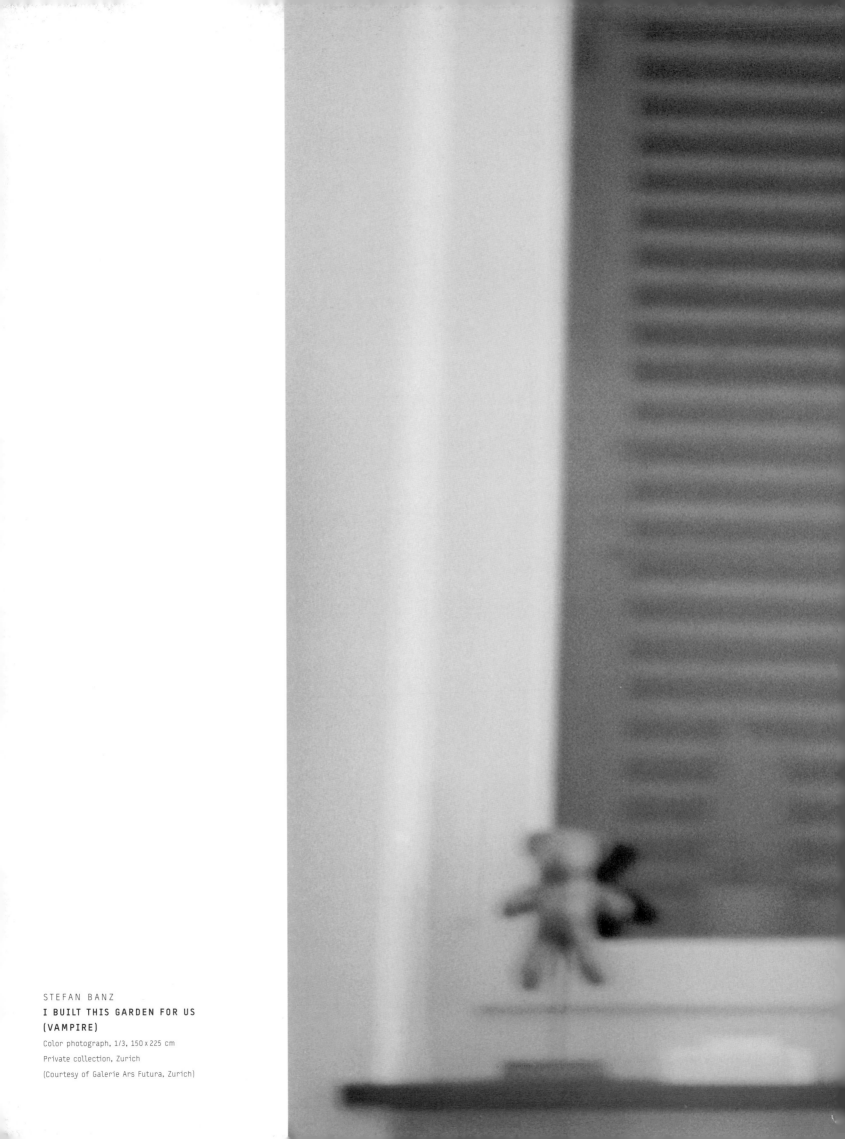

STEFAN BANZ
**I BUILT THIS GARDEN FOR US
(VAMPIRE)**
Color photograph, 1/3, 150 x 225 cm
Private collection, Zurich
(Courtesy of Galerie Ars Futura, Zurich)

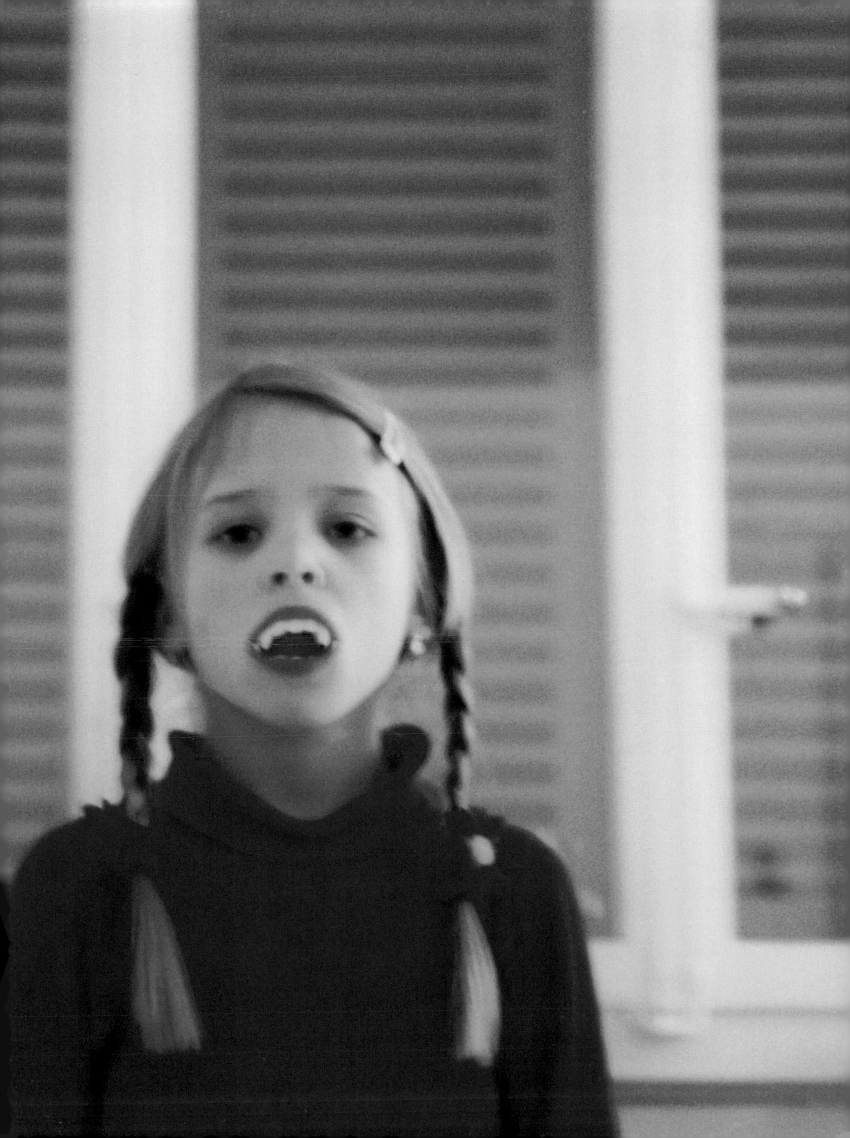

Nobuyoshi Araki

*1940, lives and works in Tokyo

Nobuyoshi Araki has made wonderful pictures of clouds and flowers. Of his more than 120 books,[1] several are devoted entirely to close-ups of food. He has paid tribute to his beloved native city of Tokyo, a metropolis whose face is marked by constant demolition and new construction, in hundreds of photographs. There is hardly a corner left in the city that Araki, a workaholic who refers to himself as a "truth machine," hasn't captured in photos.

Araki became Japan's most famous photographer for different reasons, however. Many of his photos are heavy-duty hard-core. They include photographs of women bound and gagged, in some cases even suspended from the ceiling, of schoolgirls with bananas in their mouths and of geishas posed beside vibrators. Thus Japanese vice police and Western women's rights advocates tend to regard him as a nasty pornographer whose exhibitions, which are *eo ipso* rarely appropriate for youth and children, they vociferously protest (as in Wolfsburg in 1997). Those familiar with Japanese art see him as an artist in the tradition of Hokusai, Ukio-e und Utamaro, masters of the woodcut during the Edo period (1613–1868). In his homeland, he has assumed the role of a sexual liberator who, in these very bondage scenes, parodies and bursts the real bonds imposed upon Japanese women by tradition.

With his Menjou-beard and round-framed sunglasses, Araki is a familiar figure in the city. He moves about in Tokyo's streets and nightclubs in a manner reminiscent of a Polaroid-toting Andy Warhol in the New York party scene. He is always accompanied by an entourage, and his sessions are genuine public events. Women are said to offer themselves by the dozen as models, often with quite precise ideas about the "degrading" poses they wish to assume. It is considered hip to have Araki turn one into a still life in the flesh with ropes of rice straw—and to become part of the art history of the, shall we say "pornographized" body, that began in our century with Marcel Duchamp and extends to the work of Cindy Sherman and Araki's erstwhile collaborator Nan Goldin.

According to Michel Foucault, sex has become more important over the centuries than our souls, almost more so than our own lives.[2] And no one still believes that sex is merely an act of reproduction performed for ten minutes each year. Today, sex is presumably viewed merely as an end in itself. In any event, Araki poses the question of what games are permitted and perhaps even necessary. Men appear in Araki's photos quite frequently as mere passers-by, as sado-masochistic slaves or stereotypical office dwarfs, while the gazes of "his" women are majestic. As Foucault points out, Japan has an *ars amandi*, whereas the West has sexual studies.

During the past thirty years, Araki has received high honors for photography about as often as he has been called to answer to charges of creating a public nuisance and similar crimes in court. While his works of the last fifteen years (also) trace the development of a human image that reveals the body stripped of the last vestiges of metaphysical veils, and while these works have rightly been attributed high artistic value, older pictures now possess something rather nostalgic and touching: a disreputable quality.

In his book entitled *Tokyo Lucky Hole*,[3] Araki "documents" Tokyo's Sinjuku quarter. A temporary relaxation of Japanese moral laws between 1983 and 1985 fostered the emergence of a sexual

1 The collected works of Nobuyoshi Araki are published continually by the Heibonsha publishing house in Tokyo. See also Nobuyoshi Araki, *Shikijyo—Sexual Desire* (Kilchberg / Zurich: Edition Stemmle, 1996).

2 Michel Foucault, *Histoire de la Sexualité*, (Paris: Gallimard, 1976-84).

3 Nobuyoshi Araki, *Tokyo Lucky Hole* (Cologne: Taschen, 1997).

NOBUYOSHI ARAKI
UNTITLED 1989
Black-and-white photograph, 35.6 x 43 cm
Nicola von Senger, Zurich

Jack Pierson

*1960, lives and works in New York and Provincetown, Massachusetts

Jack Pierson's photography is concerned primarily with "the autobiography of an idea. It is not my true life but a constructed life. It is not real. It contains film stills of what I think is my life." *All of a Sudden* and *The Lonely Life*,[1] Jack Pierson's two most recent books, illustrate in exemplary fashion this practice of staging fiction, of documenting a life that exists only in and through constructed images. Staging, sentimentality, banality, feeling, exaggeration, homosexuality and kitsch appear to be the key stage directions for the construction of an artificial life—a life Jack Pierson describes as a model of an artist's life. "These images from my real life are supposed to make me believe that my real life is something more, that it is lighter and has more moments of beauty than it does in reality. I have to convince myself of that [...]"[2] In a certain sense, Pierson is at work on a photographic movie about his life that is intended to encompass and/or manufacture, suggest and evoke in the viewer all of the (constructed, fictitious) image-worthy moments—a sense of life that reveals the marked influence of advertising, the cinema and the mass media as the great story-tellers of the present. *The Lonely Life* is thus also the title of a film that is shown in the shadow of hopes for a special quality of life awakened by the entertainment and advertising industries. "I am always certain that it's more beautiful, that things look better, somewhere else."[3] Jack Pierson's visual project emphasizes the fundamental interdependence between all photographic documentation and visual fragments of mass-media culture. Thus his often large-scale, retouched photographs, transformed in many cases by the application of painterly techniques, also bear witness to the impossibility of representation, revealing the gaps and the blind spots in every attempt to represent or describe. The "whole" story takes shape only when we consider these empty spaces in the photographs as well, filling them with projections, with our own desires, our own fictions and wish-images. Thus Pierson's work reveals an—aesthetically intensified—fundamental gap between reality and documentation, one that is not only a photographic phenomenon but relates to a basic desire for representation in images—a desire that leads to the overlapping of reality and pictorial narratives, a desire that seeks to transform the world into visual images.

REINHARD BRAUN

1 Jack Pierson, *All of a Sudden* (New York: Power House Books, 1995); Jack Pierson, *The Lonely Life* (Kilchberg/Zurich: Edition Stemmle, 1996).

2 Translated from Susanne Boecker, Rolf Dank, "I see everything as decoration—but decoration of life as opposed to the painting of a canvas," in: *Kunstforum*, no. 133, pp. 270-277.

3 Ibid.

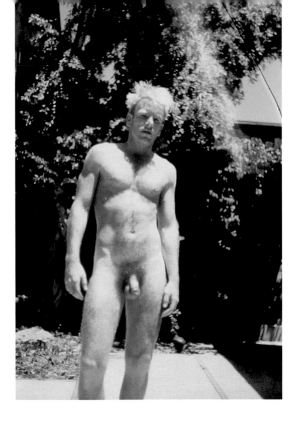

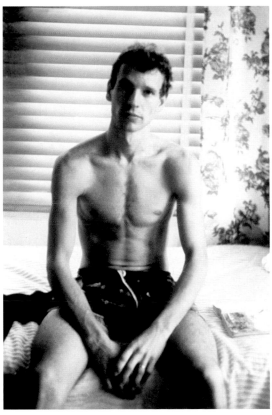

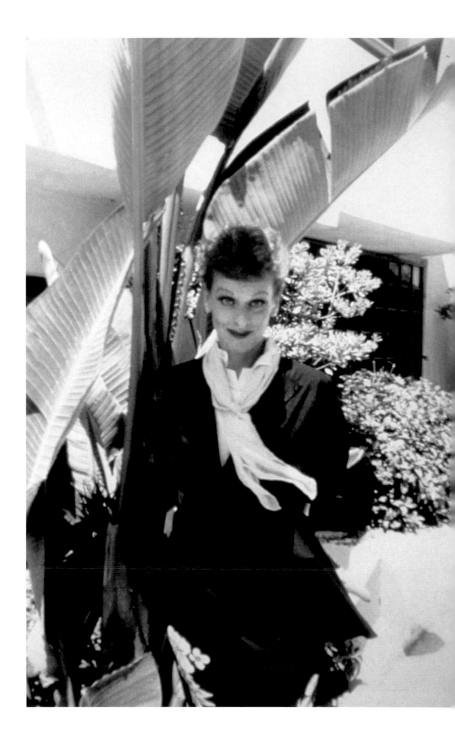

JACK PIERSON
ANGEL YOUTH, PALM SPRINGS 1990/95
Color photograph, 75 x 50 cm
Ringier Collection, Zurich
(Courtesy of Galerie Aurel Scheibler, Cologne)

JACK PIERSON
ANGEL YOUTH, OCEAN DRIVE 1985/95
Color photograph, 75 x 50 cm
Ringier Collection, Zurich
(Courtesy of Galerie Aurel Scheibler, Cologne)

JACK PIERSON
ANGEL YOUTH, THE CALL BACK 1990/95
Color photograph, 75 x 50 cm
Ringier Collection, Zurich
(Courtesy of Galerie Aurel Scheibler, Cologne)

Beat Streuli

*1957, lives and works in Düsseldorf

Beat Streuli finds his motifs in the anonymous, fast-paced chaos of the big city. His consistently large-scale color and black-and-white photographs show people in the bustling streets of such international metropolitan centers as London, Tokyo, Sydney or New York, where the individual fades unnoticed into the masses, alone with himself. Unseen by his subjects, Streuli observes and photographs them "as they are" at a given moment. His 35-mm camera discreetly makes contact with an unknown other, evoking aspects of intimacy in the encounter. The fleeting character of the moment is transformed into permanence, flowing motion is frozen as pose, a random facial expression becomes a striking physiognomy.

Streuli photographs from concealment, taking snapshots with a hand-held camera. Although he neither gives instructions to passers-by nor makes changes in his exposures, his photos have an arranged, artificial look suggestive of calculated coincidence. This may be because the Swiss photographer makes a painstaking selection from among hundreds of photos, choosing only those that meet his standards of cinematic precision. "My work is done in the gray area between documentary photography and the transformation of momentary images into something definitive, composed and almost staged,"[1] Streuli comments. He is not concerned with criticism of social circumstances nor with the dramatization of everyday situations. What motivates him is an interest in people as individuals, without anecdotal or picturesque overtones. A student of Bernd and Hilla Becher, he cultivates a pure photographic view, adopting in some cases the clear visual vocabulary of advertising aesthetics. Similarly, his use of the telephoto lens, which enables him to get close to his subject while distancing himself from his own person, calls to mind voyeuristic tendencies. It is just this curiosity, however, that drives Streuli's quest for the ephemeral moments and minimal gestures he makes visible to the viewer.

ANNA HELWING

1 Translated from Alexander Braun, "Beat Streuli. Es findet alles schon statt: man muss nur nach Mitteln suchen, die es einen sehen lassen," in: *Kunstforum*, no. 133, 1996, p. 245.

BEAT STREULI
OHNE TITEL (AUS DER SERIE NYC 1991/93)
(UNTITLED, FROM THE SERIES NYC 1991/93)
Color photograph, 137 x 201 cm
Foundation Kunst Heute, Bern (Courtesy of Galerie Conrads, Düsseldorf)

Rineke Dijkstra

*1959, lives and works in Amsterdam

In her "Beaches" series, the Dutch artist Rineke Dijkstra exploits the annual ritual migration of city-dwellers to the coast in search of summer freshness as they celebrate—for hours and even weeks on end—as a form of wild, primal lifestyle.[1] Practically nude, they expose their light-starved skin to the sun, as vulnerable as mollusks that have left their shells.

Dijkstra's photography is based upon strict conceptual principles. For her "Beaches" series, she traveled with studio equipment along numerous coasts (in Poland, the US, the former Yugoslavia, England, the Ukraine, and Belgium, for example) in search of adolescent actors for her tableaux. The horizon line of the sea is her background—a minimal yet highly symbolic setting. A sophisticated choreography of foreground lighting enables Dijkstra to generate a spectrum of atmospheric environments ranging from strange, disturbing emptiness to dramatic, stormy moods. In some cases, the atmosphere shifts toward the unreal, tempting the viewer to doubt the authenticity of the seascape that frames the figures.

Clothes make the man (or woman), as the saying goes. As the quantity of concealing cloth is reduced, the eye focuses increasingly on bare skin as the badge of identity. A chest marked by rickets, rolls of fat, asymmetric shoulders, pockmarks or a suntan become psycho-social indicators. The viewer is compelled to assume a voyeuristic position. The frontal stance of the subjects and their direct gaze into the eye of the camera imbue them with a confrontational presence. "In Rineke Dijkstra's photographs the individual steps out of anonymity into the light of intimate dignity. At the moment of exposure, the body exposes itself in frontal immediacy, appearing at the same time as a hiding place into which the subject retreats from the gaze of the other."[2] Dijkstra's portraits exhibit a striking degree of authenticity. The photographic close-up view does not jeopardize the dignity of the subject portrayed. The artist achieves an almost classical expression of beauty with astonishingly contemporary effects.

GIANNI JETZER

1 See Jean-Didier Urbain, *Sur la plage. Moeurs et coutumes balnéaires (XIXème–Xème siècles)* (Paris: Payot & Rivages, 1994).

2 Translated from Birgid Uccia, "Der Ort des Sichtbaren," in: *Rineke Dijkstra, Beaches* (Zurich: Codax, 1996), p. 9.

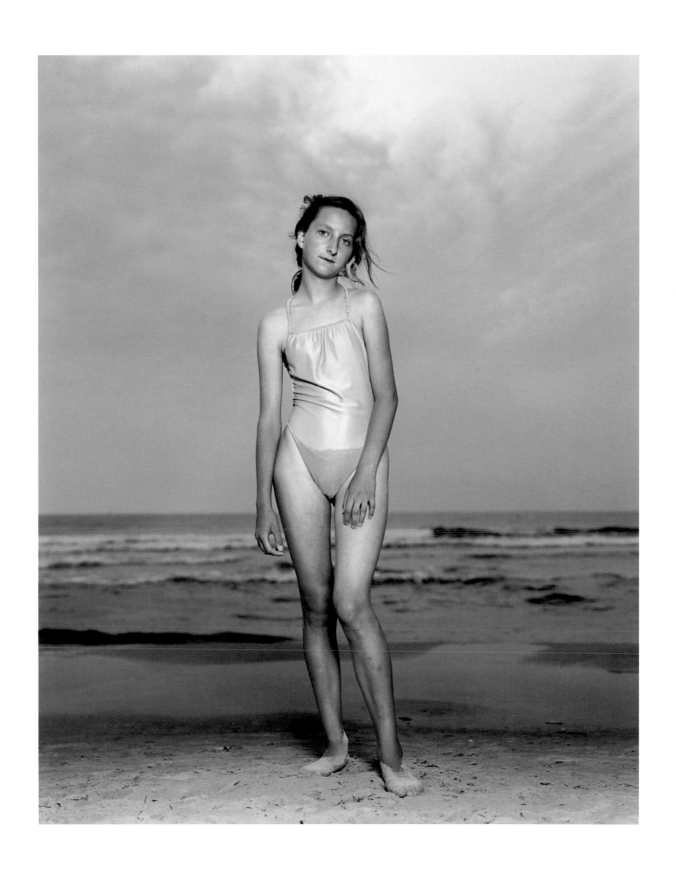

RINEKE DIJKSTRA
KOLOBRZEG, POLAND, JULY 26
(GIRL WITH GREEN BATHING SUIT) 1992
Color photograph, 5/6, 153 x 129 cm
Kunstmuseum Bern (Courtesy of Galerie Bob van Orsouw, Zurich)

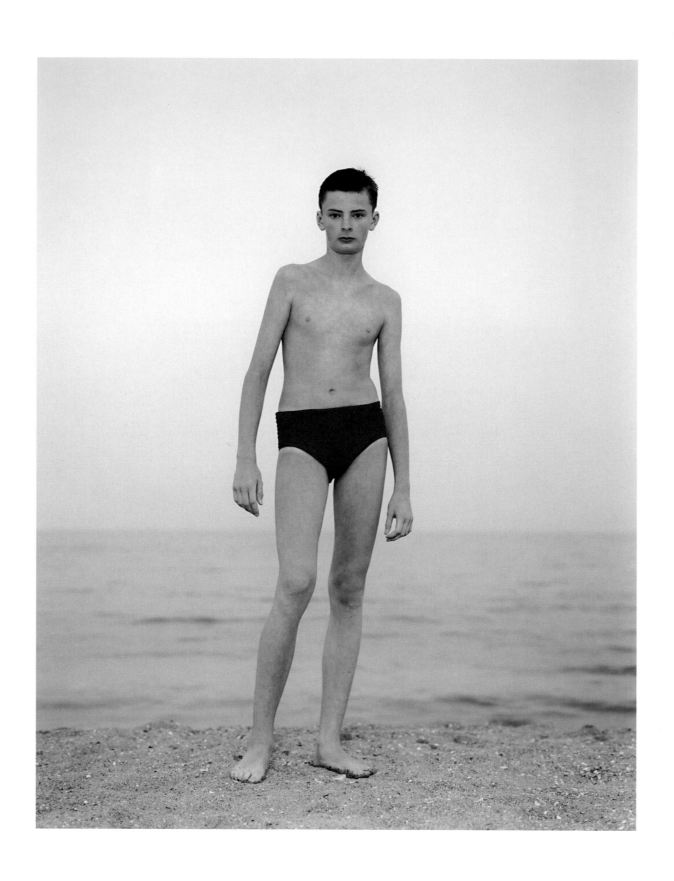

RINEKE DIJKSTRA
ODESSA, UKRAINE, AUGUST 4
(BOY WITH RED BATHING TRUNKS) 1993
Color photograph, 5/6, 153 x 129 cm
Kunstmuseum Bern (Courtesy of Galerie Bob van Orsouw, Zurich)

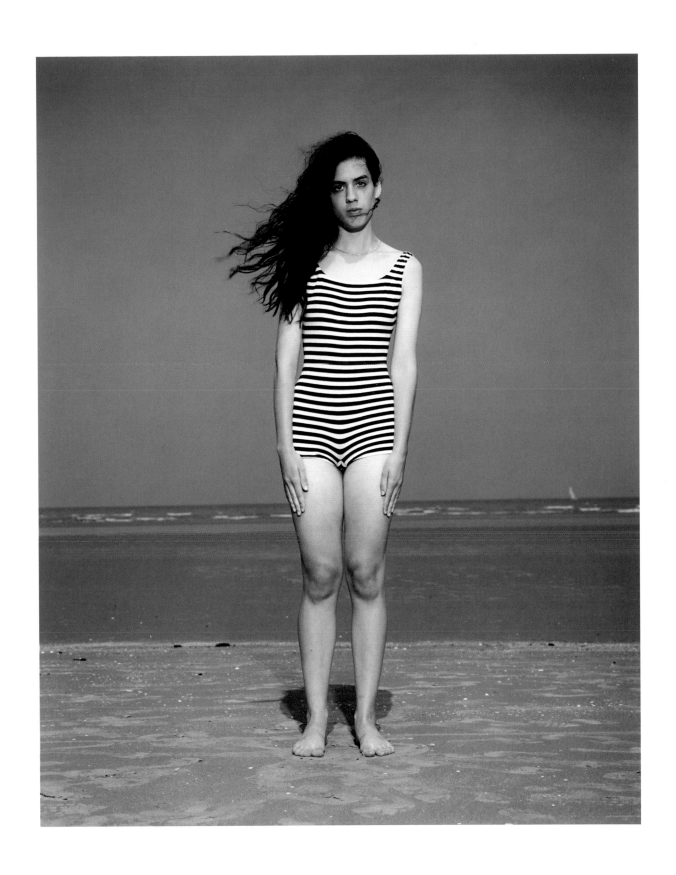

RINEKE DIJKSTRA
**DE PANNE, BELGIUM, AUGUST 7
(GIRL WITH BLACK AND WHITE BATHING SUIT)** 1992
Color photograph, 5/6, 153 x 129 cm
Kunstmuseum Bern (Courtesy of Galerie Bob van Orsouw, Zurich)

Andy Warhol

1928–1987

Then I asked Andy to do my portrait. We went to Broadway and 47th Street, where they had this photobooth. Andy met me there, and we had a bunch of quarters. He was very particular about which booth. We tried a bunch of them. [...]

It was very curios because he didn't like this booth and he did like that booth, and he maybe wanted this one, so we spent about an hour going from booth to booth. We finally decided on a booth. Andy took a few pictures, he stood there with me for a little bit and then he left me on my own. So I did the pictures all by myself. It helped being private, and he understood that, too.

Actually, if you're in a photobooth for a long time, it gets pretty boring; being photographed anyway is pretty boring. After you do one pose, how many poses can you do? I got so bored that I started to really act in them. I was a student then of Lee Strasberg, so I started to do all these acting exercises. I spent hours. Fifty dollars is a lot in a photo booth! So, when I was finished, I just gave them to Andy, and I said, "Look, you hold on to these and see what you want to do." Then I forgot about them. [...]

About a month later, I got this call from Andy. He was all excited for me to come to the studio. So I went to the studio and he's got these three silkscreens made from three different photobooths. And he asked which acetate I liked. [...] When I looked at the screens, and I said, "Oh, Andy, I hate them because my face is so round [...]."

Andy started to do the three of them. I was going to buy three. And in a month, he called me [...] and said, "I'm ready to show you the portrait." He knew I could only pay for three. When I got up there they were on the floor, there were eight on the floor. [...]

[The portrait] had exposed so much [...] it was embarrassing. I'm thinking, "Holy God, what did he do to me?" Andy was really a great portrait painter and he must have really liked me a lot. He made me into the archetype of the sexually liberated woman of our time.

It really is an icon of this liberated woman, who is just trying hard to be liberated. In the 60s there were rules, if you were an intelligent woman, you were an upset woman. Truly upset. You had to be thin. We grew up with all these rules. We were on amphetamines. I was taking Seconals to go to sleep, I weighed 87 pounds, I wanted to be an actress, I couldn't ever acknowledge that in public because my husband's family and my family would have been very upset.

HOLLY SOLOMON
(excerpt from: "Brigitte Bardot, Jeanne Moreau, Marilyn Monroe—All packed in one. Holly Solomon Reminisces," transcribed by Christoph Heinrich, in: *Andy Warhol Photography*, Hamburg / Pittsburgh: Hamburger Kunsthalle / The Andy Warhol Museum, Edition Stemmle, 1999, p. 94-99.)

ANDY WARHOL
HOLLY SOLOMON #10 circa 1965
Photobooth strip, 12.4 x 4.1 cm
Courtesy of Holly Solomon Gallery, New York

Yasumasa Morimura

*1951, lives and works in Osaka

Yasumasa Morimura is one of a number of contemporary Japanese photographers whose work must be seen in the context of Japanese society today. Aside from their focus on the encounter with American culture, Japanese people and Japanese photographers are now showing a renewed interest in their own traditions and in efforts to overcome customary local taboos.

Morimura does self-portraits, but they are self-portraits of others. The bodies of Marilyn Monroe and Marlene Dietrich serve him as "pedestals" for his own head. Or he conceals (or reveals) his own male body beneath Marilyn's gust-blown dress. Although the faces are made-up, Morimura remains recognizable beneath the paint. We recall in this context the Japanese theater tradition of assigning women's roles to male actors. By the same token, we are reminded of the contemporary techniques of digitized photography and virtual reality that make this kind of concoction possible and are capable of generating an endless chain of gender and personality substitutions. It appears that certain yearnings have been exposed here, but what yearnings are they?

It is apparently not the yearning for a different gender role alone but a longing for glamour as well—indeed for a bygone glamour. In these works, the great divas of the Western world are assimilated into a Japanese mode and vice-versa. The love of the Japanese for imitations of Western brand products, often cited in Western humor magazines, may play an ironic role here, yet these are not really true copies but travesties and montages. Irony is what we notice immediately in these photographs. The figure challenges the viewer. It questions not only itself but the medium and the viewer's sense of reality, for it is not the photographed subject that looks out at us but rather a phantom created with the resources of photographic technology. It is as if past and present were melted together: the whole world as a trunk full of props.

Hidden behind this masquerade is an attempt to achieve self-identification. The question of the credibility of the artist, the picture and the work of art is posed in the intended dialogue with the viewer. Illusion is the basis, the vantage point from which we perceive beauty, sex and glamour. The technical media, of which photography is one of the most important, have the capacity to turn everything upside down. Ultimately, they can make wishes appear to come true—there is nothing that cannot be combined with anything else. In this case, a man assumes the roles of women playing roles, insofar as they are women and not men posing as women, etc. Thus gender becomes pure idea, a figment of the imagination, a mere and ultimately non-sensual theatrical illusion.

URSULA PRINZ

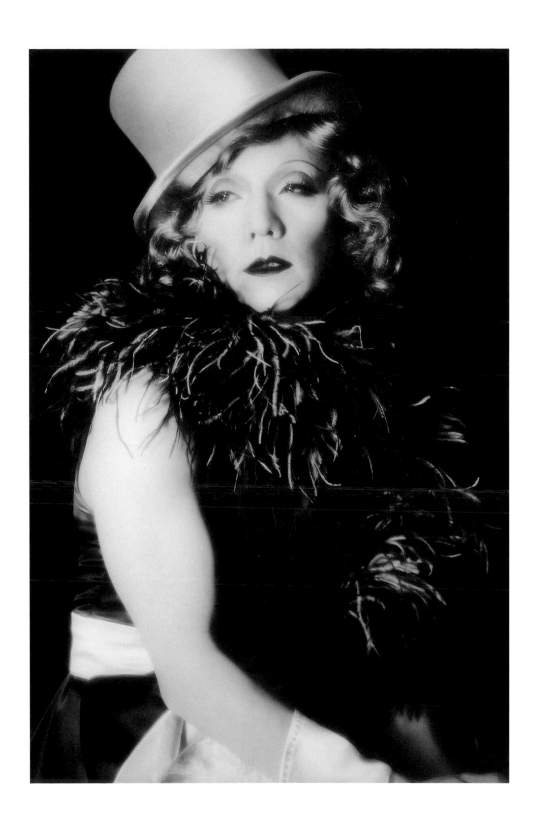

YASUMASA MORIMURA
AFTER MARLENE DIETRICH 5 1996
Lifochrome, 120 x 95 cm
Courtesy Galerie Art & Public, Geneva

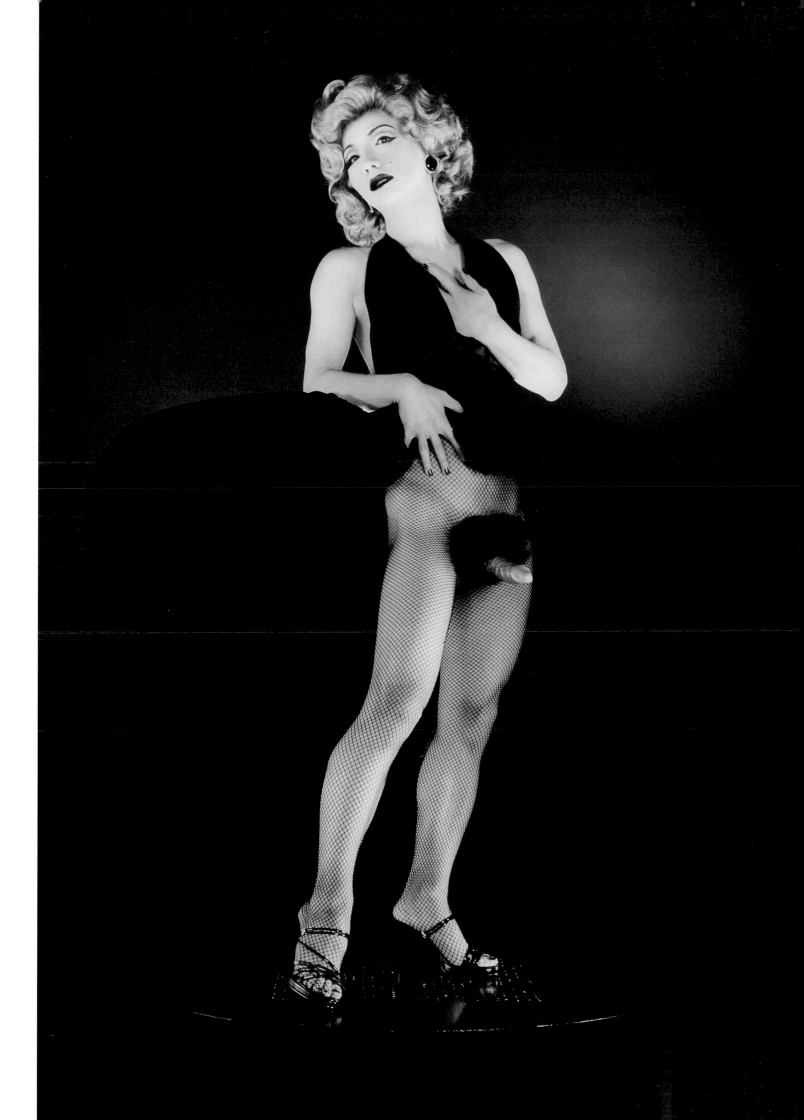

Jürgen Klauke

*1943, lives and works in Cologne

Unlike the phenomena of mass media, art involves a subjective act, an intuitive act focused upon an individual work, and it is that spark of a specific quality that bridges the gap between the work of art and the viewer. Such, at least, was my reaction upon viewing photographs by Jürgen Klauke for the first time in the early seventies. And in the years since I have realized that he has remained true to himself, which is not to say that he has solidified his style or his unique quality. Indeed, he has changed within the context of his own themes while remaining consistent in his approach, losing nothing of his artistic vigor. While preserving his own subjective mode of expression, he has still—perhaps for that very reason—succeeded in making statements of universal applicability.

Klauke began with drawings and etchings, moving on around 1970 to Body Art, or what we now call Performance Art, and photography. This was to remain the framework from which his later worked developed. Within that context, Klauke staged primarily excessive live actions, opposing the increasing pressure of the mass media with the immediate confrontation with physical pain. In doing so, he called attention to the loss of physical qualities against the background of a neutralization of the senses in simulation and mediatization.

Where Klauke makes use of photography, it is not a pseudo-affirmation of reality we recognize but rather constructed photo sequences seeking insights into the mechanisms of the dematerialization or mediatization of our world. His photo sequences are visual creations that penetrate through himself and his co-performers to arrive at the reality of images, of the images of the world in our heads as our views of the world. In the presence of his photo pieces I stand facing a world that does not confirm our ideas of reality but instead represents a way of coming to grips with life in the reality of mass media and their world of illusion. The photos show performers using light to give manifest appearance to what the darkness conceals. Indeed, viewers become photographed subjects here, images to be stared at. Voyeurism is turned around.

All art, if it is to be called art, is an expression of its time and of the prevailing discourse of that time. Yet not all art is unique and committed expression derived from a particular attitude. In Klauke's case, however, it is precisely this attitude, this steadfastly existential stance, this dedication to the exploration of the human in the all-too-human, that is at work, to a degree we recognize in few other artists. And that is why he is perhaps best regarded as an existentialist artist who has the ability to transpose life and its diversity paradigmatically into the medium of art. We are the producers of our image of the world. Yet if we are to avoid being delivered whole to the manipulative, beautiful, perfect images of microphysically implemented power, we need images of freedom that are accessible through dialogue. Jürgen Klauke develops and perfects such images in his concentration upon the most interesting subject known to mankind: the human being.

GERHARD JOHANN LISCHKA

JÜRGEN KLAUKE
ROT 1974 (RED)
Color photographs, 7 parts, 40 x 30 cm each
Kunstmuseum Bern

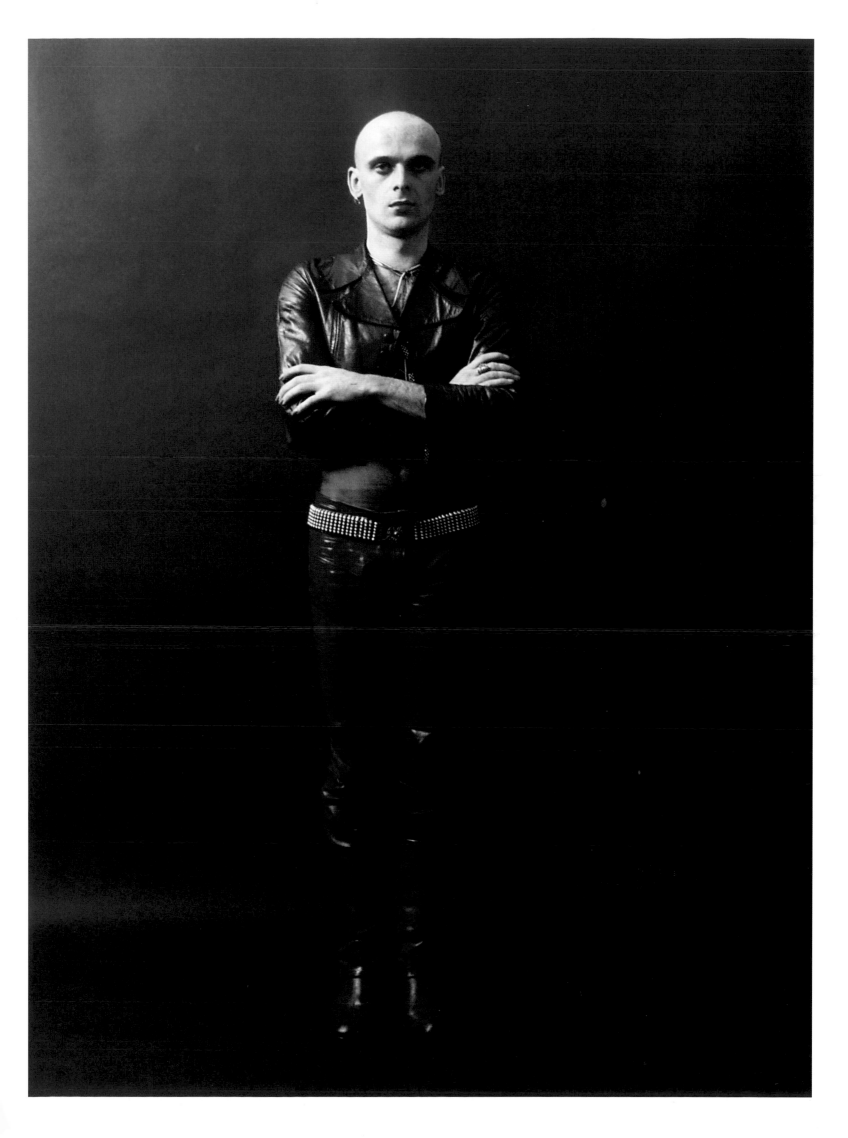

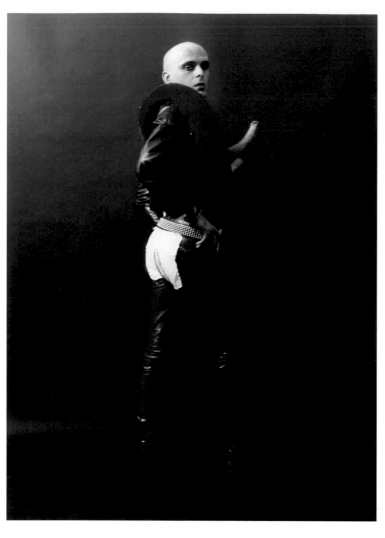
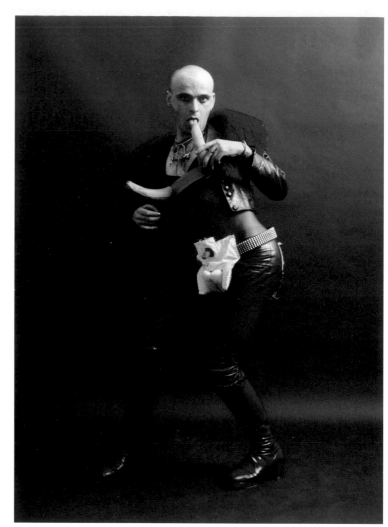
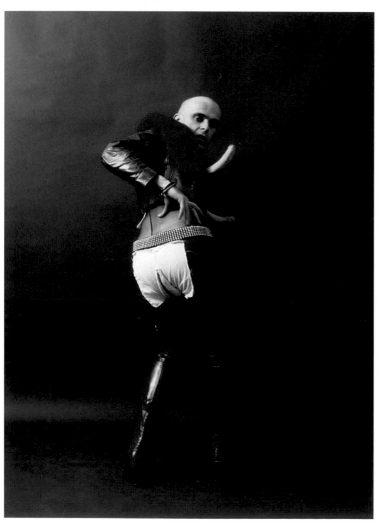
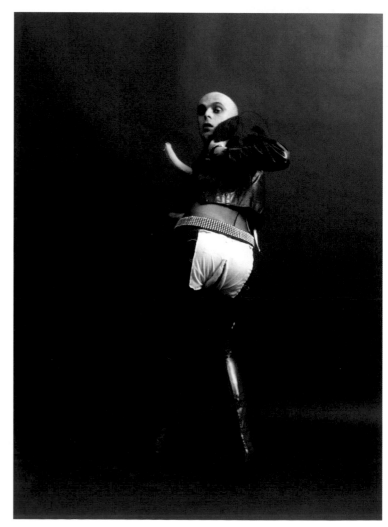

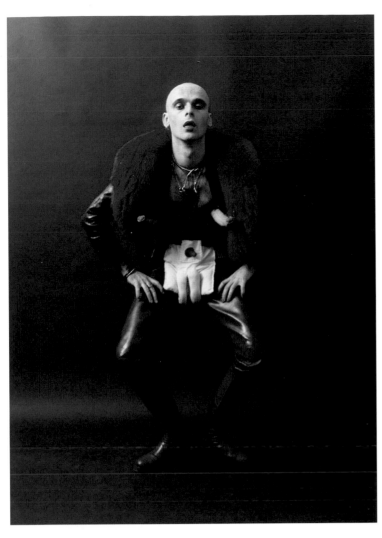

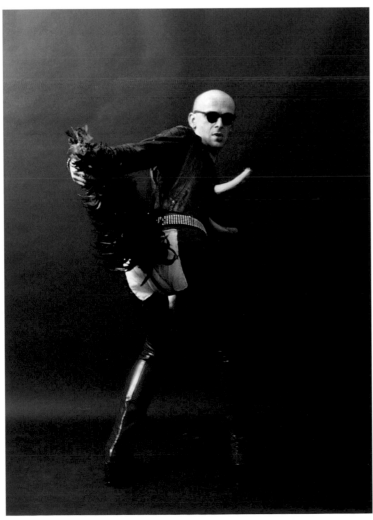

Rudolf Schwarzkogler

1940–1969

A man's head is bandaged from the top to the tip of the nose. A woman's hand with red-polished fingernails rests in a comforting gesture on the head. A dark liquid oozes from the right eye and drips onto a stone lying next to the head. Both the stone and the head are objects. The image is one of a series of photos from the "4. Aktion" (4th Action) of the Vienna Actionist Rudolf Schwarzkogler in which the head of actor Heinz Cibulka appears in a kind of still life. Documented by press photographer Ludwig Hoffenreich, the action was an outgrowth of the "2. Aktion" (2nd Action) also performed in the summer of 1965 and is regarded as one of Schwarzkogler's most significant works.

Bandages, razor blades, medical materials and a stethoscope—objects which imbue his art with strong symbolic power[1]—are important elements of Schwarzkogler's visual language, which is concerned with powerlessness, sado-masochism, passivity and suppression. According to Freud, the covering of the eyes is symbolic of the fear of castration, a fear which Hermann Nitsch sees as an essential aspect of Schwarzkogler's actions. In their amibiguity, Schwarzkogler's photographs allude to such opposites as pain and healing, sacrifice and redemption and to physical vulnerability as a metaphor of suffering.

Following the end of the era of abstract-informal art, Vienna Actionism represented an attempt to break the restricting compositional bonds of traditional painting, adopting the expanded expressive resources of a process-based art. Not only is Schwarzkogler's œuvre the least extensive of those produced by the group of artists that also included Brus, Mühl and Nitsch (it was created in only one year), it also assigns photography a precisely defined position as the only medium of communication between the artist's idea and the viewer. The photographs of his actions are clearly distinguishable from other action photos of the period by virtue of their painstaking formal composition, their clarity, their sterile, clinical atmosphere and their striking symbolic power.

Because his actions are devoid of all expressive, dramatic gesture, it is easy to forget when reviewing the photo material that this is indeed Action Art. In creating "situations" or "tableaux" for the camera and having them recorded on photo, Schwarzkogler was proposing a new type of Actionism, a form of "staged" photography. The artist did not assume the role of the photographer, however, but instead had his actions documented by others. From these photographs he selected small details in order to emphasize the singularity of the images. Schwarzkogler's art marks the point of transition from happenings to a truly media-oriented kind of art. "Instead of the pictorial construction on the flat surface," he wrote, "we now have the construction of the conditions of the act of painting as a definition of the field of action (the space around the actor, i.e. the real found objects of the surrounding environment). The act of painting itself can be liberated from the compulsion to create relics, by exposing it to the reproductive apparatus that takes possession of the information."[2]

CHRISTINA TSCHECH

1 During his studies at the Graphische Lehr- und Versuchsanstalt Wien, Schwarzkogler devoted considerable attention to Symbolism. See Hubert Klocker (ed.), *Wiener Aktionismus. Wien 1960-1971*, vol. 2 (Klagenfurt: Ritter Verlag, 1989). p. 349.

2 Rudolf Schwarzkogler, in: *Le Marais*, special issue on Günter Brus, Vienna, 1965.

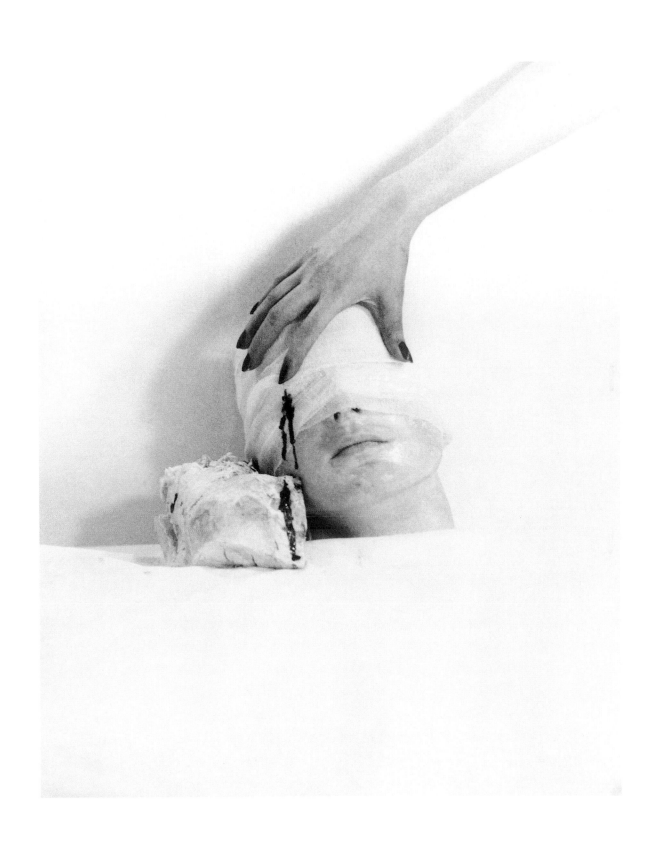

RUDOLF SCHWARZKOGLER
4. AKTION 1965 (4ᵀᴴ ACTION)
Black-and-white photograph, 62 x 50 cm
Kunstmuseum Bern

Günter Brus

*1938, lives and works in Graz and La Gomera (Spain)

A man covered completely with whitewash lies face down, legs and arms drawn up beneath his body, in the most distant corner of a white room. The shaved crown of his skull rests on the floor. His face is turned away from the viewer. In the foreground, a baby lying on its belly with legs and arms vigorously extended focuses a curious gaze toward the camera. The infant's open posture indicates interest in its surroundings, whereas the man appears withdrawn from the outside world. In "Aktion mit einem Baby" (Action with a Baby),[1] realized with his newborn daughter Diana, Günter Brus departed from the concept of the total action by composing tableaux comprising objects, colors and body parts and thus forged a link to his earliest actions. Like "Selbstbemalung" (Self-Painting), "Selbstverstümmelung" (Self-Mutilation) and "Transfusion" (all 1965), "Aktion mit einem Baby" was staged for the camera alone. Brus's living tableaux composed for the camera were a new type of action. The images are not documentary photographs that record the progress of an action (an approach frequently used by Actionists). "Aktion mit einem Baby" is the first instance of the use of theatrical props to create a fictional situation, a staged image, so to speak. Thus the photos represent autonomous works of art.

Prior to "Transfusion," an action in which Brus emphasized the erotic quality of his wife Ana's female body, using brightly colored powder and items of clothing, black and white had been dominant in all of his earlier actions, giving persons, objects and space a markedly two-dimensional look. "Transfusion" was regarded as "the last work that abandoned a purely self-analytical approach in favor of the application of traditional aesthetics in the action. Only in [...] "Aktion mit Diana" did he return once again to this type of action."[2]

Intent upon achieving total liberation through radical violation of physical and sexual taboos, Brus abandoned painting, material symbolism and theatrical staging entirely after "Aktion mit einem Baby" to focus until 1970 upon analysis of the body, a more radical type of action, in an attempt to deconstruct the constraints imposed by society on the body. During the simultaneous action entitled "Kunst und Revolution" (Art and Revolution) in the auditorium of the university in Vienna in June of 1968, Brus undressed, made cuts in his chest and thigh with a razor blade, urinated into a glass, drank his own urine and smeared himself with feces. He then lay down, masturbated and sang the Austrian national anthem. Like Otto Mühl and Oswald Wiener, he was arrested and later fled to Berlin.

Bodily injury was a central theme in Brus's work during his first productive decade. He presented an exemplary demonstration of his belief in the concept of "destruction" as an ideal, symbolic concept that could also be represented in real terms in "Zerreissprobe" (Ordeal), 1971, in which he substituted a razor blade for his paintbrush and made a long incision on his naked body.[3] From that point on, Brus, whose actions had always been accompanied by drawings and collages, concentrated entirely on the medium of paper and pursued his goals in drawings and poetry.

CHRISTINA TSCHECH

1 Also entitled "Aktion mit Diana" (Action with Diana).

2 Translated from Hubert Klocker (ed.), *Wiener Aktionismus, 1960-1971*, vol. 2 (Klagenfurt: Ritter Verlag, 1989), p. 119.

3 Justin Hoffmann, *Destruktionskunst* (Munich, 1995), p. 133.

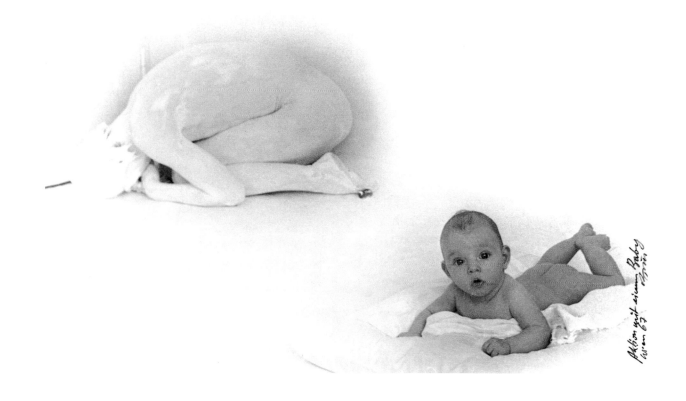

GÜNTER BRUS
AKTION MIT EINEM BABY 1967
(ACTION WITH A BABY)
Black-and-white photograph, 62 x 50 cm
Kunstmuseum Bern

Bruce Nauman

*1941, lives and works in Galisteo, New Mexico

A constant in Bruce Nauman's work is his concern with the *condition humaine*, with the influences and the dangers to which the individual is exposed by the various elements of man-made culture. Power, sex, morals, violence, death, science, politics, the role of the artist in society and the relationship between the rational and the irrational are recurring themes in his art. The unifying threads in his complex œuvre are a focus on the body as the object of manipulation and the subject of sensual experience and on language as a carrier of meaning, in its communicative function and in its manifestation in music and pictorial imagery. During the seventies, Nauman used his own body as "material" in his performances and photographs and as a model for his fiberglass sculptures. Simple activities such as sitting, reclining, standing, walking and manipulating one's own body are rendered in compelling images of culturally determined contexts, in between form and content, individual freedom and supra-individual constellations of power, that invade and pervade the body. In his "Corridors" and spatial constructions Nauman transfers bodily experience to the viewer. In later video pieces, he replaced himself with male and female performers, as in the clown videos or in the impressive, moving video installation "Anthro / Socio," in which a man's head moves in a circle on six monitor screens, reciting the phrases "Feed me / Eat me / Anthropology" and "Help me / Hurt me / Sociology" at varying levels of pitch and in a penetrating voice in a sing-song that oscillates between screaming and singing. In 1994, Nauman once again used his own body as material in "Poke in the Eye / Nose / Ear 3/8/94 Edit 94," closing the circle that began with his earliest works. In extreme close-ups and slow-motion and an alarming display of unconcerned violence, he reshaped his face by thrusting his finger into his eye, his ear and his nose. The combination of violence in the video and the seemingly neutral use of the body as a material for art, the juxtaposition of physical and psychic levels, produces a shocking effect. "Studies for Hologram" (1970) may be seen as a reference work for these videos. Here, Nauman manipulates his lips and the area around his mouth, creating grotesque shapes. The part of the body responsible for oral communication becomes a distorted, shaped, abstract and at the same time painful metaphor of the instrumentalization of the body and the subject.

BEATRIX RUF
(Translated from Beatrix Ruf, *Kunst bei Ringier 1995–1998*, Zurich, 1999)

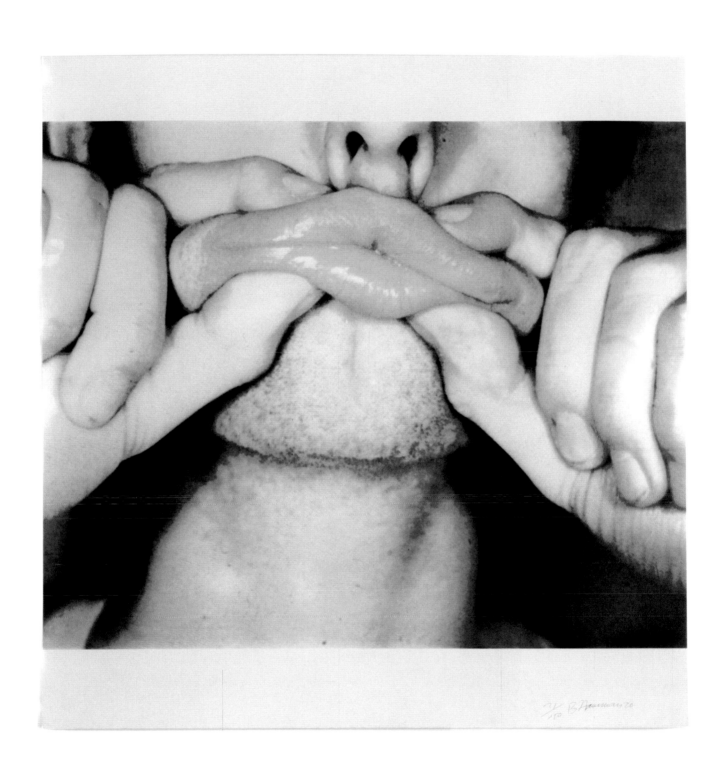

BRUCE NAUMAN
STUDIES FOR HOLOGRAM 1970
Silkscreen print on paper, 5 parts, each 66 x 66 cm
Collection of Zellweger-Luwa AG, Uster

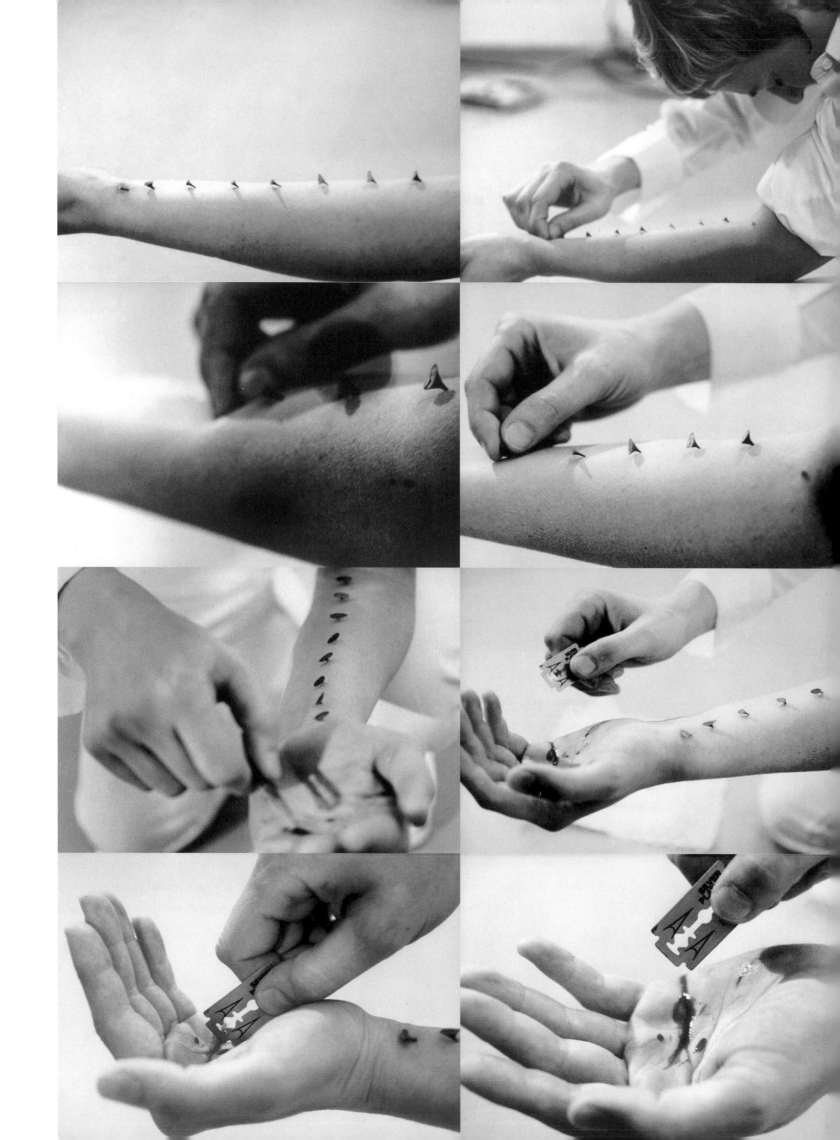

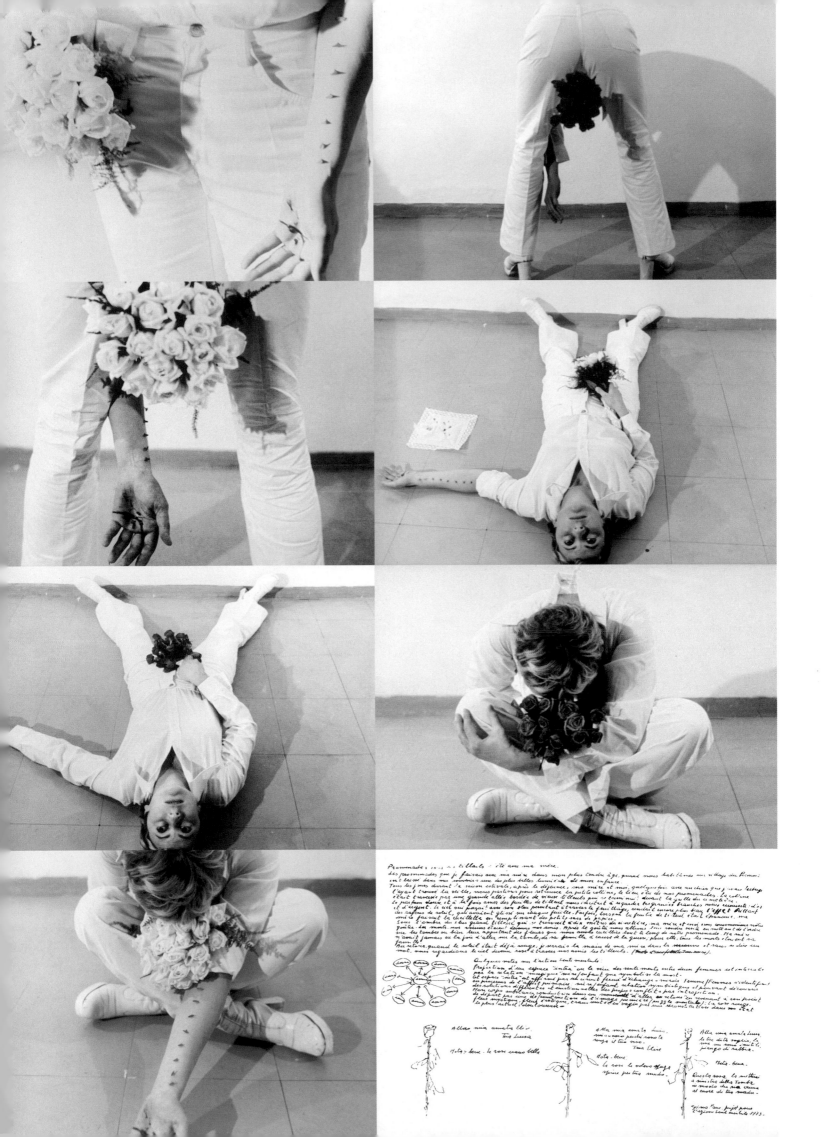

Valie Export

*1940, lives and works in Vienna

Lifeless, her arms and legs extended, her eyes closed, a woman lies in the gutter of a traffic island, facing the viewer in a lascivious pose. Her body molds itself to the geometry of the main lines of the pictorial architecture, following the curve of the curb, which is tinted orange-red and accentuated in the black-and-white photo. The female body becomes a part of the urban profile.

Valie Export completed her first photographic self-portraits in 1955/56, using them in her explorations of the medium of photography and as tools for self-analysis. In the early seventies, she began experimenting with the representation of body postures as expressions of inner states in drawings, photos and actions, placing the human body—usually her own—in relationship with nature and architecture. Her objective in these works was to emphasize the analogies between landscape and physical structures, between landscape and the mind and between architecture and the mind, "these shared forms of characteristics that have served as projection screens for expression since the birth of visual art."[1] Although the photos in the "Konfigurationen" (Configurations) series are reminiscent of fragments of actions, they are actually part of the artist's conceptual turn toward "staged photography." Export also regards this photo series as an approach to the construction of new spaces that emerge from the simultaneous presence of the body and its surroundings.

Photography is a primary medium in the context of Valie Export's whole œuvre, in which progress has often been achieved with the aid of other media. She seldom uses photographic material from other sources, and most of her self-portraits are taken with a timed shutter-release. Valie Export's practice of combining different media, of developing themes and thematic variations in other media, makes it difficult to examine her photography in isolation. Her early works were created in an artistic climate that was strongly influenced by Vienna Actionism and the Vienna Group during the early sixties. The fact that she began by using her body as a medium and then forged an increasingly strong link between the visual media, which staged her body, and issues of gender relations makes her works quite typical of the art of this period.

As a critical counter-reaction to the middle-class establishment, Export's art became a political tool, and the artist took the path toward a consistent and independent form of feminism. In essays such as her "Feministischer Aktionismus. Aspekte,"[2] she undertook a theoretical investigation of the complexity involved in the "dissolution of reality," while exploring the subject in the visual context at the same time. From the outset, she used the media of photography, film and sound, all of which were new to the context of art at the time, as an autonomous means of expression. Her work today comprises actions, feature and experimental films, expanded cinema, objects, drawings, installations and video installations, lectures, journalistic activities, and, as a broad foundation, feminist art theory.

CHRISTINA TSCHECH

1 *Valie Export*, catalogue with texts by Silvia Eiblmayr, Roswitha Müller, Florian Ritzler, Christina von Braun (Linz: Oberösterreichisches Landesmuseum, 1992).

2 Valie Export, *split: reality*, Museum moderner Kunst Stiftung Ludwig, Wien (ed.) (Vienna: Springer, 1997).

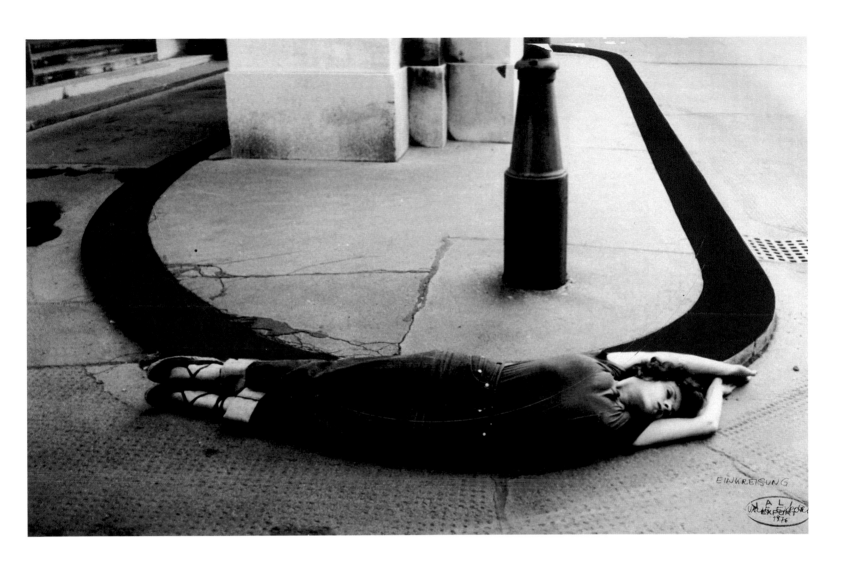

VALIE EXPORT
EINKREISUNG 1976 (ENCIRCLEMENT)
Black-and-white photograph, tinted, 36 x 57.3 cm
Kunstmuseum Bern
(Courtesy of Galerie Stampa, Basle)

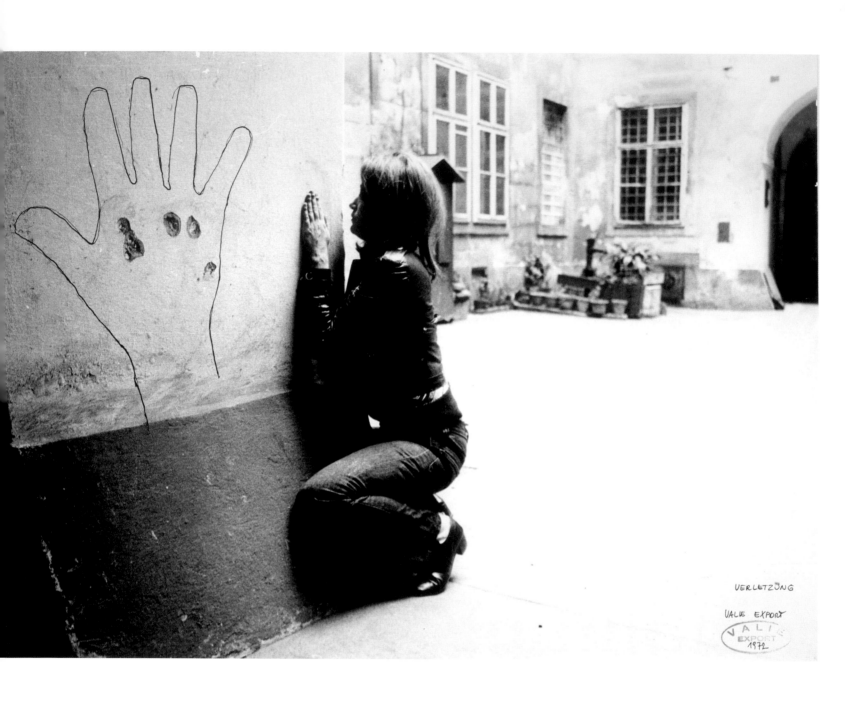

VERLETZUNG

VALIE EXPORT

VALIE
EXPORT
1972

VALIE EXPORT
VERLETZUNG 1972 (INJURY)
Black-and-white photograph, 40.7 x 55.1 cm
Kunstmuseum Bern
(Courtesy of Galerie Stampa, Basle)

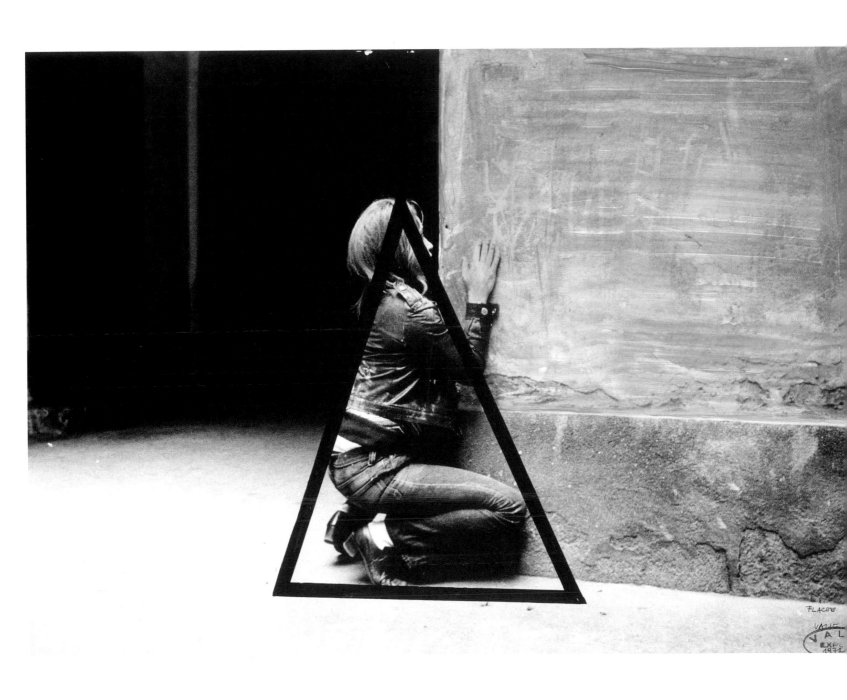

VALIE EXPORT
FLÄCHE 1972 (FLAT SURFACE)
Black-and-white photograph, tinted, 41.1 x 60.4 cm
Kunstmuseum Bern
(Courtesy of Galerie Stampa, Basle)

Marina Abramović

*1946, lives and works in Amsterdam

"I am the object. I will assume all responsibility during this period," Marina Abramović announced to visitors at a gallery in Naples, and then she allowed herself to be undressed, cursed and tormented in the course of this six-hour performance. In the performance, entitled "Rhythm 0," she focused upon the benevolence / reluctance of her audience, a group she had provided with 72 different objects with which practically anything conceivable could be done to her. Abramović played a dual role on this occasion. Although she challenged the audience, both verbally and through the objects, to take action and although she specified the duration of the performance, which was not to be exceeded, she remained completely passive during the performance itself. Like all of Abramović's performances, "Rhythm 0" involved ritualized extremes, self-imposed pain, submission and the endangerment of her own person. In most of her works, the artist is concerned with the use of traditional rituals of Eastern philosophies and religions to achieve a different state of consciousness in the participants.

In "Rhythm 5" she created a burning star of fire, cut off her hair and nails and cast them into the flames. She then lay down in the center of the star, where she remained until the lack of oxygen rendered her unconscious and members of the audience were forced to carry her from the fire. In "Lips of Thomas (Star on Stomach)," she carved a five-pointed star on her abdomen and then lay down on a bed of ice beneath a warmth-giving lamp that hastened the flow of blood from her wound.

In 1975 Marina Abramović met Ulay (Uwe Laysiepen) in Amsterdam. They lived and worked together until 1988. With the goal of exploring unknown situations, the couple declared their bodies their most important medium, continually pushing the limits of their physical and mental endurance—ultimately to the point of exhaustion and the end of their actions. "Relation Works" represent an exchange of personal and dangerous experiences in performances. In the eighties their works became calmer and more poetic. In search of encounters with other cultures, they embarked upon long journeys, documenting their travels in photographs, installations and videos.

Marina Abramović has always focused on the involvement of her audiences since the very beginning of her career in art. After separating from Ulay, she turned to the use of objects to challenge exhibition visitors to abandon their voyeur's perspective, to get involved with the work of art and to share her own experiences. The work "Transitory Objects" demands both the physical and mental integration of the human being in space and time and his / her identification with the work. Here, the artist takes up the tradition of an approach to sculpture as a non-autonomous subject, sculpture as a form of action.[1] Although her artistic tools have changed since the seventies, Abramović is still very much concerned with the dismantling of culturally defined boundaries affecting concepts of body and mind.

CHRISTINA TSCHECH

1 Beatrix Ruf, "Wei Wu Wei—Kurzschluss, Pause, Paradox," in: *Marina Abramović—Double Edge* (Sulgen: Kartause Ittingen / Niggli, 1996), p. 78.

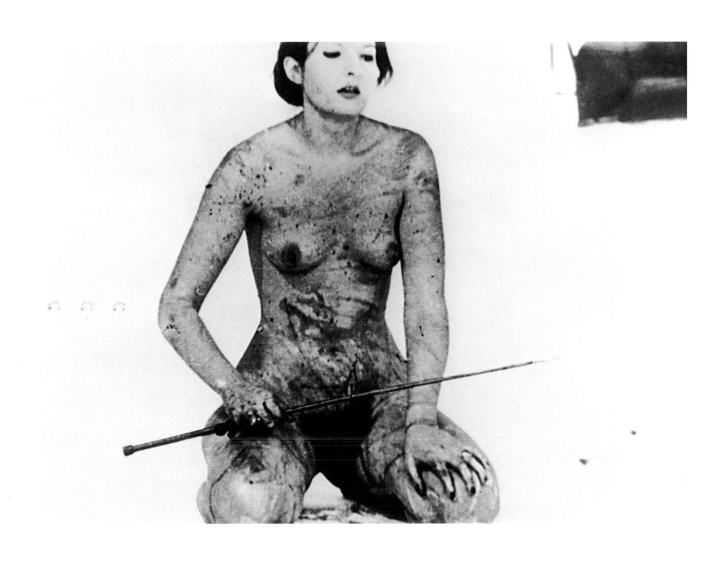

MARINA ABRAMOVIC
LIPS OF THOMAS 1974/94
Black-and-white photograph, 75.6 x 100.3 cm
Kunstmuseum Bern

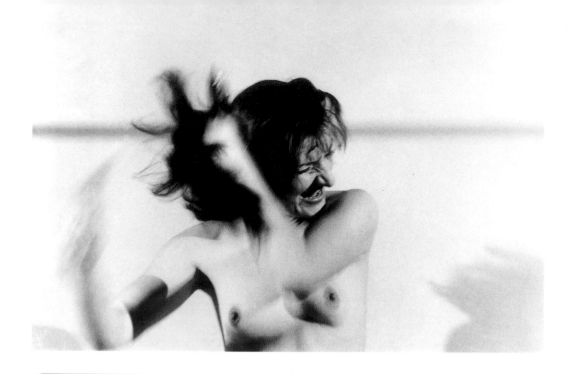

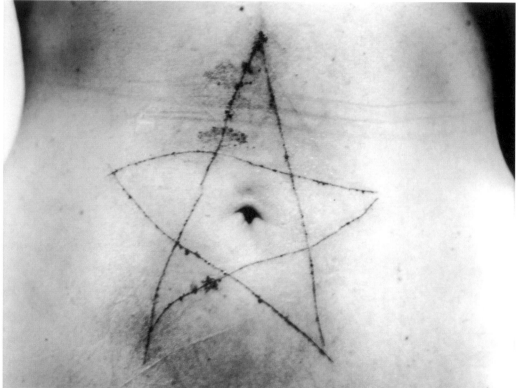

MARINA ABRAMOVIC
**ART MUST BE BEAUTIFUL,
ARTIST MUST BE BEAUTIFUL** 1975/94
Black-and-white photograph, 75.6 x 100.3 cm
Kunstmuseum Bern

MARINA ABRAMOVIC
**LIPS OF THOMAS
(STAR ON STOMACH)** 1974/94
Black-and-white photograph, 59.5 x 49.5 cm
Kunstmuseum Bern

MARINA ABRAMOVIC
FREEING THE VOICE 1975/94
Black-and-white photograph, 75.6 x 100.3 cm
Kunstmuseum Bern

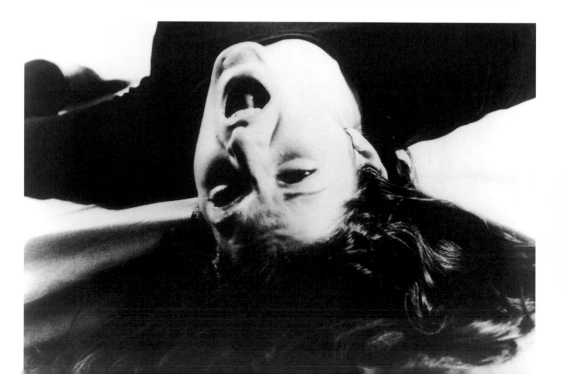

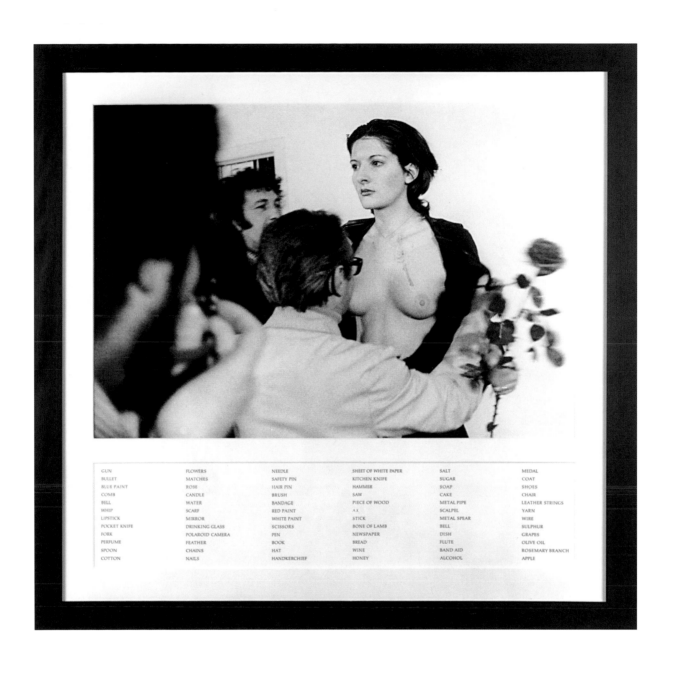

The photograph contains a list of objects:

GUN	FLOWERS	NEEDLE	SHEET OF WHITE PAPER	SALT	MEDAL
BULLET	MATCHES	SAFETY PIN	KITCHEN KNIFE	SUGAR	COAT
BLUE PAINT	ROSE	HAIR PIN	HAMMER	SOAP	SHOES
COMB	CANDLE	BRUSH	SAW	CAKE	CHAIR
BELL	WATER	BANDAGE	PIECE OF WOOD	METAL PIPE	LEATHER STRINGS
WHIP	SCARF	RED PAINT	AX	SCALPEL	YARN
LIPSTICK	MIRROR	WHITE PAINT	STICK	METAL SPEAR	WIRE
POCKET KNIFE	DRINKING GLASS	SCISSORS	BONE OF LAMB	BELL	SULPHUR
FORK	POLAROID CAMERA	PEN	NEWSPAPER	DISH	GRAPES
PERFUME	FEATHER	BOOK	BREAD	FLUTE	OLIVE OIL
SPOON	CHAINS	HAT	WINE	BAND AID	ROSEMARY BRANCH
COTTON	NAILS	HANDKERCHIEF	HONEY	ALCOHOL	APPLE

MARINA ABRAMOVIC
RHYTHM 0 1974/94
Black-and-white photograph, 98.4 x 101 cm
Kunstmuseum Bern

Manon

*1946, lives and works in Zurich

A native of Bern, Manon began her career in art as an environmental and performance artist rather than a photographer. From her actions, she created precisely staged photo series in which the artist appears herself, made-up and displaying her body in an often exhibitionistic manner.

In the 31-part series entitled "Elektrokardiogramm" (Electrocardiogram, 1979), she appears in front of a painted background which comes across in the photographs much like a long, narrow alley leading into the depths and bordered by two high walls with checkerboard patterns. The delicate figure looks confined and threatened in this setting. Geometric patterns cover parts of her body, enclose her or appear to rain down upon her. She attempts to oppose this imprisonment with diva-like poses or gestures indicating a desire for protection or resistance to the oppressive environment. In aesthetic terms, the images call to mind those of Op and Pop Art, although Dadaist and Constructivist allusions are also evident.

Manon is concerned not only with self-presentation but with self-assertion. She rediscovers herself in the mask she has chosen. To find one's own identity it is necessary to isolate oneself from otherness, in part by incorporating that otherness, pretending to be someone else. Behind the mask in which the artist appears is the place where the self can be free. The series contains only one photo of Manon without make-up. It shows her in an attitude of meditation, immersed in herself, and stands out boldly among the effectively staged diva poses.

In this particular work the theme of confinement, no matter where it may be—in fashion, in convention, in the environment or even in one's own skin—is particularly striking. The attempt to be uniquely oneself can succeed only through adaptation of the world. In creating herself or assuming other shapes, Manon finds the way to her own identity, as in the 32-part series entitled "Ball der Einsamkeiten" (Lonely Hearts Ball, 1980), in which she personifies other people and other lives. The illustration of totally different possible lives makes it much easier to grasp one's own place. The dream of self-determination and freedom of choice appears to come closer to reality. Manon is aware, however, that the body itself is not the most important single element in this process, that the outside influences of life she makes palpable in her photos are highly significant as well. Thus her works are symbols rather than self-portraits. Her self, her true identity, remains hidden from the viewer behind the mask. The viewer may find himself stimulated by these images to inquire within himself, to contemplate his own situation and the individual's relationship to its environment and its own existence.

Manon's body serves as a projection screen or a mirror for the viewer and for herself as well. It is the medium through which the artist communicates her artistic message and in which she conceals herself at the same time.

URSULA PRINZ

MANON
ELEKTROKARDIOGRAMM 304/303 1979
(ELECTROCARDIOGRAM)
Black-and-white photograph, 31 parts, 51 x 37 cm each
Kunstmuseum Bern

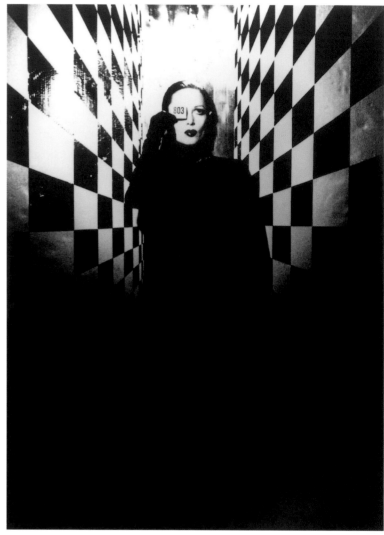

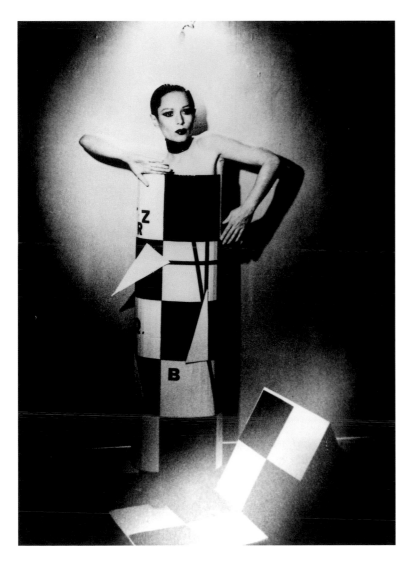

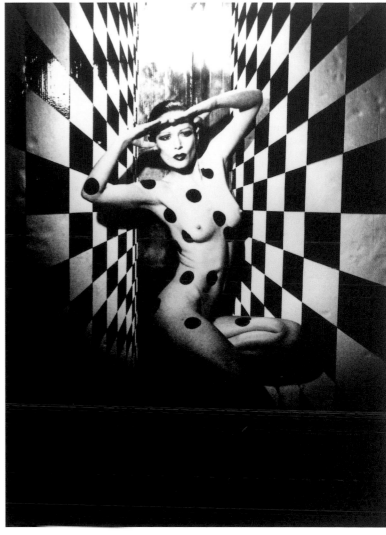

Cécile Wick

*1954, lives and works in Zurich

When Cécile Wick photographs a waterfall, it is not transformed into a monumental, frozen block but flows on in the mind. The artist is known for her beautiful black-and-white photo series of seemingly virgin mountains, islands and seascapes taken in an extremely time-consuming process with the pinhole camera, images in which the echo of a sublime 19th-century Romanticism can still be heard.

The artist introduced a completely different kind of contemporary urban and landscape photography in the mid-eighties. She organized site-specific performances at selected, ostensibly insignificant places in Zurich, both with and without audiences. From the "Begehungsvideos" (Walk-Through-Videos) used to document these actions, Cécile Wick picked out individual stills, which she photographed again, thus creating a mixture of the traditional approaches of photography, video and television. The work entitled "Zürich 1984" comprises eight "screen images," each enlarged to 100 x 150 cm. Despite the large format, however, these are not spectacular "blow-ups" that unveil particularly striking events. A shadowy figure dressed in white is seen walking through an unidentified setting in the background—perhaps an underground garage of the kind found in virtually every city.

It is not clear what the anonymous pedestrian is doing in these empty, desolate surroundings whose only inhabitant is a graffiti stick figure (Harald Nägeli?) on a concrete wall. Its gender uncertain, the moving figure emerges in the distance from the darkness that is partially illuminated by a band of light along the concrete curves. The observing eye which shows the figures from different perspectives, without revealing its identity, could be that of a concealed surveillance camera of the type installed at many different spots throughout the city during the eighties. An interpretation of the photo series "Zürich 1984" as a critical appraisal of an Orwellesque "Big-Brother" society would not go far enough. The images are in suspension. They are neither documentary "crime-scene" photos nor cinematic narrative sequences. "Photography's noeme"[1] (Roland Barthes) dissolves among the gaps in the divergent series of images that remind us of dream sequences in which memories and premonitions intermingle.

A dreamlike underworld atmosphere is particularly evident in the last photo in the series, in which a figure stands near the water beneath a bridge, a brightly shining form that appears as the extension of the rays of sun reflected on the water's surface. The aesthetic and thematic link to the later works of Cécile Wick is most apparent at the point where the figure becomes one with the architectural structures and the lighting conditions. Images of her own face are interwoven with those of rocky landscapes or waterfalls. We recognize a fluid continuum of the transitory and of multifaceted meaning, a timeless scenario that filters something lasting from everyday movements: a person, a path, light and darkness, water and stone.

BEATE ENGEL

1 Roland Barthes, *Camera Lucida. Reflections on Photography* (New York: Hill and Wang, 1981), p. 88.

CÉCILE WICK
ZÜRICH 1984
Black-and-white photograph, 2 photos from an 8-part series,
100 x 150 cm each
Foundation Kunst Heute, Bern

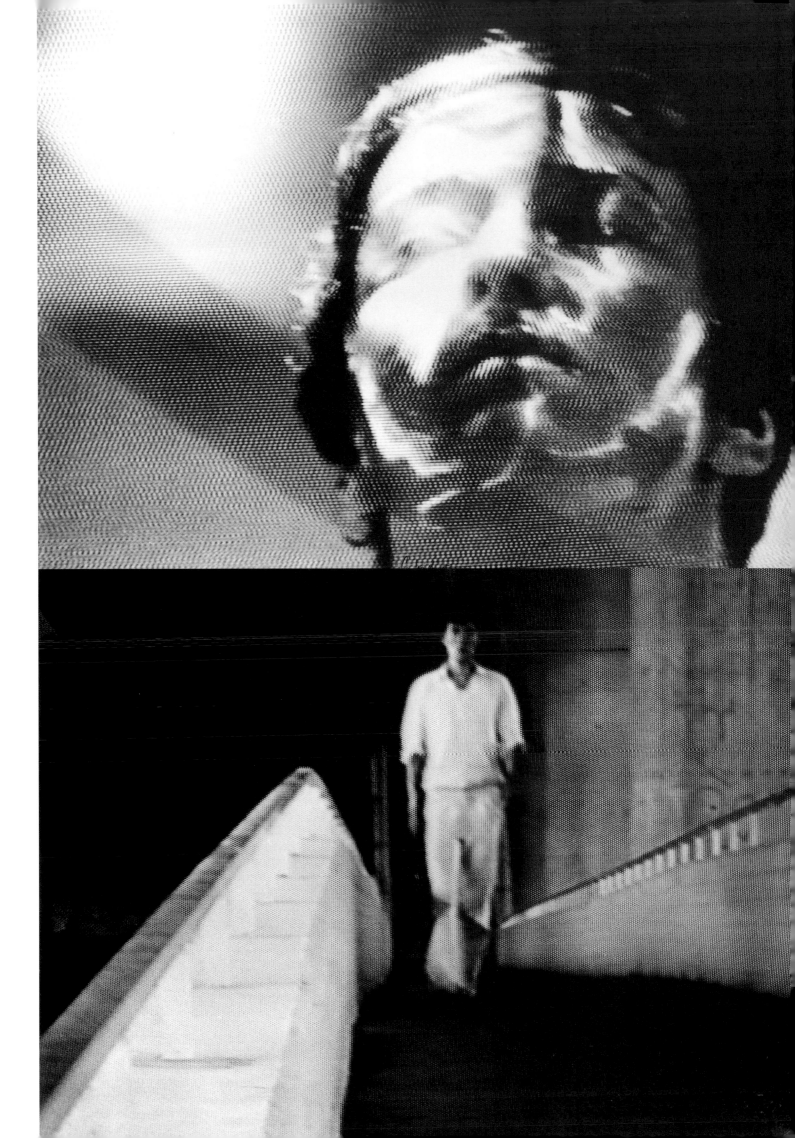

Tina Bara

*1962, lives and works in Berlin

Tina Bara took up photography in the mid-eighties, beginning with 35-mm black-and-white portraits of people she associated with, members of political opposition groups in the German Democratic Republic. These works were not conceived as psychological character profiles. The artist's objective was to engage in dialogue with her subjects and in doing so to develop an image of young adults that differed from the one propagated in the official media. Opposing private life to social life, she revealed a very specific attitude toward life that was endemic to her generation, a prevailing sense of melancholy, indeed a certain *tristesse*. Despite her openly critical view of the state, she was accepted as a member of the Künstlerbund (the official artists' union) and was thus permitted to work as an independent artist. She left East Germany in the summer of 1989 and settled in West Berlin.

During her pregnancy in 1995 she began taking portraits of herself with a simple 35-mm camera, always photographing directly, without the aid of a mirror. Although she captures many "different" faces, her aim is not to develop a complete personal psychogram. "The complexities of the psyche cannot be explored through photography. There are limits to what can be visualized."[1] Instead, she pursues a concept of personalities in which identity is not constant but subject to a certain degree of variation. What interests her in the self-portrait is the idea of stepping outside oneself, becoming the observer and the observed at the same time, inquiring into oneself. Tina Bara can do this only in moments of isolation, most often in indoor spaces she has just entered, places where she is involved with herself and her own thoughts and free from distraction. Quite often, these are moments immediately preceding a departure or just following a return. This state of oscillation between stability and volatility is a constant in her work.

She questions authenticity in her self-portraits. Certain aspects of authenticity are undeniable, of course, as she was present with her camera, yet there is more at work here. Her portraits, which become increasingly abstract by virtue of their number—and more authentic as well, in a certain sense—only seem to show how she felt at any given moment. Moreover, she always plays herself during the shooting session, an approach that creates the kind of tension between authenticity and fiction we sense in Dogma films as well.

The title "o.k. labor" refers to a chain of photo shops at which Tina Bara has prints of her self-portraits made quickly and inexpensively. She had color-laser copies made of her photographs for this exhibition, lending her works an extra quality of cheap, quick reproducibility and thus adding yet another level of abstraction.

HOLGER EMIL BANGE

1 Tina Bara in an interview with the author, Berlin, July 1999.

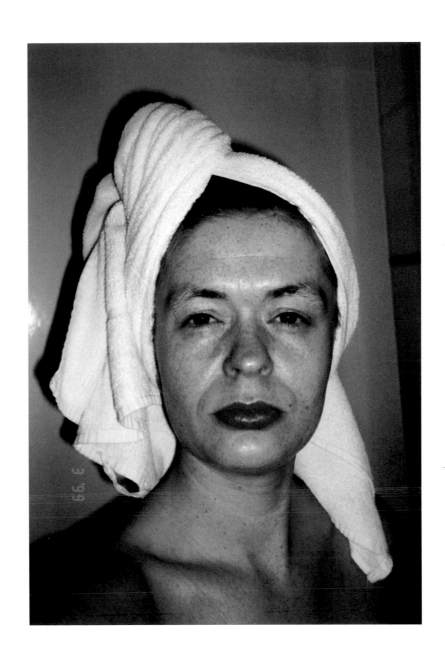

TINA BARA
O.K. LABOR 1995–99
Color-laser copy, 25 parts, 42 x 29.7 cm each
Courtesy of Galerie Christa Burger, Munich

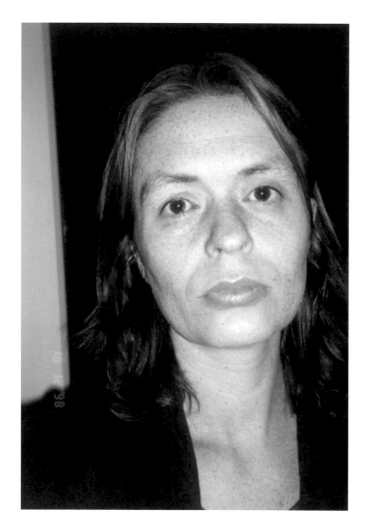
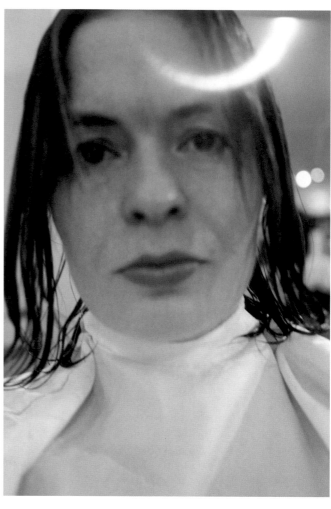

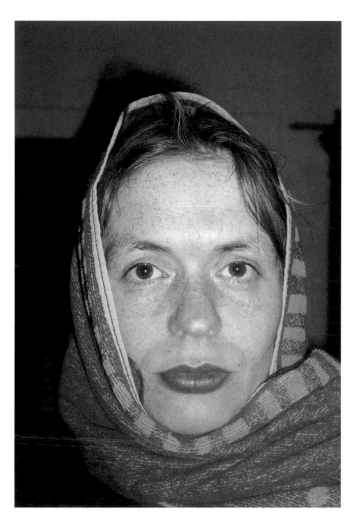 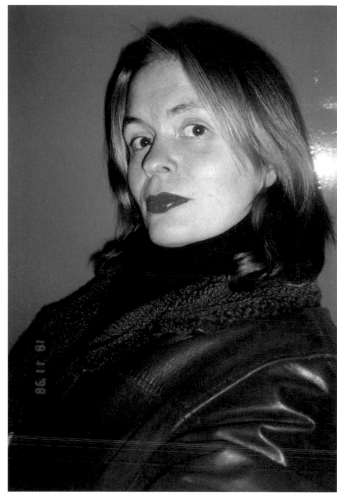

Katrin Freisager

*1960, lives and works in Zurich and New York

With "Nadja," "Bettina," "Anita," "Pipilotti," "Jacquelyn"—a series of staged, intimate, full-body portraits of young women lying on plain mattresses completed in Zurich in 1994/95—Katrin Freisager gained international attention virtually overnight. In these photos she succeeds in charging the balance between the familiar and the unfamiliar image with an unprecedented degree of energy through irritation—and that at several different levels. We are confronted initially with the portrait of a reclining woman, which—as a photograph—is presented in the vertical and thus creates tension between spatial and pictorial reality. The camera records reality, but the reality of the photograph is pure image.

In response to our mass-media-induced sense of familiarity with images of semi-nude women in advertising, tabloids and men's magazines, the artist counters with closeness and distinction. She does not destroy the erotic aura but transforms it from attraction into introspection in a view that is perhaps both male and female. In lieu of provocative undergarments, the "photo-director" clothes her models in quite ordinary, almost old-fashioned underwear. In doing so, she emphasizes the young women's sense of physical identity. They do not wish to give away their sensuality but want to feel it in their own bodies. They gaze into the camera and see the photographer, who, in this case, is also their friend, standing on a ladder, yet no communication takes place. It is as if what is seen flowed directly into the interior of the body.

The viewer's feeling of contentment is disturbed by the nakedness of the frame-filling mattresses. At the most obvious level, they serve as reclining surfaces, background patterns and color components—the pink bodice and the light-blue mattress, the striped panties and the flowered damask. Yet the mattresses are not covered; they are bare. They are not beds; they are no-man's land. By lifting the scenes from their everyday context, the artist accomplishes the transfer of space and time. The individuals become female bodies *per se*, metamorphosing into vessels for the sensual responses of the recipients—in this or that way, depending upon whether the viewer is a man or a woman.

"It is the contradictions that interest me," says Katrin Freisager, contradictions that can be brought into balance only through tension and irritation. Motivated in part by the desire to expose herself to the unfamiliar, the artist has spent much of her time in New York since 1996. In more recent series, such as her "Color of Skin" (1998), staging has come to play a more important role than in earlier works. Katrin Freisager regards content and pictorial composition as a unity. This series, which features a young woman with "porcelain skin" inside a room, also focuses on the tension between the uniformity of undefinable space and unremarkable appearance, on the one hand, and the intensity manifested in the body's expression, on the other. Katrin Freisager's photographs seek out the visible in the language of the body.

ANNELISE ZWEZ

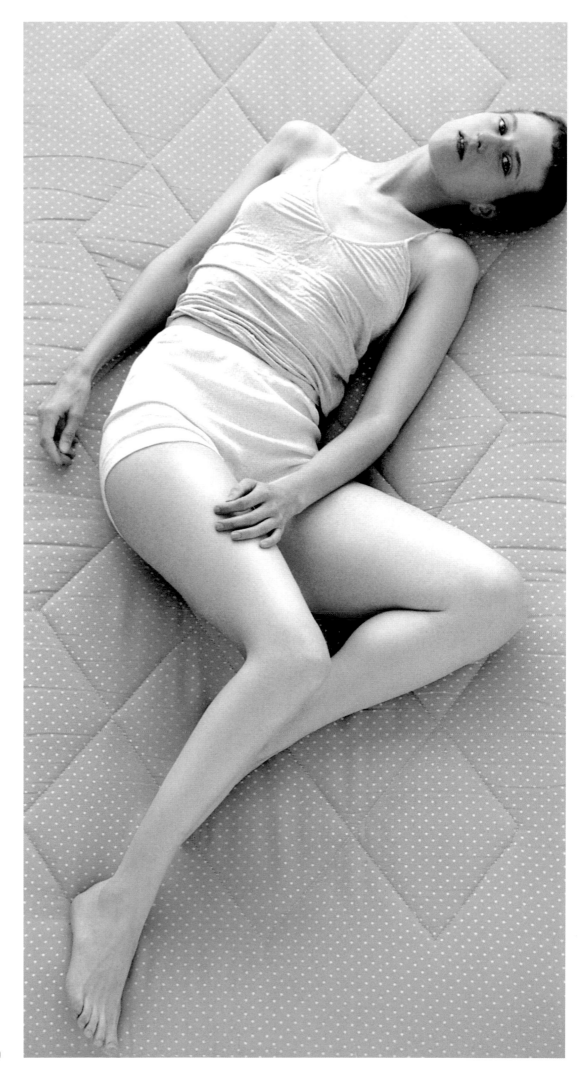

KATRIN FREISAGER
BETTINA 1995
Color photograph on aluminum, 2/3, 90 x 167 cm
Ruth Eigenmann (Courtesy of Galerie Art-Magazin, Zurich)

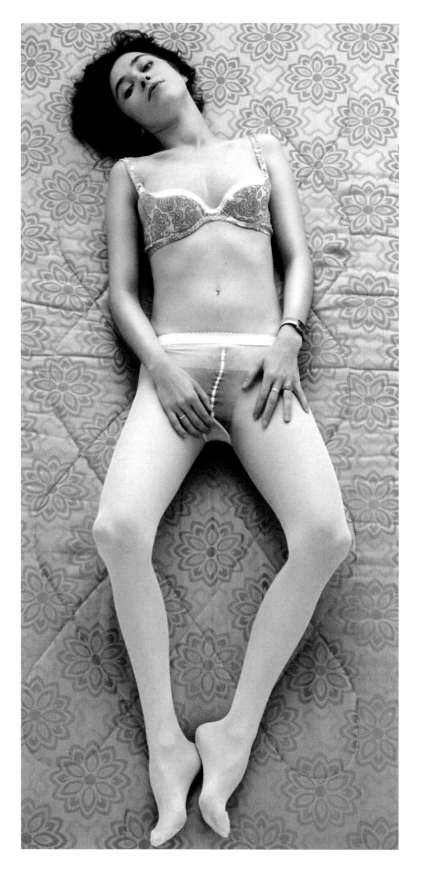

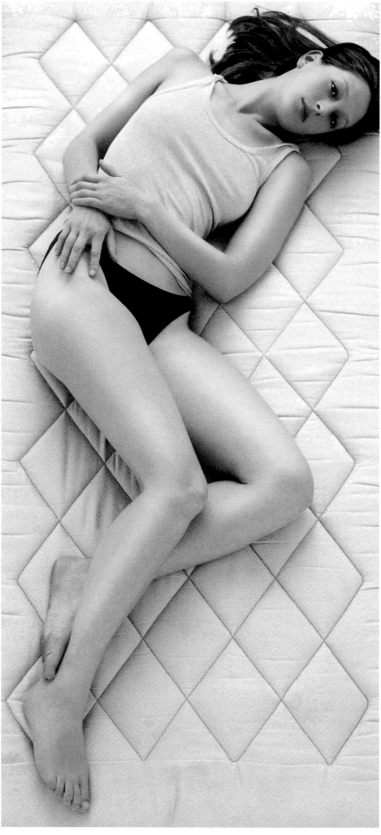

KATRIN FREISAGER
PIPILOTTI 1995
Color photograph on aluminum, 2/3, 90 x 167 cm
Courtesy of Galerie Art-Magazin, Zurich

KATRIN FREISAGER
ANNA 1995
Color photograph on aluminum, 2/3, 90 x 167 cm
Courtesy of Galerie Art-Magazin, Zurich

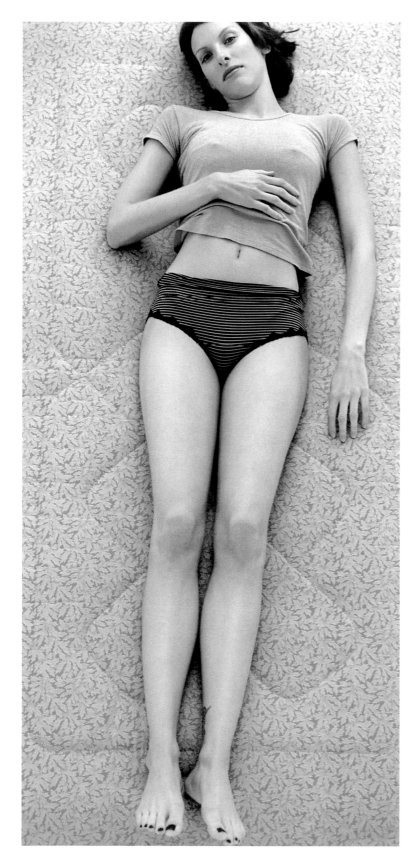

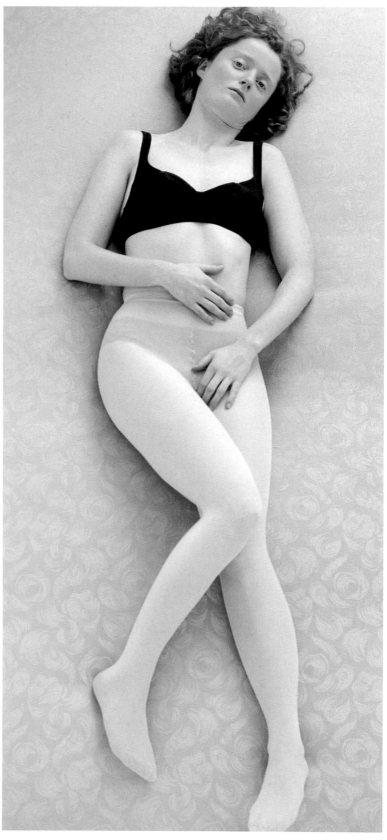

KATRIN FREISAGER
JACQUELYN 1995
Color photograph on aluminum, 3/3, 90 x 167 cm
Courtesy of Galerie Art-Magazin, Zurich

KATRIN FREISAGER
ANITA 1995
Color photograph on aluminum, 2/3, 90 x 167 cm
Courtesy of Galerie Art-Magazin, Zurich

Liza May Post

*1965, lives and works in Amsterdam

The faces of the people in Liza May Post's photographs are usually turned away from the camera or obscured by objects. The actors remain literally faceless and virtually impossible to identify, thus heightening the significance of clothing, sets and postures. Post's photos are unique personifications of anonymity, representing, in a certain sense, a playful reversal of the traditional photobooth exposure in which only the subject's facial features are shown. Post's figures are fragile tokens of identity. Their indeterminate character makes them projection screens for our imagination. They are both interchangeable and unique, individualized and stereotyped, surrogate and reality.

The scenes depicted in the photo tableaux have an enigmatic quality. Viewers find their content difficult to grasp, remain outsiders, baffled by the slick, photographic reality: "Startling and surreal, the work of Liza May Post triggers a host of psychoactive imagery beyond that displayed on the photograph."[1] Post pursues a game of irritation. Seemingly banal situations are systematically undermined by subversive elements. Stories are told, tales with plots that seem obvious at first but then dissolve into ambiguity upon closer scrutiny. The color white—known to contain all of the colors of the spectrum—plays an important role in Post's photography.

A young girl stands in a room with a band of windows running around the corner joining the two visible walls. A curtain of lightweight material hangs only inches in front of her face, obscuring her view to the outside. The girl has a thick head of long, blonde hair. She wears a short jacket of imitation fur, and her legs are clothed only in nylon stockings. She is immersed in herself. Her head is bowed slightly forward. The proximity of the curtain that veils the view through the windows underscores the inward gaze of the female figure.

The scene is so artificial that one could hardly misinterpret it as a record of a real event. Indeed, the photographic detail offers a view of an imaginary stage upon which Liza May Post presents a subtle play on the parameters of identity.

GIANNI JETZER

1 Gregor Muir, "The Parallax Eye," in untitled exhib. cat. (Breda: The Artimo Foundation, 1996), n.p.

LIZA MAY POST
UNTITLED 1994
Color photograph on aluminum, 138 x 150 cm
Fotomuseum Winterthur

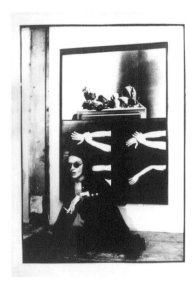
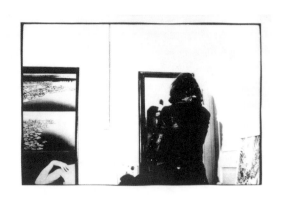
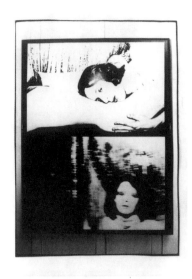
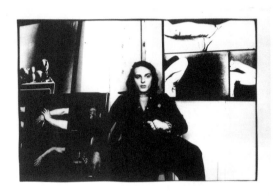
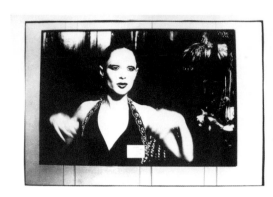
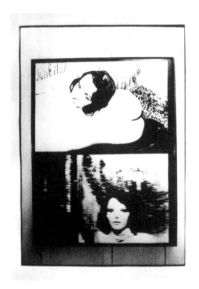

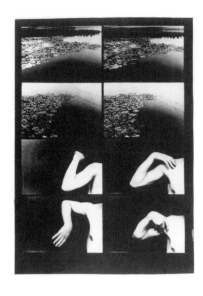

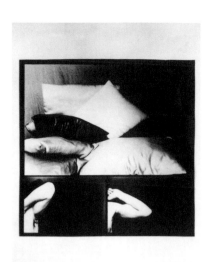

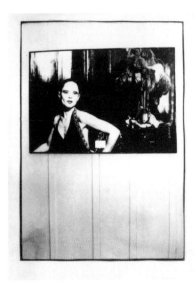

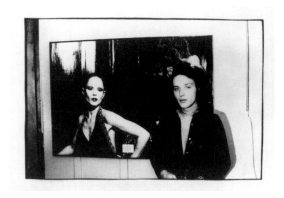

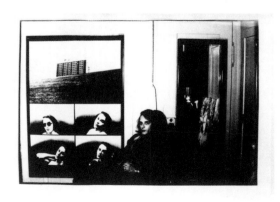

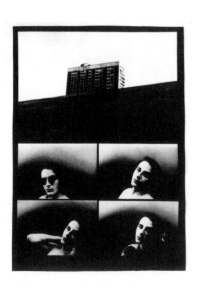

GENERAL IDEA

Jorge Zontal (†1994) / Felix Partz (†1994) / AA Bronson, lives and works in New York

A small fragment of knowledge arouses curiosity. The suggestion of a "general idea" is more likely to attract attention than complete information, as it leaves room for all sorts of projections with which to embellish the general idea in the telling. That is the way advertising promotes identification in images and corporate identities, and it is also how myths are created.

GENERAL IDEA was founded in 1968 by the Canadians AA Bronson, Jorge Zontal and Felix Partz, not as an artists' group but as a logo under which their entire production was subsumed from that point on: films, videos, performances, photographs, paintings, sculptures, multiples, books, brochures, posters, a media publishing company and their *File* magazine (1972-89), a journal that mimicked the format and design of the legendary *Life* magazine. It was in *File* that the artists began work on their "MISS GENERAL IDEA PAVILION" in 1974, a mysterious, idealized exhibition site that existed only in simulated documentation, although its glamorous opening was ostensibly scheduled for the Orwell year of 1984. In 1977 the artists announced that the pavilion had been destroyed in an "apocalyptic fire" thus giving birth to a myth. With the aid of artificial fragmentary ruins and artifacts allegedly salvaged from the blaze, they set about reconstructing something that had never been built. The pavilion became a living legend.

GENERAL IDEA is a structure which takes the shape of a promise, forging links to earlier promises, suggesting fetishes and addressing incomplete bits of knowledge in order to divert them toward other, similarly half-familiar paths. Thus it was with the parasitic transformation of Robert Indiana's famous "Love" logo into a series of "AIDS Projects" (1987–94). The work as a whole is a highly intelligent promotion campaign, not only for the group's own corporate identity but for the kind of art that GENERAL IDEA wanted to be (although it only had a "general idea" of what it might be) and for the artists who stood behind it, who had sacrificed their individual claims to authorship in the interest of a composite identity comprising three persons. In "The Three Men Series" (from which *Missing Link* presents two adaptations), "[we] displayed ourselves in manipulated photos as the greatest work of art, fashioned on the basis of our own design. [...] We made ourselves into the artists we wanted to be."[1] Whenever tripartite configurations appear in GENERAL IDEA products (as is often the case), they call forth associations with the whole world of GENERAL IDEA as a personification of the triumvirate of artists that always hides in the desire for a receptive echo. Following the deaths of Zontal and Partz (both of AIDS-related complications) in 1994, GENERAL IDEA metamorphosed into an homage to them both. It is a memorial to an artistic self-image that anticipated—years in advance—what would later develop into a broader current as Label Art after the end of GENERAL IDEA.

HOLGER KUBE VENTURA

1 AA Bronson, in: *Dream City*, Kunstraum Munich / Kunstverein Munich / Museum Villa Stuck / Siemens Kulturprogramm, (Munich / Berlin, Vice Versa, 1999), p. 260.

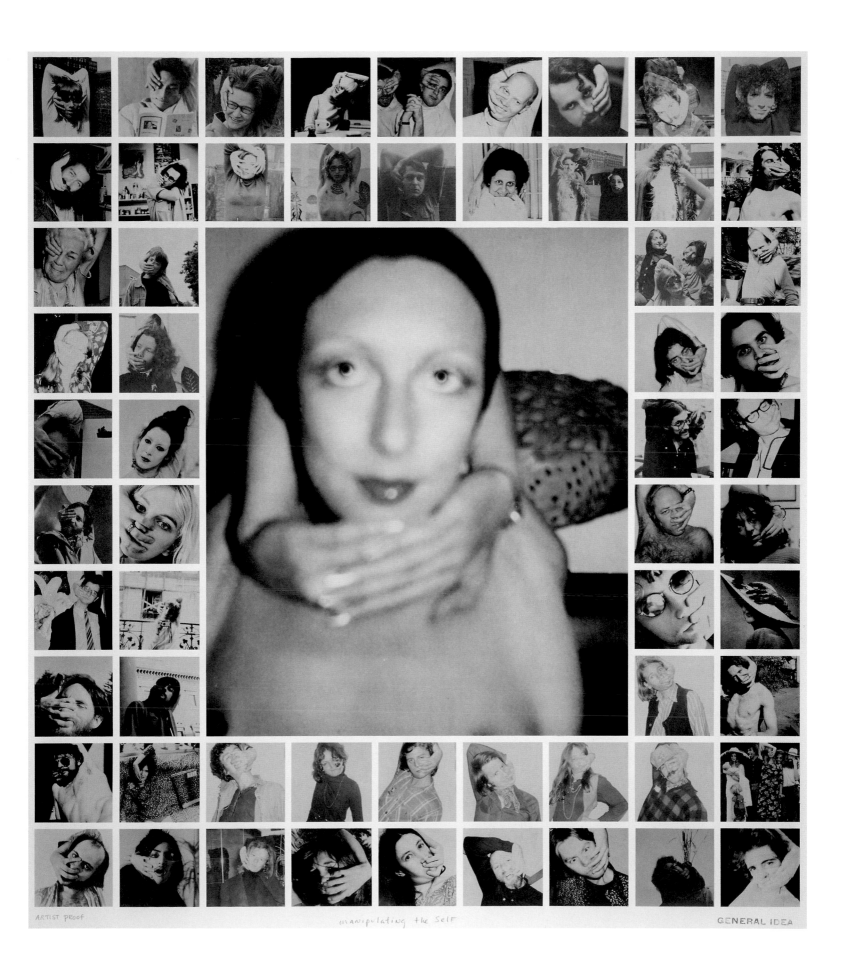

ARTIST PROOF manipulating the Self GENERAL IDEA

GENERAL IDEA
MANIPULATING THE SELF 1973
Offset print, Artist Proof, 74 x 58.4 cm
Courtesy of Galerie Stampa, Basle

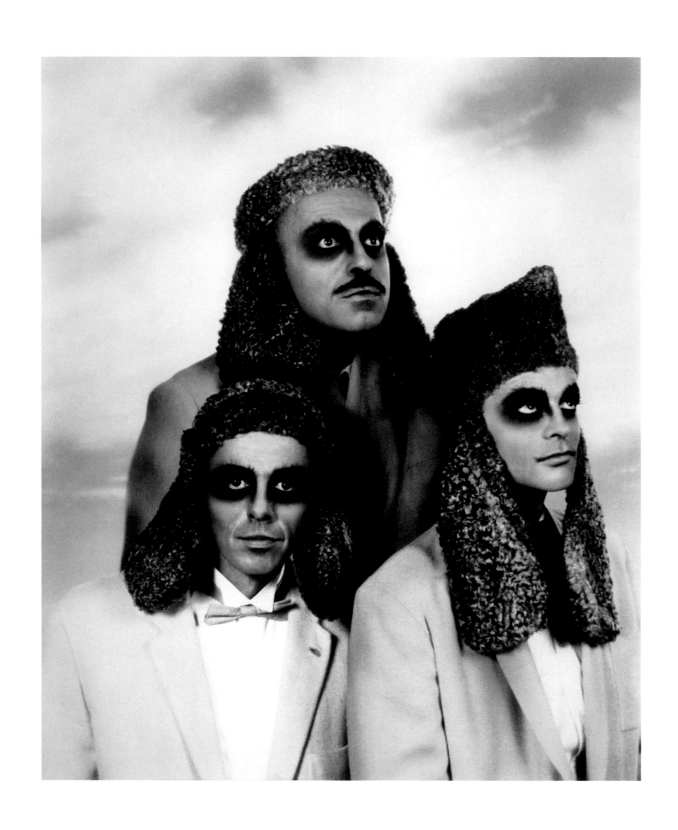

GENERAL IDEA
P IS FOR PUDDLE 1982–89
Color photograph, 76 x 63 cm
Collection of Christoph Schifferli, Zurich

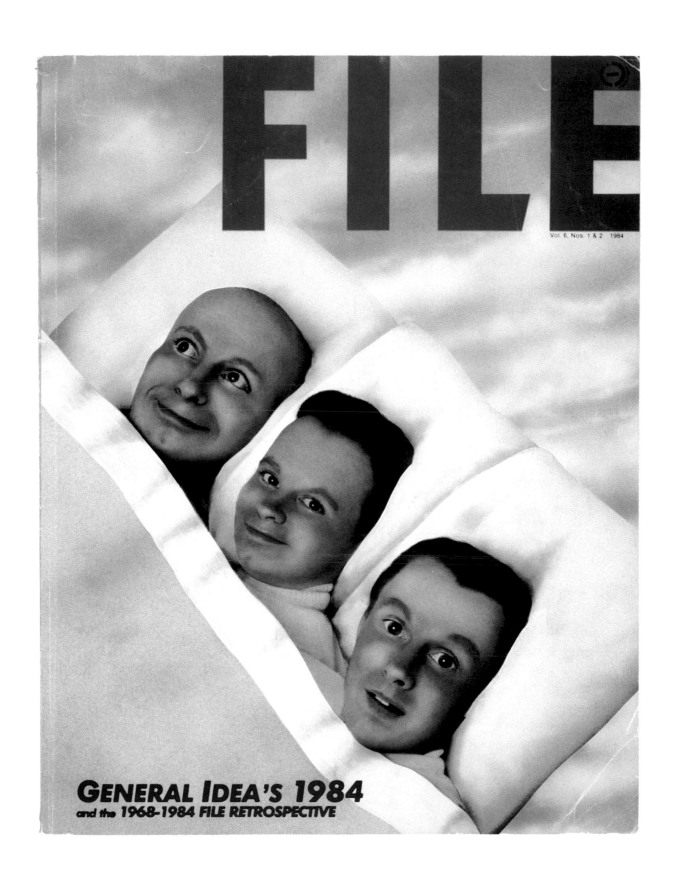

GENERAL IDEA
**GENERAL IDEA'S 1984 AND THE 1968–1984
FILE RETROSPECTIVE, VOL. 6, NOS. 1 & 2**
Offset print, 128 pages + XVI pages (selected biography and bibliography)
Courtesy of Galerie Stampa, Basle

Erwin Wurm

*1954, lives and works in Vienna

Never underestimate the power of play. Each of Erwin Wurm's photos from the "One Minute Sculptures" series depicts the artist performing various simple, often silly or outright bizarre actions: diving head long into a crate, legs flailing Jack-in-the-box style; precariously balancing on two rubber play balls, doing a push-up on four tea cups [...] Although all these capricious scenes are staged with a conspicuous absence of special effects, they nevertheless catch the eye in the most persuasive way. Wurm's photographs have several identities: part performative documents, instructional guidelines for quirky make-your-own-body-sculptures that any viewer—regardless of status or location—can, if they want, realize on their own by following the simple scenes depicted. Yet, however, whimsical or funny they might be. Wurm's clown-like concoctions also slip into something not quite as innocuous in their role as blueprints invoking the possibility of some future reenactment, the "One Minute Sculpture" photos impart the notion of "play" with a radical allowance. After all, if reenacted they will obviously turn the viewer into an engaged protagonist and—more significantly—extend the artwork as a process-directed co-creativity that could spin off into any number of unexpected awkward twists the would-be performer gives them. They also offer the promise of artwork as an expressive existential territory.

A mischievous disposition is at play here. Wurm cleverly manipulates the possibilities of art as a vehicle of direct, experiential communication rather than as an object of simple admiration and observation. These innocuous scenes are event-images; open-ended invitations, a well of fleeting, diverse and highly individuated possibilities, that each viewer can invoke through a hands-on, personal involvement. If reenacted, which is one of their objectives as artworks—these photographs tacitly leave room for "mistakes" despite their manifest simplicity, the situations proposed to us in these photographs are so wacky, so haphazard and impromptu, that they would easily become subject to a host of unpredictable exigencies that might emerge if someone decided to materialize them. Inevitably, each reenactment would come into existence on independently expressive terms based on the mental landscape, the consciousness, perception and intuition of each individual who actualizes them. In the process—signature style—the concept of the original would be profoundly displaced, torn from its moorings, raising a whole new problematic regarding reproducibility. But, the question whether everything is interchangeable or reproducible does not seem to be Wurm's objective. In fact, these pieces, strictly speaking, are not really reproducible, nor do they advocate or welcome reproduction—they can only be reenacted on very subjective terms. But, beyond structural rhetoric—the potential to swirl out of control and mutate into awkward, subjective singularities suggests an human concern. Persuasive and confusing at once, these works puncture aesthetic, formal standardization and extend the scope of the artwork as a personal and unique creative act. Reenactment is only one possible outcome—even in photographic terms, the "One Minute Sculptures" embody something mercurial and unrequited. With their almost inarticulate awkwardness, they have no pretensions of being fully "finished" or "accomplished" works of art. Instead, they allow us to sense a human scale, a fragile tenuousness, quite of the monumental, frozen gesture.

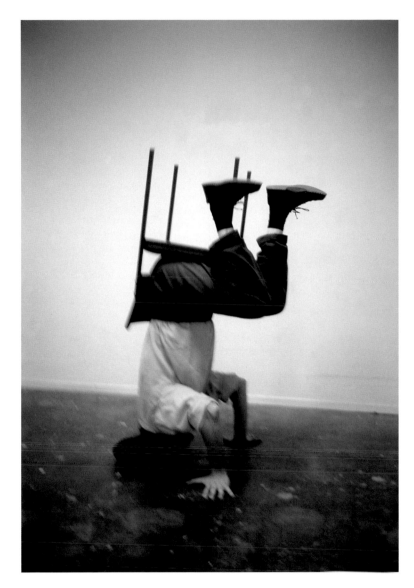

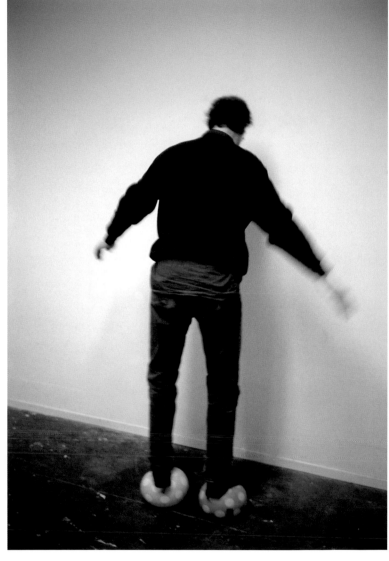

ERWIN WURM
ONE MINUTE SCULPTURES
November to December 1997
Color photographs, 9 parts, 45 x 30 cm each
Courtesy of Galerie Wilma Lock, St. Gall

Naming locates identity. Naming also articulates reality. But, does it grant us access to a privileged or sure knowledge? The "One Minute Sculptures" photos thwart our ability to clearly name them: their role, their final outcome remains undecided. It's as if they recognize the impossibility, indeed the danger of a transparent, untroubled, language that would too easily or too self-assuredly "name" things. They prefer play. In all their narrative and iconographic eccentricity, compounded by their peculiar formal status as independent photographs, blue-prints for body sculptures and performative documents—Wurm's photos challenge the imposition of dialectical methodology on the creative act. These photographs suggest the conflicts of relativism enriching communication and propose the work of art as a charged subjectivity. Through the strategy of play, Wurm's "loony tune" poetics finds its own, unique way from creative authority to dialog. To dreaming wide awake.

MAIA DAMIANOVIC

Gilles Barbier

*1965, lives and works in Marseilles

"Planqué dans l'atelier" is the title of a photo series realized by the French artist Gilles Barbier in 1995. The phrase has two possible meanings: "loafers in the studio" or "hidden in the studio." Each of the ambiguously titled photos shows an interior detail of the abandoned factory building in which the artist works in Marseilles. Pieces of wood are stored along the walls, paint buckets are distributed at various places on the floor and an odd conglomeration of randomly arranged or casually deposited articles occupies one corner of the room. At first glance, the photos look quite harmless and ordinary. In a certain sense, they portray an individual in terms of absence, preserving the traces of his activity.

Small arrows, formed as if by accident from the material lying about, structure the space. Each arrow points toward a specific point in the picture—to the place where we find the missing person. Barely recognizable, a human eye flashes from inside what we supposed was a roll of canvas. The barest shadow of a face appears in a cardboard box, and a mouth grins maliciously from beneath a wooden arch. Vermeer effects? The Velazquez syndrome? Post-modern self-reflection? Artistic insider parody? Or simply a (visual) trap—"avec piège"—as the addendum to the work title suggests? The game of associations with relics of art history is not a mere finger exercise, however. It revolves around a fundamental complex of questions relating to the artist's existence. What are the qualities that define an artist in today's society? What are his functions? His goals? Pursuing these questions, Barbier makes himself the object of research, mirroring his actions and his role in art.

In "Polyfocus," Barbier follows this investigative thread a logical step further. The photo shows him—in multiple images—surrounded by studio accouterments. The work is a computerized animation, a staged scene using digital techniques. Barbier arranged six "duplicates" of his own body in a "living tableau" depicting himself in various aggregate states of studio work: thinking and rummaging, dreaming and viewing, packing and brooding. In "Polyfocus," Barbier offers a voyeur's view of the site of auratic genesis. At the same time, however, his profane self-exposure topples high art and artistic genius from their pedestals, posing anew and with renewed vigor the more or less classical questions about the conception, production, marketing and viewing of works of art.

CHRISTOPH DOSWALD

GILLES BARBIER
POLYFOCUS 1999
Color photograph, 120 x 170 cm
Collection MJS, Paris
(Courtesy of Galerie Georges-Philippe & Nathalie Vallois, Paris)

Anton Henning

*1964, lives and works in Manker and Berlin

Anton Henning's art draws its strength from the replication of artistic source materials. His plundering of the treasure chest of modern art is an impulsive gesture of immediacy in which he pulls the object of his desire, be it a specific motif, a painterly approach or a conceptual idea, from its original context and converts it into a material for his own creative use.

This gesture is by no means a sign of low esteem. On the contrary, one has the impression that, for Henning, the appropriation of models is a necessary consequence of their overpowering presence and impact. He dilutes the effect of this show of strength through a further expropriation of the original context by integrating his photos into spatial installations in which the interrelationships among the objects achieve a maximum degree of complexity. The lost context is replaced in these installations by a self-generated system of references.

A second step in the same direction is accomplished through the medium of photography, especially in the large-format picture entitled "The Manker Melody Makers (at home)." Three musicians pose on a broad couch. Their instruments are distributed casually throughout the room. The viewer soon realizes that all three of the band members are actually the same person—Anton Henning himself is the protagonist of the scene. He has used himself as a material and thus made himself a point of reference in his own work. The model and theme in this case is the image of pop culture. The technical illusion achieved in the photograph is shattered by the theatrics of deliberate play. The multiplication of the artist's person produces a group portrait taken to the point of the absurd.

In "The Manker Melody Maker Lounge," a spatial installation created for the Galerie für Zeitgenössische Kunst Leipzig (Gallery of Contemporary Art Leipzig), where it was used as a café, Henning perfects the playful back-and-forth between fiction and reality. The photo of the band is the immediate point of reference for the installation and is, significantly, placed in front of it in a spatial sense—the photograph hangs in the dressing room. Everything in the adjacent lounge relates to the band. The colorful walls and furniture provide an atmospheric background. Painted portraits of one of the musicians, alongside other pictures, emphasize the self-centered game. One of several continuously-playing videos shows an interview ridden with pop clichés with a band member posing in front of the photograph cited above. Tunes by the Manker Melody Makers, composed and performed by Anton Henning, serve as background music in other videos. Ultimately, the question arises whether Gadamer's contention that "the effect of the game's self-presentation is [...] that the player equally achieves his own self-presentation,"[1] is true here as well or whether self-presentation in Anton Henning's case is not expressed instead as an infinite regression.

VIOLA VAHRSON

1 Hans-Georg Gadamer, *Hermeneutik I, Wahrheit und Methode*, Gesammelte Werke, vol. I (Tübingen: Mohr, 1990), p. 114.

ANTON HENNING

THE MANKER MELODY MAKERS (AT HOME) 1997

Cibachrome, 120 x 160 cm

Courtesy of Galerie Wohnmaschine, Berlin

Jean Le Gac

*1936, lives and works in Paris

Jean Le Gac explores the relationship between fiction and reality. In his "Cahiers" (Exercise books), he uses photography as a means of documentation in undermining precisely this documentary capacity attributed to photography by Roland Barthes.

Compiled between 1968 and 1971, the photo-text documentation of actions, journeys and activities is a form of "narrative art," a sub-category of Conceptual Art. Since then, Le Gac has given priority to the problem associated with the interplay of reality and fiction. In his "Le Peintre" (The painter, 1973), the work with which he first gained public attention, he merges his own biography with that of a fictitious artist named Florent Max in an exemplary portrayal of an artist's life. This fictional rendition of the genesis of an artist is a new variation on the myth of the artist. We see the painter in the field of tension between his vocation and his yearning for fame. The photos show him in the giardini at the Venice Biennale, at his weekend house, travelling, at locations in Paris and in the Centre Pompidou. Photo captions refer to the images, and vice versa. In the alternation between a quest for traces and a paper-chase, the fictional biographical fabric of photographs and texts appears, in its staged mock-neutrality, as a perfect generator of illusions. Devoid of intention, the camera becomes an accomplice in the construction of an identity.

We recognise the same strategy in "Le roman d'aventures avec trois notes en marches 1913–1972" (The adventure novel with three notes in march 1913–1972). Borrowing a number of sentences from the children's book *St. Nicholas*, Le Gac re-enacted them for the camera, reformulating them into adventures supposedly experienced by himself. Formally reminiscent of a photo-romance, the 24-part work plays a deliberately confusing game with the viewer, an effect that is heightened by the even higher degree of authenticity simulated by the typewritten notes. Revolving around an imaginary plan, around the activities of searching, escaping and pursuit, each photo-text unit poses more puzzles than it solves. "Perhaps Le Gac's dual strategy consists in concealing in order to reveal. He alters his photos so as to avoid being betrayed by them, yet it is his provocative aura of secrecy that puts the viewer on his trail."[1]

The stylistic tool of false objectivity exposes nothing but nonsense. In the interplay of performance and the construction of identity, of truth and lies, Le Gac ultimately undermines photography's claim to verisimilitude. At the same time, he anticipates the artistic strategy later pursued by such artists as Sophie Calle and Cindy Sherman in their photographically documented, feminist-inspired performances and fictionalised self-portraits of the eighties and nineties: the preservation of a deliberately constructed reality. Le Gac's art also points to the role of technically produced, mass-media images in the construction of truth.

BRIGITTE ULMER

1 Translated from Günter Metken, in: *Jean Le Gac, Der Maler* (Brussels / Hamburg: Edition Lebeer Hossmann, 1977), pp. 7ff.

JEAN LE GAC
LE ROMAN D'AVENTURES AVEC TROIS NOTES EN MARCHES 1913–72 1972
(THE ADVENTURE NOVEL WITH THREE NOTES IN MARCH 1913–72)
24 parts, 20.8 x 40 cm each
Kunstmuseum Bern (Collection of Toni Gerber)

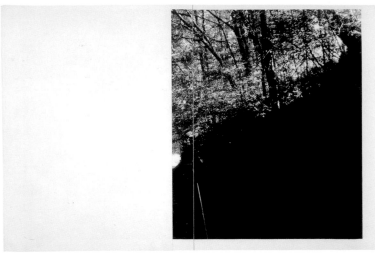

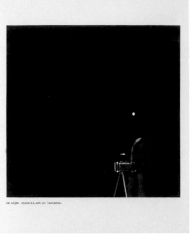

Cat: Forme un chapelet lumineux qui s'éteend en demi-cercle.

Le signe apparaît net et lumineux.

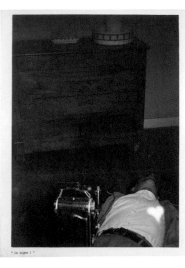

" Le signe ! "

Resté seul pour remettre les appareils en place dans le chambre...

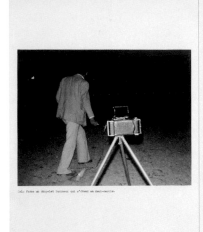

Il s'encreuse de disparaître par l'étroit escalier.

Da même vous me concentrizer d'ellens.

" J'an vue le preuve. "

Il le tire dans le couloir.

" Vous vous escargot vous cass! ?"

3:521411752391111521414314541519

Le vatik sur le crête de la muraille.

Ima m il se reproche ce qu'il ne-m se faire ?

Il apparaît enfin.

Il en vérifie le contenu.

C'est une sorte d. tour carrée.

Laquelle de ces enquêtes doit être conservée ?

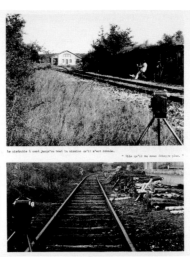

La cimétrie à cent jusqu'au bout la mission qu'il s'est donnée.

« Fin qu'il ne nous échappe plus. »

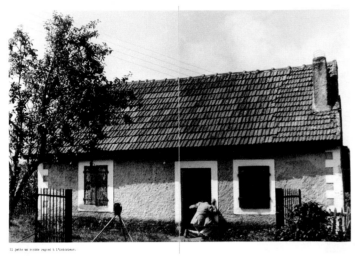

Il jette un rapide regard à l'intérieur.

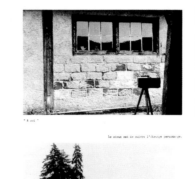

« A moi »

Le sieur est de suivre l'étrange personnage.

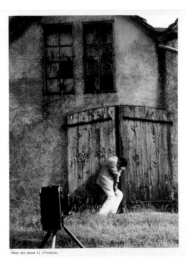

Dans une casse il s'écroule.

Il contemple une dernière fois la rivière.

Il nous regarde en silence.

Il n'a plus qu'à se constituer prisonnier.

Il est convié à une promenade à travers l'île.

Il s'interrompt tout à coup.

C'est dans une corde que son pied vient de se prendre.

La panne dangereuse est franchie.

Il débouche sur la grève.

Il n'a pas de peine à suivre la trace.

Je n'est autre que lui.

181

Saverio Lucariello

*1958, lives and works in Paris and Marseille

Idiocy is not stupidity. It is more like its antithesis. It is, in any case, the underlying issue in a sustained stance which goes from *Bouvard et Pécuchet* to Lars von Triers's *The Idiots*, from Alphonse Allais' *Monochromes* to the self-portraits of Saverio Lucariello. If no one has ever got to grips with the essence of idiocy in art as both a practice and an ethos, that is because it has never been seen in its true context. A kind of Puritanism combined with a fetishistic insistence on the nobility of art have continually prevented an objective view. They have attempted to make idiocy, which in fact is not an aesthetic category, into a marginal product of modern art, an incoherent, frothy, gratuitous and amusing foam that gathers on the top of a tradition that has supposedly never broken with the noble lineage of definitive monuments and intimidating masterpieces. Art as the ceaselessly renewed proof of human genius. According to this vision, the *Incohérents*, Ubu, Satie, the young Gide's *Paludes*, Duchamp's penchant for puns, Picabia's *Monstres* and *Transparences*, Pol Bury and André Balthazar's "Bul" philosophy ("Whatever you do, you're ridiculous!," "It's time to debag dignity"), Dada, Magritte's *vache* period, Gérard Gasiorowski's *Régressions*, together with a sizeable chunk of contemporary art—all that would constitute a parasitic underworld, a fringe of excess over the work of Genius. But no, this "margin" is in fact a center. Idiocy has never constituted the spectacular junk or lees left by modernity but its very motor, its spirit. The work of Saverio Lucariello belongs to this tradition which cannot rest content with burlesque or parody. We must accept that laughter can be the expression of the most acute anxiety and intelligence. As for the vindictive side of this work, we can see it as a demystification of seriousness, that sobriety which so many artists try to pass off as *gravitas*. Saverio Lucariello is a true alchemist, a master fluent with the depth of phenomena and the esoteric virtues of idiocy. He thus churns out self-portraits of the artist as kitsch magus or as a ghost mounted on a wheelbarrow (his nomadism is gluttonous and bulimic), dressed in disco-style folk costumes and attempting to manipulate objects or utter cabalistic incantations. Our apprehension of forms and symbols has reached the point where we begin to want to make things happen. Dispensing with the effort of a theory or initiation, the magus Lucariello throws himself into a wildcat alchemy everyday. Bits of cloth, garden tools, utensils from the kitchen and elsewhere and various bits of charcuterie are all arbitrarily treated as so many magic pentacles (nocturnal and melodic Romantic). And with his mocking eye, which is not unlike that of Peter Sellers in Blake Edward's *The Party*, our Neapolitan shaman in his acrylic robes observes the manifestations to be produced sooner or later by his fluids. But not much happens. All that we have is a floating choreography of unfounded acts, incoherent words, a baroque liturgy (volume, relief, flatness, curves). Lucariello's terrorist alchemy is science for the waxworks museum, a gallery of stylized figures frozen in their poses like so many formulae cut off from conclusion, an alchemy of absolute esotericism that finds its way back to rigor and the burlesque, working on idiocy as a superior understanding of the poetic.

Jean-Yves Jouannais

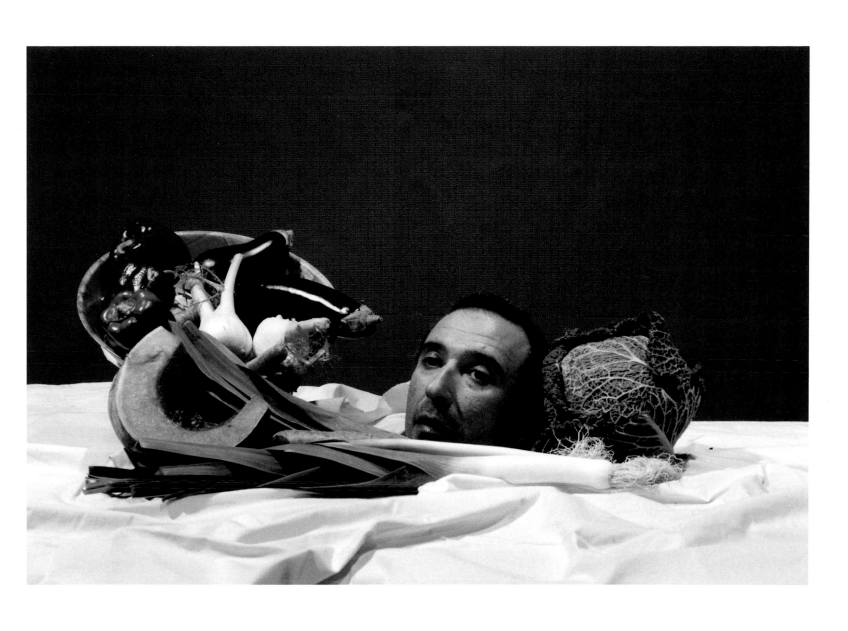

SAVERIO LUCARIELLO
VANITÉ AUX LÉGUMES 1995 (VANITY WITH VEGETABLES)
Color photograph, 70 x 100 cm
Collection Jean Albou, Paris
(Courtesy of Galerie Georges-Philippe & Nathalie Vallois, Paris)

Cindy Sherman

*1954, lives and works in New York

Cindy Sherman began the 69-part series of "Untitled Film Stills" more than twenty years ago. From the very beginning, she posed for the camera herself, slipping into a wide range of female roles, as a young girl, as a housewife, as a slut or an elegant lady—seductive, despairing or lost in thought. Sherman based each individual shot on a scene from a black-and-white film from the fifties, employing the form of the film still, in which a specific moment in a cinematic plot is captured. In mimicking the various characters, the New York artist not only used classical resources and props (make-up, wigs and special items of clothing) but also selected or designed settings in keeping with her own concepts, turning them into movie sets for her fictional, dramatized self-presentations. Yet Sherman deliberately avoided defining her figures precisely or assigning them specific identities. Because she incorporated no clear allusions into the pictures and added no informative titles, the photographs remain open-ended. The viewer is never quite sure who the subject is, what she is about to do or what might be going through her head at the moment. Although Sherman focuses the viewer's gaze on certain aspects through the use of selected attributes and accessories, these signlike motifs tend to be indicative of more generalized roles and situations. In assuming different roles, she is less intent upon questioning her own identity and more concerned with investigating the image of woman per se. She exposes a female identity constructed on the basis of power relationships, class distinctions and gender differences, an identity she no longer accepts as a given but presents instead as a cliché created by media, culture and politics. In "Untitled Film Still #34," Sherman exposes the sexual duality that emerges from the image of the innocent, girlish being, on the one hand, and the seductive object that offers itself to desire, on the other. In "Untitled Film Still #7," we see her as *femme fatale*, with negligée, garter belt and a martini glass, far removed from any hint of virginity. Thus Sherman illustrates two possible manifestations of female sexuality, each of which is ultimately the product of historical and socio-political conventions and pressure to conform.

ANNA HELWING

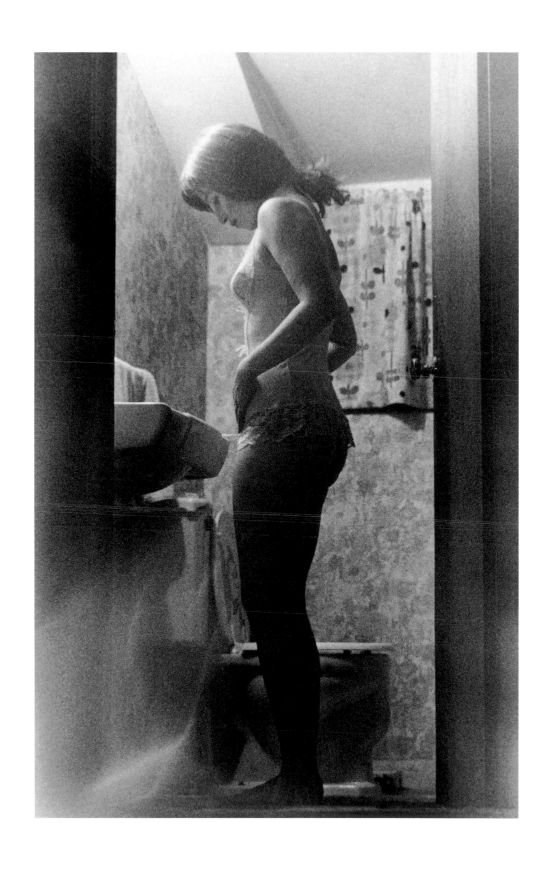

CINDY SHERMAN
UNTITLED FILM STILL #39 1979
Black-and-white photograph, 25.4 x 20.3 cm
Collection of Thomas Koerfer, Zurich

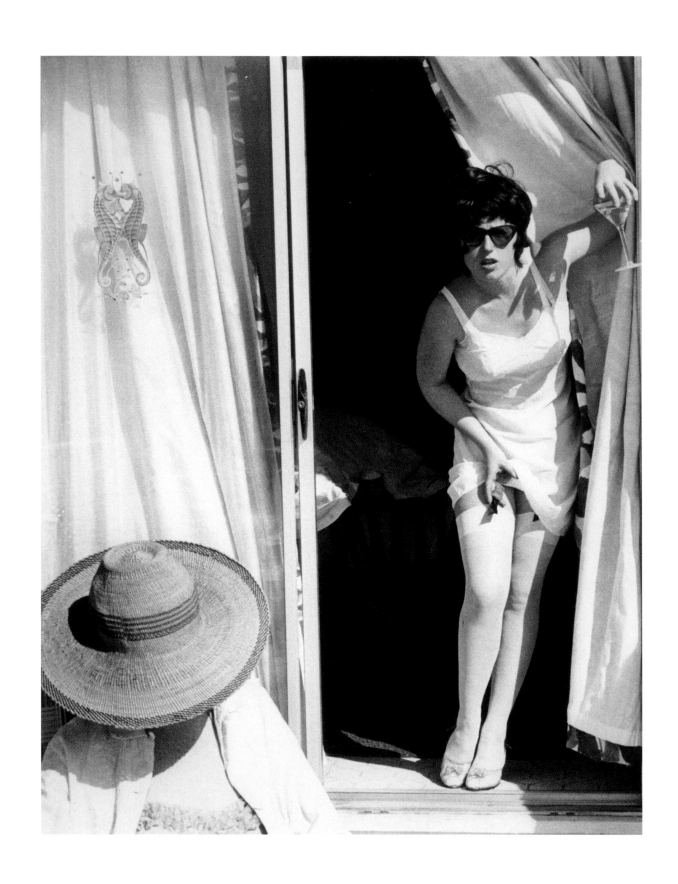

CINDY SHERMAN
UNTITLED FILM STILL #7 1977
Black-and-white photograph, 25.3 x 20.3 cm
Courtesy of Galerie Stampa, Basle

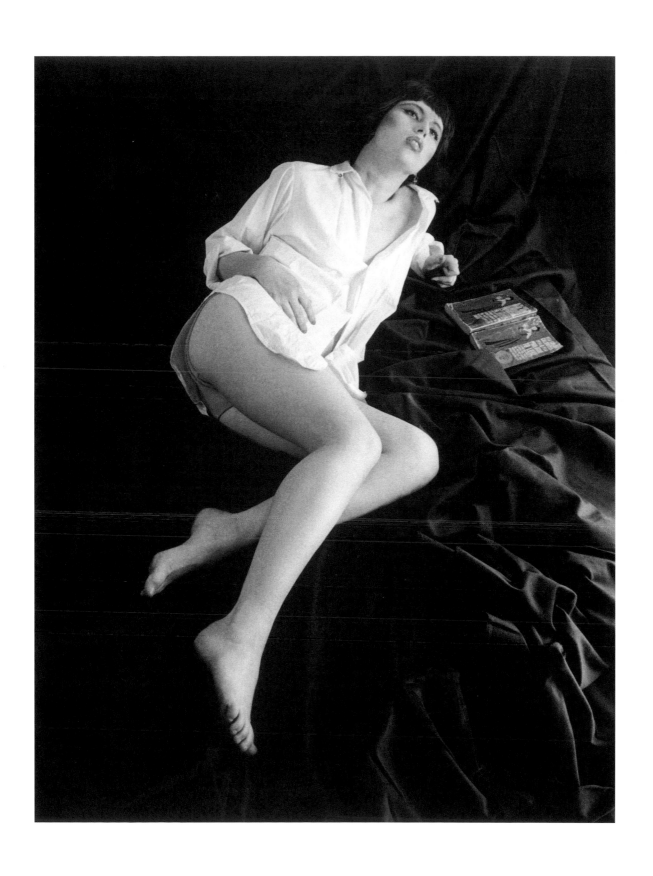

CINDY SHERMAN
UNTITLED FILM STILL #34 1979
Black-and-white photograph, 25.3 x 20.3 cm
Courtesy of Galerie Stampa, Basle

Cindy Sherman

*1954, lives and works in New York

Cindy Sherman is one of the most significant artists on the contemporary art scene. We recognize in her work the all-encompassing influence of the media world, the full impact of which was first experienced by the generation that grew up during the fifties. All of her photographic works reflect the pervasive presence of images, role models and stereotypes that bear the unmistakable imprint of movies, television, advertising and fashion. Since the late seventies, she has created a number of works in which she not only plays the leading role but also performs as director and photographer. Although she makes photos of herself, they are not self-portraits; indeed, they demonstrate that, in the postmodern world, the authentic self is a fictional construction. Cindy Sherman appears in a variety of very different scenes that encapsule entire film plots in single photographic stills, exploiting the possibilities of multiple, fictitious self-constructions, especially of women. In the field of tension between activity and passivity, between "making" and "being" an image, she uses her own body as an image-bearing medium of cultural stereotypes, staging her subjects as projection screens for unpredictable wish-images, nightmares, desires and hidden anxieties. She began work in 1977 on her "Untitled Film Stills," a large group of black-and-white photographs in which she re-enacts scenes from films made during the forties, fifties and sixties.[1] She first introduced color to her photos near the end of the eighties. Sherman has expanded her investigations of film stills in a number of series since 1983. The point of departure for her first color series was the Hollywood image of women. The series features women's portraits that deal with the public image of femininity and evoke countless personal tragedies. Other series are dedicated to role models influenced by fashion and advertising clichés or to fairy-tale worlds in which the artist conjures up images of the dark side of the realm of archetypes. In her disaster photos, she stages traumatic landscapes of decline and decay in which horrific images of the cruelty and deterioration of the world emerge from colorful, microscopically illuminated scenes. In the "History Portraits," which call to mind the paintings of the old masters, she poses as a painter's model, transforming the insignia of dominion and beauty into grotesque symbols. In her last series of "sex photos," to which "Untitled #250" and "Untitled #255" belong, Cindy Sherman makes increasingly frequent use of medical prosthetic devices and plastic anatomic surrogates of the kind used both on film sets and in medical instruction as substitutes for her own body. We are confronted with the terrifying susceptibility of the body to manipulation and with the horrors of bodies totally transformed into objects. In emphasizing the artificiality or absence of the body, these photos articulate the themes of brutality and pornography in a particularly striking and frightening manner. Drawing from the resources of second-rate horror films, Sherman heightens the sense, already present in nearly all of her photographs, of violence, of the unknown, of death and the threat they pose to humanity.

BEATRIX RUF
(cited and translated from Beatrix Ruf, *Kunst bei Ringier 1995–1998*, Zurich, 1999).

[1] See in this context the article on Cindy Sherman by Anna Helwing in this catalogue, p. 186.

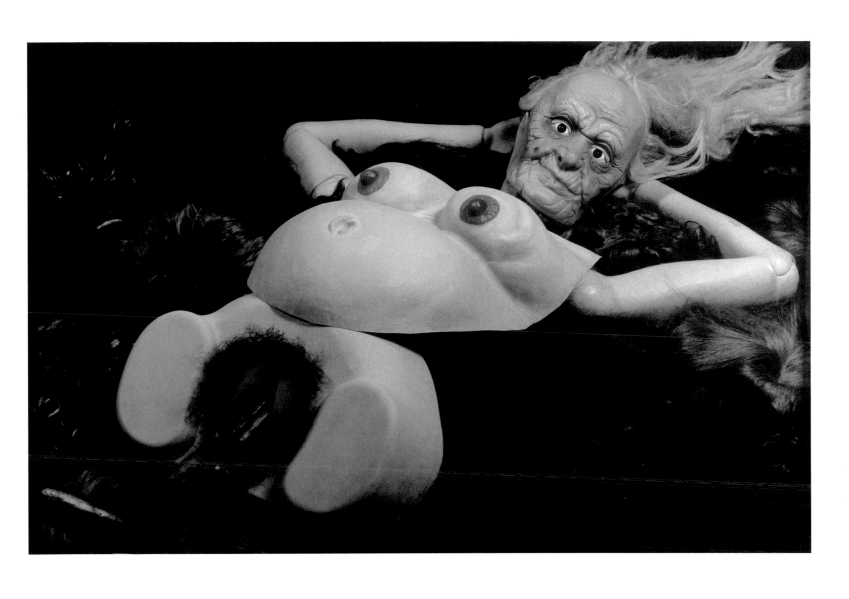

CINDY SHERMAN
UNTITLED #250 1992
Color photograph, 127 x 190.5 cm
Collection of Thomas Koerfer, Zurich

following page:

CINDY SHERMAN
UNTITLED #255 1992
Color photograph, 127 x 190.5 cm
Collection of Thomas Koerfer, Zurich

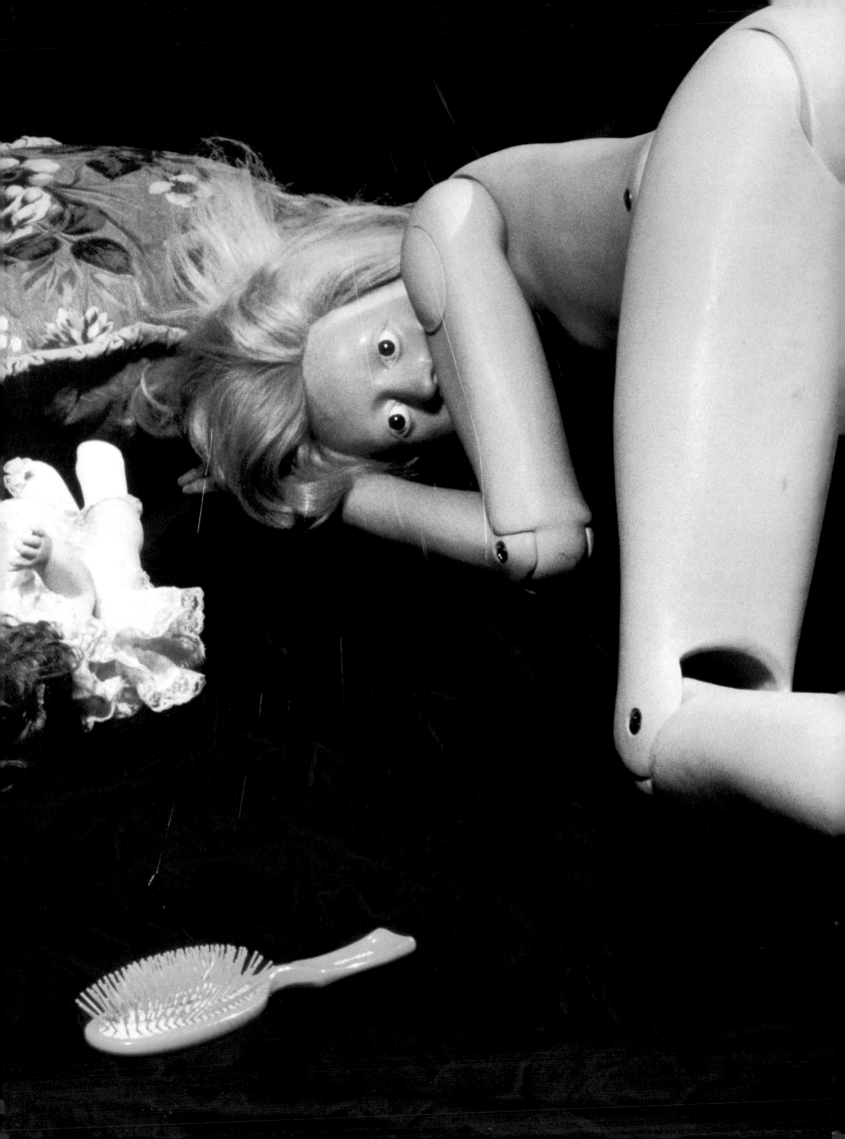

Jeff Wall

*1946, lives and works in Vancouver

Jeff Wall has often been compared with Edouard Manet, probably the most influential French painter of the 19th century, an artist who combined classical pictorial traditions with avant-garde currents in a painting style that exemplified Baudelaire's programmatic concept of *peinture de la vie moderne*. Although Wall makes consistent use of contemporary technologies, this "photographer of modern life" also draws from the historical traditions of painting, adapting traditional iconography and principles of composition as they relate to the distribution of space and light, for example. The Canadian artist first gained attention in the late seventies with large-scale slides of everyday scenes, landscapes, portraits and interiors which, presented in light boxes, often called to mind movie screens. Many of his pictures trace their origins to situations the artist experienced himself, scenes he then re-enacted as staged fragments of reality. Yet Wall makes no claim to a mimetic depiction of reality of the kind required in photojournalism. Instead, he constructs, within the context of Conceptual Art, a polymorphous, multivocal and multivalent photographic image intended as a cinematographic representation of inner, unconscious and ultimately universal truths.

Wall pursued his interest in allegory a step further in his photograph "The Giant." It was here that he first used the type of special effects we now encounter routinely in film productions to develop what he refers to as "a kind of philosophical comedy."[1] The naked old woman projected with the aid of computer technology onto the stairs of a university library appears gigantic in relation to her surroundings—a monumental physical presence. While Wall employs a motif from traditional nude painting in this work, he resists academic conformity, for his concern is neither a painstaking study of the human body nor a representation of ideal beauty or male erotic fantasies. Instead, we may view the image of woman at an advanced age in a setting representing cumulative knowledge as a symbol of mature wisdom, of learning per se. For as Wall himself says, "We learn; we never stop learning, and thus learning is a sign of imperfection and limitation but also an image of hope."[2]

ANNA HELWING

1 Kerry Brougher (ed.), *Jeff Wall*, The Museum of Contemporary Art, Los Angeles (Zurich / Berlin / New York: Scalo, 1997), p. 34.

2 Ibid.

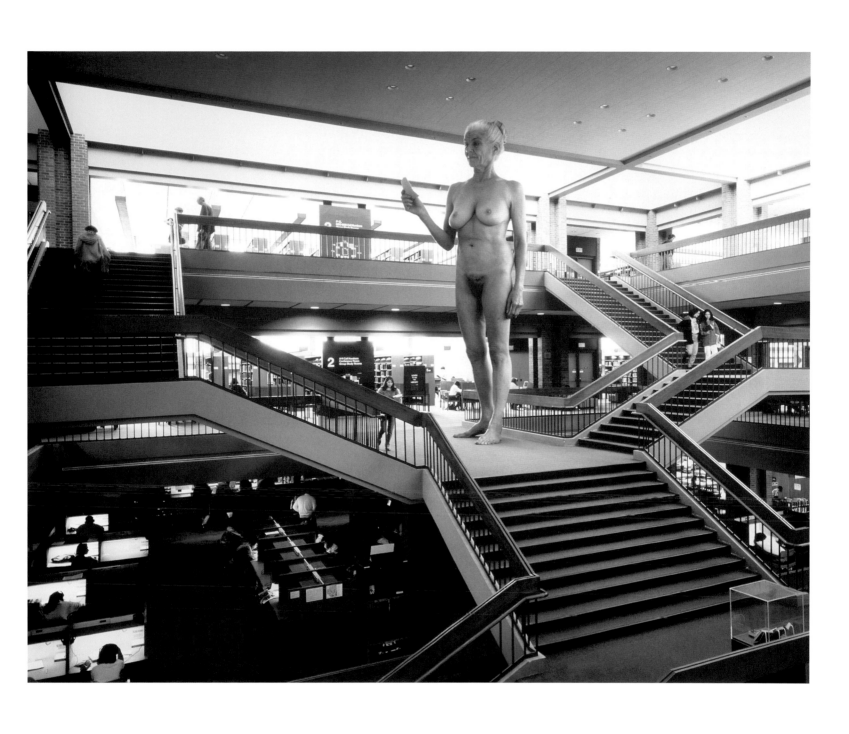

JEFF WALL
THE GIANT 1992
Large-format slide in light box, 39 x 48 cm
Collection of Zellweger-Luwa AG, Uster

Yinka Shonibare

*1962, lives and works in London

More recently, Yinka Shonibare's focus has increasingly turned towards issues of class, aristocracy and artifice in British culture. These concerns seem to extend some of the extensive debates in the 1980s around what it means to be British. However, Shonibare's investigation is not focused on the practice of an identitarian model of citizenship, but rather on the more intricate understanding of the historical place of minority discourse in what is known today as Cool Britannia. Shonibare's Britannia exists in the way that the feudal concept of aristocracy tends to create a distinction between citizens in a modern, global democracy. But it isn't with aristocracy as an anachronism that his work is concerned, but rather its very construction. Today the aristocracy has certainly been revealed as part of popular kitsch.

Interrogating this history, Shonibare's recent installation, "Mr and Mrs Andrews Without Their Heads," 1998, is based on the famous Gainsborough painting that was part of a popular genre in the 18th century known as the "conversation piece" in which a figure or a group is represented in a setting of nature. It has been suggested that this painting exemplifies not so much a portrait of the couple as a portrait of the land. Indeed this is not just a picture of landscape, but of one which also produces wealth. The land then represents the very source of the British aristocracy, in which concepts of ownership also define stature in the affairs between men, between those who work the land and those who own them. So in a way, the portrait is not simply a demonstration of ownership of the land, but of ownership of everything in it including those who work on it, but are not represented in the picture. Remarkably, Shonibare has taken this image of an idyll linked to a brutal, discriminatory class system and reproduced it exactly in bronze and fibreglass. The only difference is that he has refitted the couple in a patchwork of "African" fabric.

Thus the work alludes to the British class system's social and cultural relationship to the people of its minority cultures, such as Asians, Arabs, Africans, many of whom emigrated to England shortly after the World War II. But it is also a commentary on the history of slavery in England and colonialism, and the place of the African subject in this gentle but perverse ideology of class.

This questioning of the ideology of class is also present in "Victorian Philanthropist's Parlour," 1996, a meticulous mise en scène that comments on Victorian morality and patronage through the recreation of a parlour in reduced scale. Every element is reproduced to Shonibare's design, printed in silkscreen. "Victorian Philanthropist's Parlour" takes on the British obsession with recreating period rooms and wax museums as dioramas of tourist kitsch. Rather than representing history, these recreations instead serve as fantasy spaces, exploiting the fascination for period taste to critically engage the question of colonial relationship and imperial trophy.

A more recent project, "Diary of a Victorian Dandy," 1998, may mark the culmination of all the elements of Shonibare's investigation so far on issues of class, fantasy, masking, etc. For "Diary of a Victorian Dandy," he staged a performance with real actors and himself, going through a series of routines associated with the dandy as a classic lounger, pretender, and anxiety-ridden figure,

YINKA SHONIBARE
DIARY OF A VICTORIAN DANDY: 14.00 HOURS 1998
Color photograph, 183 x 228.6 cm
Courtesy of the artist and Stephen Friedman Gallery, London
Commissioned by InIVA

looking for acceptance in a world of the aristocracy from which he is permanently exiled. These photographic tableaux have all the qualities, charm, and artifice of Merchant / Ivory film stills. As images for mass consumption, they also play off the theatre of the fashion industry in their endless recycling of styles, image, fantasy, and artifice. While there is an essential fiction and sense of parody about these photographs, they also have a melancholic air about them. Despite their hints of high jinks and histrionics, these are not simply images of joy, buffoonery and desire. Their drama is melancholic almost in a vaudevillian sense both chic and camp. No one captures the ironies of what the dandy may mean in today's techno-culture than that bard of decrepitude, Charles Baudelaire, when he writes that "Dandyism is a setting sun; like the star in its decline, it is superb, without heat and full of melancholy." If only dear Oscar Wilde had paid heed to this superb observation. Indeed, it takes an artist like Shonibare to invest today's questioning of identity with the pathos of its inherent constructedness, along with his continuing investigations of the meaning of modern culture, in a world powerfully radicalised by what Arjun Appadurai calls the globalisation of mass commodification and mass mediation.

OKWUI ENWEZOR
(excerpt from: Okwui Enwezor, "Tricking the Mind: The Work of Yinka Shonibare," in: *Yinka Shonibare—Dressing Down*, Birmingham: Ikon Gallery, 1999).

YINKA SHONIBARE
DIARY OF A VICTORIAN DANDY: 19.00 HOURS 1998
Color photograph, 183 x 228.6 cm
Courtesy of Stephen Friedman Gallery, London

Sarah Jones

*1959, lives and works in London

Nothing and no-one in Sarah Jones' photographs is innocent, but what they might be guilty of is never stated. Silent girls inhabit silent rooms, their faces and bodies frozen into enigmatic gestures and inscrutable expressions. Traditional hierarchies of value are blurred—objects are as significant as people, while people are as inscrutable as objects. In Jones' world everything is a possible conduit for feeling, but it's a feeling which is constantly deflected or internalised. Her photographs explore similar gestures, facial expressions and locations again and again, but it's a repetition predicated on the fact that nothing can ever be literally repeated. She reiterates photography's role as a kind of obituary—that when it captures a moment, it also, in a sense, registers its death: that what and who the photograph reveals no longer exist in the same way. As a result—and despite their crisp physicality and often cool minimalism—her photographs reference the past as much as they describe a strange allegorical present. Complex histories and feelings are expressed in the most oblique of languages: in the awkward hovering of two feet above a bedroom floor, in the intense blue of a wall, the unfocused gaze of a child or the relationship between a hand and a mouth.

An elegant young girl in a privileged home hides beneath a table with the stealth of a trapped animal caught in a surreal, interior cross breeze, while another girl, her face hidden behind her hair, sits behind her on the stairs with her arms crossed. Although almost uniformly middle-class, Jones reveals the order that upholds these environments to be as innately unstable or elusive as the ordering of adolescent confusion. Which is not to say that she represents ordered environments as necessarily negative ones—the homes that provide the settings for the girls, although possibly repressive are also protective of their inhabitants. Many of the environments in Jones' photographs look artificial or staged, as if everything natural has been replaced by their approximation. Apart from lighting and choreography, however, she rarely interferes with the rooms that interest her. As a result, what constitutes reality becomes increasingly unclear. These photographs are not portraits—Jones makes pictures that resist any attempt at naturalism, using her camera not to reveal any particular truth, but to mine possible physical manifestations of certain states of mind. The girls, despite their individuality, come to represent all girls tangled in the awkward transition between childhood and adulthood. The rooms we live in are integral to the shaping of our experience in the world. Over time, they can become littered with psychic debris, stained with the invisible impressions of anonymous lives. This was something the best Dutch and Flemish painters of the 16th and 17th centuries understood—how the silent relationship between places, objects and the people who used them or moved through them could be as expressive as any Greek drama. Jones' photographs often reveal a similar type of gravitas: a sense of waiting and anticipation, expressed in a language where the smallest shifts in body language reflect major shifts in mood.

JENNIFER HIGGIE

SARAH JONES
THE DINING ROOM (MULBERRY LODGE) I 1997
Color photograph on aluminum, 150 x 150 cm
Courtesy of Maureen Paley Interim Art

SARAH JONES

THE DINING ROOM TABLE II 1998

Color photograph on aluminum, 150 x 150 cm

Courtesy of Maureen Paley Interim Art

SARAH JONES
THE DINING ROOM TABLE (MULBERRY LODGE) I 1998
Color photograph on aluminum, 150 x 150 cm
Courtesy of Maureen Paley Interim Art

Philip-Lorca diCorcia

*1953, lives and works in New York

The American artist Philip-Lorca diCorcia is one of several photographers from Boston—a group that includes Jack Pierson and Nan Goldin—who documented their own private lives in often extremely intimate photos in the late seventies. It was not until many years later that diCorcia achieved his own breakthrough with his series of "Portraits of America." In this work he explored the dark side of the United States and its "brutal clear conscience,"[1] presenting compelling, melancholy color tableaux of staged scenes with male prostitutes in back streets, outside cheap hotels or in parks. The titles inform us only of the name, age, location and model fee paid to each young man: "Ralph Smith, 21 years old; Ft. Lauderdale, FL; $25."

In 1993 diCorcia began to work on a series of photographed street scenes in various large cities. The moods of light in these scenes are characterized by a dramatic *chiaroscuro* and often lean toward the apocalyptic. Darkness and cold flash reflections stand in stark contrast to one another, an effect similar to the gradual onset of darkness preceding an eclipse of the sun. Heavy shadows cling to the figures. Bright light entering from one side highlights wrinkles and folds in faces and clothing, giving them a ghostly cast.

The settings for diCorcia's scenes are urban—historical facades, signs, billboards or the physical features of his protagonists identify the locations noted in the work titles. New York, Tokyo, London, Naples and Paris are places already familiar to many. Other identifying characteristics include faces photographed from a frontal perspective. Their concentrated gazes ordinarily focused on some distant point, their facial expressions are frozen into stereotyped masks. In their programmatic estrangement from reality, diCorcia's subjects call to mind figures in Madame Tussaud's Wax Museum. "In the dramatized artificiality of his photographic images, reality is fictional and fiction is real."[2]

DiCorcia's street photos range from snapshots to meticulously staged studio exposures. The subtle manipulation of light offers a subjective view of the condition of urban communities on the threshold of the third millennium. For a fragment of a second, the point of intersection between the public and the private, between society and the individual, is brightly and harshly illuminated.

GIANNI JETZER

1 Translated from Jean Baudrillard, *Amerika* (Munich: Matthes & Seitz, 1995), p. 17.

2 Beatrix Ruf, "Philip-Lorca diCorcia," in: *Kunst bei Ringier 1995–1998* (Zurich: Ringier, 1999), p. 44.

PHILIP-LORCA DICORCIA
TOKYO 1994
Color photograph, 65 x 97 cm
Ringier Collection, Zurich

following page:

PHILIP-LORCA DICORCIA
PARIS 1996
Color photograph, 65 x 97 cm
Ringier Collection, Zurich

Teresa Hubbard and Alexander Birchler

*1965/1962, live and work in Basel and Berlin

The figures in the photographs of Teresa Hubbard and Alexander Birchler are storyless, as they exist in a mode of contingency. What at first seems so strikingly certain and firmly established in them turns out to be mere possibility. All of the relationships and small details which strive to merge into a visual statement in the photographic image simply dissolve away around these figures. The spaces in which they seem to await a change which the frozen arrangements do not even suggest is possible, are deceptively realistic studio sets. The folds in the curtains, the presumed age of a door, the outside nighttime light and the abandoned house in barren terrain are illusory background elements and constructed sleight-of-hand of the kind we expect from film stories. Yet these photographs are not stills from such stories but rather tableaux composed of elements that seem intent upon breaking away from one another. A black line appears as a gap between them. The figures lean against this boundary, a section of wall that separates the two pictorial spaces like a sharp ridgeline which only the camera can cross. The camera perspective is reminiscent of Hollywood-style studio cinematography. It shows the spaces on this side and the other simultaneously, along with the space open to the front along which the movie camera glides as if it could pass through walls. Hitchcock's technique of stretching the movie scene in time and delaying the next cut[1] finds its parallel here in an extension, an overextended documentation of two competing perspectives.

1 In *Rope*, for example. Transatlantic Pictures, USA, 1948.

Thus the photographic eye transcends the perspectives of its protagonists. It affirms the very same omnipotence that is the point of departure for this photo series. Teresa Hubbard and Alexander Birchler interpret Gustave Flaubert's *Madame Bovary* in terms of the psychological realism of its reprimand of the figure, as a case study in photographic depiction. "Stripping" refers in this case not only to the removal and elimination of protective walls, to a virtual penetration, but also to the revealing intervention of photographic logic, according to which all of the qualities of surrounding space are attributed to the figures within it as character evidence. The black dividing line has three functions. It exposes the pictorial space itself as staged illusion. It also calls to mind the unexposed interval between two images on a roll of film. Ultimately, however, it bears witness to the illusory nature of the deconstruction itself. Although part of a set is incorporated into the image, the objection to uncritical acceptance of ostensible photographic authenticity is itself expressed through the techniques of photographic documentation. Finely-tuned coloration reveals the dividing wall as a visible space susceptible to illumination rather than a digital splice joining two halves of an image. The unifying forces of the technically reproduced image are dissipated by the image's own precise and unimpeachable representation of the illusion: a paradox that renders all value judgments, attitudes and views provisional in the picture. "Stripping" does not deal with stories but instead illustrates the inertia of images. The gloss of the factual, as Hubbard and Birchler say, is a transfiguration.

GERRIT GOHLKE

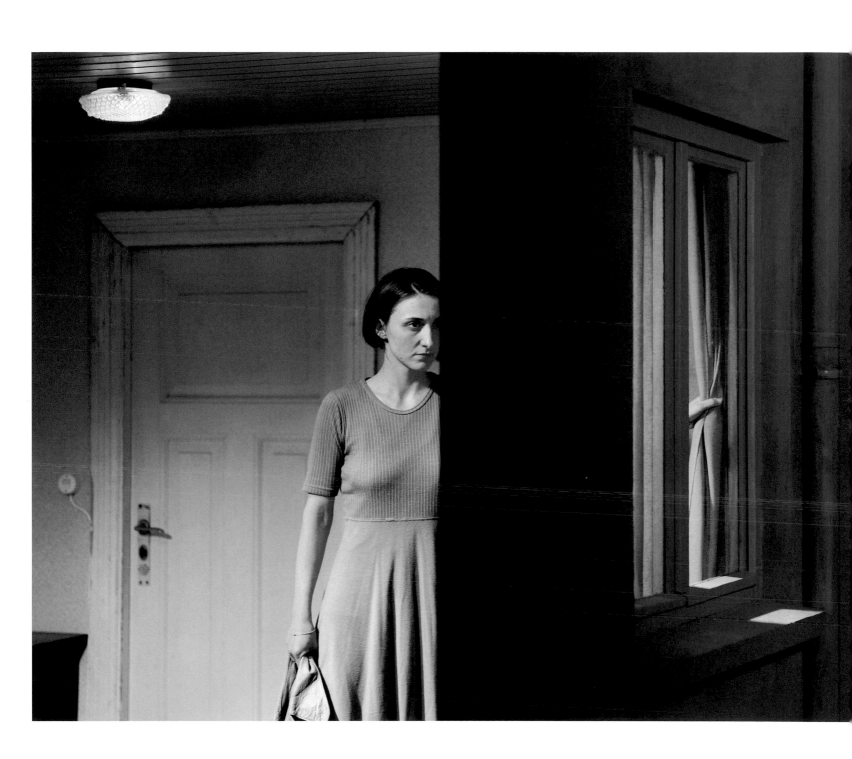

TERESA HUBBARD AND ALEXANDER BIRCHLER
STRIPPING 1998
Color photograph, from a 5-part series, 145 x 180 cm
Courtesy of Galerie Bob van Orsouw, Zurich

TERESA HUBBARD AND ALEXANDER BIRCHLER
STRIPPING 1998
Color photograph, from a 5-part series, 145 x 180 cm
Courtesy of Galerie Bob van Orsouw, Zurich

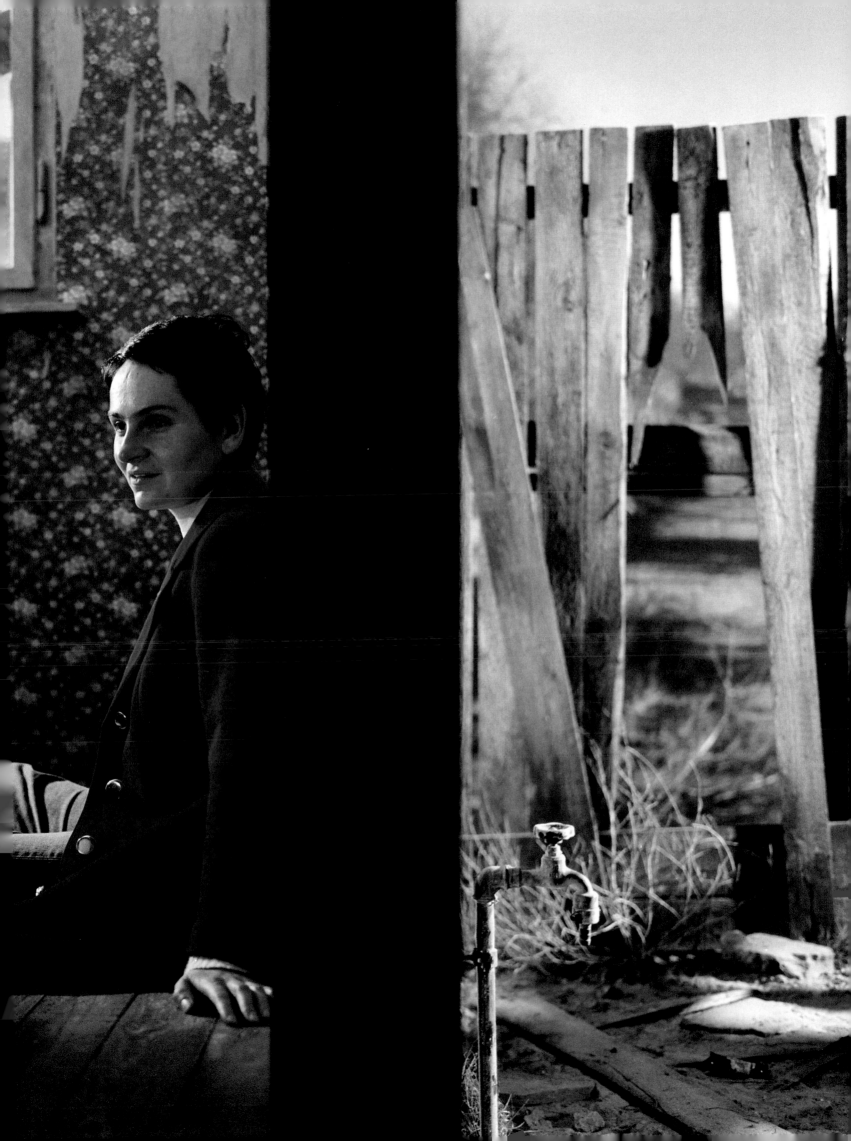

Pierre et Gilles

live and work in Paris

Surrounded by guilt rococo decor, a nude young man contemplates himself lasciviously in a mirror, presenting an appealing rear view. A curtain pulled away to one side makes way for the appearance of the face, which is visible only in the mirror. The viewer's gaze is halted once again at the outermost pictorial level, where a black oval frames the intimate scene of narcissistic self-contemplation and forcing the viewer to assume the role of a voyeur. Enzo, a model presumably familiar only to visitors of certain gay clubs in Paris, plays Casanova, the legendary eighteenth-century erotomaniac, in a rather unusual situation: not locked in embrace with a woman but somewhere between fairy-tale self-inquiry ("Mirror, mirror on the wall …") and the autoerotic pool of Narcissus.

The Parisian artists Pierre et Gilles have lived and worked together since 1976. Pierre photographs, Gilles retouches with brushes and acrylic paint. Their art is deliberately positioned in the gray area between art and commerce. They do advertising work, video clips, CD covers and magazine pieces as well as works for galleries and museums. Their pictures, often condemned as "kitsch," mark the dividing line between high and mass culture. In most cases, their models are cast in mythological, religious or popular cultural roles: the figures of the sailor, the torero, the cowboy, the saint and even Casanova are heavily charged with symbolic meaning—and not only in middle-class heterosexual culture. Since as early as the 19th century, they have often been appropriated and reinterpreted as women-free preserves of male fantasy by the gay subculture as well. The iconic portraits of Pierre et Gilles celebrate the gaze of desire focused upon men.

Their inimitable style is evident only from the gay perspective. The sugar-sweet, artificial, theatrical, transvestite—in short, the false-bottomed, self-centered—game of role playing reflects the spirit of "camp," an aesthetic current described by Susan Sontag in 1964 and hailed even in Oscar Wilde's culture of dandyism. Pierre et Gilles do not attempt to rehabilitate their trivial subjects through sophisticated philosophical reflections. They reject the intellectualization of art. They are visual seducers who offer their audience a lusty, voyeur's view of the objects of their desire. Far removed from the reality of our time, they present eternally youthful, idealized figures of the kind that has long since disappeared from art but is still an awesome presence in the world of fashion and advertising. They celebrate the beautiful illusion, the masquerade, the staging of oneself as image. They use masks to transfigure—yet in a different way than, for instance, Cindy Sherman. One must read their pictures at a second level, in quotation marks, so to speak, in order to find their underlying message. Pierre et Gilles define identity solely as a choice of masquerades.

SILKE BENDER

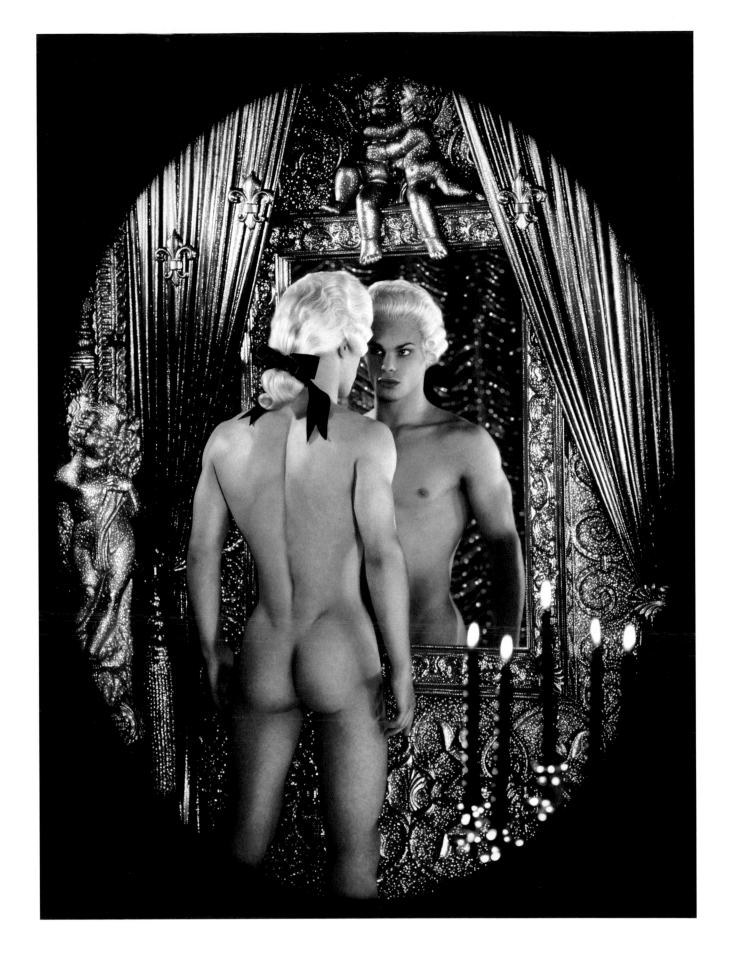

PIERRE ET GILLES
CASANOVA—ENZO 1995
Color photograph, retouched with acrylic paint, 100 x 80 cm
Christoph Schweinfurth, Zurich
(Courtesy of Galerie Jérôme de Noirment, Paris)

Jan Saudek

*1935, lives and works in Prague

With very few exceptions, Jan Saudek's introverted world of visual imagery does without outside
space. Completely staged and populated with naked men and women, his interior world answers only
to the need for spicy phantasmagorical scenes. Saudek's creations derive their threatening sexual
overtones entirely from the artist's imagination. The Prague artist, who lived for many years in a
shabby basement room, cut off from the outside world, pursuing the paths of his imagination, devel-
oped a style for which the term "allegorical" provides only a rough description. A decaying cellar
wall with an opening admitting a shaft of pale light served as a projection screen for his erotic
fantasies. Here Saudek found an entire cosmos of sexual symbols incorporating well-tempered images
of tastelessness. According to one critic, Saudek does not always succeed in achieving the balance
between hand-colored kitsch and nostalgic provocation. A custodian writing during the seventies
found his photographs ragged and simply obscene. Harsh colors added by hand, a sultry aura of decay
and his openly pornographic scenes provoked considerable controversy. The frailty of his models is
indeed a central motif, and Saudek did not hesitate to employ even the grossest of symbols. The
drastic quality of his staged scenes reflects both the pleasures and sufferings of its creator.

In the work "The Love" (1991), a man thrusts his hand into a woman's vagina. This picture is an
"encroachment" in the true sense of the word. It is not only repulsive, it also crosses a boundary—
the border between the ambivalence of erotic imagery and the undeniable sexual act. It is no coinci-
dence that the faces of all the actors are concealed in shame. This is the iconographer Saudek's way
of articulating his own thought on his work, as if to say "Look. This is how the human being acts in
his restrictive environment—shamefully in his shamelessness." Does the concealment also relate to
the topos of masking? Who is to decide? Executioners, beaux and people sentenced to death have
often been depicted as masked figures in historical paintings. A different picture, "The Gurl" (1992),
shows a young female dancer, her legs crossed behind her head and her genitals clearly visible
through the open slit in her ruffled, baroque undergarment. The portrait is a preliminary study for
the staged scene "Dame in der Theaterloge" (Lady in a Theater Box, 1994). It is not clear whether
"Gurl" is a misspelling or an invention involving a play on the words "girl" and "curl."

Saudek has repeatedly drawn from the chest of props of a bygone theater world. One critic
has remarked that his photography, particularly in his later work, is decorative, mannered, some-
times contemptuous and inclined to emphasize ugliness. Art scholars disagree in their assessments
of Saudek. Some reject him, while others express admiration. In his own Czech homeland the artist
suffered under the influence of the dull nomenclature of Bohemian socialism and was even prohi-
bited from practicing his profession for some years. Nor has his work been welcomed into the great
art collections in every case. Schooled in painting, Saudek undoubtedly deserves to be regarded as
a talented erotic savage who—the controversy surrounding his work notwithstanding—has created an
"obscene œuvre" of great power and intensity.

KLAUS KLEINSCHMIDT

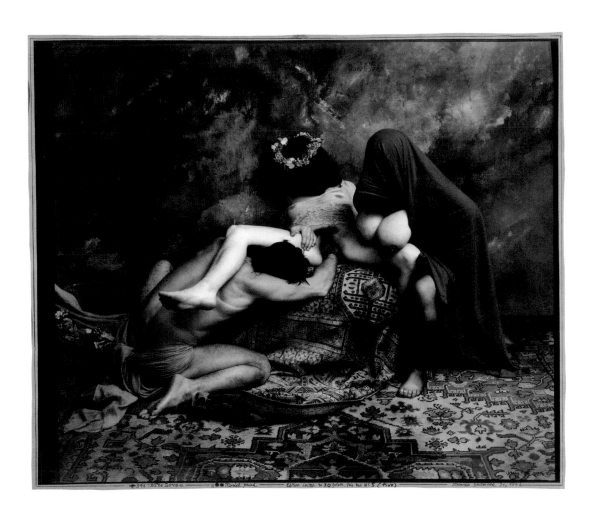

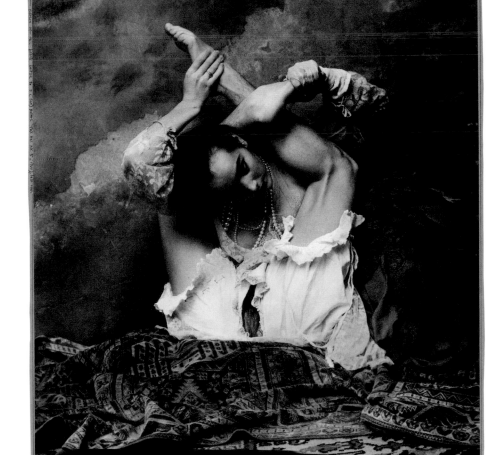

JAN SAUDEK
#394 THE LOVE 1991
Black-and-white photograph, colored, 50 x 60 cm
Collection of Thomas Koerfer, Zurich

JAN SAUDEK
#362 THE GURL 1992
Black-and-white photograph, colored, 60 x 50 cm
Collection of Thomas Koerfer, Zurich

Joël-Peter Witkin

*1939, lives and works in Albuquerque, New Mexico

"Head of a Dead Man:" a board, a shallow bowl placed on the board and a man's head in the bowl. At first glance, this composition appears unusually simple, judged by Joël-Peter Witkin's standards. Witkin often uses severed heads, hands, feet, paws and whole cadavers in his photos. His models include monstrosities of all kinds. He drapes and arranges cripples, misshapen figures, transsexuals and hermaphrodites to form gruesomely beautiful visionary tableaux with multiple narrative planes, referring frequently to works by Arcimboldo, Velazquez, Goya and others. Were its sheer simplicity less cleverly constructed, "Head of a Dead Man" could easily be mistaken for a photo taken for the purposes of forensic medicine or anatomical study. Yet it clearly relates to the traditional iconography of John the Baptist, whose head was presented on a plate.

New Mexico: Joël-Peter Witkin, born in Brooklyn in 1939, the son of a Russian orthodox Jew and his Neapolitan, Catholic wife, has consistently pursued the trail of the religion of his mother and grandmother, with its fixation on visions of holiness. He has lived and worked in New Mexico since the mid-seventies. The border between Mexico and the US is both an iron curtain and a permeable line of demarcation between the Third World and the First. Here we witness the emergence of a baroque Catholicism, modified through the integration of Indian elements, from the underbelly of America. Everything excluded by white, Anglo-Saxon Protestantism is brought to the surface again in Witkin's taboo-bashing imagery.

1990: The irritating, disturbing, ambivalent qualities of his photographs are also products of Witkin's practice of simulating aging processes artificially through manipulations of his negatives or positives and thus visually back-dating his images, making it impossible for viewers to determine their age. A drawing by Witkin entitled "Drawing for 'Head of a Dead Man,'" done in 1991, illustrates the carnival-booth-style construction used to create the illusion of the severed head. The body of a man is concealed beneath a wooden panel. Only his head protrudes above it. The picture bears a religious dedication. Above the head of the equally depicted photographer, the names Arbus—Sander—Weegee—Atget—Daguerre—Negre form a kind of halo. Witkin himself refers to his photography as "sacred work," and regards it as his "way of praying."[1] The first visual experience he consciously remembers came at the age of six. A terrible accident occurred in front of his house as he was on his way to church. "From where I was standing [...] I could see something rolling out of one of the cars that had tipped over. [...] It stopped rolling [...] where I was standing. It was a little girl's head."[2] In retrospect, Witkin speaks of this experience as his "initiation to photography" and the origin of his "interest in violence, pain and death."[3]

AXEL SCHMIDT

1 Joël-Peter Witkin, in: Germano Celant, *Witkin* (Zurich / Berlin / New York: Scalo, 1995), p. 249.

2 Joël-Peter Witkin, "Revolte gegen das Mystische," in: op. cit., p. 49.

3 Ibid.

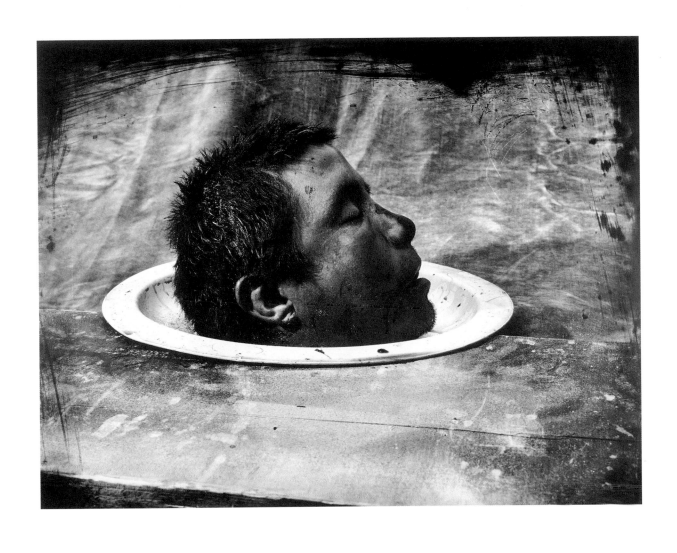

JOËL-PETER WITKIN
HEAD OF A DEAD MAN, MEXICO 1990
Gelatin-silver print, 64 x 83 cm
Collection of Thomas Koerfer, Zurich

Balthasar Burkhard

John Coplans

Sinje Dillenkofer

Noritoshi Hirakawa

FRAGMENTATION

Robert Mapplethorpe

Magnus von Plessen

Anatolij Shuravlev

Hannah Villiger

Andy Warhol

John Coplans

* 1920, lives and works in New York

A nude male body, somewhat stocky and shapeless, with strong, heavy limbs, leathery, wrinkled skin, spotted in places with calluses and dry patches, and thick, unruly body hair. There is no face that might suggest the subject's identity. The body parts are anonymous. Are we sure it is a person and not an elephant or a hippopotamus?

No, the man in the photo is John Coplans. The large-scale diptych, each section divided into three parts, shows him as he actually looks at the age of 79. Nothing distracts our gaze from the unembellished body—no eye-catching background, no coloration, no clothing or jewelry. The fragmented torso is the central focus. Our attention is directed toward the human body as an abstract form.

John Coplans first began working with the camera in the late seventies. Having abandoned abstract painting in the sixties and devoted himself initially to art criticism (Coplans was a cofounder of *Artforum*, an art journal that continues to enjoy tremendous success today), he turned to photography, a medium that permitted him a more impersonal, less expressionistic and at the same time more rational, systematic approach to his interests. The American based artist began exposing himself to the camera at the age of fifty-nine, photographing his body piece by piece, from head to toe. "What interests me about this is the contrast between the nude drawing and total photographic exposure, exhibition of the naked body,"[1] Coplans explains. Although these images of the body reduced to its pure physical nature are reminiscent of Donald Judd's concept of minimal forms, they also remind us of the mass-reproduced images of Pop Art. Coplans is not interested in social criticism, however. His formalism is focused instead on the experience of abstractive perception. The photographic documentation of his own body, in various different poses and positions, as fragment or as montage, is ultimately a process of self-exploration, a means of investigating manifestation of human life which may sometimes resemble animal forms.

ANNA HELWING

[1] John Coplans, "My Chronology," in: *A Self-Portrait*, New York, P.S.1 Contemporary Art Center, 1997, p. 137.

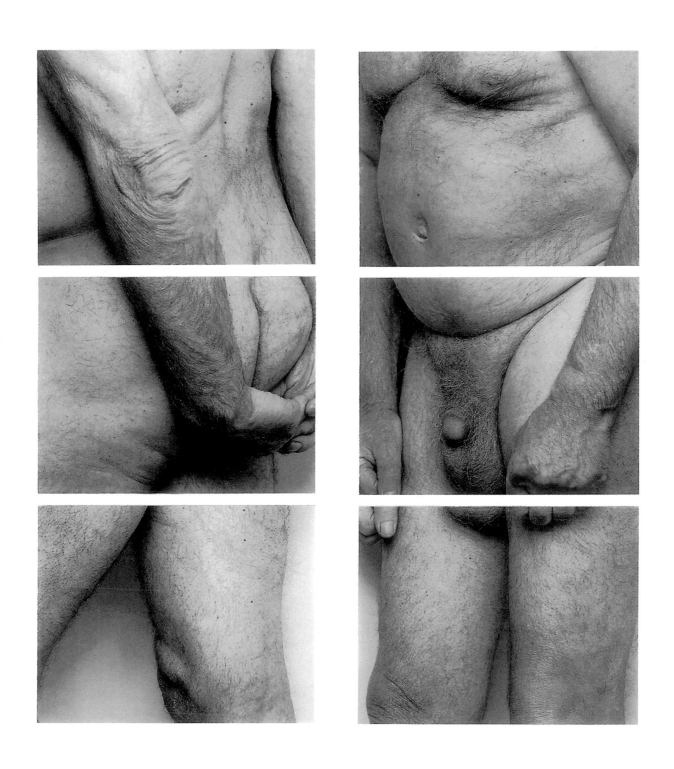

JOHN COPLANS
FRIEZE NO.1 1994
Polaroid positive / negative, diptych, 198 x 86 cm each
Courtesy of Galerie Peter Kilchmann, Zurich

225

Hannah Villiger

1951–1997

Five fingers extend like five antennae from the metacarpal fan, rising up against gravity. It is possible to describe a hand but hardly to understand it. Controlled by the brain, functioning with utmost rationality yet subject to reflexes, it mediates as instrument and object between tenderness and aggression, between motility and construction. Undeniably a three-dimensional phenomenon. Is it perhaps also a symbol for primal sculpture?

Hannah Villiger always regarded herself as a sculptress, although she never exhibited the least interest in hewing, welding or casting. Arte Povera was the model for her fantasy. At age twenty-five, she began her search for a sensual expression of non-materiality, turning to photography before the medium became fashionable. She photographed strange everyday sensations: boccia balls landing in a bed of sand, a burning palm frond tossed into the air, a water-canon in action. She remained the fixed point. Unmoving, she sought to capture quickly passing situations as topographic states. After 1980, she refocused her gaze, concentrating on her own body, the closest stranger of all. Using herself as a model, she explored a very personal and fragile sculptural territory that vehemently resisted permanent monuments, material hierarchies and materiality. Occasionally, Hannah Villiger tolerated her body, without actually liking it, examining its extremely sensitive yet amazingly durable organic architecture with its responsive covering of skin with the precision of a surgeon. She deliberately excluded the face and rejected all forms of introspective self-contemplation. Naked, stripped of all vanity, the woman looked with open eyes and mind around herself. With minimal equipment, armed only with a Polaroid camera, she saw every fragment as a whole and turned her body into a continent on which she eliminated all conventional aids to orientation. Without top or bottom, weightless, yet with a number of different vanishing points these images glide, speeding as if blindly toward their objective, defying perspective and taking in so much that they make perception uncertain. The body denied itself aesthetic refinement until beauty finally overpowered it: no soma without soul.

Hannah Villiger arranged her systematic, obsessive photographic investigation in precisely composed sculptural "blocks." Within these abstract, monumental, oddly baroque-looking series we find occasional solitary images—a foot, a hand, a bit fresh and almost abandoned, suspended between too little and too much. What are we to do, gain a foothold, extend a hand, get a firm grip or run away? Art is a balancing act. Divided by two, a sum of shortage and surplus is at best an arithmetic equality but still not harmony. Perhaps these self-confident, uncertain extemporaneous images offer little mantras to counter big fears.

LUDMILA VACHTOVA

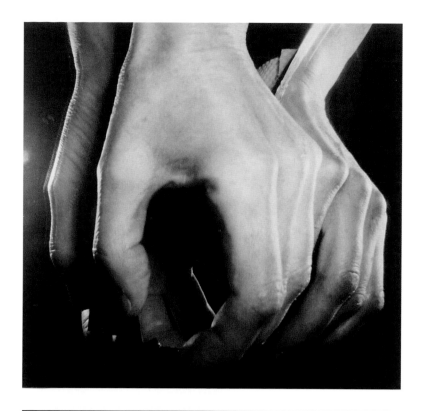

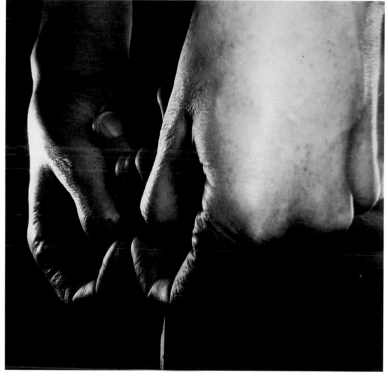

HANNAH VILLIGER
SKULPTURAL 1988/89
(SCULPTURAL)
Color photograph, enlarged from Polaroid, 2 parts, 123 x 125 cm each
Kunstmuseum Bern (Swiss Confederacy)

Balthasar Burkhard

*1944, lives and works in Bern

In his monumental photographs, Balthasar Burkhard investigates the relationship between depicted subject and semantic content. Employing a dual artistic strategy—selecting familiar subjects and altering them by stripping away their context—he makes the viewer an astonished explorer of the ordinary. Soberly, with true-to-life detail and apparently without interpretive intent, he becomes involved with his subjects—a torso, a knee, a navel, a snail, an orchid, a stalk of bamboo, a camel—in order to "portray" them. Yet the result is not a portrait but a picture. Burkhard's photography is not merely what it shows. It points beyond the immediate content of the visible image.

Burkhard's work at the Kunsthalle Bern, where he documented exhibitions organized by Harald Szeemann, sharpened both his sense of detail and his appreciation of artistic visions. During the sixties he made photographs of interiors, working with large formats (unusual at the time) and soft image-bearing material (canvas), thus drawing attention to the tension between material and content.

A group of works completed during the eighties revolved around the subject of the human body. He dissected the body with clinical detachment, excising the parts that interested him with his camera: arms, feet, knees, torsi, heads, ears, navels, testicles, vaginas. He examined each part with his lens, presenting it as if he had used a huge microscope. By eliminating the surroundings, fragmenting the subject and enlarging it many times over, he altered the values of each depicted object. That fact that every point in the photograph has the same depth of field heightens the effect of irritation. Like Gulliver, the viewer wanders amongst the hairs of an exotic *mons venus* and over the swollen veins of an arm.

Burkhard employed similar strategies beginning in the late eighties in a group of works concerned with the elements of nature. In photos of birds' wings, snails, orchids, meadows, rock formations, clouds, snow and finally in oversized animal portraits, he appeared to offer an objective depiction of what he saw—yet by removing his subjects from their surroundings he achieved an alienation effect. "Balthasar Burkhard opts for the distance of the 'New Objectivity,' yet his subjects are more than what they represent."[1]

"Vene I und Vene II" (Vein I and Vein II) are larger-than-life images of forearms with unusually prominent blood vessels. Seen through Burkhard's eyes, the arms become landscapes with meandering streams; they also have the quality of models, like the plant stalks of Karl Blossfeldt, and of sculptures, like Alberto Giacometti's human images. Their lack of attachment or belonging gives them the character of signs. The arm stands for an arm and for itself. Unlike Robert Mapplethorpe, whose photographs of body parts create a sense of distance by virtue of their cool aestheticism, Burkhard sends the viewer on a journey across his anatomical topographic maps.

BRIGITTE ULMER

1 Translated from Harald Szeemann, in: Balthasar Burkhard, *Lob des Schattens* (Baden: Lars Müller, 1997), p. 200.

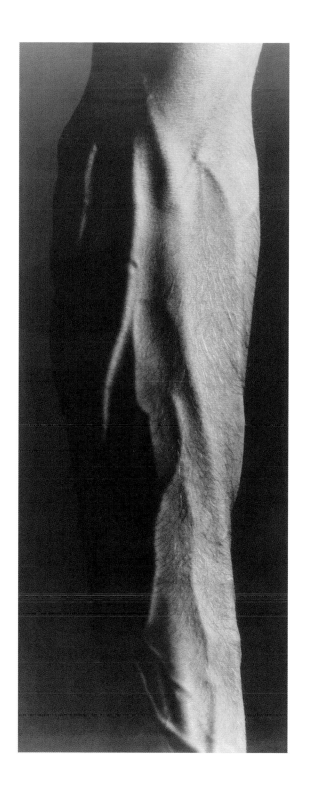
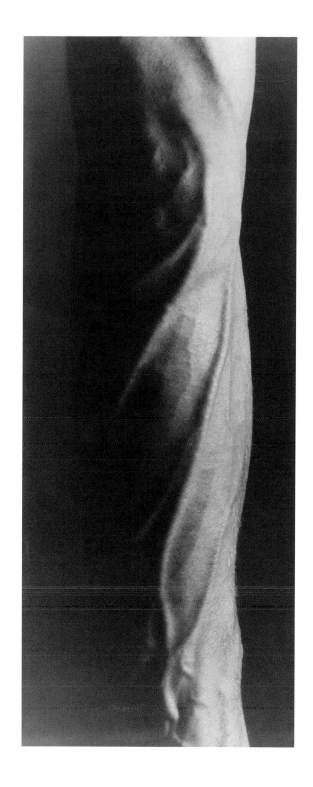

BALTHASAR BURKHARD
VENE I UND VENE II 1988
(VEIN I AND VEIN II)
Black-and-white photograph, 2 parts, 180 x 70 cm each
Kunstmuseum Bern (Swiss Confederacy)

Magnus von Plessen

* 1967, lives and works in Berlin

In his series entitled "S.A.L.I.G.I.A," Magnus von Plessen presents symbolic illustrations of the Seven Deadly Sins. The title of this seven-part work is composed of the first letters of the Latin words *Superbia* (pride), *Avaritia* (avarice), *Luxuria* (lust), *Invidia* (Envy), *Gula* (gluttony), *Ira* (wrath) and *Accidia* (sloth). The artist uses his own naked upper body to illustrate the Seven Deadly Sins. The images of his body are illuminated and modulated in a manner similar to that of Caravaggio, by three separate light sources. The body, always presented as a fragment without a face, is offset against a blue background. A monochrome (black) rectangle covers the lower segment of each photo from left to right. The body is reduced to a torso.

According to traditional Christian thought, the Deadly Sins are transgressions against the Holy Spirit, sins that cannot be forgiven and thus bring about the loss of grace and divine mercy. Pope Gregory I specified the concept of sin with respect to the canon of seven. It was he as well who argued that one sin never appears alone but always in synergy with others. Plessen takes up this synergetic concept of the Deadly Sins as justification for the use of a single body, namely his own, as the sole projection screen. He stylizes the body in keeping with the iconography of representations of the Body of Christ as we have known them in the *Crucifixi dolorosi* since 1300. The torso motif is a primal image of vitality and fullness of life—devoid, of course, of all indications of individuality and randomness. The torso becomes a symbol of anonymity and humility in the human image. The artist presents allegorical images of the Seven Deadly Sins, illustrating each of them with a frozen image of a body movement. The torso is a personification and, as such, an allegory. As a rhetorical device, the allegory is substantially associated with fragmentation, incompleteness and imperfection. In selecting this stylistic form, von Plessen creates an analogy of human weakness out of the formal fragment and imbues the topos with a profoundly human quality that transcends stylization.

WOLF-GÜNTER THIEL

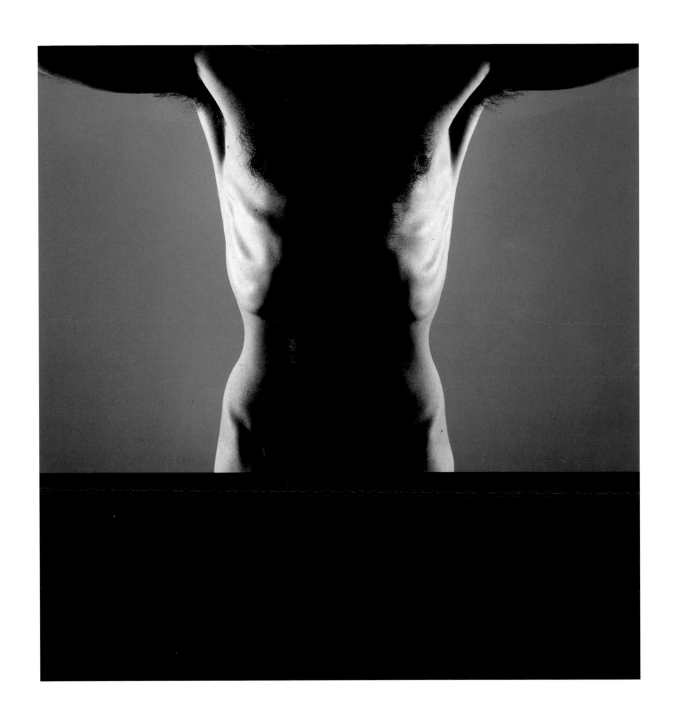

MAGNUS VON PLESSEN
S.A.L.I.G.I.A. 1997
Color photographs, 7 parts, 89 x 65–90 cm each
Kunstmuseum Bern (Courtesy of Galerie Volker Diehl, Berlin)

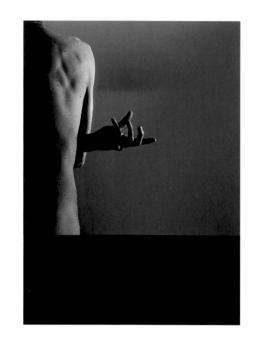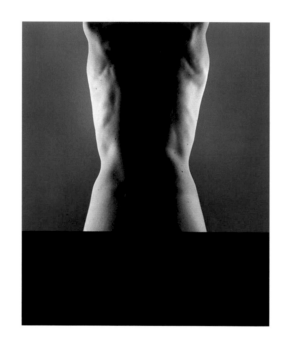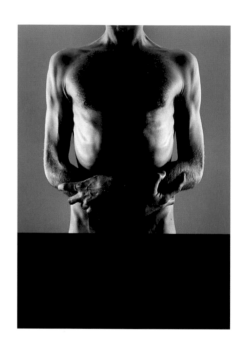

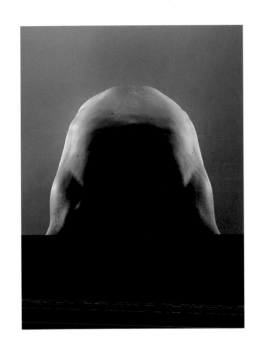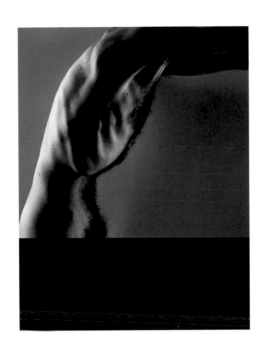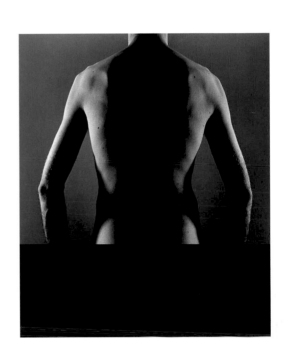

Robert Mapplethorpe

1946–1989

It is ironic that the repertoire of motifs used by Robert Mapplethorpe, the artist most inimical to the guardians of public morality in America during the eighties, comprises the classical, acceptable subjects of art: still-lifes, flowers, portraits and nudes. Inspired by the photographs of classical masters he collected during the early seventies, Mapplethorpe took up photography himself, using a Polaroid at first and eventually moving on to large-format cameras. Beginning in the mid-seventies, most of his photographs featured naked torsi, buttocks and male sexual features. By applying classical principles of art—particularly with respect to composition and the use of light—to sexual themes, he transposed them into the sphere of art. Regardless of whether his motif was a tulip or a penis constricted in typical sado-masochist style, he always approached it with the same vision and the same desire to achieve absolute aesthetic perfection. "My approach in photographing a flower is no different from the one I use when photographing a penis. It is essentially the same thing. What is important is the use of light and the composition."[1]

Mapplethorpe's photographs draw their power primarily from the tension between their aesthetic qualities and their content, which, judged by conventional standards, is repulsive. In his tight-wire act between pornography and art, he blurred the first impression evoked at the level of content by creating classically pure, precisely controlled images that bear no resemblance to the shabby, cheap visual presentations of pornography magazines. Mapplethorpe's œuvre became a manifesto of homosexual aesthetics and a challenge to Puritanical America in the eighties. It stood for a form of sexual liberation that made it possible to address themes that would have been impossible to deal with before: sado-masochistic techniques, oversized penises, anal penetration, etc. Yet the resulting censorship scandal and the debate on pornography in 1989—carried out under the shadow of AIDS—undeniably represented a setback for the gay movement.

The "Z-Portfolio" shows a series of nude, muscular, black men. They face the camera in decorative poses, sitting on pedestals, abstract, as if carved in stone. With these figures, Mapplethorpe created perfectly illuminated images in tight compositions reminiscent of style studies of the kind typically produced in painters' studios of the early 19th century. Oscillating between sexual appropriation and formal objectives, Mapplethorpe triggers an ambivalent response in the viewer, who finds it difficult to choose between voyeurism and sublime contemplation of art. "Man in a Polyester Suit" (1980) is typical in this sense. The man to whom the penis belongs remains a fragment, cut off at the legs and above the chest. Mapplethorpe plays a deceptive game of attraction (through his handling of light and shadow) and irritation (triggered by the flaccid penis that protrudes boldly through the open fly) with the viewer.

BRIGITTE ULMER

1 Mapplethorpe, cited and translated from Arthur C. Danto, in: Mark Holborn / Dimitri Levas (eds.), *Mapplethorpe* (Munich: Schirmer / Mosel, 1992), p. 340.

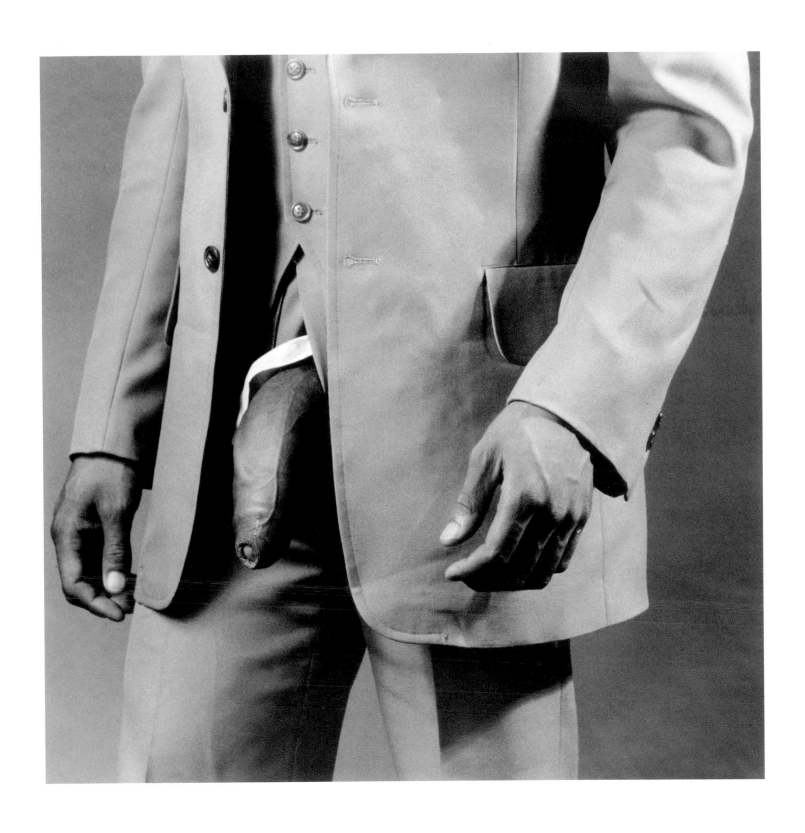

ROBERT MAPPLETHORPE
THE Z-PORTFOLIO 1979–81
Black-and-white photographs, 13 parts, 19 x 19 cm each
Collection of Thomas Koerfer, Zurich

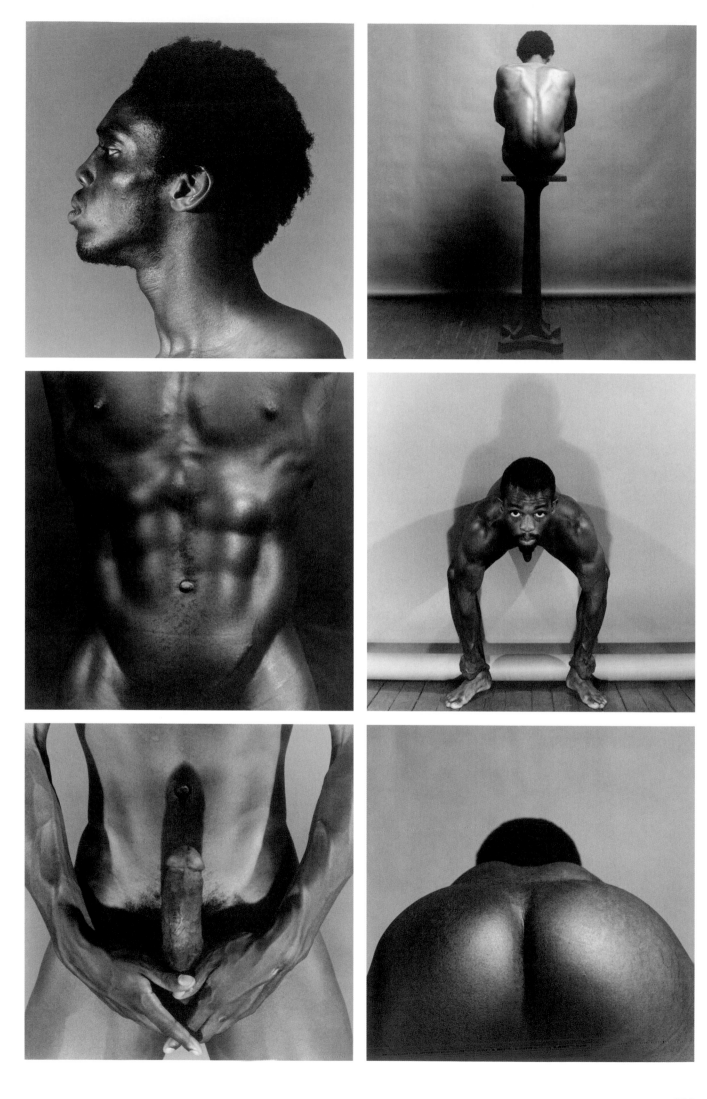

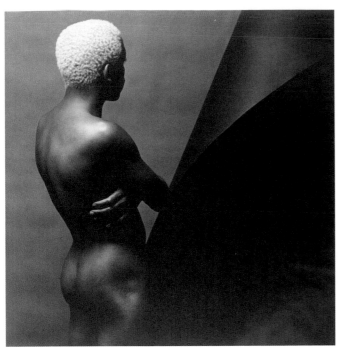

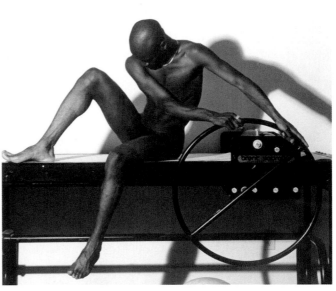

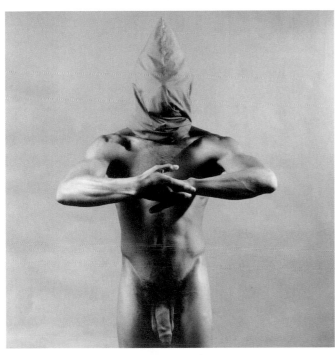

Andy Warhol

1928–1987

Warhol's interest in the male figure dates back to the early fifties, to delicate line drawings done in ink or ball-point pen. He focused primarily on details, sketching rows of eyes in various different shapes, drawing numerous feet, which he often adorned with fruits, and devoting attention to the penis, which he presented in elegant curving lines or as a gift decorated with hearts.[1]

The isolated body part remained one of the artist's favorite motifs. In the late seventies, years that witnessed the rise of a cult of the body in American society, he took photos of hundreds of well-built models recruited by his assistants at the Factory. With his SX-70 Polaroid camera, known as the "Big Shot," he photographed these young men and several women under the bright light of a flash in front of a white wall. In photographs showing Warhol at work, we see him in close proximity to his elevated nude models—separated from them only by the camera, which functions both as an extension of his eye and a protective shield.

Virtually without exception, Warhol's voyeuristic gaze and artistic interest were focused on the section of the body between the waist and the thighs, which he examined from all possible angles. The models are shown bent over, spreading their legs in a sitting position or standing on their heads. In some cases, two men appear in front of the camera together, and Warhol photographed them performing sexual acts, which were not always merely suggested. Whereas most of the penises in his early drawings are flaccid, those in the photos of the seventies are for the most part erect, as signs of unflagging potency.

Although the photos show anonymous, fragmented bodies whose rigid postures often give them the appearance of abstract forms, they capture the individuality of their subjects nonetheless. Avoiding the exchange of glances, Warhol, who was known for his extreme shyness, appears to have sought this individuality in a different, more intimate place. "Andy was fascinated by the naked body. He delighted in the fact that every organ of the body varies in shape, form, and color from one individual to the next. Just as one torso or one face tells a different story from another, so to Andy one penis or one ass told a different story from another."[2]

Warhol used the Polaroids, which his assistant Bob Colacello collected in a box, as models for his silkscreen prints on paper (portfolio "Sex Parties," 1978) and canvas ("Torsos," 1977). As if seeking to negate all relationships to the people he portrayed, Warhol referred to these paintings, done in pale green, gray and purple tones, as "landscapes."[3] Yet his penetrating gaze, which he passes on to viewers of his works, is more indicative of obsession than of purely aesthetic interest.

KARIN SCHICK

1 See *Andy Warhol. Zeichnungen 1942–1987* (Basle: Kunstmuseum, 1998).

2 Ultra Violet, quoted from Victor Bockris, *The Life and Death of Andy Warhol* (New York: Bantam Books, 1989), pp. 306ff.

3 See David Bourdon, *Warhol* (Cologne: DuMont, 1989), p. 364.

ANDY WARHOL
NUDE FEMALE 1977
Polaroid, 10.8 x 8.6 cm
Collection of Thomas Koerfer, Zurich

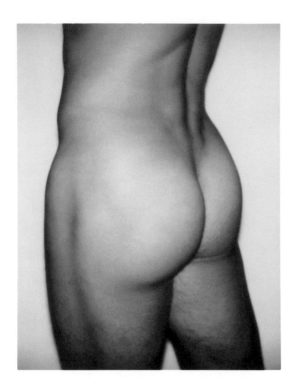
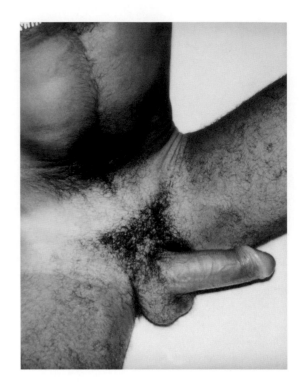
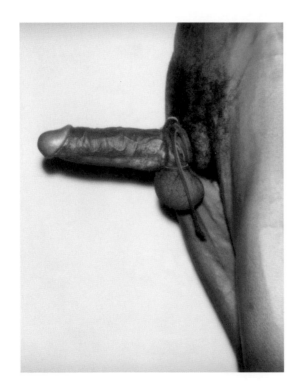
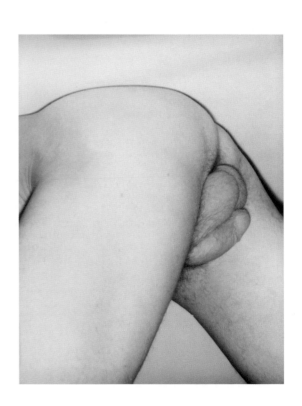

ANDY WARHOL
NUDE MALE 1977
Polaroid, 7 parts, 10.8 x 8.6 cm each
Collection of Thomas Koerfer, Zurich

242

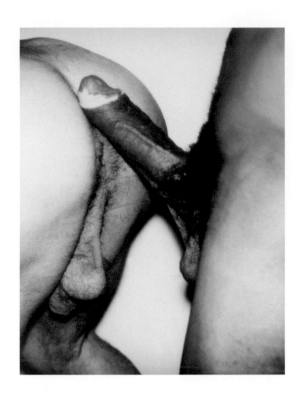

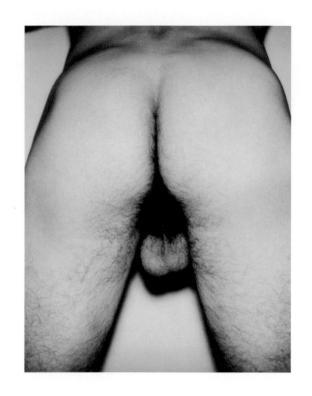

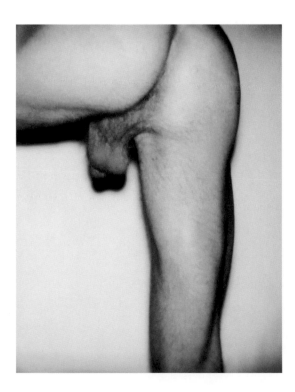

Noritoshi Hirakawa

*1960, lives and works in New York

Noritoshi Hirakawa presented his "Yesterday, Today and Tomorrow" for the first time at an exhibition curated by Jerôme Sans at the Vienna Secession. In his commentary on the work, which was also printed in the catalogue, Hirakawa cites the concept of freedom expressed in the Motto of the Vienna Secession: "For each time its art—for each art its freedom." In this work, a photographic triptych, he also touches upon a central theme of the revolutionary art of turn-of-the-century Vienna—that of sexuality. In his remarks, the artist, whose entire œuvre is concerned with sexual taboos (in his homeland of Japan), speaks of the work as an expression of the tension between personal identity, the institution and the function of art as the product of an inevitable struggle.

In "Yesterday, Today and Tomorrow," Hirakawa stages three scenes set in a place that is paradoxically both utterly private and public at the same time: a public toilet. His dramatization, to use a stage term, unfolds in one of those toilets found frequently in the US in which a wide gap between the floor and the partition (which is set on "stilts") offers a view of the feet of the persons using the toilet inside. Through this opening one may observe the activities of persons within and catch a glimpse of "indecent" sexual acts in progress. Private space becomes public.

Hirakawa presents a vivid dramatization of possible sexual practices, featuring a pair of partners in each photo. The male participant is identified by the cuffs of trousers, the female by shoes. In the first part, the female figure faces the wall, in the second she is turned toward the door, and in the third she performs oral sex (although not in full view) on her partner. The consummation of the action remains a suggestion. The viewer adds the necessary details in his imagination.

Jean-Christophe Ammann notes with respect to Hirakawa's work "Dreams of Tokyo" (1991), on exhibit at the Frankfurter Museum für Moderne Kunst, in which the artist photographed a series of girls in crouching positions without underwear, that the viewer's gaze inevitably wanders back and forth between the genitals, which are subject to strict taboo in Japanese culture, and the face. What is clearly apparent there remains concealed in this work. We may identify Marcel Duchamp's "Etant donnés" (1946–66), in which the role of the voyeur was deliberately planned, as a possible precursor of Hirakawa's piece. But as Ammann quite rightly points out, "As a censor, Noritoshi Hirakawa appears to decensor the aspect of voyeurism as a form of censorship."

PETER WEIERMAIR

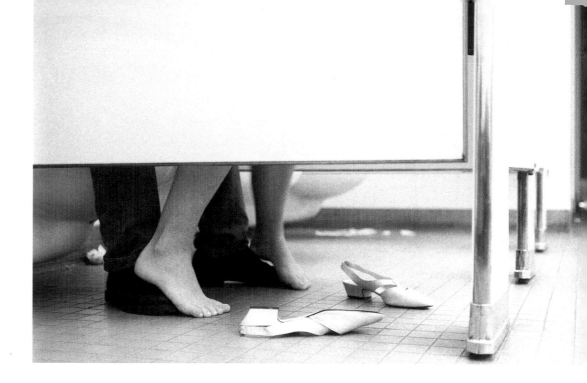

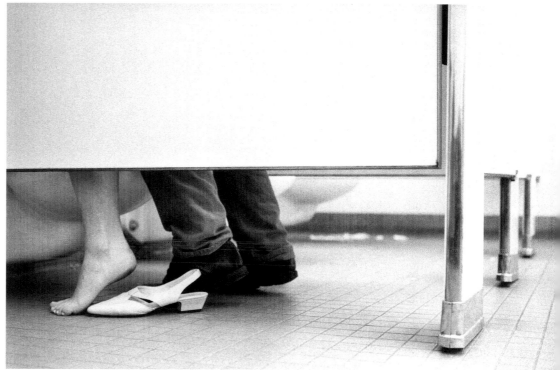

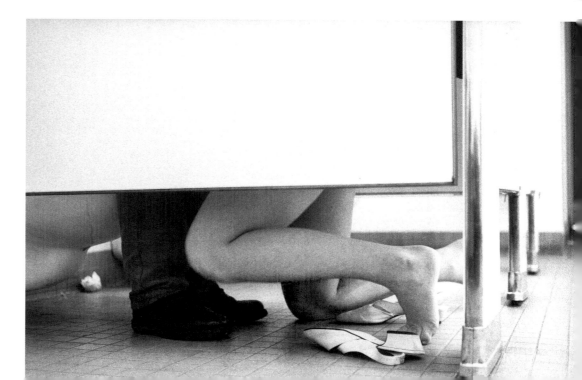

NORITOSHI HIRAKAWA
YESTERDAY, TODAY AND TOMORROW 1993
Black-and-white photographs, 9/10, 3 parts, 40 x 50 cm each
Courtesy of Galerie Mai 36, Zurich

Anatolij Shuravlev

*1963, lives and works in Berlin und Moscow

Anatolij Shuravlev's photo series presents dramatic views of younger and older men that have a decidedly disturbing quality. The portraits derive dynamic power from striking facial expressions and extreme perspectives. The figures' attention appears focused on something outside the frame of the picture, which suggests a certain narrative intent, although the viewer is given no clues whatsoever about what might be taking place there. At the same time, the figures seem lifeless and rigid, indeed frozen, by virtue of the petrified creases in their foreheads and the cold intensity of their gazes.

As the title indicates, the subjects represent the biblical Apostles—people long since dead, in other words. And one is tempted to ask how the artist managed to lure these historical-mythological figures in front of his camera today, at the close of the 20th century. It soon becomes obvious, however, that Shuravlev employed neither contemporary models nor the resources of photographic staging. The physiognomy is much too alien, the gestures much too frozen. The photo series is actually based upon Gothic wooden sculptures from the Church of the Virgin Mary in Krakow, works created by the German sculptor, painter and copper-engraver Veit Stoss between 1477 and 1485. Shuravlev did not photograph them himself in Krakow but instead relied upon illustrations of the sculptures found in art-history books, which he processed using a kind of photographic recycling technique—breathing new life into them, so to speak. The figures in Shuravlev's series take on a new dimension of reality. They develop an authentic presence that is typical of photographic portraits of "living" subjects. They have been "reanimated."

Shuravlev's "Apostles" series presents multiple layers of different forms of visual and textual representation ranging from the textual source in the Bible via the figural representations in Gothic sculptures and their photographic reproductions in art-history books to the photographic portraits of the current series itself. In this sense, the "Apostles" personify Shuravlev's unique artistic approach, which is dedicated to the exploration of issues connected with the "politics of representation."

The various (historical) forms of representation cited by Shuravlev are subject to political determinants and an ideological dimension that permit one to draw conclusions about the intentions of the portraitist (and his client). This political dimension affects the historical process indirectly, shaping ideas about historical events and persons in the absence of a rigorous investigation of historical appearances. Shuravlev is concerned with the contribution made by the work of art to the formation of cultural knowledge, and he applies another layer to the palimpsest of portraits of the Apostles.

KATHRIN BECKER

ANATOLIJ SHURAVLEV

UNTITLED (APOSTLES) 1996

Cibachrome print on aluminum, 4 parts, 120 x 100 cm each

Courtesy of Galerie Urs Meile, Lucerne

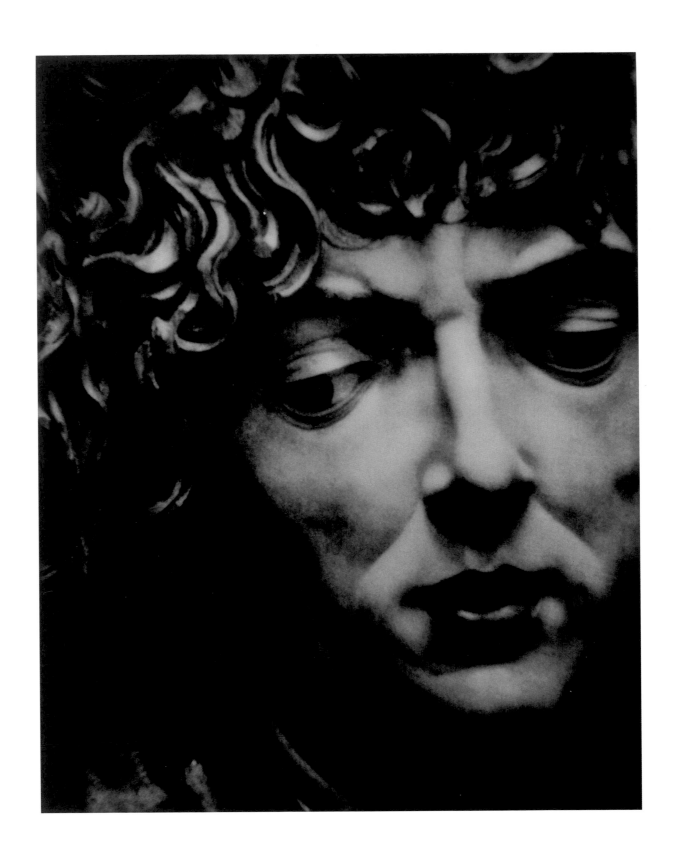

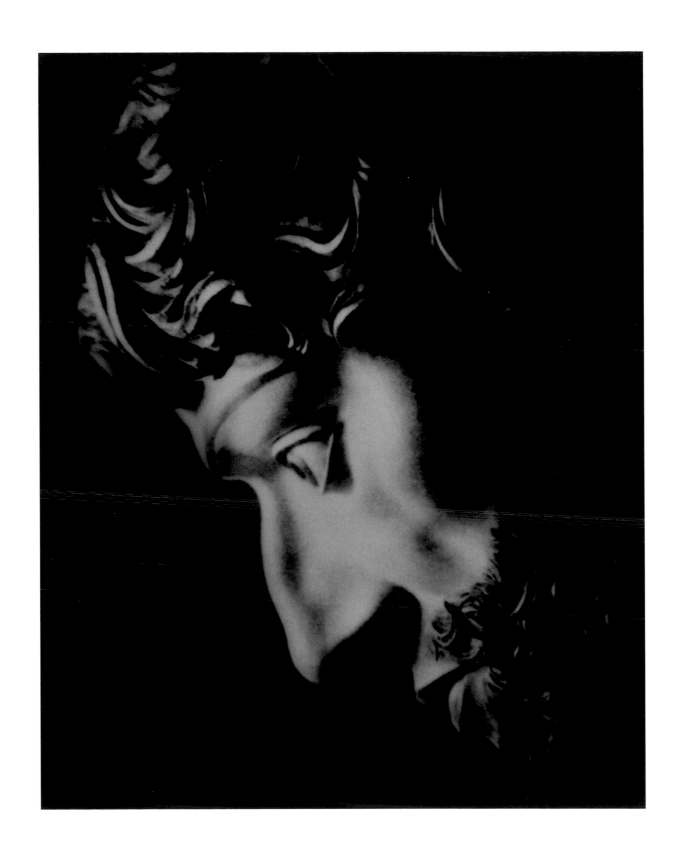

Marion Strunk

lives and works in Zurich

They have come to the Guggenheim Museum in New York, expecting to enjoy looking at the paintings. Now they are standing on the spiral gallery staircase. Bright light enters the open interior space from above. There are mirrors on the outer sides of the staircase, and they gather in and distort everything around them. Many people are there. Some are immersed in conversation with their companions. Others are leaning, alone or in pairs, over the balustrade, just standing around or looking for a certain picture. We cannot quite make it all out. This is a photograph.

Markers made of black wool have been erected. They metamorphose into figures, into dark human forms. We do not recognize them, but it seems as if they are looking at us. Their black wool does not reflect. They don't allow the expectations of some other human being to be projected upon themselves. We cannot find our thoughts in them. Surrounded by mirrors, these figures defy reflection in a dual sense, and they transform the room into something uncanny. The black throws all projections back to us. An unknown place emerges within the supposedly familiar room. How are we to find our way around there, when no subject offers a point of reference? Still, it looks as if some of the figures have merely been covered with black wool—or been embroidered away, invented, really never been there at all? Who can say for sure?

The boundary between the hard materiality of the photograph and its counterpart in the soft, black wool dissolves away. Yet the black figures appear to promise an encounter—although they are outside the mirror.

Suddenly we see the whole room and not the mirrors, and we realize that everything is connected and interwoven. We have now entered an impossible, virtual whole.

But only for a moment. For the distorted reflection leaves no doubt in our minds that these recognizable faces are merely an illusion created by the rays of light. The only figures anchored firmly to a place are the black ones, which shy away from us.

All at once we see them as warning figures in an allegorical theater, as representatives of a law of reality that proclaims the fallibility of the imagination. Because of the wool, the room depicted is revealed as a genuine simulation and thus sets the game of illusory representation in motion, while evading it at the same time.

And so we are thrown back upon ourselves and reminded of our wish to have the image of the other reinforce our perception of ourselves. Yet we also understand how impossible that is. The others gaze darkly at us. They have become what we secretly wish to be: an empty space onto which anything could be projected and which ultimately condemns this imaginative process to failure. Like fragments that remain after a significant cut that separates the subject from a former state of inadequate knowledge, these dark people direct our attention to the traumatic core of the matter: the core inherent in every attempt to develop a conclusive picture of an event or a place. The desire to take possession of surrounding material phenomena on the basis of an imaginary reconfiguration is tempting, but it points at the same time to the futility of any attempt to describe the world coherently.

MARION STRUNK
**EMBROIDERED IMAGES (PICTURE WITH EMBROIDERED
BLACK FIGURES IN THE MIRROR ROOM)** 1997–99
Color photograph with thread, 100 x 70 cm

The woolen figures show us what images can be: artificial reconstructions and material for the eyes that enable the contradictory phenomenology of our world to manifest itself. It is not the lack or loss of direct proximity to things that prompts our desire and our constant search for reflection in others. We tend rather to seek out a realm of apparent safety that promises us a recognizable image of the other, based upon the knowledge that we cannot escape the proximity to this matter that is so foreign to us, that we cannot tame this closeness by translating it into figures that reflect ourselves.

The closeness remains a foreign body, a filled void: a black body we cannot evade and which stubbornly denies itself in the picture. The woolen bodies anchor us in the sparkling shower of refracted light, in the beautiful illusion of distorted representations. As disturbing and uncanny as these black spots appear to be, they become familiar as soon as we accept the irresolvable contradictions they express.

And then the room—which seems alien only so long as one attempts to find one's way in it—radiates a mysterious, long-established wisdom, and our searching gaze can abide in one place.

The illusion of self-reflection in others is not sustained here. Instead it becomes possible to confront the other as the other, as an opposite which has fallen out of the mirror. All images fade away in black. Yet they become visible at the same time, just as the impossible encounter in the mirror shows what an encounter with the other makes possible.

ELISABETH BRONFEN
(Translated from: Marion Strunk, *Wolle 2 / embroidered images*, Zurich, Memory / Cage Editions, 1999.)

MARION STRUNK
EMBROIDERED IMAGES (PICTURE WITH EMBROIDERED PEOPLE) 1997–99
Color photograph with thread, 100 x 70 cm

Daniele Buetti

*1956, lives and works in Zurich

Daniele Buetti's art is characterized by a deliberately staged aesthetic of disparity which oscillates between such supposedly opposing poles as glamour and austerity, gravity and ironic lightness, reality and fiction. The artist first drew attention with systematic manipulations of photos found in fashion magazines. In his work complex entitled "Looking for Love," for example, he scratched vine-shaped ornamentations with a ball-point pen onto the mass-media skin of supermodels. The relieflike appearance of the penstrokes gives them the look of scars—both eye-catching and repulsive—exhibited proudly on the décolletés, chins or cheeks of the beauties. The inscribed mark is a blemish on the uniform patina of the ideal body and even gives it a momentary appearance of vulnerability.

The loss of ostensibly innocent perfection also plays an important role in "Good Fellows." In this work, Buetti appropriates the names and logos of such multinational corporate giants as Coca-Cola, Louis Vuitton and Nike, tattooing them on fragments of skin he has photographed himself. The intimate alliance of brand names and human bodies is a commentary on both the immortality of products that have accompanied us throughout our lives (and are likely even to outlive us) and the systematic dissemination of standardized ideals of physical beauty in advertising.

Buetti's photos are votive images of the cult of beauty, yet their glossy brilliance is often qualified by an element of melancholy. Above a pensive starlet with streaked hair falling across her face we encounter the enigmatic question "Will I ask for help?". To be quite honest, one is tempted to offer one's assistance, unsolicited. The seductive strategies Buetti employs in getting his subject matter across have been commercially tested and are therefore quite familiar. A face that settles into the sediment of memory (as a substitute for one's own condition), a terse slogan (the thematic extension of what Umberto Eco has referred to as "open" in the context of the work of art) combine to form an emotional "brand" with lasting effects. Half adapted, half staged, the panels are appeals to what is commonly referred to as feelings.

Buetti is a man of magic who voluntarily discloses his simple tricks: "His analyses are diagnoses, materialized in atmospheric installations, staged with calculated, ironic nonchalance and presented in tragicomical metaphors. They expose the snares of our perceptions, which is increasingly influenced by mediatized rather than immediate reality."[1]

Daniele Buetti's stars are borrowed from a distant dream-world. To ask for help is to admit weakness, but it also fosters closeness. Pictorial interventions, headlines and banners—like the plea "Touch me here"—mediate in visual scenarios between unapproachable ideals of beauty and real life. When supermodels and film stars take us into their confidence, their world gains credibility, and ours takes on an enchanting hint of glamour.

GIANNI JETZER

1 Christoph Doswald, "Never enough of you —Eine Schnitzeljagd durch die Medien," in: *Daniele Buetti. Never enough of you* (Ulm: Kunstverein, 1996), p. 38.

DANIELE BUETTI
LOOKING FOR LOVE 1997
Color photograph on aluminum, 110 x 75 cm
Courtesy of Galerie Ars Futura, Zurich

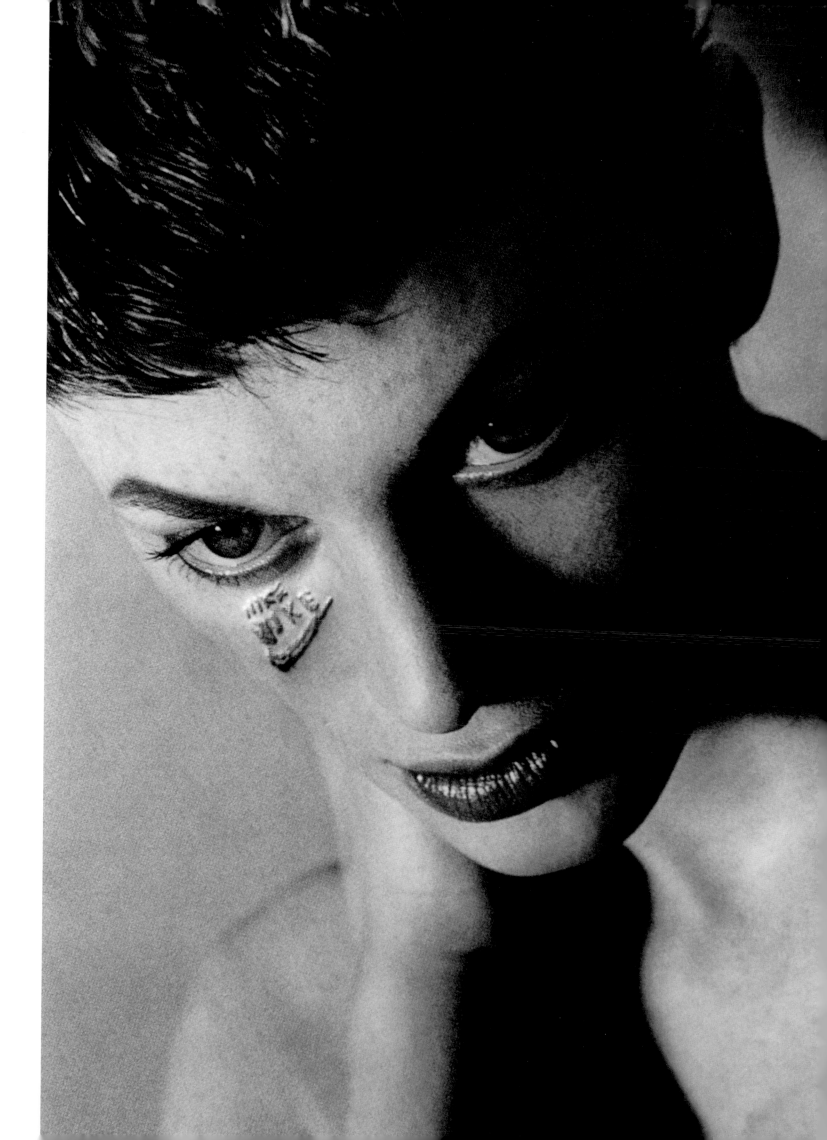

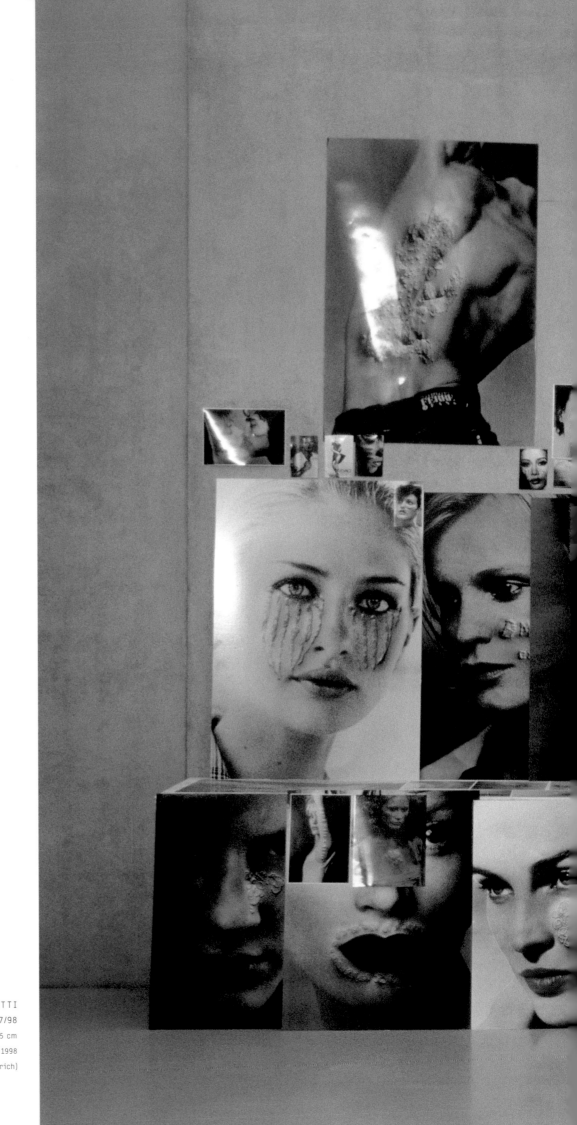

DANIELE BUETTI
LOOKING FOR LOVE 1997/98
Color photographs, some on aluminum, 300 x 420 x 75 cm
Exhibition photo, *Lifestyle*, Kunsthaus Bregenz, 1998
(Courtesy of Galerie Ars Futura, Zurich)

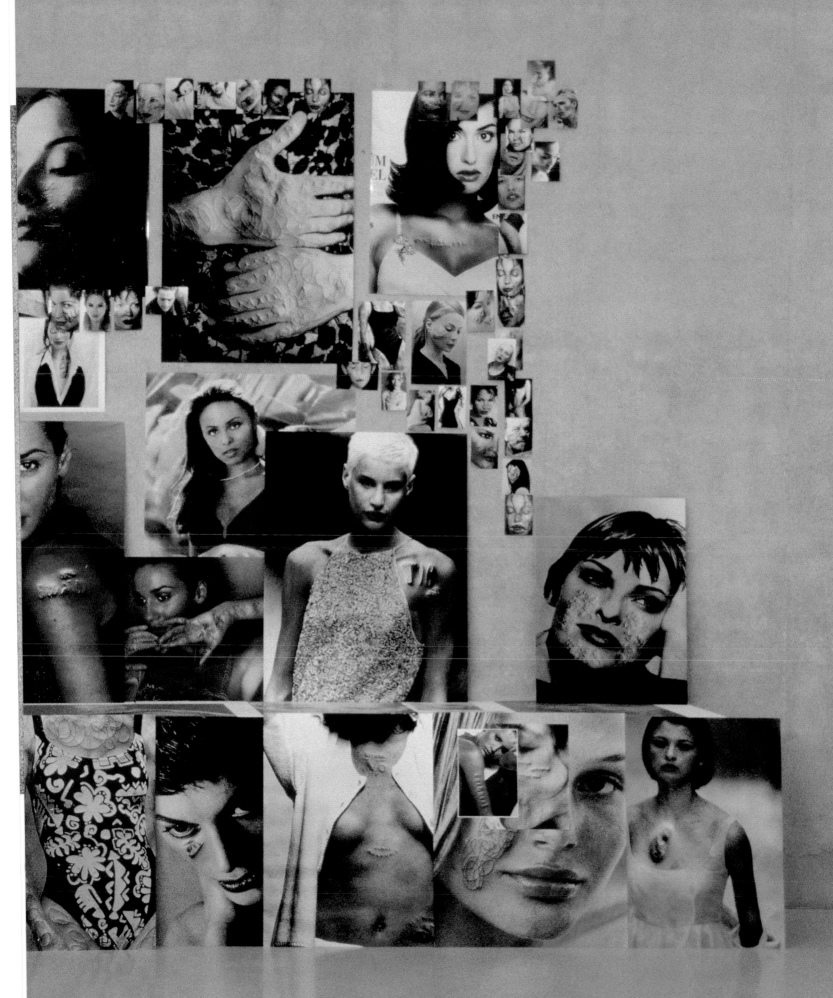

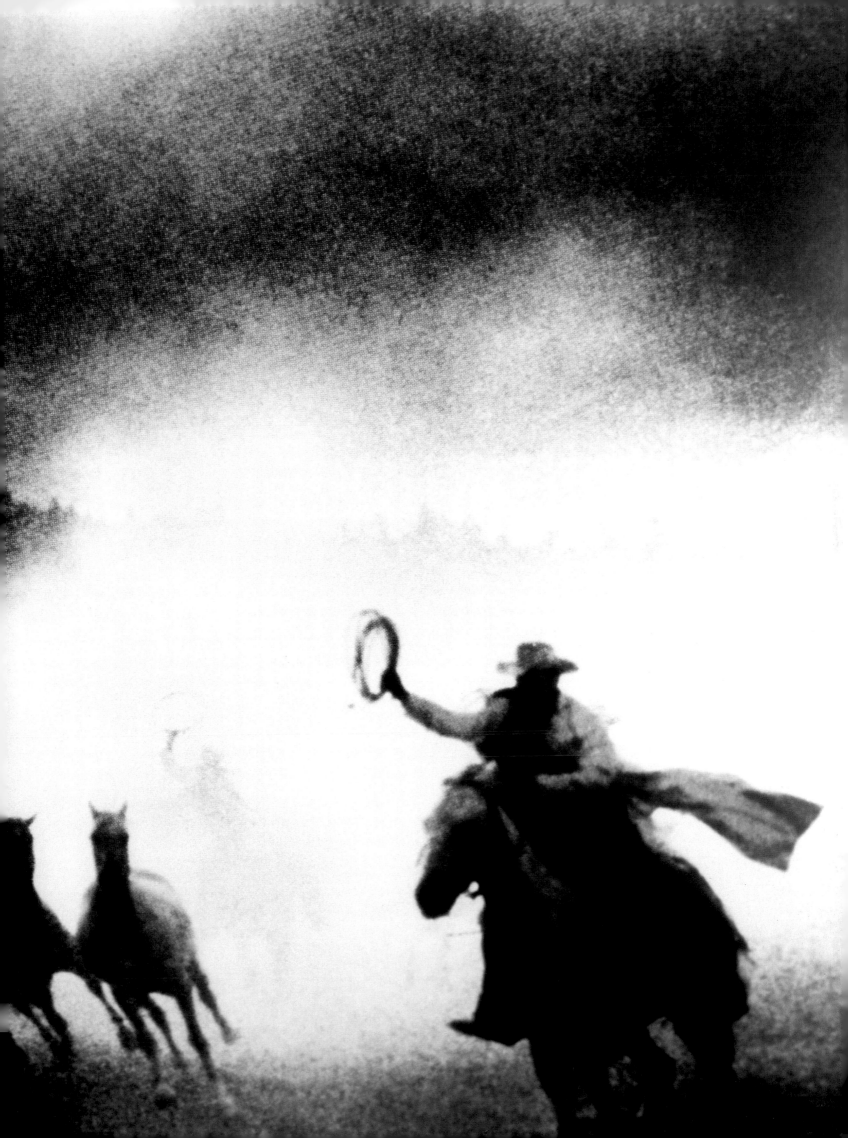

Tracey Moffatt

*1960, lives and works in Sydney

The Australian artist Tracey Moffatt appears often in her own photographs and videos. With skillful command of her resources, she mixes the autobiographical and the imaginary, the past and the present, to achieve a subjective form of reality. An Aborigine raised by white adoptive parents, she frequently deals with family conflicts and/or racial issues—the latter is a particularly pervasive theme in Australia's melting-pot society.

"Scarred for Life" (1994) is a photo series focusing on traumatic episodes from various children's biographies. Humiliation, physical punishment and even sexual abuse are presented in artistic form in short pictorial narratives. Viewers become witnesses to conflict situations in the lives of youths, from the relatively harmless insult to the legally punishable offense. In her nine-part series, Moffatt imitates the reportage style typical of *Life* magazine, with its combination of photographs and text captions, thus lending the staged images a degree of credibility and a heightened aura of authenticity.

In "Mother's Day" we see the face of a young woman (played by the artist) who turns her head away in a reflex action. The caption provides an explanation of the circumstances surrounding the scene. The girl has received a backhand slap in the face from her mother in front of her entire family. We learn nothing about the reason for this act of punishment. Moffatt's penetrating look behind the facade of the middle-class household is disturbing: "There is a certain cruelty hidden in these everyday scenes. It does not emerge as a sudden shock but reveals itself as a constant penetrating presence of generational conflict or a manic desire for equality. Tracey Moffatt exposes cruelty and horror beneath the sediment of normality."[1]

Colorism and a hip retro look, along with a pathetic artificiality of pose (her poses are reminiscent of melodramatic movie stills), are typical elements of Moffatt's style. In a manner quite characteristic of Tracey Moffatt, the effect of the gentle warmth of her colors is undermined in "Scarred for Life" by the melancholy nature of the subject. "It is a curious mixture of lightness and gravity, of comedy and horror, that we encounter in Moffatt's work."[2]

GIANNI JETZER

1 Translated from Rainer Metzger, "Plot and Pleasure: Zur Arbeit der australischen Film- und Fotokünstlerin Tracey Moffatt," in: *noëma*, no. 47, April/May 1998, p. 31.

2 Translated from Adrian Martin, "Tracey Moffatts Australien (Eine Annäherung)," in: *Parkett*, no. 53, p. 33.

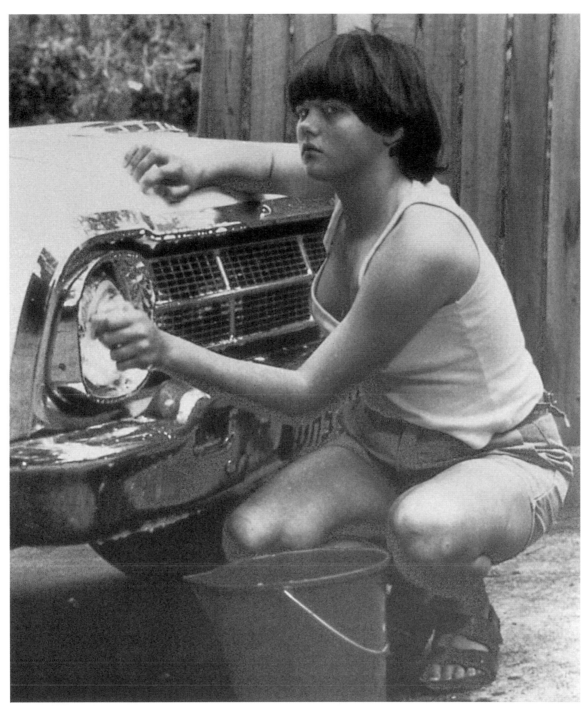

Tracey Moffatt

Useless, 1974

Her father's nickname for her was 'useless'.

TRACEY MOFFATT
SCARRED FOR LIVE 1994
Offset prints, 9 parts, 80 x 60 cm each
Ringier Collection, Zurich

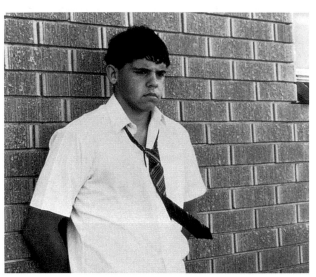

Tracey Moffatt

Job Hunt, 1976

After three weeks he still couldn't find a job.
His mother said to him, *'maybe your'e not good enough'.*

Tracey Moffatt

Charm Alone, 1965

His brother said, *'crooked nose and no chin –
you'll have to survive on charm alone'.*

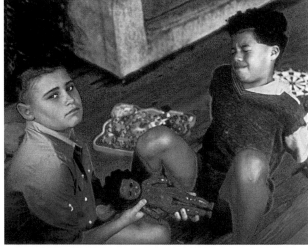

Tracey Moffatt

Doll Birth, 1972 His mother caught him giving birth to a doll.
He was banned from playing with the boy
next door again.

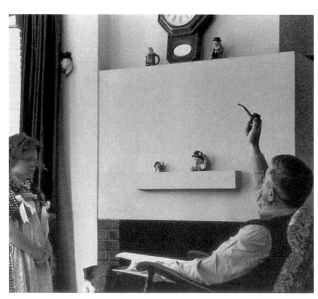

Tracey Moffatt

The Wizard of Oz, 1956

He was playing Dorothy in the school's production of the *Wizard of Oz*.
His father got angry at him for getting dressed too early.

Mother's Day, 1975 On Mother's Day, as the family watched,
she copped a backhander from her mother.

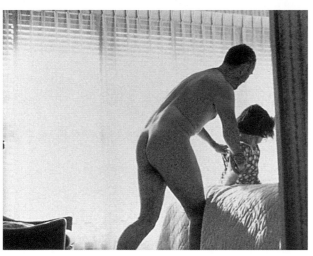

Tracey Moffatt

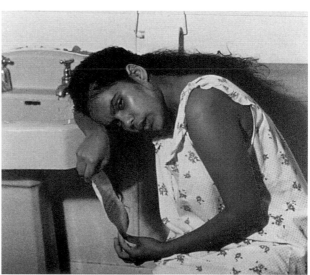

Tracey Moffatt

Heart Attack, 1970 She glimpsed her father belting the
girl from down the street.
That day he died of a heart attack.

Telecam Guys, 1977

Later, her sister said, 'the Telecam guys told me I was
far more more attractive and vivacious'.

Birth Certificate, 1962 During the fight, her mother threw her birth certificate at her.
This is how she found out her real father's name.

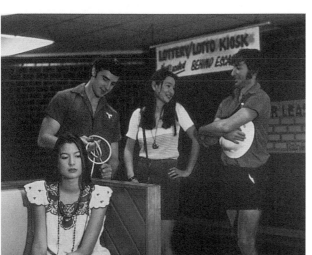

Tracey Moffatt

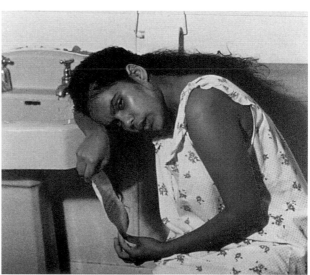

Tracey Moffatt

Sylvie Fleury

*1961, lives and works in Geneva

The occasion: Sylvie Fleury's solo exhibition "Hot Heels" at the migros museum für gegenwartskunst, Zurich, 1999. (The objects of her research: art as prosthesis, art as fetish, art as an agent of transfer, art and customizing, the power of seduction, the product of culture as an icon and the reconstruction of the cultural product.)

The subject of discussion: Fleury's fashion shooting for "Hot Heels." The question: Are Fleury's works stigmatized as pure decoration? Participant: Nicolas Trembley, *bdv*, Paris. Trembley publishes video editions featuring contemporary artists like Sylvie Fleury. He is a freelance exhibition organizer and art editor of *Self Service*, Paris.

Michelle Nicol: Is there really any interaction between fashion and art?

Nicolas Trembley: The fashion people are learning more and more about art. They no longer regard art as pure decoration but as a concept. And contemporary art inspires them. You can see that in this whole minimal-chic trend that has emerged from the idea of the white cube and Minimal Art. Of course, interaction also takes place when artists play with the codes of fashion. Sylvie Fleury was one of the first. But art and fashion have really always been interconnected. Think of Saint-Laurent and Mondrian or, more recently, the Frida Kahlo Collection of Gaultier. We will be seeing an increasing number of pictures like those Steven Meisel did for *Vogue*, which were shot at the New York Culture Center PS1 and show girls running around in front of works of art.

Nicol: Sylvie Fleury has functionalized her work as a background for her fashion shooting. Are we to see her work in this sense as decoration, or is there some dynamic relationship with photographed fashion?

Trembley: Sylvie has always worked with the idea of the "decorative"—when she was using patterns by other artists as backgrounds for her own work, for example. Look at her video piece "Walking in the Museum." We follow two girls wearing Patrick Cox shoes decorated with Mondrian patterns as they wander through the collection at the Mamco in Geneva and pass by a black circle by Olivier Mosset that is part of the collection. It strikes me as amusing that Fleury is now using her own art as a background. If I had a trend agency, I'd work with her. She's smart and knows exactly how to relate things to each other. The things she did as beauty editor for *Self Service* are very good, and they could actually be used for major campaigns. She did some brilliant abstract Richter paintings with lipstick. The "Is Your Make-up Crashproof?" series is great, too. She simply drove her car over

SYLVIE FLEURY

IL EST PAS TERRIBLE AU LIT? 1995

(HE AIN'T TERRIBLE IN BED?)

Color Photograph on dibond, 160 x 120 cm

Andreas Fuhrimann (Courtesy of Galerie Bob van Orsouw, Zurich)

a pile of cosmetics packages. The outcome was an abstract messy smear on the asphalt. Neither Clinique nor Chanel seems quite ready for that yet—too trashy or too artistic. But we should wait and see.

Nicol: Do you think fashion has a therapeutic effect?

Trembley: Yes, of course. Marc Jacobs rescues a lot of people from serious mental depression. But many people become depressed because they can't afford Marc Jacobs shoes. And if you need them, you simply need them. It is a kind of double therapeutic healing.

MICHELLE NICOL

SYLVIE FLEURY
LE BELLE TROVANO L'AMORE. LE BRUTTE ANCHE 1995
(THE BEAUTIFUL FIND LOVE. THE UGLY TOO)
Color photograph on aluminum, 160.5 x 116.5 cm
Ringier Collection, Zurich (Courtesy of Galerie Bob van Orsouw, Zurich)

COSMOPOLITAN

APRILE 1995 L. 5.000

Queste inutili diete
Smettiamo di farci del male!

Tradirlo?
Forse...
Negare?
Sempre!

**Le belle trovano l'amore.
LE BRUTTE ANCHE**

Parlare in tv
sogno o INCUBO?

Idee per viaggiatrici speciali

REGALO
il profumo per lui

SESSO
L'ultimo tabù

VOCI DAL MONDO
Punite perché donne

UOMO
messi a nudo
(o almeno in mutande)

50 cose che sappiamo di loro

50005

9 771121 547002

Wolfgang Tillmans

*1968, lives and works in London

Documents of a moment or precisely staged scenes, fashion sequence or memento-style snapshots—
it is difficult to find clearly delineated categories for Wolfgang Tillmans's photographs. Boundaries
are blurred, and the attempt to draw distinctions between commercial and art photography,
between documentary and staged photography leads nowhere. Photos can no longer support the
claim of "authenticity," for the photographic view and people's behavior in front of the camera
always refer to existing images. In his pursuit of the "idea of beauty and of the world in which I
would like to live"[1] in portraits, still lifes, draperies, landscapes, cityscapes and travel photos, he
journeys through the collective legacy of imagery that influences our perceptions. We may see the
photograph as an attempt to pluck a personal context from the stereotypes through the choice of a
particular subjective point of view. Yet subjectivity is no guarantee of absolute truth, either.
"Authenticity is always a matter of one's standpoint," Tillmans points out. "My pictures are
authentic to me, since they 'authentically' reflect my fictional view of a specific moment. But for
viewers, they can be no more than suggestions encouraging them to see the subject in the same
way."[2]

Because his photographs initially related to his own scene, he soon gained a reputation as a
documentarian, not only of his own life but of that of his generation as well. The first cited
presentations of his art took place at the "Café Gnosa" and the "Front," both well-known landmarks
in Hamburg's gay scene. Tillmans worked for the city journals, took photos of clubs, night-owls,
church conferences. There were fashion sequences, portraits of musicians for *i-D* and *Interview*,
leading magazines of culture and aesthetics that had influenced him during his own youth. His
clients also included other music and culture magazines such as *Spex*—of which he has since
become coeditor. Tillmans takes advantage of the artistic liberty offered to him in these media to
inject his own personal taste as a kind of "aesthetic infiltration"[3] at a position of prominence. He
represents his time, not as a documentarian but by virtue of an aesthetics he has helped to shape,
an aesthetics in which the everyday begins to take precedence over the extraordinary, in which
privacy becomes public domain and thus a political matter as well. It is an aesthetics whose
apparent immediacy often demands painstaking preparation: "I stage situations with my models
or friends in order to see how they react. [...] I tell them what to do, and I select their clothing
and the locale; I put them in position."[4] In his books and full-wall installations, the results
consistently generate new dramatized images of an identity in the process of becoming.

JÖRN SCHAFAFF
(From *ZOOM—Ansichten zur deutschen Gegenwartskunst*, Collection of Landesbank Baden-Württemberg, Ostfildern,
Hatje-Cantz, 1999.)

1 Tillmans, quoted from Vivienne Gaskin, "Interview," Chisenhale Gallery, London, July 3, 1997, p. 6.

2 Tillmans, quoted from Martin Pesch, "Wolfgang Tillmans," in: *Kunstforum*, vol. 133, 1996, p. 258.

3 Tillmans, quoted from Carlo McCormack, "Wolfgang Tillmans," in: *Camera Austria*, no. 64, January 1999, p. 48.

4 Tillmans, quoted and translated from P. Halley / B. Nickas, "Wolfgang Tillmans," in: *Index*, March 1997, p. 40.

WOLFGANG TILLMANS

LUTZ & ALEX, HOLDING COCK 1992

Color photograph, 2/3+1, 60 x 50.2 cm

Nicola von Senger, Zurich

WOLFGANG TILLMANS
GERITH, MICHAEL, STEFAN & GREGORIO 1998

Color photograph, 2/3+1, 60 x 50 cm

Nicola von Senger, Zurich

WOLFGANG TILLMANS
YOUNG MAN, CHEMISTRY 1992

Bubble jet on paper, 1/1+1, 172 x 116 cm

Nicola von Senger, Zurich

Olaf Breuning

*1970, lives and works in Zurich

"My works are supposed to be products," explains Olaf Breuning, the creator of fantastical, chilling scenes of pleasure. His surreal landscapes, bizarre fairy-tale figures and mysterious happenings are both fascinating and shocking, images of seeming miscarriages of an imagination nourished by the subconscious. We fail to probe deeply enough, however, if we interpret Breuning's photographs, video clips and installations solely from the standpoint of post-Freudian theory. They must be approached instead within the context of the reality around us, for they incorporate contemporary forms of visual language with which we are all familiar from film, advertising, art and the press. With their promise of exciting worlds of adventure, these images ultimately influence us all more or less as we proceed to construct our own personal realities.

The large color photograph "Independence Day" (1997) occupies a position of particular importance within Olaf Breuning's œuvre. It serves as an exemplary illustration of a trained photographer's working concept based upon a mixture of reality and fiction, manifest and non-material phenomena, the sublime and the base. The photo shows an artist's studio furnished with tables, stools, easy chairs and other household goods, conveying the impression of a domestic landscape. Inserted into the foreground are photographs of scantily dressed people, cut out by Breuning along the outlines of their bodies. The figures seem to be wading in wet concrete, as the floor completely swallows their feet and calves. Floating above their heads is a bright red mattress, held in place only by an intricate web of string, which appears to be on the verge of falling at any moment and crushing everything and everyone beneath it. The drama of this artfully staged illusion is heightened by the title "Independence Day," an allusion to the science-fiction movie that caused such fear and trembling several years ago. The constructed character of the illusion-laden image becomes obvious against the background of the artist's studio cum living space, however. Although the image suggests an autonomous reality, it is ultimately the product of special effects. In this way, Olaf Breuning questions the mechanisms of image production while reflecting at the same time upon the work of the artist.

ANNA HELWING

following page:

OLAF BREUNING
CHRIS CROFT 1998
Color photograph, 3+2 artist's proof, 122 x 155 cm
Courtesy of Galerie Ars Futura, Zurich

OLAF BREUNING
INDEPENDENCE DAY 1997
Color photograph, artist's proof, 122 x 155 cm
Private collection, Zurich
(Courtesy of Galerie Ars Futura, Zurich)

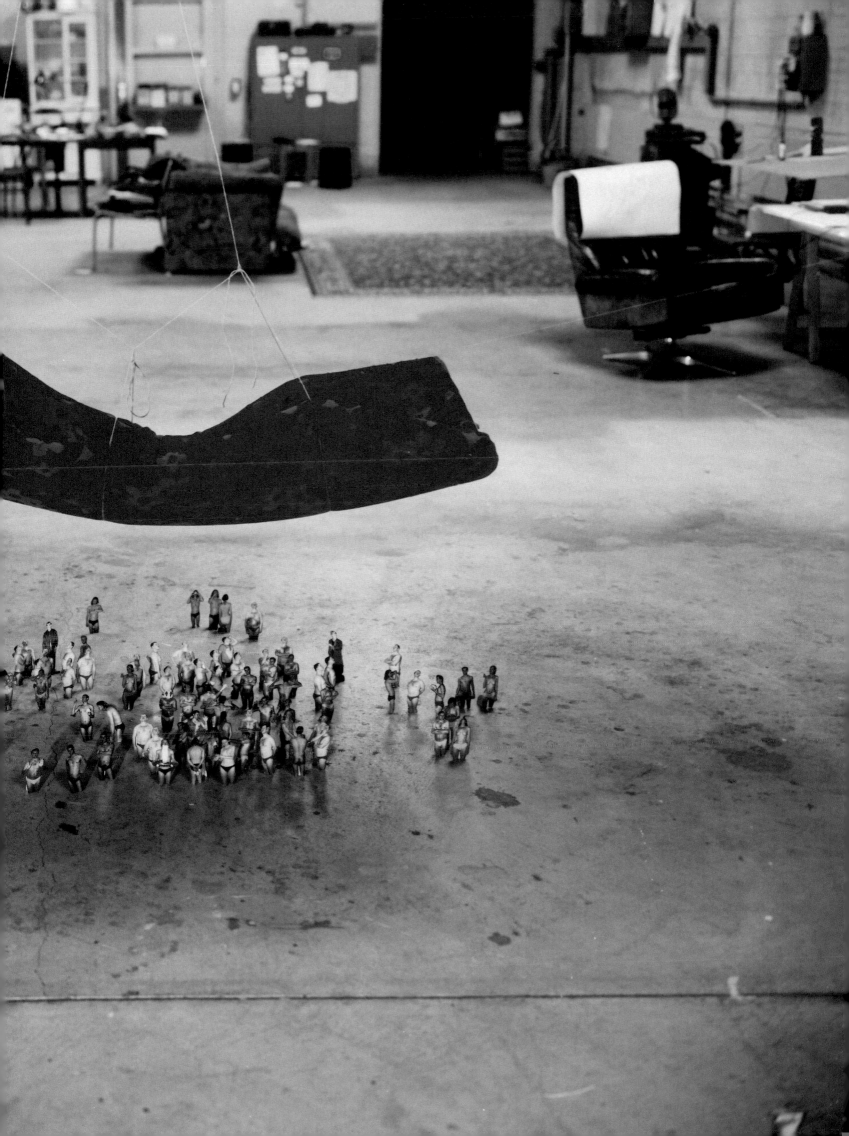

Steffen Koohn

*1971, lives and works in Zurich and New York

Nearly everything done by sons with their fathers and by fathers with their sons is painful. Chronos devoured his young, and for a brief moment it seemed as if God the Father had abandoned Christ. Somewhat later, Dr. Freud spoke of the myths of Tacheles: sons driven to murder their progenitors, who evade them adeptly, becoming invulnerable and diffuse.

Steffen Koohn's "Recherche du père perdu" (Search for a lost father) is not a metaphor. His own father, a young GI stationed in Germany, impregnated his mother, a German *Fräuleinwunder*, and then quickly vanished across the sea. "Much Love, Larry" is the dedication on a yellowed photograph, the icon showing the "nobodaddy" in uniform.

So Koohn doesn't know him, has never seen him, the man he should have been permitted to liquidate during the wild phase of his youth at the latest, if only in the interest of psychological hygiene. The prodigal son is left without a link to his paternal ancestry. Thus Steffen stages his showdown with its surrogate in the gallery, making alter ego out of ego, carrying the red marks of western insignia like murder weapons on his body: Stetson, boots, leather gloves. Looking straight ahead into the camera, he offers both cheeks, refusing to play the game of hide-and-seek in profile. The viewer recognizes one who is ready to face the facts—if it weren't for the transcendence of the Far West that lives on only in the hunting grounds of the imagination, in the "Village-People" pose of the asphalt cowboy on his search. Father and son merge together in this larger-than-life portrait into a double phantom. Genetic resemblance. Son shoots father and wounds himself in the chest.

Sadly, the infant always draws the short straw when biology draws the argument of sex from its holster. And Steffen has long since discovered his own Eros. Since then, he, too, plays with father's trigger. The competition between imagination and reason, between brotherly desire and estranging accusation has sharpened Steffen Koohn's psychotic perception of the world, making him a late-Surrealist wonderer, convulsively shaken by the vision of the object of desire that constantly evades him in both its first and second derivation. The photos from the series entitled "Pumping Nine" are from an old sex film. Deep astonishment at the sight of inflamed lovers and bodies. Stallions that have shed their latex skins line the way of the installation-artist Koohn. Tailor's busts with horns to be shed, monster dolls and bull-ride replicas escort Steffen Koohn, plunking out the blues of a fragile human being with exposed nerves along the road to desperation or to Oz.

It is no surprise that Nan Goldin showed the work of the young Swiss artist in an exhibition she recently curated in New York. Steffen has thus moved closer to Larry's stomping grounds. What if the ex-GI is interested in contemporary art?

JURI STEINER

STEFFEN KOOHN
PUMPING NINE
(#5,6,8,9,11,22,24,28) 1998
Color photographs on aluminum, 28 x 39 cm each
Courtesy of Galerie Peter Kilchmann, Zurich

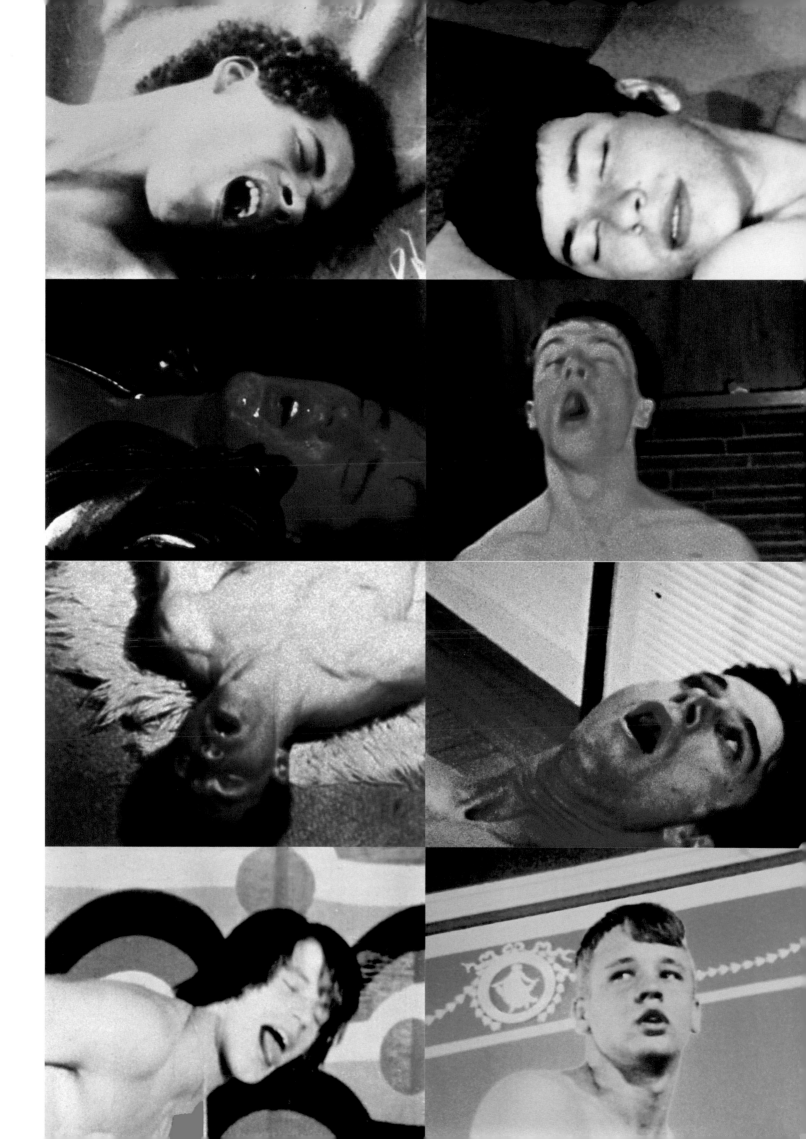

Jiri Georg Dokoupil

*1954, lives and works in Santa Cruz de Tenerife

The notoriety of pornography has not prevented porno stars from establishing a place for themselves in western pop culture. Dolly Buster, Donna Vargas, Carol Lynn and Tracy Lords are as well known to heterosexual males as Michael Jackson or Madonna. Their vulgarity is safely nestled in the imagination. Pin-ups have replaced teenagers' posters.

The series entitled "Madonna in Ecstasy" presents large-format portraits of well-known porno stars, many in blocks of six or nine photographs. Although the technique is new to Dokoupil, his use of these images from the mass media is a logical strategic extension of his artistic practice, which is focused primarily on painting. Having achieved first recognition in the early eighties, Dokoupil is one of a group known as the "Junge Wilde" (Young Savages). His work balances on the dividing line between subjective, neo-expressionist gesture—in keeping with the spirit of speed and shabbiness that typified that decade—and aspects of a conceptual approach to the canvas devoted to a systematic analysis of the classical medium. Dokoupil replaced traditional painter's utensils with tires and candles in an effort to disassociate himself from ideas about the quality of his own brushwork, a feature of his work that brought him immense success as a member of the group known as "Mülheimer Freiheit" (Mülheim Liberty).

Characterized by its speed, the medium of photography correlates closely to the kind of direct artistic access practiced during the eighties. Yet for Dokoupil and many other artists, it also represents a point of departure for the selection of pictorial motifs. In line with his use of everyday utensils that are alien to painting, he appropriates subjects from the unfiltered tide of mass-media images that inundates us even in our own homes. That he presents porno stars as the Madonnas of the waning 20th century strikes us as a drastic strategy, particularly against the historical background of classical painting. The Madonna image is one of the most pervasive subjects in sacred art. Despite its religious aura, it possessed a certain mass-media quality and could be found as a decorative feature in virtually every church and Christian home in western societies. At the same time, the Madonna figure personifies the full complexity of womanhood. In casting this sacred theme in profane porno images, Dokoupil focuses on the increasingly paradoxical reception of femininity, sexuality and their mediatized models that is so typical of our time.

ULRICH SCHÖTKER

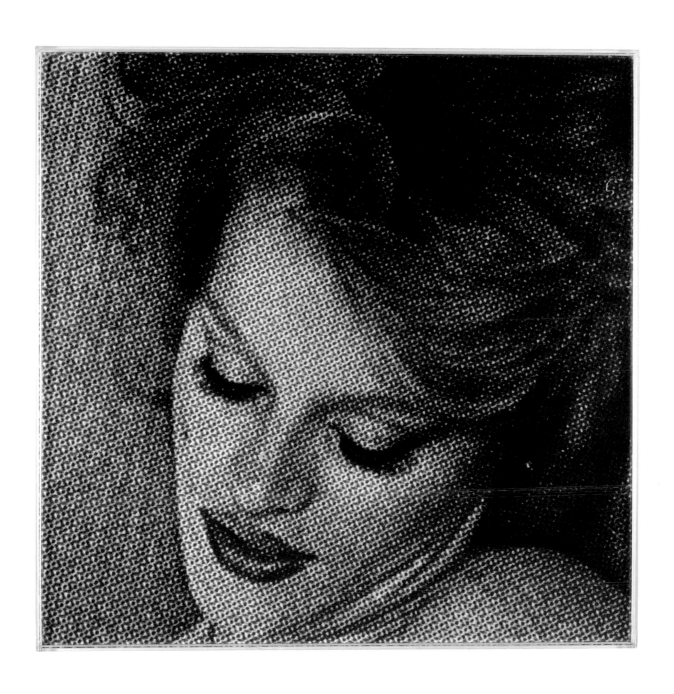

JIRI GEORG DOKOUPIL
MADONNA IN ECSTASY, NO. 69 1987
Cibachrome in acrylic-glass frame, 100 x 100 cm
Nicola von Senger, Zurich

Christian Marclay

*1955, lives and works in New York

Christian Marclay became involved in the hybrid sphere of visual signs and sounds long before people began to celebrate the crossover between visual art and music or "clubbing" in museums and galleries.[1]

Marclay works with the non-material medium of music and with physical recording media, which he employs as sculptural material in his installations. In his performances and concerts he uses programmed record players—noises, audio plays, historical and contemporary music are woven into a polyphonic symphony of sound in live experiments. This dynamic concept is oriented toward "the flood of acoustic information between art and everyday life, which we must deal with constantly and which also shapes our patterns of perception."[2] Marclay does not appear in art settings only. He deliberately seeks contact with the music world. As a conductor and sound mixer, he has developed a new kind of musical performance: monumental concert happenings featuring a variety of radically different styles and configurations (DJs and alphorn players, for example) in live sessions.

Christian Marclay's first solo album was *Record Without a Cover*. In keeping with his programmatic intent, he made no attempt at the time to present his musical product in visual form. He once referred to photography as "visual recording," thus establishing a link to the vinyl storage medium. Accordingly, an LP consists of a musical and a photographic recording, each of which has a determining influence upon the other.

It is interesting to note that the term "album" has been assimilated into a number of languages as the word for a single long-playing recording. On the basis of the photographic images on the album covers, it is possible to trace chapters in the history of music and fashion (like in a photo album). "These photos by professionals have experienced significant booms and developments under the influence of different factors."[3] Marclay has pursued the themes of self-presentation and allegorical representation in photography in several different works. In establishing relationships between covers from the records of various different performers, he undermines each idol's claim to uniqueness. The serial structure exposes the often simplistic iconography of the cult of stardom.

Viewed in direct juxtaposition, the aesthetic compatibility of individual covers is so astonishing that we are immediately reminded of the still living legends and conspiracy theories of rock music according to which certain things cannot be steered by coincidence alone.

GIANNI JETZER

1 See *Crossings. Kunst zum Hören und Sehen* (Vienna: Kunsthalle, 1998), and "Cool Club Cultures," in: *Kunstforum*, no. 135, 1996/97.

2 Birgit Wiens, "Vom Eros der Dinge," in: *Christian Marclay. Arranged and Conducted* (Zurich: Kunsthaus, 1997), p. 43.

3 Diedrich Diederichsen, "Verbrannte CDs sind geruchlos," in: *Kunst-Bulletin*, June 1995, p. 23.

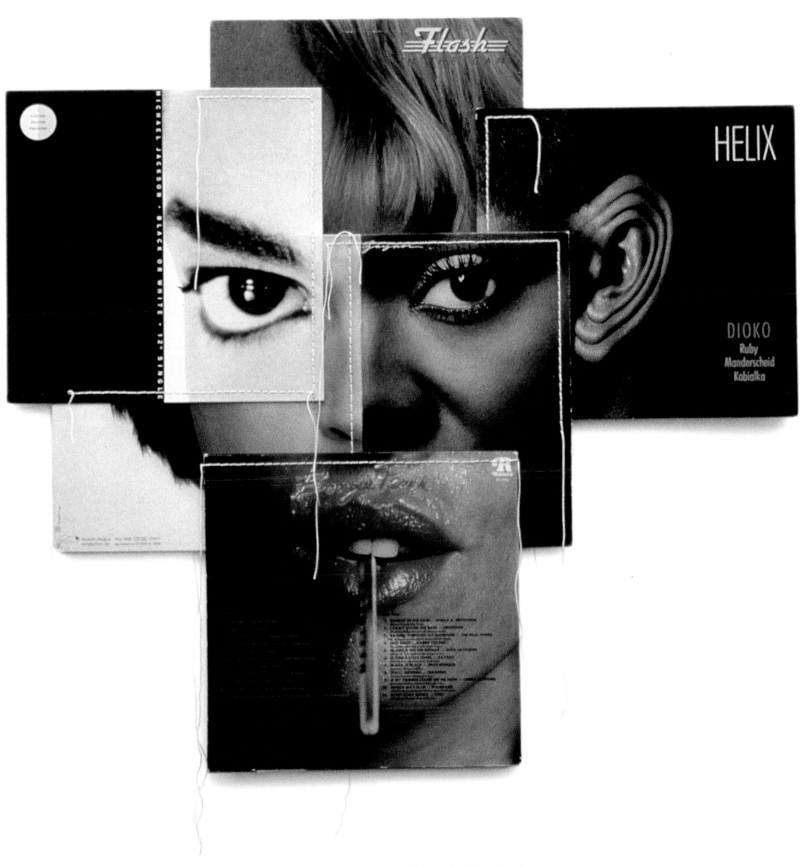

CHRISTIAN MARCLAY
BLACK OR WHITE 1992
Six used album covers, 78.7 x 75 cm
Courtesy of Galerie Art & Public, Geneva

Rémy Markowitsch

*1957, lives and works in Berlin

A visual artist himself, Rémy Markowitsch does not describe the visual archives of wisdom but illuminates them instead, invading them with light, breaking through their opacity in order to draw an image from the two-sided deposits. That is a little bit like visual surgery: books "sliced open." What we see is genuine. It was really there, rendered visible as it was by the penetrating light. The worlds of imagery dissected through a process of combination deal with injuries and deformations. Some—the source for which was a manual of home medical care, third edition, 1944, published by the Swiss Red Cross—imitate states of injury and simulate medical aid. Others— adapted from a book on posture training released in 1967 by the state publishing house "Volk und Wissen" in Berlin—are concerned with the precautions against "changes in the physical and mental stress suffered by working people as a result of the technical revolution" in the form of simulated preventive posture exercises. Rémy Markowitsch imitates classical artistic postures in his work by suggesting the workings of creative design, almost in counterpoint to his theme and to the act of mechanical appropriation, and providing his enlarged exposures with rather stable frames, as if to seal their fragility and artistic geniality and prevent them from seeping out into surrounding space, into the less educated banality of contemporary everyday life. [...]

One aspect of Rémy Markowitsch's art which is concealed and not immediately evident in the works itself, is that of collecting; initially the collecting of books full of stored, written knowledge, with compressed views of the world from different eras and "pressed," i.e. printed, with a variety of different techniques. This is not a collection of berries but of cultural legacies, images of the world. These are prefabricated goods, yet Markowitsch treats them like raw material, casting light on it, driving light through it, as if to determine what it is, transforming opaque medium-material into a luminous screen. This enlightening process casts a strong light on things. Modern art did the same with an increasingly complex array of apparatuses, hoping to derive insights from views, to get behind things, to identify structures beneath the surface, to move the boundaries of the visible ever closer, ever deeper. Even at the lowest level we had to return regularly (too regularly) to the screen room. The goal of all of this invasive exploration was a greater, more authentic truth, the recognition of structures and deviations from them—of disorders. Markowitsch's screen images, his visual palimpsests obscure by making things visible. Exposed to light through and through, the images become blurred. Information and media are given equal value. The rustling of the paper structure, as the primary material medium, the clashing of the matrix points, as the actual bearers of information, disturb the representations. [...]

Markowitsch takes mimesis to the absurd. His mechanistic copy of a mechanistic printed copy of a mechanistically photographed copy of some specific reality assumes monstrous pictorial reality, looking almost like a digitally generated arrangement of plants, like a somewhat strange original that has just been produced, a *Natura naturans*, a somewhat strangely self-generating nature. His commentary on 154 years of the insanity of photographing the world. [...]

We live in "nature in an era of its technical reproducibility," writes Gernot Böhme in an

RÉMY MARKOWITSCH
AFTER NATURE, M3 1993
Color photograph, acrylic glass, iron,
180 x 120 cm
Courtesy of Galerie Urs Meile, Lucerne

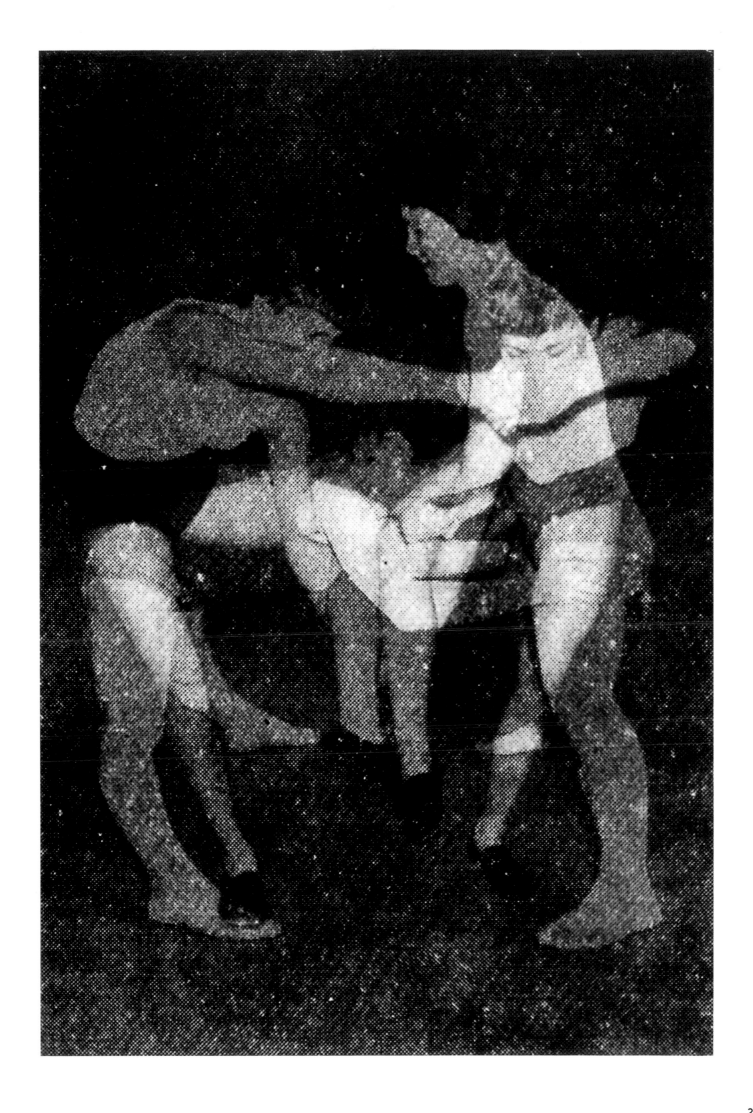

allusion to Walter Benjamin's famous title; we live with it, and we embody it ourselves. Before, nature was what had always been there, and technology was what we created. We would drink only sour wine and eat only sour apples if the two had always been as strictly separate as we think. But a merger of nature and technology is possible today, a union that is no less significant than nuclear fusion. We have not yet exhausted the possibilities of nature. We could spend centuries exploring and imitating, content with mimesis. But in our precociousness we have discovered a few secret keys that will alter our interventions in a fundamental way. At certain crucial points we humans have changed from imitators to creators—claiming, in our delusions of grandeur, that we have everything under control. Markowitsch's hybrid, idealized humans, animals, plants and landscapes call to mind the Surrealist practice of cropping, duplication, multiplication. The Surrealists sought to conjure up the phantasmagorical, to give the act of informing (in the sense of Bataille's "informe") and the suppressed counterworld their due. Markowitsch's "cadavres exquis" have Dr. Dolittle, after finally achieving his goal, find the "push-me—pull-me." His almost still double-animal portraits enlarged to a scale of 1:1 appear to create tension in the ambivalence between dignified portrait and mechanical illumination, a tension suggestive of the future orgy of technology and nature. "So that we can sleep at night," as advocates of genetic engineering would like to have us believe.

URS STAHEL

(The excerpts printed here are from the publication *Rémy Markowitsch, Nach der Natur*, Lucerne, Galerie Meile, 1993 [no longer in print].)

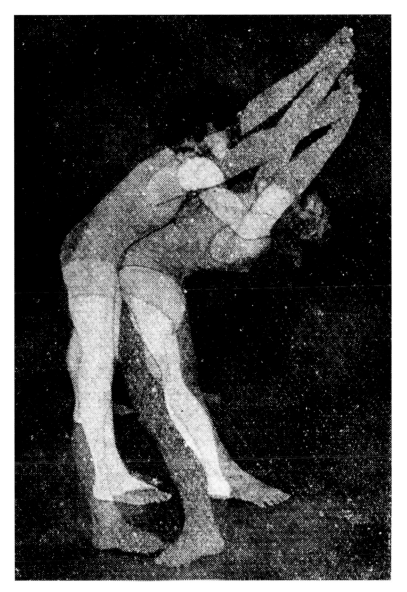

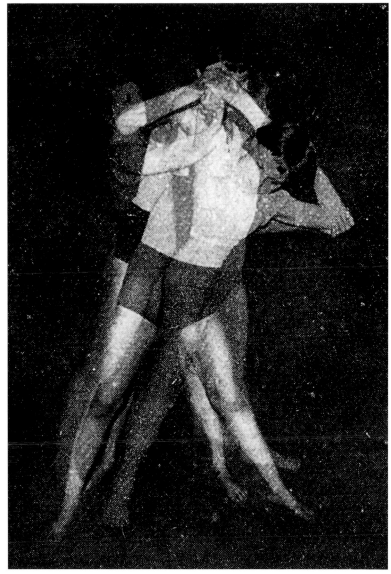

RÉMY MARKOWITSCH
AFTER NATURE, M2 1993
Color photograph, acrylic glass, iron, 180 x 120 cm
Courtesy of Galerie Urs Meile, Lucerne

RÉMY MARKOWITSCH
AFTER NATURE, M4 1993
Color photograph, acrylic glass, iron, 180 x 120 cm
Courtesy of Galerie Urs Meile, Lucerne

Matthew Barney

Vanessa Beecroft

Erik Dettwiler

Inez van Lamsweerde

RECONSTRUCTION

Mariko Mori

Ugo Rondinone

Thomas Ruff

William Wegman

William Wegman

*1943, lives and works in New York

William Wegman has a cross-eyed gaze to thank for his highly unusual mode of artistic perception. In his photos, he is often seen looking with one eye into the camera, while the other wanders slightly to one side. Viewed in this way, the photo on the upper right in "Family Combinations" appears as a self-portrait. The title helps establish the identities of the other persons. Thus the first row shows father, mother and artist. Yet identification of the faces in the lower row is somewhat more difficult. These portraits bear a strange resemblance to each other. A closer look reveals them to be double exposures: a cross between mother and father, one between mother and artist, a third between father and artist. Wegman does not appear to take his family portrait very seriously, and thus it is not only the 1972-style hairdoes that make the subjects look like characters created by Loriot. The sense of caricature evoked by the second row, in particular, is enough to dispell any overly earnest thoughts about this work. Humor of this kind is typical of Wegman. It was he who gave the conceptual photography of the time its ironic spark. He enriched the media of video and photography, employed ordinarily for documentary purposes, by adding a narrative, often deliberately banal aspect. Having "gone to the dogs" himself in 1972, he used the animal as a model from that time on. Presented in colorful, costumed *tableaux vivants*, the brown hunting dog named "Man Ray" soon became a popular calendar motif, and Wegman kept the promise made by the avant-garde to merge art with everyday life.

Early in his career, his view of things was characterized by duplications, triplications and sextuplications—as if to demonstrate that the right eye has a different perspective on the world from the left. People, dogs and rooms are mirrored in black-and-white images that cause irritation by virtue of his clever variations. Arranged in an orderly side-by-side presentation, these views parody the methods of Minimal Art. "Family Combinations" also deals with fine distinctions. Motifs and approaches to presentation are simple and unpretentious. Wegman's playful systems of combination stand in contrast to such objective theories of heredity as those articulated in Gregor Mendel's laws.

His self-portrait entitled "Reduce / Increase" also features duplications, and that in a dual sense: in terms of content, we find the exposure of the two faces of travesty; in terms of form, there is the double surface. Wegman has noted in ink on the photographic paper how his masculinity, exhibited rather awkwardly in a negligé, could be transformed into something more ladylike. This "sewing-pattern" image, like Wegman's "Family Combinations," has none of the critical social overtones found in photographic-artistic treatments of such themes as genetics and gender twenty years later.

TOBIAS VOGT

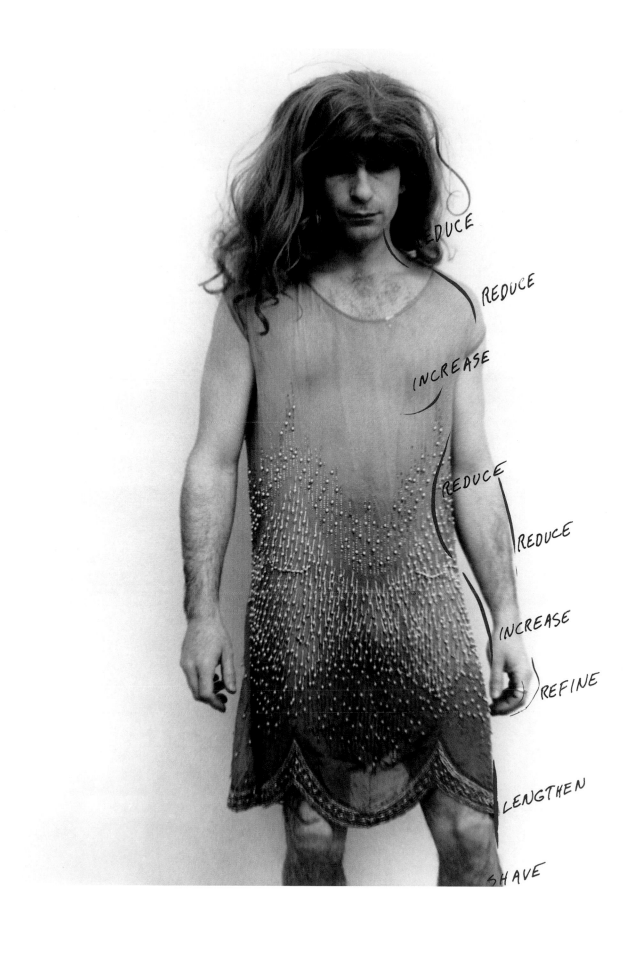

WILLIAM WEGMAN
REDUCE / INCREASE 1975
Edited black-and-white photograph, 35.5 x 28 cm
Courtesy of the Holly Solomon Gallery, New York

WILLIAM WEGMAN
FAMILY COMBINATIONS 1972
Black-and-white photographs, 6 parts, 29.8 x 26 cm each
Courtesy of the Holly Solomon Gallery, New York

 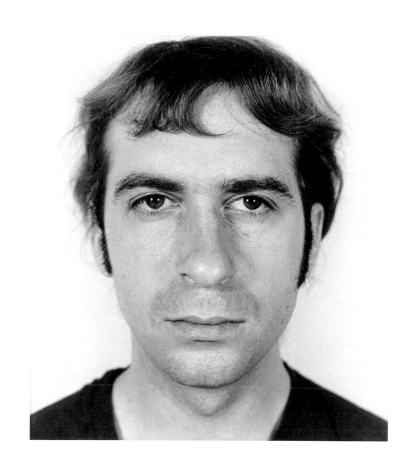

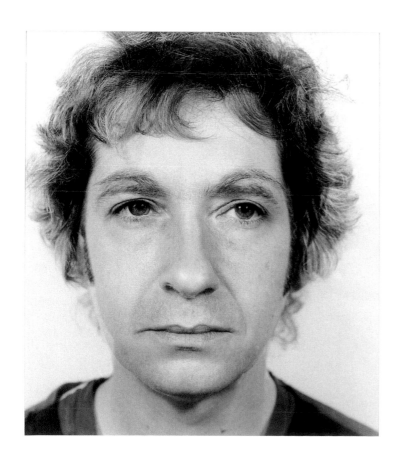 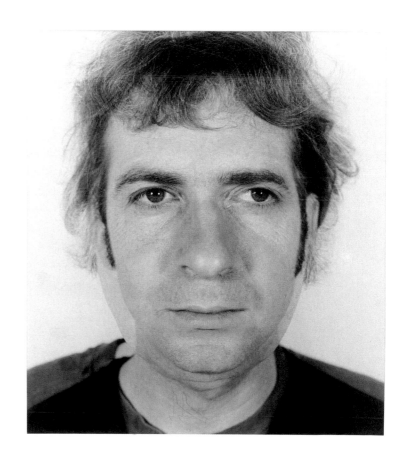

Thomas Ruff

*1958, lives and works in Düsseldorf

Thomas Ruff is concerned with the portrait, one of the most imporant genres of photography. This choice alone is indicative of Ruff's interest in fundamental issues of photography-presentation and representation, a focus that is evident in his exclusively serial works. While studying under the Bechers at the Düsseldorf Akademie, Ruff first employed photography as a detached, objective means of gathering evidence of reality. In the course of projects in which Ruff "let the machine work just as it normally does,"[1] he formed doubts about the medium's capacity for representation. With reference to his extensive portrait series, Ruff himself speaks of the categorical non-representability of the human being. A paradox? His practice of working in series suggests a fundamental distrust of the individual image. To the extent that it captures a specific moment, the single image always excludes whatever might have been present outside the picture. Thus the visual rhetoric of the photographic image is highly selective, focused, reductive and—by definition—based upon exclusion.

In portraiture, however, this circumstance should actually contribute to a heightened concentration on the visual object—and it is this very concentration, which is underscored by the format and the hyperreal quality of the representation, that estranges the photographic image from any kind of "genuine" reality. It is impossible to study the physiognomies of people in that kind of detail in everyday situations. Yet these portraits give human visages a practically hallucinatory presence, making them inaccessible to "real" perception in the process. What they engender is not representation but rather communication with the photographic apparatus, communication with a visual object that can be produced in this particular form only through photography. Ruff's "Andere Portraits" (Other Portraits), exhibited at the Venice Biennale in 1995, can be viewed within the context of this research project, as it were. Actually, they are not photographs at all but black-and-white silkscreen prints which roughly match the formats of the "Portraits" (200 x 150 cm). Yet the juxtaposition of two faces in this case makes scrutiny of the portraits difficult. The products are new, artificial metamorphoses of faces which ultimately emphasize the artificiality of photography and the need for productive input on the part of the viewer. "The viewer can learn something about the depicted subject only with the help of his/her own projections."[2] Reality in the works of Thomas Ruff is not exhibited as something that is captured and brought closer to the viewer's eye, as it would appear at first glance, but as something that merely finds its point of departure in the photographs, something that takes on meaning and relevance only when completed through the process of perception.

REINHARD BRAUN

1 Thomas Ruff, "Gespräch mit Stephan Dillemuth," in: *Thomas Ruff, Andere Portraits + 3D* (Venice Biennale, Ostfildern, Cantz, 1995).

2 Ibid.

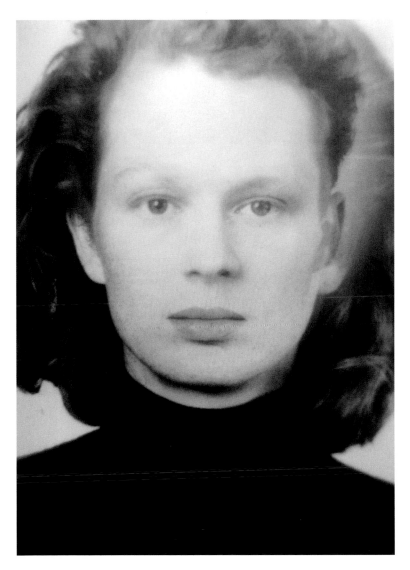

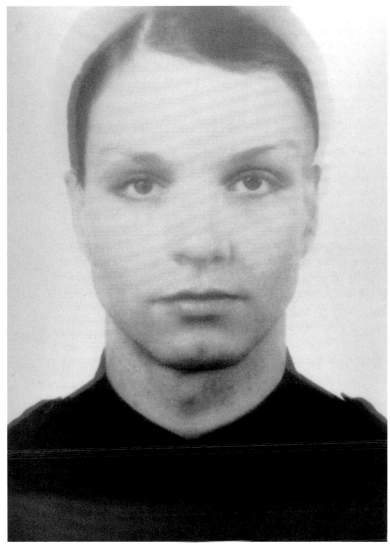

THOMAS RUFF

ANDERES PORTRAIT NR. 102/125 1994/95

(OTHER PORTRAIT, NO. 102/125)

Silkscreen print on paper, 73 x 56 cm

Courtesy of Galerie Mai 36, Zurich

THOMAS RUFF

ANDERES PORTRAIT NR. 71/65 1994/95

(OTHER PORTRAIT, NO. 71/65)

Silkscreen print on paper, 73 x 56 cm

Courtesy of Galerie Mai 36, Zurich

Ugo Rondinone

*1963, lives and works in Zurich and New York

Ugo Rondinone makes frequent use of collectively understood motifs that evoke clearly identifiable associations and enhance sensual perception at the visual level. Whether in photographs, landscape or circle images, sculptures or installations, Rondinone's playful experiments with everyday aesthetic phenomena touch a nerve and ultimately question the role of the artist as a communicator of personal experiences in the era of mass culture and media omnipresence.

In his extensive photoseries "I don't live here anymore," begun in 1995, Rondinone focuses on his own artist persona in an attempt to reflect the factors that constitute identity and to investigate shifts in perspective. His five most recent works are also concerned with elements of everyday aesthetics associated with conventionalized values. In this case, Rondinone used fashion photos of the international supermodel Eva Herzigova shot by star photographer Mario Testino for the English lifestyle magazine i-D. He altered these originals, however, by projecting his own face over that of Eva Herzigova, deliberately preserving her somewhat distant yet firmly fixed gaze. Covered with white make-up, the moustached face with its red eyes framed by dark shadows tends to suggest a disturbed nature rather than an ideal image of perfect beauty. Given these altered circumstances, even the red blood smears can no longer be viewed as a mere advertising trick meant to emphasize the existential aspect of the fashion on display. They congeal into symptoms of psychopathic-schizophrenic tendencies. With this polarizing imagery, Rondinone turns the visual language of advertising on itself, making it a projection screen for self-exposure in the style of a psychogram. Rondinone's self-construction is entirely in keeping with the mirror theory articulated by the French psychoanalyst Jacques Lacan. His concept of a self cannot be thought of as distinct from the outside world as communicated through the media, the self rather incorporates the manifold influences that affect the subconscious and ask for a serial production of self-images. Rondinone visualizes the idea of polymorphous identity at the level of presentation as well. The side-by-side arrangement of the photographs against a uniform background allows them to be viewed as a whole that nevertheless exhibits a variety of different facets.

ANNA HELWING

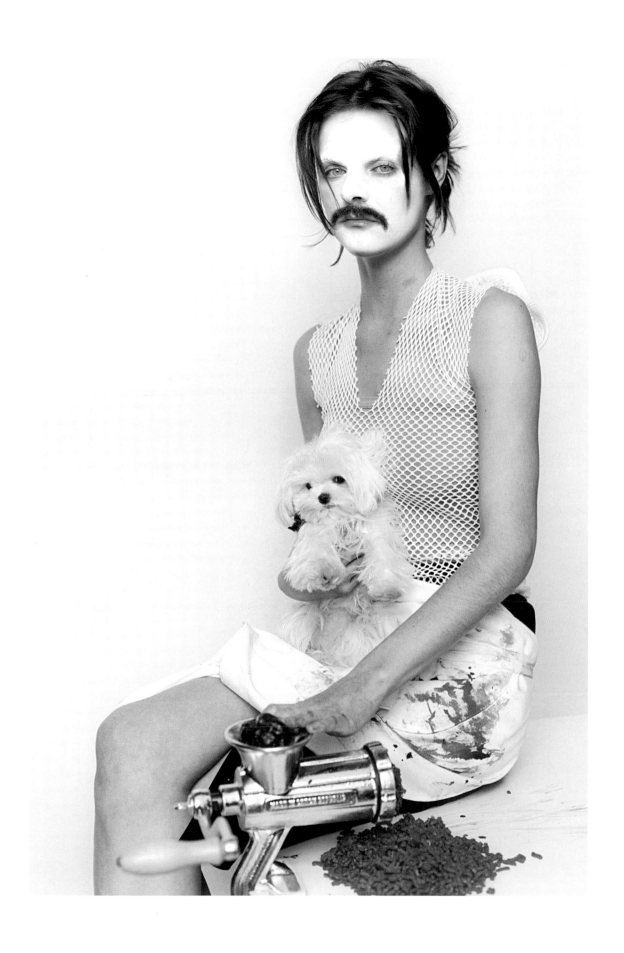

UGO RONDINONE
I DON'T LIVE HERE ANYMORE 1999
Color photograph on Plexiglass, 150 x 100 cm
Courtesy of Galerie Hauser & Wirth & Presenhuber, Zurich

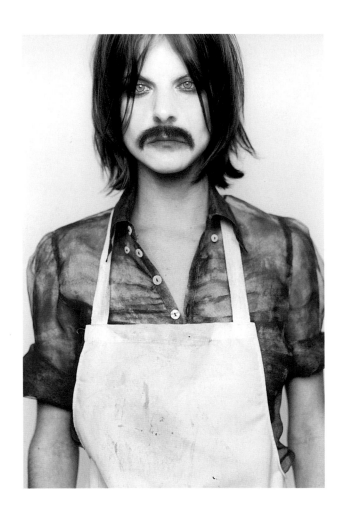
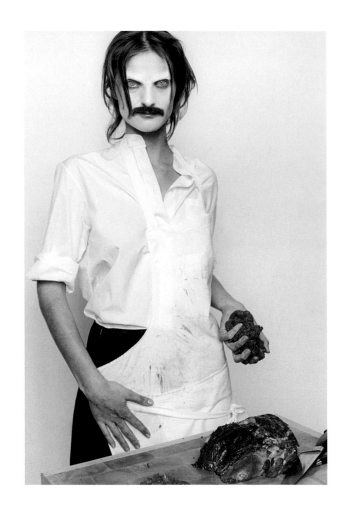

UGO RONDINONE
I DON'T LIVE HERE ANYMORE 1999
Color photographs on Plexiglass, 70 x 50 cm
Courtesy of Galerie Hauser & Wirth & Presenhuber, Zurich

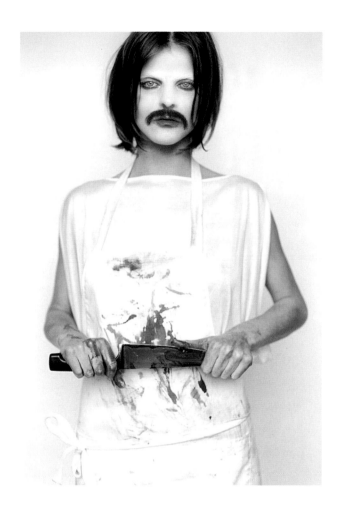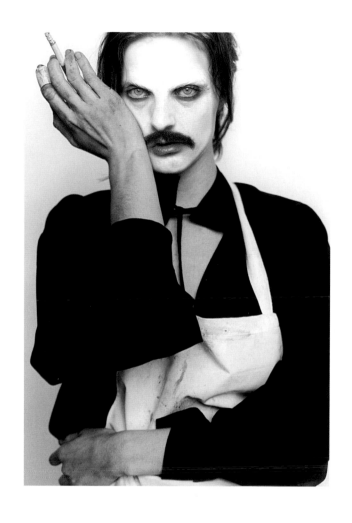

Vanessa Beecroft

*1969, lives and works in New York

Vanessa Beecroft has made a name for herself by presenting nude and semi-nude girls in museums and other spaces devoted to art—hybrid performances that appear to vascillate between fashion show and absurd situational drama. Each girl is held accountable for her own situation, derives enjoyment from it, is part of a whole, plays with its spectacularity. The girls stand around for brief periods of time. Sometimes they move. Thus far, the models have worn flesh-colored under-garments, stockings, reddish wigs, yellow wigs, strap sandals, red Strass bikinis by Gucci, or have appeared totally naked. All of the girls featured in a given performance—sometimes as many as twenty at once—must be similarly dressed. That is a rule. Thus their bodies are presented for comparison. They have the look of an army. Rebelling against nature. Because they are beautiful, of course. Strangely beautiful. And there is usually a significant gap between their thighs, which do not touch, as author Wayne Koestenbaum once pointed out with astonishment in *Artforum*. His question: Can that be healthy?

Recently, the Zurich-based magazine *Material* planned to feature a portrait of Vanessa Beecroft—a photographic portrait by the Japanese artist Noritoshi Hirakawa. A horrible idea. He works with many different women. With their beauty. With their strangeness. With their sexuality. With their difference. Beecroft doesn't like being photographed, but she agreed to the project nonetheless. Good. Surprising. Exciting. To make a long story short, she backed out shortly afterward. Hirakawa pursued his plans without her cooperation, and what we found in the magazine were three portraits of Vanessa Beecroft—without Vanessa Beecroft. A model had taken her place. Yet because the model appears in soft focus in all three photographs, we can be permitted to imagine that it is Vanessa Beecroft shown posing there. Beecroft herself has focused her attention lately on the US military. On US Marines, for example. They have replaced the girls in her earlier works. She glorifies these men in large-scale photographs. Where this obsession of Beecroft's will eventually lead is uncertain. Pleasant it is not.

MICHELLE NICOL

VANESSA BEECROFT
VB 34, PERFORMANCE ROYAL OPENING,
MODERNA MUSEET, STOCKHOLM 1994

Vibracolor Superglossy Print, 100 x 150 cm

Courtesy of Galerie Analix Forever, Geneva

Erik Dettwiler

*1970, lives and works in Zurich

Two hundred and three confrontations with the face of Erik Dettwiler, smiling mysteriously, distantly at passers-by on the steps leading to the museum café in eleven plotter strips showing the frames of an eight-second video clip.

The video was done for the performance entitled "Latte di Lupa" (Wolf's milk) at the Istituto Svizzero in Rome. Inside a black-velvet box, Eric Dettwiler freely associated sequences of words from live local radio. The artist's face could be observed in reflections on the outside of the box and as a video projection. An eight-second loop—a camera pan from the Victor Emmanuel monument to St. Peter's—formed the background for the face in its fixed circle in the foreground. The performance was presented with much the same structure, although with different thematic contents, at the Kunstmuseum Thun (*Alpenmilch*) and the Künstlerhaus Mousonturm in Frankfurt (*Performance-Index*). Isolated in the dark interior of the velvet box, Dettwiler presented a ceremony for the outside world at each site.

Erik Dettwiler's repertoire encompasses works of photo and video art, performances and spatial installations. His strategy involves the use of multiple media, which he ultimately presents as distinct from one another. The isolation of video stills is also an integral aspect of this generalizing approach. The artist's body passes through several phases of dramatic staging in different media, assuming features that range from the androgynous to the feminine.

The chronographic photographs of the 19th century analyzed entire sequences of motion on the basis of multiple exposures in series. They made it possible to deconstruct human movement and break it down into the dimensions of time and space. Such photographers as Eadweard Muybridge (USA), Thomas Eakins (USA), Jules-Etienne Marey (France) and Ottomar Anschütz (Germany) were fascinated with the perception of minute changes that had previously remained hidden from the human eye. They exploited photography's suitability as a tool for compiling precise visual information. This property is a component of one particular photographic aesthetic. The video still involves a different inherent aesthetic. Low resolution and subdued coloration, electronic artifacts and soft focus characterize these images of a moment. They are electronic pictures created for presentation via light projection, and they lose brilliance and sharpness when printed on paper. Stills often relinquish the narrative character of the video clip and thus often exhibit a decorative quality.

Erik Dettwiler's video stills reconstruct a situative presence. The artist's presence is grounded in his focus on the mediatization of essential human experiences, such as social isolation and death, self-perception and perceptions of the self by others and emotional indifference to these situations. Hidden phenomena find their place in the soft focus.

CLAIRE SCHNYDER LÜDI

ERIK DETTWILER
LATTE DI LUPA 1999 (WOLF'S MILK)
Bubble jet on paper
Installation along the steps to the museum café

313

Matthew Barney

*1967, lives and works in New York

[1] "Reality, fantasy and fiction amalgamate to form a single source of inspiration for a new type of personality." (Jeffrey Deitch)

[2] "Cremaster" is the title of a 5-part film series by Matthew Barney. Four parts have been realised up until now. The "cremaster" is the muscle which suspends the male gonads and plays a role in the temperature regulation. Barney is not interested in the function of this muscle as such, but rather in the image of the testicles in an extended sense. This image serves more or less to demonstrate that the will lacks the strength to gain control over the muscle. For no matter how much a man may try, it is impossible for him to draw his testicles up against the torso. Unless he is gripped by fear, in which case this happens automatically—the strength of the muscle suffices. And this is precisely the point that interests Barney: the muscles' potential. For they produce strength by overcoming obstacles, and in Barney's eyes, there are certain parallels that can be made to artistic expression and art criticism: intense training transforms not only the muscles, but also art and the definition of it.

[3] Matthew Barney is an actor, film writer, dramatic adviser, director, performer and sculptor: Matthew Barney is an artist, whose productions are a compound of the "sexual-physiological" and "mythical-religious." In them the "creation" and "divine-earnestness" can be seen to merge into each other resulting in cinematic games that climax in a mixture of sport, travesty and cabaret. The main protagonists wear seductive underwear, suspenders and high heels and, on top of props, and with props reminiscent of medical instruments, they perform acts whose significance hovers between pointless games and aesthetic calculation.

[4] Matthew Barney addresses in his art all the major issues of life such as desire, instincts, sexuality, pain and dreams. In so doing he launches an assault, as Clement Greenberg suggests, on the American art tradition, in which art deals mainly with pure forms and strives for the absolute.

[5] Matthew Barney makes films and carves them apart. The same way as a sculptor chips away at a block of marble, Barney draws everything out of his films that is needed for them to be born. Actors, architecture, interior decoration, props, costumes and scenery form an environment from which each of these elements can be separated to stand in their own right as autonomous sculptures, photographic or performance works. The photographic series "Drawing Restraint 7," for example, originates from one of his videos: two satyrs in the back of a white limousine, which is driven by a third satyr, are locked into a dispute over who should make a scratch mark with their horns on the inside of the glass sunroof. Such absurd and cryptic images reveal that it is nonetheless possible to produce art, despite the existence of artificially introduced hurdles.

KLARA WALLNER

LITERATURE

Christian Kämmerling, "Interview Matthew Barney," in: *Süddeutsche Zeitung Magazin*, no. 46, 1998, pp. 34ff.

Dieter Scholz, "Matthew Barney," in: *Sammlung Marx*, vol. 2, (Berlin, 1996), pp. 217ff.

Noemi Smolik, "Matthew Barney und Constantin Zvezdochotov," in: *Kunstforum*, no. 119, 1992, pp. 155ff.

Sabine B. Vogel, "Matthew Barney—Sport, Sex und Kunst," in: *Artis*, June 1992, pp. 40ff.

Christoph Doswald, "Der Körper als Instrument, Gespräch mit Matthew Barney," in: *Kunstforum*, vol. 135, 1996/97, pp. 312ff.

P.S. Matthew Barney is not gay although he keeps his objects wet with the help of a lubricant. He uses lubricants exclusively in order to take away the balance from his sculptures which makes them seem epic and aseptic at the same time. Matthew Barney is heterosexual and his topics are autoerotic. The different figures turning up in his work are, all in all, a single body that can be anything: man or woman, architecture, a country or a still life.

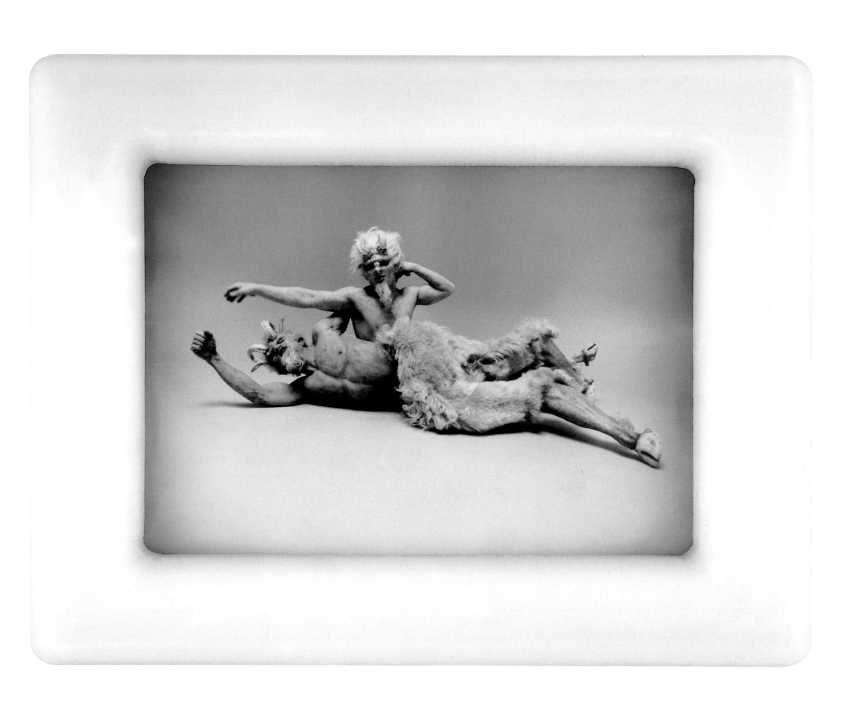

MATTHEW BARNEY
DRAWING RESTRAINT 7 1993
Color photogaphs (nylon frame), 7 parts, 30.5 x 40.6 cm each
Collection Zellweger-Luwa AG, Uster

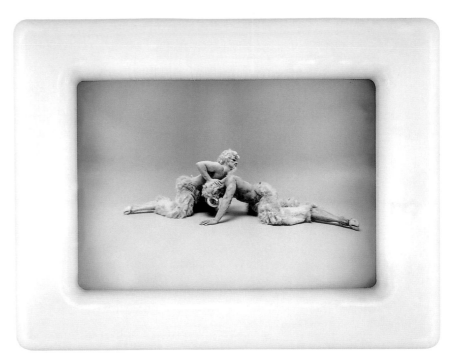

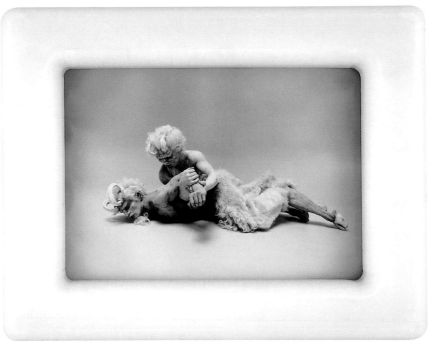

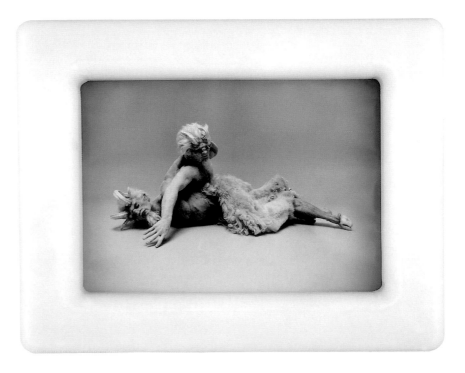

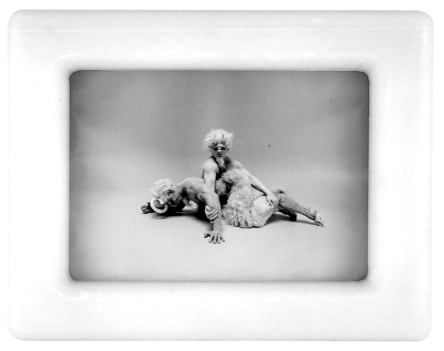

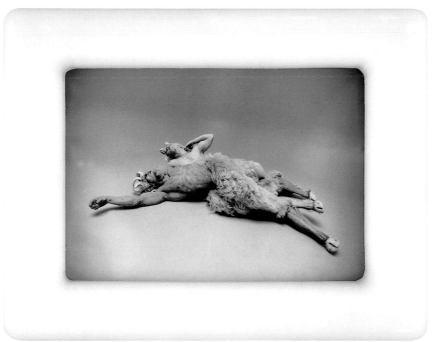

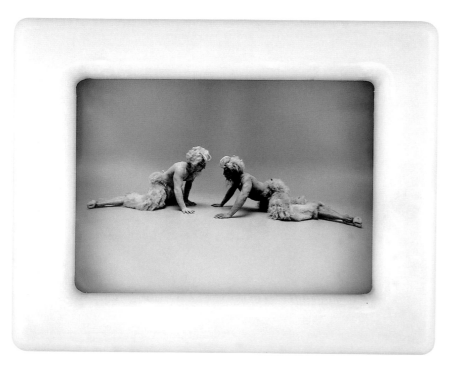

Inez van Lamsweerde

*1963, lives and works in New York

Her name is Rebecca. Just like the title of the photograph in which she appears. Rebecca is lascivious. She hasn't got a lot on, just a light blue checked bikini. She is also wearing stilettos with platform soles and transparent straps. And an ankle chain. In one hand she's holding a cigarette. It is hard to say if it's the left or the right hand. That's because Rebecca has her head on backwards. Or let's put it another way: Rebecca, who seems suspended in space, has her back turned to us with her legs flirtatiously bent at the knees, while she stares us straight in the eyes. If you therefore orient yourself by her head, then it is the left hand, but in relation to her body it is the right. Yet despite this biological defect, there can be no doubt that Rebecca provides us with quintessential physical beauty, which is communicated through an assortment of signs and tropes appropriated from the world of high fashion. The incongruous head is nothing but a glitch. It ensures that Rebecca does not end up a common sex kitten. She is perfect. Just as perfect as any picture can be. A manipulated picture. However, she is a long way from being just a Barbie doll. The Rebecca construct rings of insane mutants, of cyborgs, of the abnormal. Baudelaire once said: "There is always something odd about beauty." This *odd* body called Rebecca is an object, a thing. It becomes fetishistic. A fetish is a substitute for what one is really trying to attain. It satisfies one's yearnings. The fetishist says: "Je sais bien, mais quand même" (I know very well, nontheless ...). In this case: I know it is a computer-generated image, but I can't help myself, I desire it. Suddenly, the Rebecca-body assumes another meaning, something that means obsession for other people. Now it becomes evident: Rebecca's hyperbolic glamour is more than just a picture on the topic of the superficial beauty of the body or an image about the beauty of the image. The same applies to Lamsweerde's other photographs. They have an eerie beauty about them. And through the commercial distribution of millions of them they become flippant agencies, the subjects of both criticism and praise.

MICHELLE NICOL

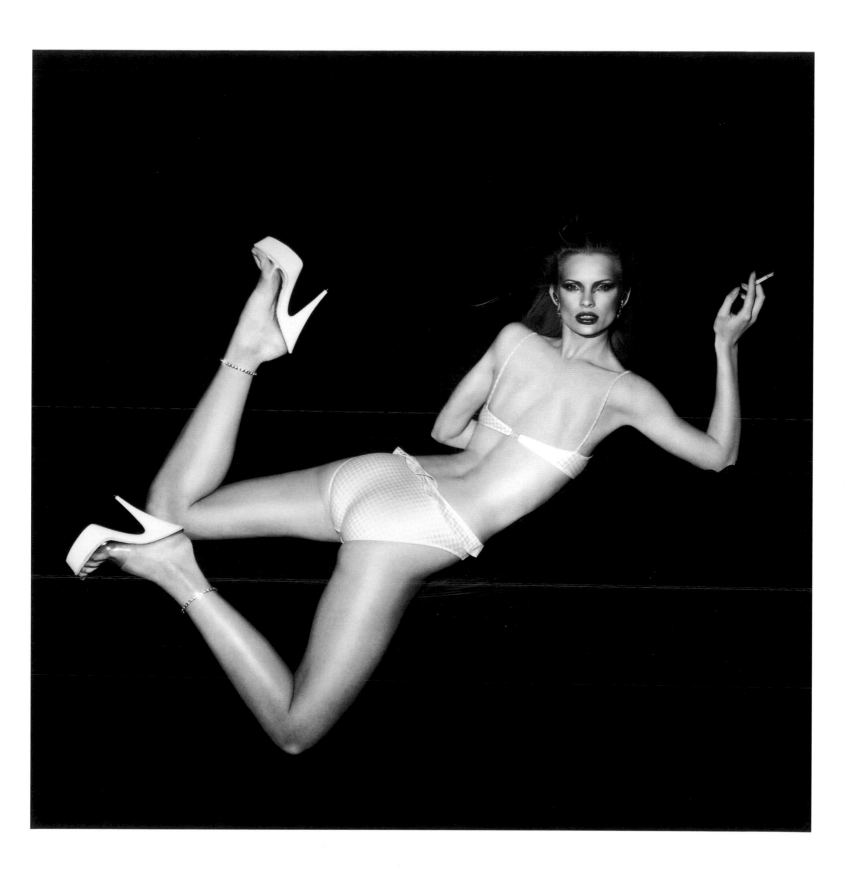

following page:

INEZ VAN LAMSWEERDE / VINOODH MATADIN
**A TWO TONE STRECH SATIN
AND LACE PANTSUIT PETRA** 1994
Duraflex print on aluminum, 120 x 180 cm

Jasmin Kienast
(Courtesy of Matthew Marks Gallery, New York)

INEZ VAN LAMSWEERDE / VINOODH MATADIN
REBECCA 90—61—93 1993
Color photograph on dibond, 100 x 100 cm
Courtesy of Matthew Marks Gallery, New York

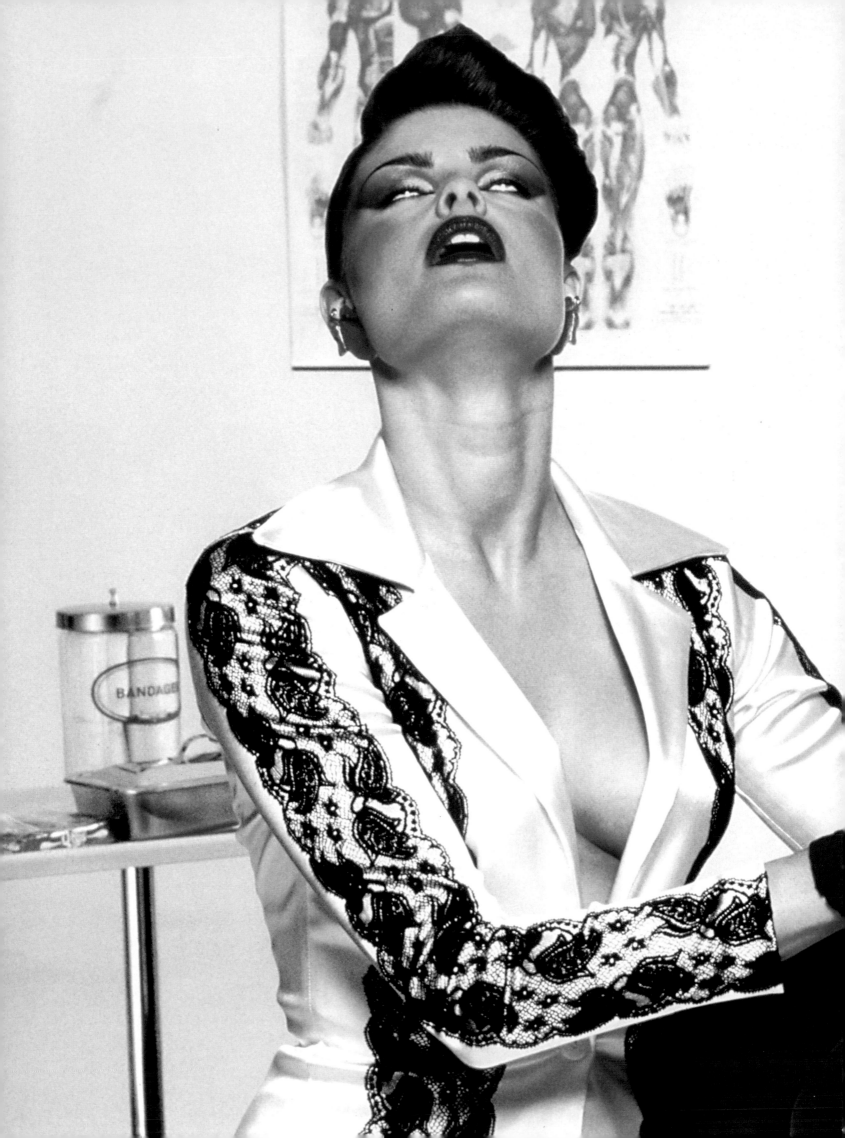

Mariko Mori

*1967, lives and works in New York

Mariko Mori is always present in her works as the main protagonist. Futuristically dressed, she resembles a visitor from a distant galaxy. Her works confront the observer with fictitious roles and scenery that appear to have been adopted from computer games or Japanese comics. This serene juxtaposition of everyday life and fiction is captured in her photos. As an emissary of a highly technological future, Mori mediates between different states of reality such as (childlike) fantasy and the adult world, cybertronics and the planet earth—in short: between the virtual and the real.

In her earlier photographs, the art persona Mariko Mori used to appear in real settings: for example, as a fairy-like office employee ("Tea Ceremony") during a business meeting or as a warrior from the stars ("Warrior") in an amusement arcade. The costumes are designed by her, products of her fashion-school training. She is able to employ her artistic identity within these sociorealistic works as a means of infiltrating the banalities of every day life in a playfully subversive manner: "Mori does not make an analytical commentary on modern Japan's fragile plastic world, instead she metamorphoses to embody the social reality."[1] This dainty warrior with her perfect makeup does not aim to be threatening. As a kind of subtle version of her American counterpart, Lara Croft, she seems to be trying to recruit players from the surrounding consoles to unite forces and overcome with impish verve the evil forces on earth. She is an amiable cyborg, a synthetic phenomenon deeply rooted in the age of intelligent weapons and genetic engineering.

In her self-portraits, Mariko Mori examines the potential of contemporary visual codes: "She uses her body like a lens to capture today's torrent of images and through certain exaggerations and reinforcements, she reveals to us what the aim of this deluge really is."[2] She skillfully toys with the fluid transition between fiction and reality and even with the occasional merging together of realness and simulation evident in the late nineties. This realm is the playing field for the seductive strategies that she employs in her images.

GIANNI JETZER

1 Norman Bryson, "Unwiderstehliche Zukunft. Mariko Moris Techno-Aufklärung," in: *Parkett*, no. 54, 1998/99, p. 85.

2 Ibid.

MARIKO MORI
GENESIS (SOAP BUBBLES) 1996
Duratan print (three-dimensional) in light box,
180 x 120 x 35 cm
Ringier Collection, Zurich

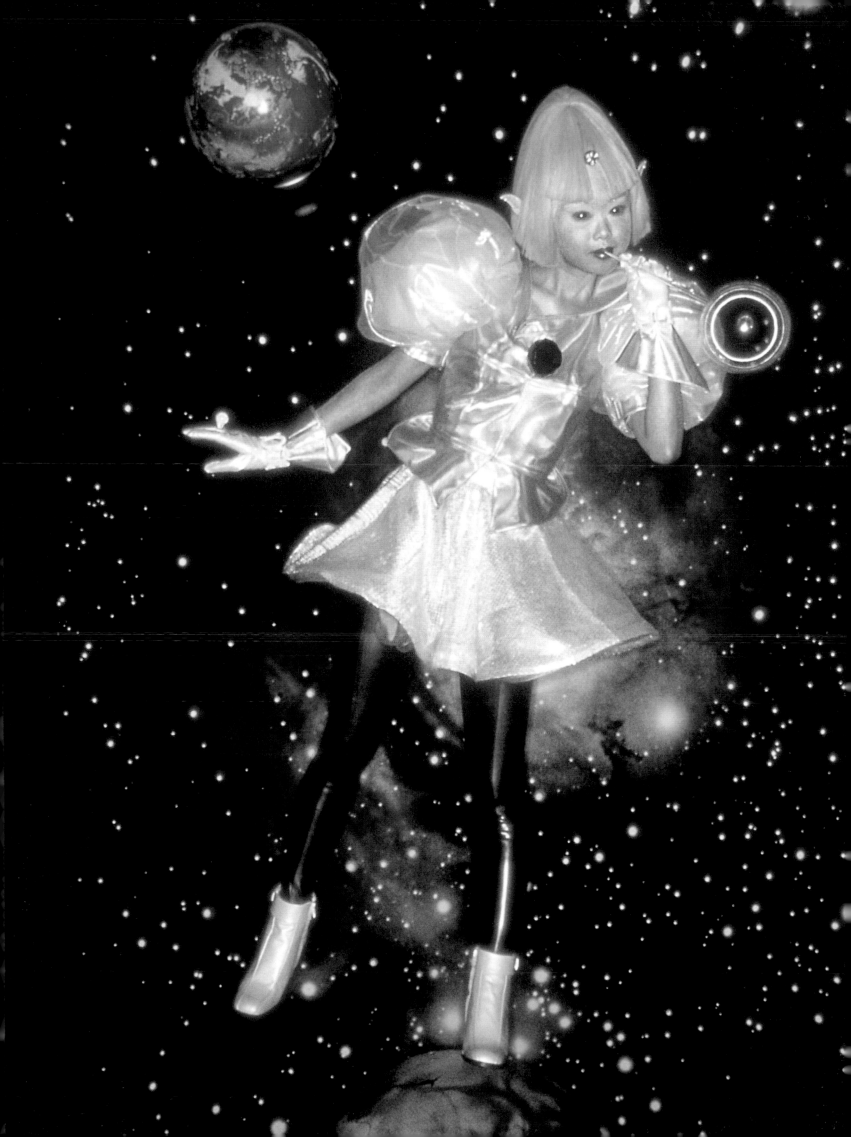

THE AUTHORS

CARL AIGNER *1954, author of numerous publications and lectures on photography, new media and contemporary art; active as a curator in Austria and abroad; university lecturer and adjunct instructor at the Hochschule für angewandte Kunst in Vienna; founder and editor of the art journal *Eikon—Internationale Zeitschrift für Fotografie und Medienkunst* (published in Vienna since 1991); managing director / art director of the Kunsthalle Krems since 1997.

HOLGER EMIL BANGE *1967, art historian, lives and works in Berlin and Cologne; music project in collaboration with Max Mohr since 1998; involvement in numerous projects in the fields of music and art, including *Nonchalance Revisited*, Berlin, Akademie der Künste, 1998; *Beige and Sneakers*, Berlin, BüroFriedrich, 1998; *Die Tödliche Doris—Kunst*, Berlin, Kunstamt Kreuzberg / Bethanien, 1999; *Zum 25. Todestag von Holger Meins*, Berlin, Volksbühne, 1999.

STEFAN BANZ *1961, artist, lives and works in Lucerne.

RALF BARTHOLOMÄUS *1956, director of the Galerie Weisser Elefant in Berlin since 1987; has written occasional music and art reviews.

DANIEL BAUMANN *1967, conservator at the Adolf-Wölfli-Stiftung, Kunstmuseum Bern; works as a freelance critic and curator; lives in Geneva.

KATHRIN BECKER *1965, art historian, curator and publicist; lives and works in Berlin. Selected exhibitions / publications: *Stalin's Choice—Soviet Socialist Realism 1932–56*, New York, P.S. 1, 1993 (cat.); *The Institute of Theore(c)tical Painting*, Berlin, Galerie Likörfabrik, Kunst-Werke, 1994/95; *pop mix / vol. I*, Berlin, NBK, 1996 (cat.), and *pop mix / vol. II*, Berlin, shift, 1996, art club berlin, Berlin / Vienna / Barcelona, 1997/98; *Last House on the Left*, Stockholm, 1998 (cat.), crossLinks, Berlin, Marstall, 1999 (cat.).

SILKE BENDER *1968, art historian, master's thesis on Pierre et Gilles; she now works as a journalist in Berlin, Paris and Los Angeles.

PAOLO BIANCHI *1960, culture publicist, art critic and freelance exhibition organizer. He is the senior curator at the O.K. Zentrum für Gegenwartskunst in Linz; guest professor at the Universität für Kunst und Gestaltung Linz; guest editor of the journal *Kunstforum*; Bianchi lives and works in Baden (Switzerland).

MANUEL BONIK *1964, works as an artist and author in Berlin, critic for *Flash Art*, *Spiegel Online* and *Vogue*; collaboration with Oswald Wiener and Robert Hödicke on *Eine elementare Einführung in die Theorie der Turing-Maschinen*, Vienna / New York, Springer, 1998; editor of the art journal *01*; exhibition activities in 1999: Eigen+Art, Berlin; Schirn Kunsthalle, Frankfurt; Stalke Galleri, Copenhagen; see also *www.art-exchange-berlin.de*.

REINHARD BRAUN Lives in Graz, freelance author and curator; publications, lectures and research projects on the history and theory of photography and the media; project-oriented collaboration with artists in the field of media art (selection): *on dis/place/ment*, steirischer herbst 97; *Giving the Self a Home*, Graz, Forum Stadtpark, 1999; see also *http://thing.at/braun*.

ELISABETH BRONFEN Literary and cultural scholar, author, lives in Zurich; her publications include *The Knotted Subject: Hysteria and Its Discontents*, 1998; *Over Her Dead Body: Death, Femininity and the Aesthetic*, 1992; *Dorothy Richardson's Art of Memory: Space, Identity, Text*, 1999.

MAIA DAMIANOVIC Lives and works in New York. The curator and art critic studied at the Ecole des Beaux Arts and the Sorbonne in Paris and at the University of Toronto, Canada. Damianovic writes for *Tema Celeste* and *Artecontemporanea*. She recently curated the exhibitions *Transformal*, Secession, Vienna, and *Dissin' the Real*, New York, Lombard Freid Gallery / Vienna, Galeria Krinzinger.

CHRISTOPH DOSWALD *1961, exhibition organizer and art critic (*Parkett*, *Kunstforum, neue bildende kunst, Siksi, Facts*, and others); lives and works in Zurich and Berlin; publications and exhibitions include *Alberto Giacometti*, Kunsthalle Wien, Vienna, 1996 (cat., ed. in collaboration with Toni Stooss); *Nonchalance*, Bienne / Berlin, Centre PasquArt / Akademie der Künste, 1997/98; *stefan banz: i built this garden for us*, Zurich, Edition Patrick Frey, 1999 (ed.).

BEATE ENGEL *1964, lives and works in Bern, art critic and curator; director of the Berner Stadtgalerie since April 1999; catalogue articles include "Interview with JOKO," in: *Wenn zwei in ihrem Namen sich treffen*, cat. and CD-ROM, Landesmuseum Innsbruck, 1998; "Der Zeitgeist aus der Antike," in: *Biefer / Zgraggen, Skulpturen*, Linz, O.K. Centrum für Gegenwartskunst, 1998; "An der Grenze schweben," in: *Bessie Nager. Offene Türen*, Meggen, Galerie Benzeholz, 1998.

OKWUI ENWEZOR Critic, curator, author, art director of *documenta XI* (2002) in Kassel; numerous articles on contemporary African art; has written for such international art journals as *Nka: Journal of Contemporary African Art*, *Flash Art*, *Atlantica*, etc. Enwezor is currently at work on a book entitled *Structural Adjustment*, a discussion of the work of African artists of the nineties. He lives and works in New York, Chicago, London and Kassel.

GERRIT GOHLKE *1968, lives in Berlin; author of essays and critical art reviews. He has worked since 1994 as an editor on the staff of *Be Magazin* and at the Künstlerhaus Bethanien in Berlin, where he has also assumed responsibility for program planning and concept development for the Media Arts Lab, a media studio devoted to Internet art.

ANNA HELWING *1968, art historian (graduate thesis on Franz West) and art critic; lives and works in Zurich; has written for the *Neue Zürcher Zeitung*, *Kunst-Bulletin* and other publications.

JENNIFER HIGGIE Australian author, lives in London and works as review editor for the art journal *Frieze*.

GIANNI JETZER *1969, lives and works as an art critic and assistant curator at the migros museum für gegenwartskunst in Zurich.

JEAN-YVES JOUANNAIS *1964, art critic and exhibition organizer; lives in Paris. He was editor-in-chief of the French art journal *artpress* and now teaches at the Université Paris VIII. Jouannais most recently organized an exhibition on the theme of idiocy, which opened in Moscow in December 1999. His most important publications include *Artistes sans Oeuvres*, Paris, Hazan, 1997. His most significant exhibition to date was *Histoire de l'infamie*, Venice Biennale, 1995.

TOMAS KADLCIK Studied philosophy and art history; has authored small literary works and photo projects; lives and works as a photo editor and freelance author in Zurich.

KLAUS KLEINSCHMIDT *1959, lives and works in Wiesbaden as a photo critic (with articles published in *Frankfurter Rundschau*, *Focus*, *Neue Zürcher Zeitung*, among others); runs *photonet*, an agency for contemporary photography.

THOMAS KOERFER Film and theater director, lives in Zurich. His films include *Der Tod des Flohzirkusdirektors* (1972), *Der Gehülfe* (based on a work by Robert Walser, 1994), *Die Leidenschaftlichen* (based on Goethe's Werther, 1981), *Noch ein Wunsch* (based on Adolf Muschg's novella, 1987), *All Out* (1989), *Die Afrikanische Nacht* (1999). Theater productions include *Claus Lymbacher* (Hürlimann / Inglin, Schauspielhaus Zurich), *Die Reinheit des Mörders* (Nothomb / Koerfer, Schauspielhaus Zurich).

JUTTA KOETHER Artist, lives and works in New York.

MAX KOZLOFF Lives and works in New York; critic and author of numerous books on photography, including *Cubism / Futurism, Now becoming then, Lone Visions Crowded Frames—Essays on Photography*; staff editor at *The Nation*, 1961-68; chief editor at *artforum*, 1974-76; Kozloff teaches at the School of Visual Arts, New York. He has also gained recognition through his own photography; exhibitions in the US and Europe.

ANDREAS KRASE *1958, art historian, concentration in the history of photography; lectures on the history of photography at the HGB Leipzig (1985–93); adjunct lecturer at the Fachhochschule für Technik und Wirtschaft Berlin; director of the Krone-Archiv at the TU Dresden since 1999; numerous publications on contemporary and historical photography, including most recently *Fritz Kühn. Das photographische Werk 1929–1967* (Berlinische Galerie, 1998).

HOLGER KUBE VENTURA *1966, lives and works in Hamburg and Constance; art scholar, critic and curator; member of the board of directors of the Kasseler Kunstverein; editor of *Dekonstruktion x Video*, Kassel, 1994, and *Surfing Systems*, Kassel, 1996; at work since 1997 on a post-graduate project on modified concepts of art and politics in the nineties.

GERHARD JOHANN LISCHKA *1943, cultural philosopher and author; book publications include *Splitter, Ästhetik*, Bern, 1993; *Schnittstellen. Das Postmoderne Weltbild*, Bern, 1997; teaches at the F & F Kunst- und Medienschule, Zurich, the Hochschule für Theater, Bern, and the San Francisco Art Institute; has organized numerous symposia on current issues in the philosophy of aesthetics; editor of the paperback series *Um 9. Am Nerv der Zeit*; editor of many issues of *Kunstforum*.

MICHELLE NICOL *1966, studies in art history and film; art critic for *Parkett, Self Service, Neue Zürcher Zeitung* etc.; director of *glamour engineering*; she has served as curator of contemporary art at the Museum Ludwig, Cologne, since 1999, and is currently working with Nicolas Trembley on *Album*, a photo book on teenage culture. Michelle Nicol lives and works in Cologne and Zurich.

ALI ONUR *1964, lives and works in Stuttgart; instructor at the Staatliche Akademie der Bildenden Künste, Stuttgart; a freelance art and architecture critic, he has written for the *Frankfurter Allgemeine Zeitung*, the *Stuttgarter Zeitung* and *neue bildende kunst*.

KATHRIN PETERS *1967, lives in Berlin; studied communication design in Essen and art and cultural sciences in Berlin; she is currently working on her dissertation on sensuality in photography in the years around 1900.

THOMAS PFISTER Conservator of the photo collection and director of the film program at the Kunstmuseum Bern.

URSULA PRINZ *1942, art historian. Deputy Director of the Berlinische Galerie since 1977; exhibitions include *Androgyn*, Berlin, Neuer Berliner Kunstverein in der Akademie der Künste, 1986; *Stationen der Moderne*, Berlin, Berlinische Galerie im Martin-Gropius-Bau, 1989; *Berlin—Berlin*, Venice Biennale, 1990; *Berlin—Moskau*, Berlin, Martin-Gropius-Bau / Moscow, Pushkin Museum, 1996. Her most recent publication is *Kunst im Foyer. Zehn Jahre Malerei in Berlin*, 1989–1999, Berlin, Gebr. Mann, 1998.

HANS RUDOLF REUST *1957, art critic; director of the art program at the Hochschule für Gestaltung, Kunst und Konservierung, Bern; numerous publications in catalogues and international journals; a regular contributor to *artforum*, *Frieze* and *Kunstforum*; developed the concept for the exhibition *ex passim*, Bern, Kunsthalle, 1994; project manager for the planned Museum für Kunst der Gegenwart, Bern.

BEATRIX RUF *1960, conservator at the Kunsthaus Glarus until 1998; curator at the Kunstmuseum des Kantons Thurgau; instructor at the Hochschule für darstellende Kunst, Bern; exhibitions with and publications about such artists as Jenny Holzer, Marina Abramović, Josef Kosuth, Muda Mathis, Eija-Liisa Ahtila, Olaf Breuning, Fabrice Hybert, Liam Gillick, Ugo Rondinone.

JÖRN SCHAFAFF *1970, studied applied cultural sciences in Lüneburg; responsible for exhibition and acquisition activity for the collections of the Südwestdeutsche Landesbank; exhibition and catalogue *KUNST . . ARBEIT*; has authored numerous articles and represented various institutions and artists.

KARIN SCHICK Studied art history, philosophy and German language and literature in Tübingen and at Tufts University in Boston; doctoral dissertation on the reception of Cézanne in the US (1998); staff scholar at the Hamburger Kunsthalle since 1998; involved in preparations for the exhibition *Andy Warhol. Photography*, Hamburg / Pittsburgh, 1999/2000; she is currently working on an exhibition devoted to Sonia and Robert Delaunay.

ANDREAS SCHMID *1955, lives in Berlin, works as an artist, critic and curator; numerous exhibitions in Germany and abroad; he has specialized in contemporary Chinese art: extensive travels and research activity in China and Japan; he has been a member of the board of the European Council of Artists (ECA) for the Internationale Gesellschaft der Bildenden Künste (IGBK); spokesman for the board of the IGBK since 1999.

AXEL SCHMIDT *1959, freelance critic in the fields of art, photography, literature and film; photo editor for the Archiv für Kunst und Geschichte in Berlin; manager of the Paris branch; photo editor for *John Phillips, Freier Geist in unruhiger Zeit*, Zurich / Berlin / New York, Scalo Verlag, 1996; photo editing and introduction for *Paul Almasy, Zaungast der Zeitgeschichte*, Bern, Benteli Verlag, 1999; currently doing research on the work of Daniel Frasnays.

CLAIRE SCHNYDER LÜDI *1961, lives in Thun and works as a freelance curator in Bern; exhibitions include *Contes à rebours: Heinrich Gartentor und Jan Kopp*, Kunsthalle Palazzo, Liestal, 1998; *Heartbreak Hotel—Vollpension*, Thun, 1999, see also *http://www.heartbreakhotel.ch*; collaboration with the publishing house "report—Künstler verlegen Künstler."

ULRICH SCHÖTKER *1971, lives in Berlin and Madrid; artist, critic, art agent; has worked as a staff scholar for *documenta X*, the Goethe Institute Madrid, BüroFriedrich, Berlin; collaborated as co-curator in the realization of the exhibition project *Nur Wasser lässt sich leichter schneiden*, Hamburg, 1999.

HOLLY SOLOMON New York gallery owner.

URS STAHEL *1953, Director of the Fotomuseum Winterthur; curator, editor and/or author of numerous exhibitions and publications, including *Wichtige Bilder—Fotografie aus der Schweiz*, Zurich, 1990; Paul *Graham—New Europe*, Winterthur / Manchester, 1993; *Lewis Baltz: Regel ohne Ausnahme*, Zurich / Berlin / New York, 1993; *Peter Hujar—Eine Retrospektive*, Zurich / Berlin / New York, 1994; *Jean-Louis Garnell: Werke 1985–95*, Winterthur, 1995; *Bilderzauber—Ein seriöses Spiel*, Winterthur, 1996; *Weltenblicke—Reportagefotografie und ihre Medien*, Zurich, 1997; *Unheimlich*, Winterthur, 1999; *Young—Neue Fotografie in der Schweizer Kunst*, Basle, 1999.

JURI STEINER *1969, art historian and exhibition organizer in Lausanne and Zurich; has published articles in the *Neue Zürcher Zeitung*, *Parkett*, *Neue Bildende Kunst*, *Das Magazin*, *Merian*, and *Weltwoche*, among others, and in numerous exhibition catalogues; his last exhibition, *Freie Sicht aufs Mittelmeer. Junge Schweizer Kunst*, Kunsthaus Zurich / Schirn Kunsthalle, Frankfurt, was co-curated with Bice Curiger; he is currently on the art committee for *Expo.02*.

WOLF-GÜNTER THIEL Lives and works as a publicist and cultural engineer in Berlin.

CHRISTINA TSCHECH *1969, lives and works in Paris; studied history and art history at the Sorbonne; master's thesis (1997): *Oskar Kokoschka et la Poupée*. DEA (1998); *Les photo-actions de Günter Brus et de Rudolf Schwarzkogler*. Thesis (since 1998): *Artistes démiurges et artistes mutants: La marionnette dans l'art du XXe siècle*; collaboration on the catalogue raisonné of the works of Franz West; collaboration on the exhibition *L'autre moitié de l'Europe*, Paris, Galerie Nationale du Jeu de Paume, January to May 2000.

BRIGITTE ULMER *1963, lives and works as a culture journalist in Zurich; she has written for a number of different Swiss media since 1987, including *Cash*, *Tages-Anzeiger*, *Basler Zeitung*, etc. Her fields of specialization include photography and literature; she has written portraits and critical reviews on Nan Goldin, Henri Cartier-Bresson, René Burri, Stefan Banz; her most recent publication, *Zahlen bitte!*, a report on the state of funding and sponsorship projects for photography in Switzerland, appeared in the 1999 Kulturbericht (culture report) of the Swiss Ministry of Culture.

LUDMILA VACHTOVA *1933 in Prague; art critic, art historian, art journalist; has worked in Zurich since 1973 writing for *Neue Zürcher Zeitung* (1974–1982) and *Tages-Anzeiger* (1983–89), since 1990 for *Weltwoche*. Her book publications include *František Kupka*, Werkmonografie, Prague, Odeon-Verlag / New York, McGraw Hill, 1968/69; *Varlin*, Frauenfeld, Huber-Verlag, 1978; *Eigentum ohne Besitz—Malerin Hanny Fries*, NZZ Verlag, 1999; Czech Prize for Art Criticism, 1968.

VIOLA VAHRSON *1968, art historian; in 1996 guest curator for the photography exhibition *Permanent—Impermanent* at the Jacksonville Museum of Contemporary Art, Florida, USA, 1997–99; internship at the Berlinische Galerie, Landesmuseum für Moderne Kunst. She is currently at work on her dissertation, *Wiederholung als künstlerische Strategie in der zeitgenössischen Kunst*.

TOBIAS VOGT *1970, art historian, lives in Berlin; currently at work on a book on 20th-century artists and patrons of art.

KLARA WALLNER Lives and works in Berlin; freelance curator and publicist; guest curator at the Literaturforum of the Brechthaus, Berlin, 1990–94; founded the travel institute *art club berlin* in 1997; curator at PODEWIL, Berlin since 1999; exhibition projects include … *space without art*, exhibition trilogy, Berlin, 1990–93; *Landschaft mit dem Blick der 90er Jahre*, Koblenz, 1995; *Juergen Teller—The hidden Brecht*, London, Cubit Gallery, 1998; *come and find out*, Berlin, PODEWIL—Center for contemporary arts, 1999.

PETER WEIERMAIR *1944, studied German language and literature, art history and philosophy in Innsbruck and Vienna; director of the Frankfurter Kunstverein, 1980–98; curator of *Prospects* since 1986; director of the Museum für moderne und zeitgenössische Kunst, Rupertinum in Salzburg, since 1998.

THOMAS WULFFEN *1954, art theorist, critic and curator; lives and works in Berlin; staff writer for various journals; has written articles for numerous catalogues; editor of the documentary *Betriebssystem Kunst*, *Kunstforum*, Cologne, 1994; has curated various exhibitions, including most recently *Laboratorium Berlin—Moskau*, Moscow, 1996 and *Le Futur du Passé*, L. A. C., Sigean, 1998. He is currently concerned with non-linear processes in contemporary art.

ANNELISE ZWEZ *1947, studies in Grenoble, Cambridge and Zurich; has written critical art reviews for daily newspapers and art journals in Switzerland and abroad since 1972; author of numerous articles for catalogues and books; part-time culture editor of the *Bieler Tagblatt* since 1998; lives in Lenzburg and Twann (Switzerland).

This volume was published for the exhibition *Missing Link—Menschen-Bilder in der Fotografie (Missing Link—The Image of Man in Contemporary Photography)* at the Kunstmuseum Bern, Switzerland

Kunstmuseum Bern
Editor: Christoph Doswald
Editorial team: Ulrich Schötker, Holger Emil Bange

Edition Stemmle
Translation from the German: John S. Southard, Julian Cooper
Editorial direction: Sara Schindler, Andreas Ritter

Design: Stephan Fiedler, Berlin, Germany
Typesetting: F&S Satz und Montage, Rielasingen, Germany
Litho: Licht und Tiefe, Berlin, Germany
Printed and bound by Graphic Group Van Damme BVBA, Oostkamp, Belgium

Photographic credits: Hansueli Jordi (pages 165-167), Franziuska Krammel (page 127), Kurt Kren (page 129), Peter Lauri (pages 79, 89-91, 101, 103, 117, 119, 121, 131-133, 135-137, 139-141, 169-171, 179-181, 187-189, 193-195, 219, 221, 229, 237-239, 241-243, 265, 267-269, 291), Eric Pollitzer (page 55), Dominique Uldry (pages 261-263)

Cover photograph: Daniele Buetti LOOKING FOR LOVE 1997, color photograph on aluminium, 110 x 75 cm, Courtesy of Galerie Ars Futura, Zurich

Endpapers: Erik Dettwiler LATTE DI LUPA 1999, Bubble Jet on paper

Sponsored by

ISBN 3-908163-12-9